The Sculpture of Nancy Graves

The Sculpture of Nancy Graves

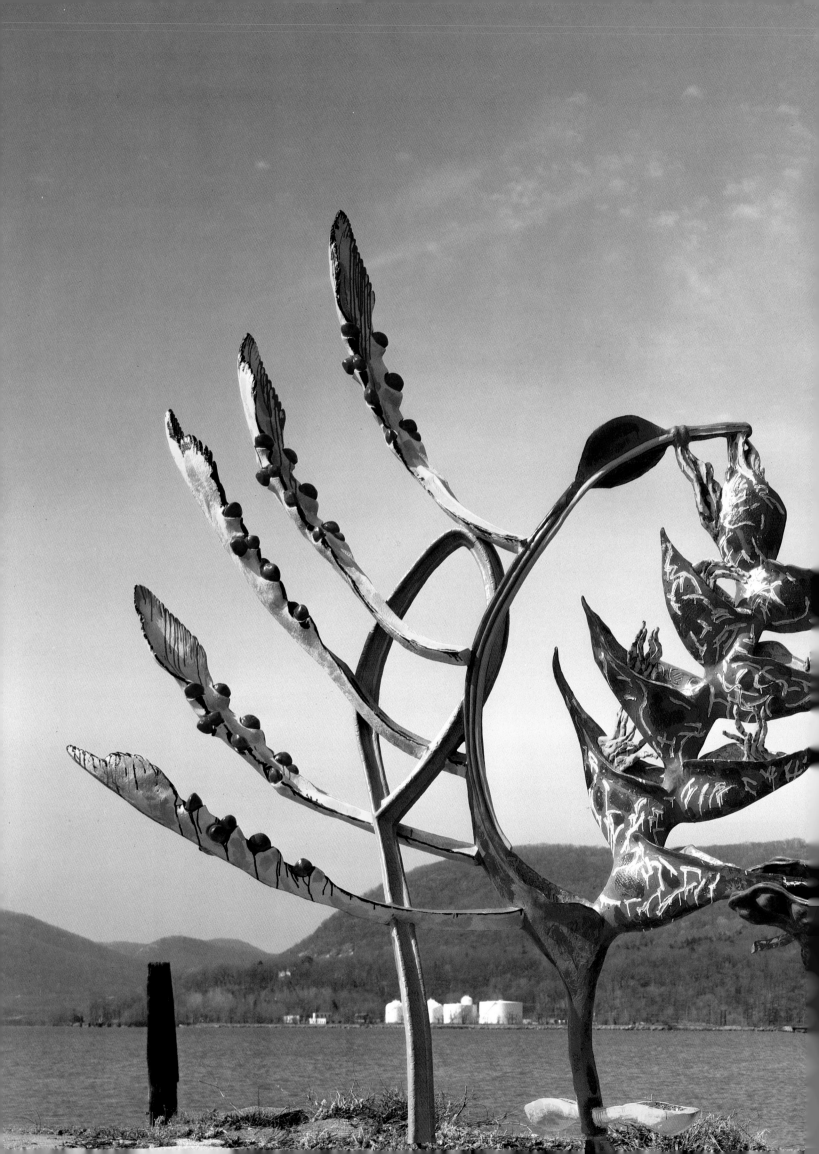

The Sculpture of Nancy Graves

A *Catalogue Raisonné*

With Essays by

E. A. Carmean, Jr. Linda L. Cathcart Robert Hughes Michael Edward Shapiro

Hudson Hills Press, New York
In Association with the Fort Worth Art Museum

First Edition

© 1987 by the Fort Worth Art Museum
All rights reserved under International and Pan-American
Copyright Conventions.

Published in the United States by Hudson Hills Press, Inc.,
Suite 1308, 230 Fifth Avenue, New York, NY 10001-7704.

Distributed in the United States, its territories and possessions,
Mexico, and Central and South America by Rizzoli International
Publications, Inc.
Distributed in Canada by Irwin Publishing Inc.
Distributed in the United Kingdom, Eire, Europe, Israel, and the
Middle East by Phaidon Press Limited.
Distributed in Japan by Yohan (Western Publications Distribution
Agency).

Editor and Publisher: Paul Anbinder
Copy editor: Eve Sinaiko
Index: Gisela K. Knight
Designer: Christopher Holme
Composition: U.S. Lithograph, Typographers
Manufactured in Japan by Toppan Printing Company

Library of Congress Cataloguing-in-Publication Data

The Sculpture of Nancy Graves.

 Bibliography: p.
 Includes index.
 1. Graves, Nancy, 1940– –Catalogues raisonnés.
I. Graves, Nancy, 1940– II. Carmean, E.A.
III. Fort Worth Art Museum.
NB237.G74A4 1987 730'.92'4 86-29970
ISBN 0-933920-78-4 (alk. paper)

Frontispiece: *Sequi* (cat. no. 208)
Cover illustrations: *Tanz* (cat. no. 175)

Contents

List of Text Illustrations

Acknowledgments

This publication, and the exhibition of Nancy Graves's spectacular sculpture which it celebrates, required the time and efforts of a great many dedicated individuals. Foremost is Nancy Graves herself, who has given most generously of her daily schedule for the past three years in the realization of this venture. Her assistants, Mina Roustayi and especially Deborah Beblo, have also been of invaluable aid.

In addition to presenting all of Nancy Graves's sculpture, this book offers insight into her work from three noted authorities: Michael Edward Shapiro, curator of nineteenth- and twentieth-century art, the Saint Louis Art Museum; Linda L. Cathcart, director, Contemporary Arts Museum, Houston; and Robert Hughes, art critic for *Time* magazine. We are most grateful for their contributions. This volume also contains the catalogue raisonné of the sculpture, prepared by Ruth J. Hazel, curatorial associate at this institution. All of us interested in the study of modern art know well the arduous task of compiling such a catalogue, and applaud here her scholarship and thoroughness.

In organizing the exhibition and in preparing this book we had several collaborators at M. Knoedler & Co., Inc., in New York. Lawrence Rubin and Ann Freedman can be singled out for their ever-enthusiastic support. Laura Y. Taylor, assistant to Mrs. Freedman, helped answer endless questions at the start of this project, and Lori Friedman, her successor, helped answer endless questions at its conclusion.

Many staff members of the Fort Worth Art Museum also played key roles. The organization and coordination of the show were orchestrated initially by Dr. Diane Upright, our former senior curator, and continued by Dr. Marla Price, our chief curator. The assembly of *Nancy Graves: A Sculpture Retrospective* was undertaken by James L. Fisher, assistant to the director for exhibitions, and Rachael Blackburn, registrarial associate. The installation of the exhibition was designed by Scott Minner, Tony Wright, and John Hartley of our design and installation department. And throughout the project, my secretary Susan Colegrove has been of invaluable support. We also extend our appreciation to their colleagues at the other museums sharing this exhibition: the Hirshhorn Museum and Sculpture Garden, the Santa Barbara Museum of Art, and the Brooklyn Museum.

We would also like to thank those responsible for this publication: Paul Anbinder, president and guiding light of Hudson Hills Press, Inc., Eve Sinaiko, the editor, and Christopher Holme, the designer.

No exhibition is possible without the lenders. We offer our grateful appreciation for their willingness to part with their Nancy Graves sculptures for this exhibition's year-long journey.

Finally, a personal note of thanks to Nancy Graves. During the three years we have worked together on this project, she has been a full and keen participant. Like her sculpture, she can be at once philosophical and fun, serious and seductive. She is a wonderful artist and a wonderful lady.

E. A. Carmean, Jr., Director
The Fort Worth Art Museum

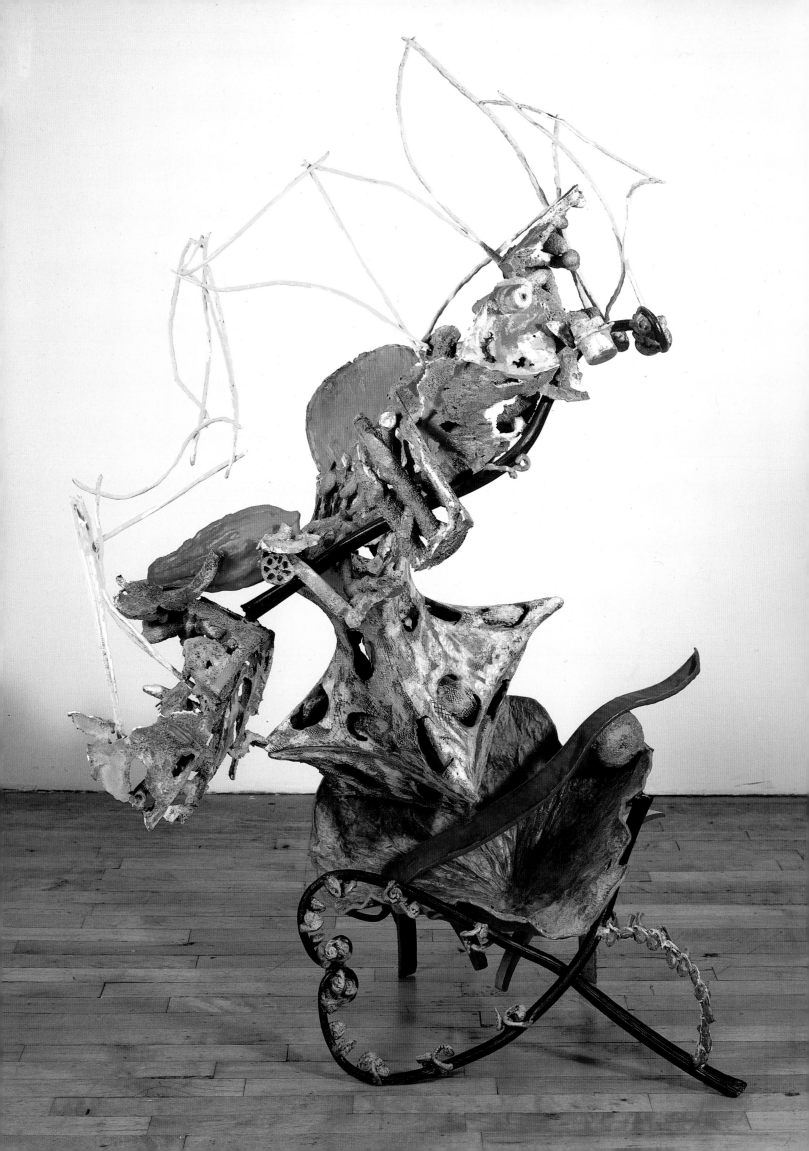

A Note on Nancy Graves's Titles

E. A. CARMEAN, JR.

"When I think of Nancy Graves, I come up with a series of action verbs.
She's as fast as light and luminous as she goes."

TRISHA BROWN

"Titles are necessary for cataloguing the works, and
so dealers can remember the sculptures.
I'd prefer people just looked at the image."

NANCY GRAVES

The act of naming or titling a painting or a sculpture has an interesting and varied history in twentieth-century art. Already in modernism's twin origins —the work of Pablo Picasso and Marcel Duchamp—we find opposites. Picasso, perhaps out of a fear similar to that which caused him to avoid writing a will, never titled any of his works, preferring to date them precisely by day, month, and year, so as to assure their place in his long creative parade. Duchamp, on the other hand, employed titles directly on the face of his works, either in a deadpan fashion, as in the phrase "Broyeuse de Chocolat" at the lower left of his *Chocolate Grinder, No. 1* (1913, Louise and Walter Arensberg Collection, Philadelphia Museum of Art), or for provocative purposes, as in *L.H.O.O.Q.* (1919, private collection), in which those letters were placed under a reproduction of the *Mona Lisa*—the letters, pronounced in French, form the expression "She has hot pants."

By mid-century, artists in America were trying various other means of titling their works. Jackson Pollock preferred in many instances to complete a painting, then select what he considered an appropriate title from a list of possibilities previously given to him by friends. *Lavender Mist*, the title of his classic 1950 picture (National Gallery of Art, Washington), for example, was a name supplied by Clement Greenberg. In other instances, Pollock titled the works by numbers and the year of their making, as in *Number 23, 1951* (Chrysler Museum of Art, Norfolk, Virginia). But dealers soon applied nicknames to these works, "titles" that were often appended to the work; in this case, *Number 23, 1951* became *Frogman*.

Pollock and other painters of his generation also used titles derived from literary or other sources, only to see them misunderstood. The sharpest example was Robert Motherwell's use of Federico Garcia Lorca's bullfighting phrase "at five in the afternoon" for one of his early *Spanish Elegy* paintings; he was later asked, "I saw a marvelous picture by you—what was the name? Something to do with cocktails." Given this kind of misreading of a title's meanings, it is no wonder that by mid-century numerous artists chose to follow Picasso's example and leave their works unnamed. Or more ironically, to prevent dealers or the public from attaching nicknames to works after they left the studio, artists now actually began to title their works *Untitled*, so as to ensure an intended unnaming.

Lacinate (cat. no. 127).

Nancy Stevenson Graves has always employed titles for her sculptures, beginning with *Camel I* of 1966 (cat. no. 1A) and continuing to the present. While she states that this naming is a mere aid to cataloguing the works and for making them easier to remember, there are, nonetheless, other factors involved with the titles she has given to her constructions. Now numbering over 240, these titles reveal—and conceal—many of her intentions in the sculptures. They also show an extraordinary range of phrasing, from simple, matter-of-fact names such as *Camel* to poetic pairings such as *Et Sec* and *Sequi* (cat. nos. 121 and 208) to titles that show sheer whimsy, as in *Crows at the Bar* (cat. no. 187). Graves's titles also show the depth and breadth of her learning, her knowledge of art history, archaeology, anthropology, and biology, as well as her literacy and the effects of much travel. In sum, the titles are very much a reflection of the artist.

These titles can be gathered into several general categories. Certain of them refer to the world of mythology and religion and touch different cultures; these include the Welsh *Ceridwen, out of Fossils* (cat. no. 33), the Indian *Naga* (cat. no. 103), and the Greek *Medusa* (cat. no. 131). Measurement and record-keeping are reflected in such names as *Evolutionary Graph* (cat. no. 13), *Abacus* (cat. no. 109), and *Quipu* (cat. no. 38), while archaeology and geological mapping are sensed in *Fossils* (cat. no. 14) and *Bathymet-Topograph* (cat. no. 45). The realm of anthropology appears with *Mummy* (cat. no. 17), *Shaman* (cat. no. 20), and *Totem* (cat. no. 22), and those of ancient cultures in *Etruria* (cat. no. 95), *Fayum-Re* (cat. no. 97), and *Coptic* (cat. no 231). The world of exotic animals exists in titles such as *Mongolian Bactrian* (cat. no. 8).

Single words or phrases are also important in Graves's titles, from foreign words like *Oiseau* (cat. no. 202) to the Old English *Byrd* (cat. no. 112) and *Moththe* (cat. no. 168), to scientific terms, including *Fungible* (cat. no. 126) and *Lacinate* (cat. no. 127). Finally, and perhaps most engaging, are the words Graves herself makes up, such as *Zeeg* (cat. no. 155) and *Paindre* (cat. no. 170).

Specificity and Inversion

Within these groupings of titles we find shifts that correspond to the changes in Graves's development of her sculpture. "The early titles," she said recently, "were about specificity, because the sculptures were something other than what the titles were. Now, in the recent sculpture, it's the inverse."

Nothing could be more specific than the title *Camel*, used for the first eight of the artist's presentations of the camel form. But in fact these camels were not intended either as portraits of a specific animal or of "camelhood" in general. Rather, the aim was to force attention elsewhere—a shifting obscured by the seeming obviousness of the naming.

Subsequent titles became more elusive. The word *Shaman*, here with its reference to Native American spiritualism, ritual, and the figure of the magic-endowed human intercessor, names the sculpture with the greatest sense of dedifferentiation or denial of gestalt, a work that cannot be experienced whole, but only through a continuing mental process. Parallel works such as *Totem* and *Ceridwen, out of Fossils* continue this denial of unity. *Ceridwen, out of Fossils* combines the Welsh name for the goddess of death and immortality with the phrase "out of fossils," referring both to the artist's earlier work *Fossils*, a prototype of this piece, and to her continued interest in the processes of making and building. The work expresses a technical evolution out of fossils as well as a conceptual one. This sense of generation is also suggested in the later *Phoenix* (cat. no. 73), which used elements of an extant work. Titles of this sort are also found in other early works that reflect anthropology and archaeology, including *Pleistocene Skeleton* (cat. no. 18) and *Aurignac* (cat. no. 34), both referring to the period of the emergence of Cro-Magnon man. Other works also state their archaeological references directly, such as *Archaeoloci* of 1979 (cat. no. 42), which combines the Latin roots *archaeo* and *loci* to form the neologism "places of archaeology," while the title of the slightly later (1979–80) *Trace* (cat. no. 60) and the larger 1981 version (cat. no. 75) indicates what the archaeologist finds.

A sense of specificity, or precision, is implied in an additional manner in the titles of works that refer to measurement, including *Measure* (cat. no. 36), *Calipers* (cat. no. 11), and *Quipu*, all early sculptures. *Quipu*, referring to an ancient Peruvian system of counting using ropes, corresponds to two later sculptures also about unit counting, *Abacus* and *Counter* (cat. no. 118).

The greater part of Graves's early sculptures can be gathered in two groups whose titles, while specific, only hint at the complexity of the structures they name. The first of these is the series of works bearing titles that refer to shadows. *Cast Shadow Reflecting from Four Sides* of 1970 (cat. no. 12) was cast as a bronze of the same title in 1981 (cat. no. 63). It was followed, in the next eight years, by *Hanging Skin Bisected: Shadow Reflecting Itself* (cat. no. 15), *Shadows Reflecting and Sun Disks* (cat. no. 19), *Ombre* (cat. no. 37), *Shadow Reflection* (cat. no. 40), and *Shadow, Six Legs* (cat. no. 41).

The second group of early works linked by similar titles is also joined by the manner in which their structures defeat gestalt—the dedefinition of the earlier work *Shaman*. These central early works include *Obviation of Similar Forms* (cat. no. 9), *Variability of Similar Forms* (cat. no. 23), *Variability and Repetition of Variable Forms* (cat. no. 32), *Obviation of Similar Forms, Second Variation* (cat. no. 49), *Obviation of Similar Forms, Third Variation* (cat. no. 50), *Variability and Repetition* (cat. no. 53), and *Variability and Repetition of Similar Forms II* (cat. no. 54).

The grandeur and complexity of the *Shaman, Obviation,* and *Variability* works are matched principally by *Trace,* a work that in many formal ways provides the key transition to Graves's present creations. As a title, too, *Trace* is transitional, for it is not only a noun but also a verb, and this sense of activity is a hallmark of Graves's work in the 1980s—activity often directly stated in many later titles.

Action!

Gravilev, 1979–80 (cat. no. 57), and a second work, *Varilev,* 1981 (cat. no. 78), also mark this transition. Both made from molds of the earlier sculpture *Vertebral Column with Skull and Pelvis* of 1970 (cat. no. 24), these two later works are given more active titles. *Gravilev* is most likely a combination of the words "gravity" and "levitation," central preoccupations of any sculptor, while *Varilev*—as a variation of *Gravilev*—is a combination of "variant" and "levitation." (The title *Gravilev* may also mean "Graves lifting.") A similar word-joining and sculpture-pairing are also present in *Locomorph* (cat. no. 58) and *Relocomorph* (cat. no. 74), which borrow from "location," "morphology," and possibly "locomotion."

These invented words introduce a series of titles, used between 1981 and 1983, that employ a mixture of extant and made-up words as titles. Read in sequence, they create a clear sense of Graves's increasingly complex compositional undertakings: *Combinate, Conjugate, Conjunctive, Conjuncture, Convolute-Concave, Equebrate, Equipage, Indicate, Append, Bridged, Cantileve, Circumfoliate, Elacinate, Extend-Expand, Fungibla, Fungible, Lacinate.*

Other sculpture names used during the early 1980s reflect the artist's travels and continued interest in ancient civilizations. *Fayum* (cat. no. 66) and *Fayum-Re* refer to her 1981 trip to the Fayum region in Egypt, while a journey to India is associated with *Agni* (cat. no. 80), the Indian god of fire, *Colubra* (cat. no. 84), a variation of "cobra," and *Naga,* another Indian deity. A later work from 1985, *Stupa* (cat. no. 214), refers to a Buddhist architectural form in which sphere tops sphere in a vertical progression, seemingly *ad infinitum*.

The concept of the column—an important corollary in vertical sculpture—is carried in the titles of four works of 1981–82: *Columniary, Urbscolumna, Columnouveau,* and *Corinthia* (cat. nos. 64, 77, 85, 90), and reference is made to ancient vases or containers in *Etruria, Krater,* and *Kylix* (cat. nos. 95, 100, 102). Another, later work, *Vessel,* 1985 (cat. no. 224), also belongs to this group.

Parts and Actions

Beginning in the early 1980s, Graves introduced another kind of title into her work. This was the use of a term describing only a part of the piece, usually in association with how it functioned, either physically or compositionally or both. Thus *Pilot* and *Rotota* (cat. nos. 105 and 139) refer to their top elements, which rotate, while *Triped* and *Bipe* (cat. nos. 151 and 159) refer to the lowest components in the pieces, the three separate supporting points in the former, and the "biped" or feetlike base in the latter. Other sculptures that have hanging elements are gathered together as the Pendula Series, their titles again associated with only one component of the overall composition: *Penda, Pendula, Pendule, Pendelance, Pinocchio, Jato, Vertilance,* and *Whiffle Tree* (cat. nos. 135, 136, 137, 171, 172, 195, 223, and 227). Another pair of works referring to

elements, rather than to the whole, do so with whimsy: *Crows at the Bar* contains six crowbars on a horizontal "bar," and *Hay Fervor* (cat. no. 193) focuses on a nineteenth-century farm tool.

Artists

Since 1983 Graves has also made several sculptures with titles alluding to the works of other artists. Three important compositions—*Zag, Zaga,* and *Zeeg* (cat. nos. 153, 154, and 155)—all refer to David Smith's Zig Series of 1961–63, while Graves's *Fought Cight Cockfight* (cat. no. 164) was inspired by his sculpture *Cockfight* (1945, Saint Louis Art Museum). Her *Nuda* (cat. no. 169) derives its title from the resemblance between one of its forms and a Henri Matisse nude, while *Ensor* (cat. no. 233) establishes a direct connection with the painter James Ensor.

Ensor is also one of four works Graves made inspired by Picasso's sculpture, in this instance his *Femme* in the Musée Picasso in Paris. *Le Sourire* ("the smile"; cat. no. 211) takes note of Picasso's 1929–30 *Head of a Woman*; *Morphose* (cat. no. 237) relates to *Metamorphose I*, 1928; and her *Griddle Man* (cat. no. 192) follows Picasso's *Pregnant Woman* of 1949, all of which are in the Musée Picasso. The title *Griddle Man*—if not the composition—may also refer to David Smith, in particular to his *Personage from Stone City* (1946, Collection of Candida and Rebecca Smith, New York).

Graves's command of words in her titles reaches a new level in her most recent works, in a series of monosyllabic four-letter terms, another pairing, and a string of action phrases. The four-letter terms occur in a 1983 series of ten enameled-bronze works. All beginning with the letter "s," they include extant and imaginary words and establish an interwoven rhythm: *Sine, Slen, Sote, Spin, Spun, Sron, Stan, Stay, Stur, Swen* (cat. nos. 140–42, 144–50).

Her recent oeuvre also contains a related pair, a work that, like *Trace*, was subsequently enlarged in a second version. Graves is at her most poetic in her naming of these pieces. The Latinate *Et Sec* titles the initial work, and the Latin *Sequi* names the second. Their translation—"and the following" and "the following"—beautifully establishes the sense of promise and fulfillment of promise between these two interdependent sculptures.

As with her 1981–83 series of titles using single active words, so in more recent works Graves has also employed terms that convey movement. But where the earlier names suggested compositional passages, the current titles are descriptive of new elements in her work, as these recent sculptures are capable of motion and have whole sections that can be rearranged. The visual, or implied, "variability" of the early work is made physical and actual in these structures, and their roll call of titles indicates just how much moving around is going on: *Closed-Open-Down, Extent, Over Under, Span Link Cross, Swivel Turn, Wheelabout,* and *Uplift*.

It should be observed that with these changes in her titles—from simple specificity to the naming of parts or actions—Graves has remained at the same time consistent in intention. Just as she intended that the *Camel* appellation should point *away* from the sculpture's "camelness," so *Wheelabout* tells us only what it can "do," not what it "is." Her titles continue only to suggest what remains to be learned through looking.

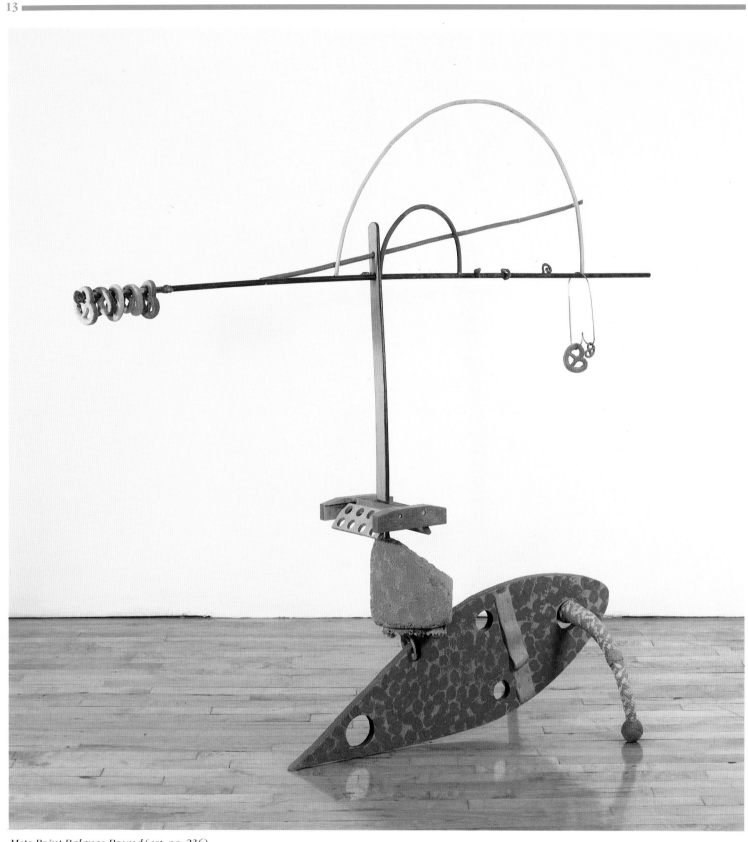

Mete-Point-Balance-Bound (cat. no. 236).

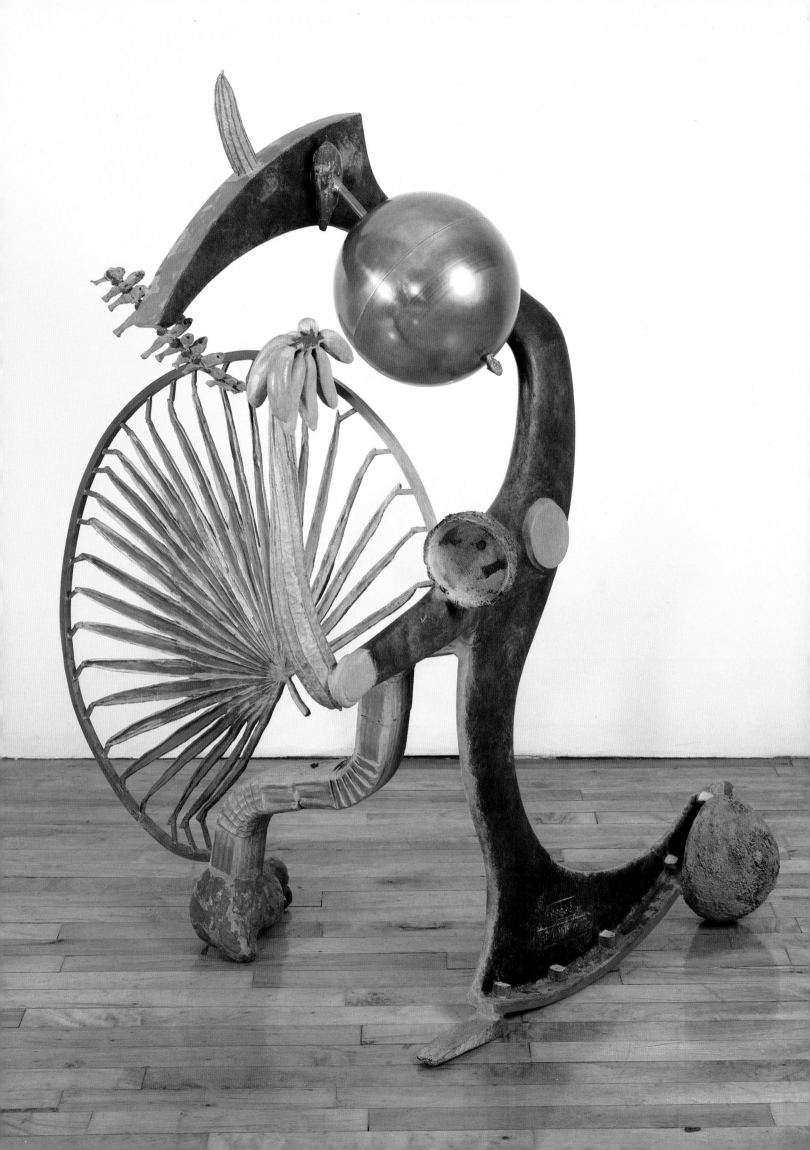

Nancy Graves

An Introduction

ROBERT HUGHES

All Nancy Graves's sculpture is about nature. Since the beginning of the 1980s its parts have been "taken from life," as our ancestors used to say of photographs—directly cast from ordinary things like vegetables or crayfish, whose presence in a sculpture is bizarre. Yet the ideas behind her work are tempered by Graves's immersion, during her youth in the 1970s, in the New York milieu of Minimal and Conceptual art. A rather dry oeuvre might have come from that mingling of literal-minded quotation with far-fetched system; but no—before she is anything else, Graves is an aesthete, putting strange objects together with a freedom and élan worthy of any Surrealist poet in the 1920s. Few sculptors since Joan Miró have been closer to the spirit of the *cadavre exquis*, that Surrealist version of the old party game of Consequences, in which successive, connected drawings, or written phrases, are added by the players to a sheet of paper folded in order that no one can see the work of his predecessor, so that the sum of the parts is a set of random, exotic, or goofy combinations.

Graves's art is wonderfully inclusive; formally rigorous, it spreads a wider fan of poetic association than does any other sculptor's of her generation. Her sculpture speaks of the permeability of the world, its openness to recombination. It draws on a great range of sources, in art and out of it: on botany, anatomy, paleontology, anthropology; on the products of other cultures, from Sepik masks (whose combination of carved wood, hair, shells, wicker, and mud influenced the heterogeneous look of her sculptures) to the silhouette shadow-puppets of Bali (whose delicately scrolled and pierced bodies in paper-thin leather, supported on sticks, have much in common with Graves's elegant webs of metal); on classic modernist sculpture both in the Constructivist tradition (Pablo Picasso, Alexander Calder, Miró, David Smith) and out of it (Alberto Giacometti); on Jackson Pollock's flung and dripped skeins of paint; and on the context given by some of her contemporaries, such as Barry Le Va, Bruce Nauman, Richard Serra, and Eva Hesse. It is fastidious, sweetly funny, and not too bothered with purity. Sometimes her sculptures are figures, sometimes plants, and sometimes (as in *Fayum*, 1981, cat. no. 66, or *Catepelouse*, 1982, cat. no. 83) entire landscapes or even seascapes. If Graves wants to adopt the idea of sculpture-as-totem, much discounted a decade ago by serious artists of her generation, she does it with the speculative curiosity of a mind looking at recently neglected territory. A piece such as *Morphose*, 1986 (cat. no. 237), is plainly descended from Picasso's *Metamorphose I* (1928, Musée Picasso, Paris); its main element, a cast of the rotor of a ship's turbine, evokes a human body, the copper ball a head, and a string of sardines the hair, while bronze bananas become fat Picassoesque fingers.

To list all this may make her work seem more eclectic than it is. Graves, as sculptor, is the equivalent of a well-read writer—alert to any source of stimulus, but fastidious in taste. An educated mind disports itself in ceaseless argument and reflection; to be typecast by one gesture is not Graves's way. Her work restores meaning to a word much overworked in modern art: metamorphosis.

Morphose (cat. no. 237).

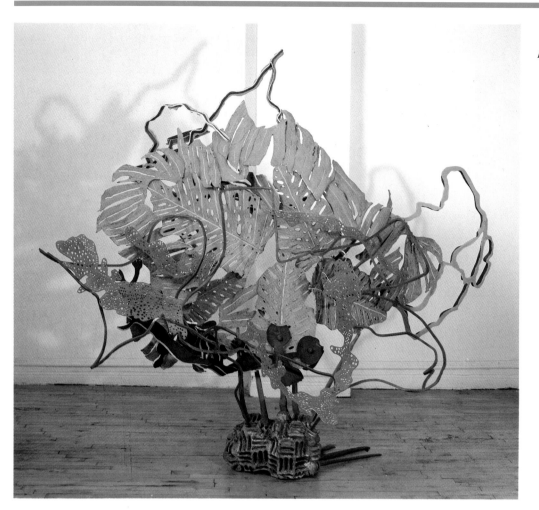

Fayum (cat. no. 66).

Catepelouse (cat. no. 83).

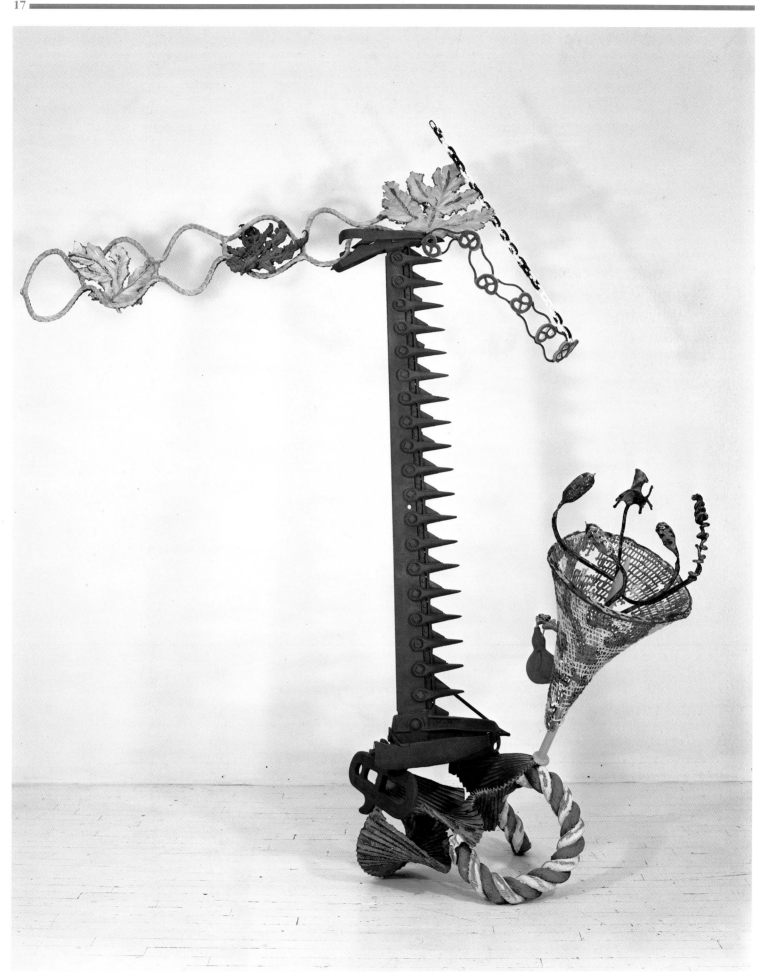

Hay Fervor (cat. no. 193).

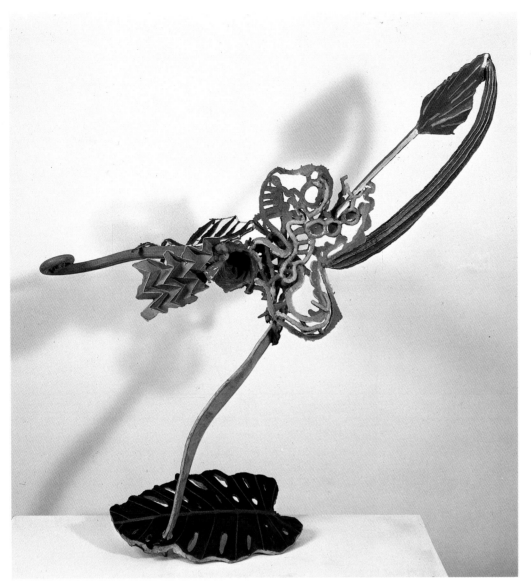

Consider one sculpture in detail. *Hay Fervor*, 1985 (cat. no. 193), is a totem of visual plays and transpositions capped off with a punning title. This refers to the central element, the bar of a brush cutter whose sharp prongs suggest both a weapon and a row of huge vertebrae. Graves found it rusting on a New York farm. It rises from a base made partly of frills (cut-up lampshades removed from their armatures, stuck together with wax, and then cast in bronze, with a rough slag surface on one side) and partly from a thick curl of three-inch marine hawser, bronze-cast and then colored blue, green, and white. Being solid metal it is many times heavier than it looks, and so balances the sculpture's topknot, a row of huge leaves, like maple leaves but much bigger, which Graves scrounged from the Philadelphia Botanical Gardens and cast in bronze. They are held in a rigid wriggle of directly cast bronze rope that shoots into space with a confidence that can only be called oratorical. Opposite these is a smaller yellow wriggle, more tremulously drooping from the topknot: a row of six bronzed pretzels, colored lime green and linked by quarter-inch bronze bar that resembles the gating wax used in foundries to make casting sprues. Gradually *Hay Fervor* begins to look distantly but distinctly like a head with hair, its form suggested, in the manner of Miró, by the dark serrated "neck" of the brush cutter's blade. It has some of the menace of the hideously vehement women's heads Picasso painted at the time of his breakup with Olga Koklova in 1928–29. To make the thing less humanoid, while stressing its general organic character, Graves added a pink trumpet like the bell of a flower (a bronze cone cast from a rope fish trap) shooting up at another angle from the base. Graves calls this her "cornucopia." Things on stalks, like stamens, pour out of it. Three are bronze gourds, enameled; one is cast from the breastbone of a turkey, which Graves salvaged from a Christmas soup made by her friend of long standing, the dancer and choreographer Trisha Brown; a fifth is a corkscrew of dried pigs's gut, found in a Chinese market. A bright red, bell-shaped squash of solid bronze, hanging

from a hook, emits a rueful clank, if lifted. Surfaces tend to the matte and the coralline; colors, to the brightness of photos of a barrier reef.

The sculpture looks like Constructivism gone haywire, weirdly mutating. Her work focuses on structure, not mass. It is open, not solid. It emphasizes welding and connecting, not casting (though its parts are cast); it is made of bits and pieces that do not necessarily match, that argue for the world's heterogeneity, instead of creating metaphors of its seamlessness, as marble and bronze traditionally do. What do pretzels, lampshades, and a brush cutter's blade have in common? About as much as the tin, wood, and rope in a 1913 sculpture by Vladimir Tatlin; or a chicken, an Ingres postcard, and a pillow in Robert Rauschenberg's *Odalisk*, from the 1950s—that is, their presence in the same work of art. The difference is that each of the objects in Graves's work, translated into bronze, becomes structural and weight-bearing. Her sculptures are improvised from a vast inventory of objects, ready to hand in foundry and studio. Their structure and color are not designed in advance. In a recent interview she described her working methods:

> NANCY GRAVES. I would say I have at least a thousand forms sitting on shelves at the foundry, covered with dust: some organic, some utilitarian, such as a bronze of a pitchfork and one of a wagon jack.
>
> ROBERT HUGHES. Tell me how you figure out the stability of the pieces. They lean, they go at odd angles; many of them look inherently unstable. Do you start from a mockup?
>
> GRAVES. No. Not after 1980. I try to defy, conceptually and visually, the logic of building, while the foundry makes the pieces structurally sound. The engineering is less complex in the small pieces, as they don't come apart for travel. There's a piece called *Bilanx* [cat. no. 81]. I realized, after finishing it, that I had made a Degas dancer. A Chinese cucumber, directly cast in solid bronze and weighing at least twenty pounds, cantilevers from a catalpa bean welded at a diagonal to a *Monstera*-leaf base that touches at only three points. It shouldn't stand up, but it does! The cantilevers in *Bilanx* are a structural tour de force.
>
> HUGHES. The eye can't gauge the weight of the elements. You have an irrational playoff between what the eye supposes the weight of the piece is and its actual weight; you shift the relationship of mass to the visual.
>
> GRAVES. Exactly. And that's why it can't be determined in advance whether the assembly will work, because of that dichotomy between an object's history and its weight in bronze.

It is no surprise that Graves mentions David Smith among her sculptural forebears. Her trial-and-error dreaming, her use of the intuited possibilities of studio stock to make sculpture, rather than fixing a scheme and working to fit it, reflect the same mix of Surrealist and Constructivist impulses that produced Smith's *Australia*, 1951, or his 1952 Agricola Series.

The twentieth-century gluers and assemblers all worked with inert material, mostly from the world of industrial production: the steel-engravings of Max Ernst's collages, or the tram tickets and bottle tops in Kurt Schwitters's. Classic Constructivism was a paean to the notion of Utopian social order based on the machine's power to regularize; classic collage and assemblage were equally based on the excess leavings of the machine's abundance—the inorganic waste in which modernity inscribed its name. The idea of making an organic assemblage occurred to few, and when it did it seemed dated and quaint, like the spring fruits and autumn vegetables from which Giuseppe Arcimboldo had composed his faces in the sixteenth century—not modern, and not practical either. How can a sculpture celebrate enduring nature rather than culture, when fruit and fish rot? Graves's answer, first worked out in 1979, was to create an art of construction and assemblage of real, perishable objects cast in bronze.

That year she was making sculptures at the Tallix Foundry in Peekskill, New York, on the Hudson River. She had just come back from the American Academy in Rome, where, she says, "I ransacked the library for Mediterranean archaeological references." The ones she liked best were not the articulate, high-style forms of antiquity, the Corinthian capitals and egg-and-dart moldings; they were more archaic and less identifiable than that: the coarse, gridlike meanderings of excavated archaic foundations, troglodytic dwellings, and Etruscan tombs. The base of *Aves*, 1979 (cat. no. 44), is a three-dimensional model of the ground plan for a single temple. On top of it sits a

kind of archaic "vase," which Graves, doodling in wax on the New York–Peekskill train, had made and brought to the foundry. Above that is another architectural element, this time taken from the site plan for a whole group of ancient buildings, and above that dotted, stamped paper depicting a fragment of a building. From this sprout two curving rods, and on them bronze shards are threaded; originally these were scraps of brown paper reinforced by strands of gating, the spaghettilike wax rods used in the foundry to make sprues. The models of site plans in *Aves* are made from similar rods.

Aves is Latin for "birds," and the winglike shapes, with their bronze feathers that were once paper, burnt to ash in the casting, evoke one of the most romantic images that cling to archaic Mediterranean technology. Flapping above the grids of buried foundations, they suggest the escape of Daedalus, with his son, Icarus, from the labyrinth he had made for King Minos of Crete, on artificial wings held together with wax. (Icarus died when he flew too near the sun and the wax on his wings melted; this semi-secret parallel to the lost-wax process of bronze casting is typical of the way in which technology and imagery entwine in Graves's thinking.) But the consequences of such pieces for Graves's work in the 1980s do not lie so much in their imagery, rich though it is, as in their technique. To use gating wax, which is merely a bronze founder's aid, as a sculptural element struck Graves as a twist on traditional bronze casting. When a sculpture leaves the mold, the pipes and sprues left by the gating are surplus metal and normally must be cut and filed off. "I found I was subverting the gating process in using its throwaway cast-bronze forms as ready-made sculptural elements," she says.

If she could discover one ready-made form in the casting process, why not others? Graves thought a lot about lost-wax casting. In its course, the wax model is built on a core and mantled in fireclay; the mold is heated, the wax pours out, metal is poured in. Suppose one dispensed with the wax model and used objects that would simply burn to ash in the heat, leaving their forms in the mold? Though Graves did not know it at the time, this had long been regarded as a founder's test of virtuosity: Daedalus, *artifex maximus*, was said to have cast in gold a bee on its own wax honeycomb. In the mid-1980s a friend, Michael Shapiro, showed Graves photographs of a whole floral basket cast directly in bronze in the nineteenth century by a German firm, as a demonstration piece for "Mad" King Ludwig II of Bavaria. The first organic thing Graves brought to Tallix for casting in 1979 was a favored houseplant (the front of her loft was, and is, a jungle), which her cat had taken an unfortunate fancy to, and used as a litter box. The plant had died and, she explained, "I liked it too much to let it go." From that small beginning, Graves and her collaborators have built a huge repertory of forms, the words from which the poetry of her sculpture is made—from oyster shells to *Monstera* leaves, from a gingerroot to part of a railroad tie, from a turk's-head gourd to a wart cucumber bought in Chinatown.

Perhaps the best guide to Graves's subversiveness (a word that crops up often in her conversation, not in a political context, but in reference to the techniques and operations of art) is by Linda Nochlin.[1] Her demonstration-piece is Graves's best-known, because conceptually most startling, early sculpture: a painstakingly constructed set of life-size effigies of camels, built on wooden armatures of plastic foam and burlap covered with animal hides (though not the skins of real camels) and painted. Seen in a gallery, these bizarre and intrusive beasts confound our distinctions between effigy and sculpture. The camels, Nochlin points out, are not found objects thrust Marcel Duchamp–wise into an art context; nor are they taxidermy, like Rauschenberg's 1959 sculpture of a goat, *Monogram* (Moderna Museet, Stockholm). They are made, nose to tail, by an artist—reinvented, as it were, like the exact replica of *Don Quixote* written by Pierre Menard, in Jorge Luis Borges's story. Nochlin's claim that "Graves's constructed camels are, paradoxically, more camellike than any individual camel might be"[2] would not impress a Bedouin. But it is certainly true that our anxiety about them (which was far sharper in the late 1960s, when Graves's ships of the desert first lurched into the territory of Minimalism) comes, in Nochlin's words, from "the fact that their status can never be satisfactorily resolved: they can never be defined as clearly art or as non-art,"[3] or even as wholly abstract or figurative.

On one hand they are products of a real taxonomic passion: Graves read everything she could find about camels, their morphology, anatomy, social uses, and environmental

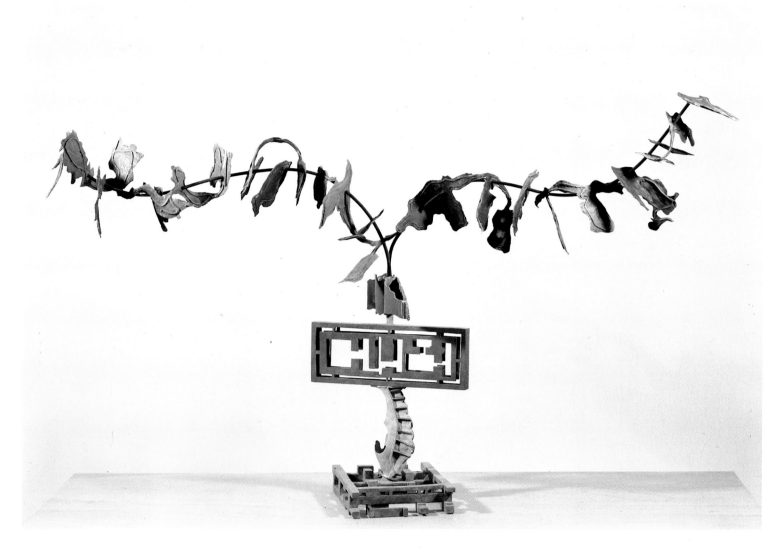

Aves (cat. no. 44).

relations. She went to the slaughterhouse as well as the natural-history museum. Her researches took on some of the soberly demented character (and do we call it scholarship or obsession?) of the notes on cetaceans in *Moby-Dick*. On the other hand the results look both factual and straight-faced; it is the idea of imagining such a confrontation in the gallery, and then carrying it out step by bizarre step, that melts the distinction between thing and image, fact and art, poesis and taxidermy. Graves's camels are art that question their own status with élan and freshness, and without boring the viewer—a rarity in the tedium of Conceptual art.

Color, too, matters greatly to her. It provides an alternative structure; a run of nuances that sometimes parallels and sometimes opposes the rhythm of the metal forms. It keeps the work "on point," as it were, on the edge of instability:

> GRAVES. My sculptures aren't evenly balanced in the obvious visual way. They're balanced by imbalance. None of them defy gravity physically. But they do defy it visually.

> HUGHES. How do they defy it visually? Do you think of the color as making the forms lighter or heavier?

> GRAVES. Yes, absolutely. Let's say a casting wasn't perfect or the welded elements didn't quite cohere. With color I add surface incident or increase focus. A sculpture before color is a complete piece; the addition of color imposes a second composition that can augment or contend with its forms and structure.

> HUGHES. That must be rather risky, no? You've made a structure that addresses the eye in a certain way, and the task of the painting is to move in and violate that—to tune it, or reverse it. Have you ever done a piece in which all the colors are settled right from the start?

> GRAVES. No. I make a patina gradually, and as I walk around the piece I develop the patination and its color relationships. I don't come in there with a drawing; I let the piece work on me. It *is* risky and difficult, but the risk is why I enjoy doing it.

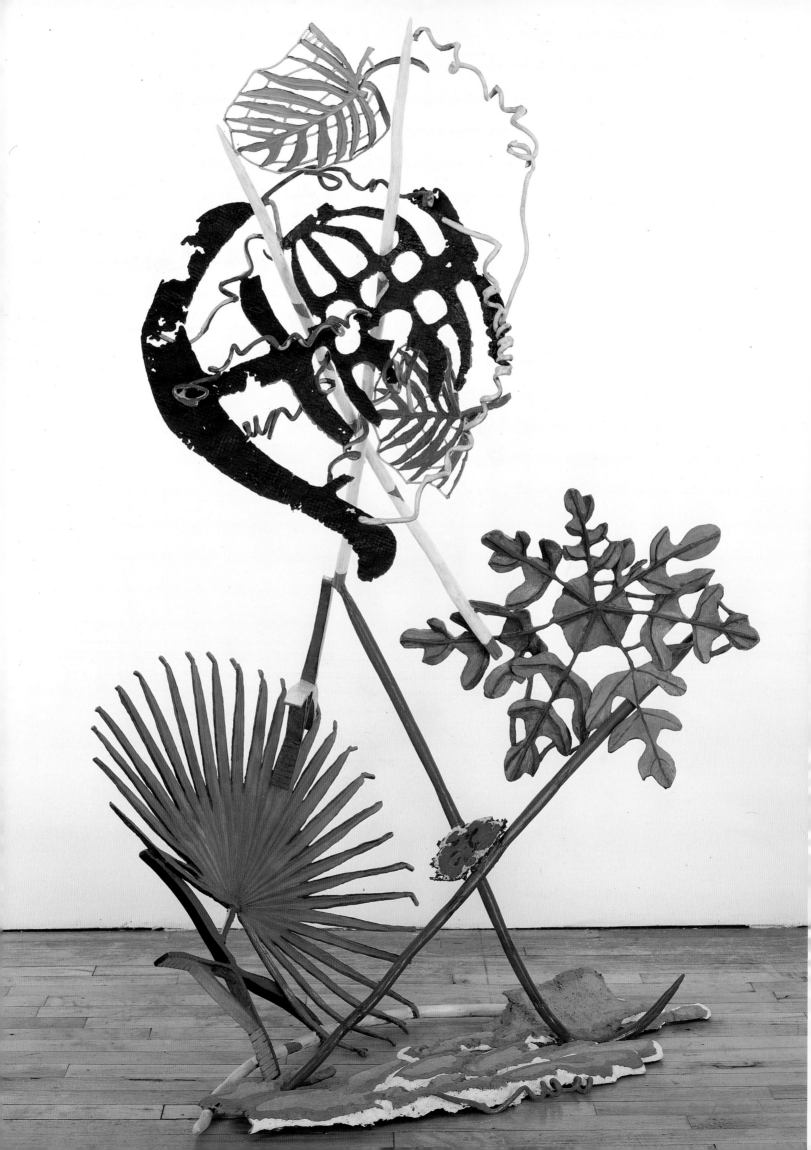

Graves has three ways of coloring her sculpture: patination, fired enamel, and polyurethane paint. Of these, patination is the most typical, in that it is unique to her work; no other modernist sculptor has used colored patinas to such an extent. The patination is added by stages and its color is intensified step by step, as in successive applications of watercolor. First the pieces are sandblasted to give them a matte, porous surface. Then they receive two or three coats of cupric nitrate and a coat of pigment in acid; a thorough heating with a gas torch follows, causing the skin of the metal to bond with the pigment and chemicals. In traditional bronze sculpture the range of color patinas has always been limited, running from arsenical greens to deep brownish blacks, colors that connect the skin of the bronze to the earth from which its constituent copper and tin were drawn. We accept these hues, hallowed by thousands of years of sculptural use, as the natural color of bronze. Hence it seems discordant, a subversion, to see a bronze form that is glazed with cadmium red or orange, leaf green, violet, yellow, or dusty cobalt blue. Patination leaves visible an immense amount of detail that paint, thicker and more viscose, hides: the veins on a leaf, the smallest wart on a cucumber, the gills of a tiny dried smelt. The contrast between the autonomy of the color (which is not naturalistic, and thus urges Graves's found forms toward abstraction) and the faithful effigies it lies on becomes all the sharper.

By such means Graves's sculpture, with its perverse balance and powerful linear drawing in space, finds fresh terms on which to enter art's long discourse on nature. "We are surrounded with things which we have not made,"[4] wrote Kenneth Clark nearly fifty years ago, in the first sentence of *Landscape into Art*. Nothing could be less true to the experience of the Western art audience in 1987. Most of us live in cities and see trees through the system of quotation known as parks and public gardens; from our foreground to the horizon, we are surrounded by artifacts. The idea that nature is the regulator of art, the great motor of culture in the nineteenth century, is lost to us and can only be revived by stubborn acts of critical will, in defiance of the electronic landscape of our *fin de siècle*. Graves's sculpture immobilizes the exotic forms of nature, places them in a different matrix, and holds them up to our startled inspection, helping us to see a gourd or a stalk of brussels sprouts with the same sense of discovery that greeted the use of newsprint in collage, or of street flotsam in Dada. In the spirit of her modernist predecessors, but with organic and perishable things, Graves celebrates nature's immense power of mass production, along with its alienness and its reconciling beauty.

[1] Linda Nochlin, Introduction to *Nancy Graves: Painting, Sculpture, Drawing, 1980–1985* by Debra Bricker Balken (Poughkeepsie, N.Y.: Vassar College Art Gallery, 1986), p. 13.

[2] Ibid., p. 15.

[3] Ibid., p. 16.

[4] Kenneth Clark, *Landscape into Art* (London: John Murray, 1949), p. 1.

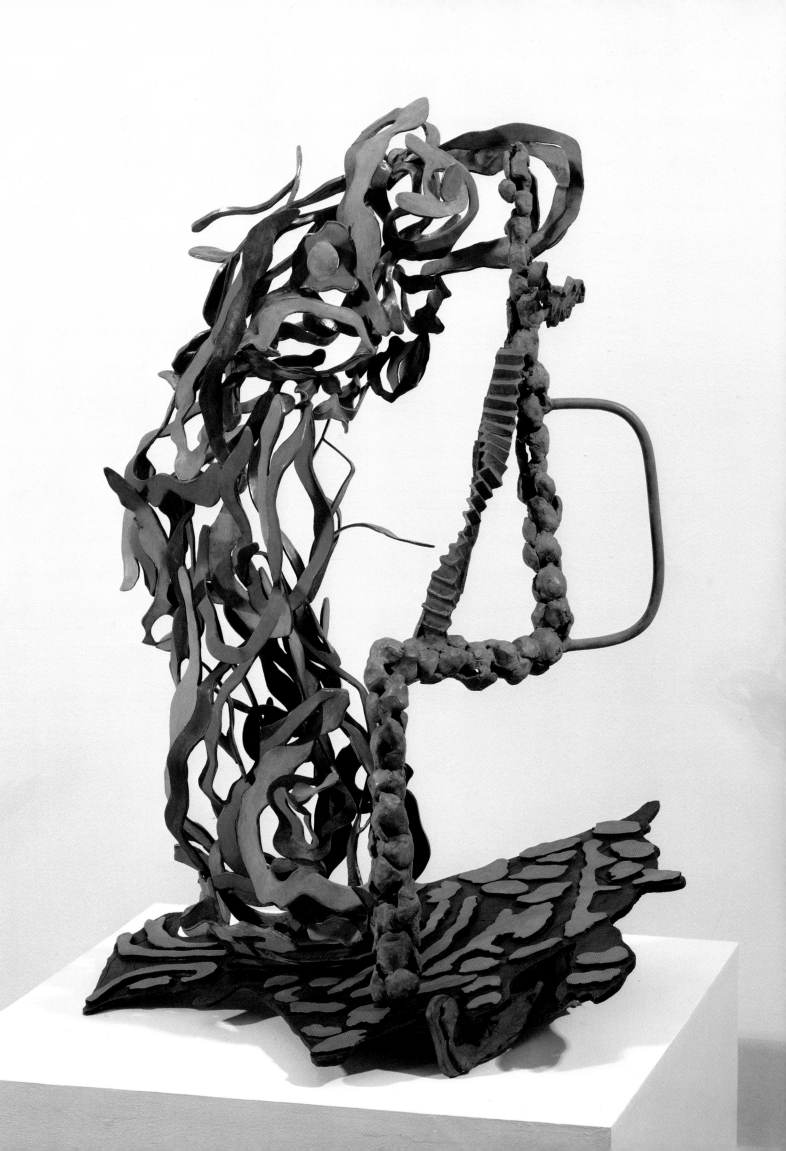

Inside-Out/Outside-In

The Anatomy of Nancy Graves's Sculpture

MICHAEL EDWARD SHAPIRO

Curator of Nineteenth- and Twentieth-Century Art, The Saint Louis Art Museum

The *écorché*, a man or animal whose skin has been removed to reveal the musculature and bones beneath the exterior surfaces, is an appropriate metaphor for the sculpture of Nancy Graves. Her sculpture has consistently been concerned with finding inventive ways to articulate and build structures that resemble, but never duplicate, the internal and external forms of natural things. An *écorché* figure is a teaching device to assist art students to make sculptures whose palpable and convincing outward appearance suggests firm knowledge of unseen inner structures, yet it also serves as a symbol for the direction of Graves's sculptural development from works that duplicate the exterior of forms (camels) to combinations of unlikely organic objects that have been cast, welded, and patinated. Graves has long dissected and studied natural forms to make her sculpture of inventive structures as organic as sinew and muscle.

The *écorché*, as a symbol of the teaching of sculpture, is also appropriate for this sculptor's work, since her work is very much an intellectual inquiry into how and why sculpture can be made. While her interest in anthropology and archaeology is well known, her sculpture has also been an ongoing meditation about the medium itself. To underscore the technical and theoretical aspect of Graves's sculpture is the goal of this essay, yet this objective is enfolded within the larger purposes of her art.

A formative influence upon Nancy Graves's sculpture occurred during her 1965–66 residence in Florence, when she visited the city's natural-history museum and saw the extraordinary wax *écorché* works of Clemente Susini, an eighteenth-century anatomist, whose works depict the internal configuration of humans and animals. Startlingly lifelike, the wax forms stirred Graves to think about the internal structure of things as a viable subject for her art and also, on a more practical level, suggested the malleable properties of wax for making sculpture. Stimulated by Susini's work to combine her interest in natural history with her art, Graves made two sculptures of camels in Florence, but she destroyed them before leaving the city in August 1966.

From 1966 to 1969 she studied the physical structure of camels intensively, in order to make full-size sculptures that seemed to duplicate these wild and exotic animals. While the finished works suggested that she was primarily concerned with giving the beasts a convincing outward appearance of dirty, matted fur and a natural pose (cat. no. 2), the sculptures were built rather than cast or carved, as a more traditional work would have been. Her careful studies led her to devise, and to commission a carpenter to construct, a complex, six-part armature for the internal structure of the camels.

She rejected the conventional idea of making a small model and the use of traditional sculptor's materials. Instead of suggesting the nubby and matted fur by incising the surface of a clay model and then transforming it into cast bronze, Graves used sheep- and goatskins to provide an actual fur surface. Was this some sort of modern form of *trompe l'oeil* sculpture? In a certain sense the camels were just that,

Clemente Susini. *Cross Section of a Woman's Womb*, ca. 18th century, wax.

Archaeoloci (cat. no. 42).

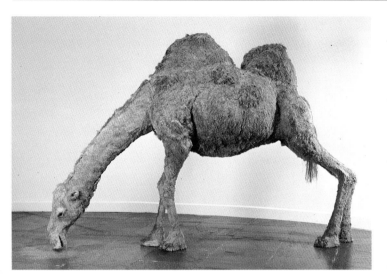

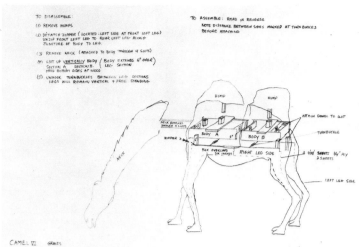

but they were also far more. They were seminal works in Graves's career, their sculptural implications so rich and complex that the meanings they suggest could be pursued for a lifetime. Her camel sculptures marked the beginning of Graves's journey into what can only be called the anatomy of sculpture making, a self-conscious inquiry into ways of making sculptures that are about both the outsides and insides of natural forms. In the course of this journey, Graves has wedded the unconventional methods of process art, in a seemingly unlikely direction, to the tangible replication of forms of organic life, and her interest in permutation has led her to the serial reproduction of these forms. One might say that Graves was involved in a genetic engineering whose outcome was not new cells but works of art.

While the camels (cat. nos. 2, 3, and 4) were conceived with the visual effect of an end product in mind, they were made from the inside out. When completed, the convincing exterior forms of the three camels suggested to the artist that their interiors could serve as an instructive subject for her next sculptures. In the works that followed in 1969 and 1970, Graves produced a series of sculptures based on the interiors of the camels: *Miocene Skeleton from Agate Springs, Nebraska (To David Schwendeman)*, *Fossils*, *Taxidermy Form*, and *Variability of Similar Forms* (cat. nos. 7, 14, 21, and 23).

These sculptures represent Graves's move within sculpture, within the *écorché* itself. The bone-strewn configuration of *Fossils* is neither an earthwork nor an environmental piece, but is a kind of modern tomb sculpture that eliminates both the traditional armature and structure of a sculpture, as well as the ephemeral materials of muscle and sinew and skin, while being faithfully realistic. In these pieces Graves's interest in process art and her ties to verisimilitude led her both toward and away from traditional methods of figural sculpture.

Inside-Outside, 1970 (cat no. 16), joins the inside and outside parts of a sculpture in a new way. Within the sliced torso and legs of one of her original handmade camels, Graves placed bones that she had made of wax, marble dust, and acrylic over a steel armature. The bones she placed within were unconnected to the skin of the outer form. Spread on the ground, the pieces imply the dissection of a traditionally complete sculpture and pointedly and ironically refer to the illusionistic nature of such traditional sculpture. Embedded within this piece was the direction her sculpture would go next: away from the natural armatures and layers of flesh wrapped around bones, toward the articulation of her own combinations of organic structures. Her style has little in common with Jean Arp's supple biomorphic sculptures, which seem to undulate before our eyes. While his vision was muscular, Graves's is more skeletal, in the constructivist tradition of David Smith.

Many of Graves's early sculptures make reference to sculptural processes and to paleontology. *Bones and Their Containers (To Martin Cassidy)*, 1971 (cat. no. 26), for example, seems to make reference to the mold-making process in sculpture by showing both positive and negative forms. But this also refers to the containers that paleontologists place around bones at a site to insure their safe transport to a museum. Graves has never used traditional mold-making processes. In these early works she made additional positive forms, wrapping plaster and gauze around an extant positive form. She then separated the plaster and gauze and modeled the remaining form into

Camel VI (cat. no. 2).

Armature, 1969, ink on paper, 18 × 24 (45.7 × 61). National Gallery of Canada, Ottawa.

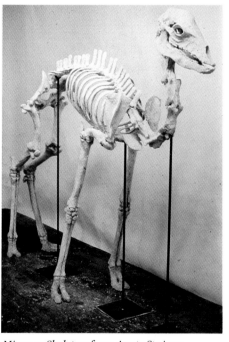

Miocene Skeleton from Agate Springs, Nebraska (To David Schwendeman) (cat. no. 7).

Inside-Outside (cat. no. 16)

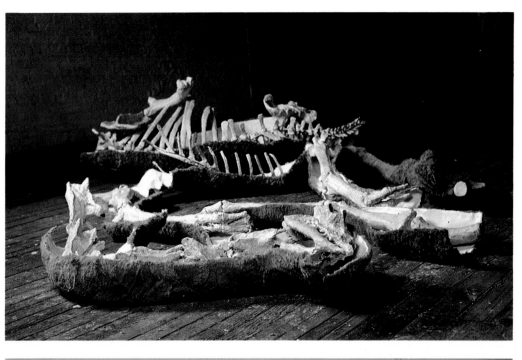

Bones and Their Containers (To Martin Cassidy) (cat. no. 26)

a unique sculptural element. In 1977 this method of replication was superseded by her adoption of direct casting.

In the early 1970s Graves continued to dissect and separate the internal elements of figural sculpture in such pieces as *Hanging Skins, Bones, Membranes*, 1971 (cat. no. 30), in which bones, skins, and membranes are literally hung out to dry. Camel bones were the subject of *Variability of Similar Forms* and *Variability and Repetition of Variable Forms*, 1971 (cat. no. 32). As the title states, the former work suggests the pleasures of repeating and repositioning similar but varied elements in a number of groups, while the latter work repeats a variety of related forms in a more complex and colorful rhythm. They are pendant pieces, both concerned, in part, with the role of armature. In one sculpture bones allude to the role of the skeleton as the armature of natural forms, while in the other steel rods are simply what they appear to be: central, free-standing stems.

Variability and Repetition of Variable Forms marked the first time the artist welded exposed elements of a sculpture and the first time she used fired and glazed clay, a technique that would lead, a dozen years later, to her use of baked enamel to patinate bronze. The work stands upright and has no base other than the floor it rests on. The elements (which are all artificial replicas) are affixed to the five-eighths-inch-steel rebar shafts and consist of bones, butterflies, clam shells, beetles, cowrie shells (made

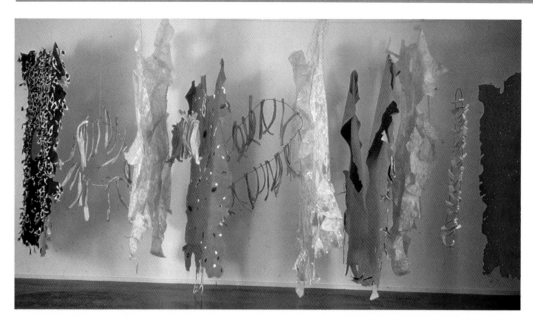

Hanging Skins, Bones, Membranes (cat. no. 30).

Variability of Similar Forms (cat. no. 23).

Variability and Repetition of Variable Forms (cat. no. 32).

of fired clay), and wax, wire, and gauze feathers. The objects prefigure Graves's use in the 1980s of natural objects as the basis for direct casting in bronze.

In 1972 her six-year-long involvement with sculpture ceased. Graves stopped making sculptures in part because the necessity of having many assistants in their production became a burden. In addition to the five to ten assistants in her New York studio, she had worked in one year with fifteen to twenty assistants to prepare her one-person exhibition at the Ludwig Museum, Aachen, West Germany, as well as with five to ten other assistants in San Francisco, to prepare *Variability and Repetition of*

Fossils (cat. no. 14).

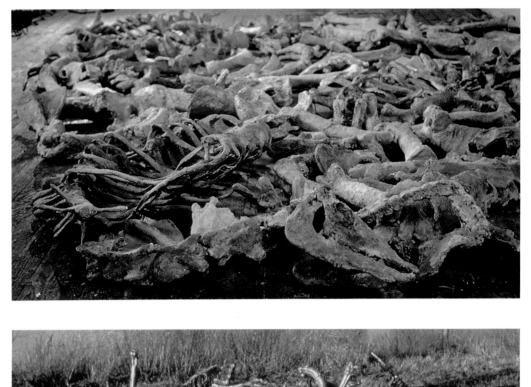

Ceridwen, out of Fossils (cat. no. 33)

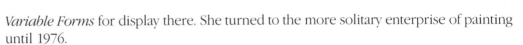

Variable Forms for display there. She turned to the more solitary enterprise of painting until 1976.

Her first bronze sculpture, *Ceridwen, out of Fossils*, 1969–77 (cat. no. 33), was a commission for the Museum Ludwig, Cologne, in 1977. The elements for this piece consisted of the front and hind leg bones of a Pleistocene-period camel, vertebrae, scapulae, a rib cage, a pelvis, and a skull. The pieces had been made seven years earlier for *Fossils*, 1969–70 (cat. no. 14), and together they constituted a complete skeleton. Molds were made from each, and from each mold a number of waxes were made. The forms were then varied in the wax by the artist. To have the waxes cast, Graves was referred by master printer Ken Tyler to the Tallix Foundry in Peekskill, New York. It was at Tallix that she first learned the lost-wax casting process. The casting of *Ceridwen* marked the end of her permutations on the camel theme and the beginning of her experimentations with bronze.

Bronze had several advantages over the materials Graves had previously been using. It replaced ephemeral substances with a permanent material whose great tensile strength meant that it could support itself. Using cast bronze also meant that she could shift the act of translating her models into finished sculptures to the foundry. Finally, the use of bronze and her collaboration with Richard Polich, the head of Tallix Foundry, opened new avenues for her to explore—unusual methods of casting and of patination.

Coinciding with this change of method and material was a shift in the subject matter of Graves's sculpture. Her residence at the American Academy in Rome in 1979 provided the motivation to move from paleontology to archaeology, to shift from fossils to maps of archaeological sites as subject matter of both her sculpture and her paintings. Both paleontology and archaeology look to the past for their sources, and both are concerned with the discovery of connections and linkages—routes from

place to place or from part to part of a body. Inspired by maps of archaeological sites, many of the bronzes that stem from her Roman experience are not immediately readable. The techniques Graves devised for her map sculptures, such as *Archaeoloci*, 1979 (cat. no. 42), would be used later in building her more recent directly cast bronze sculptures. Unlike her recent works, which are constructed improvisationally, *Archaeoloci* was made after a preparatory drawing that defined its parts.

Each of the colored bronze elements of *Archaeoloci* was cast from a different substance. The red base represents a map and was originally made from sheet wax and then heat-laminated. The yellow core of the structure, which looks as though it were traditionally modeled, was cast from polystyrene chips over a stainless-steel rod. Two parts of the core element are joined by a miniature staircase that was cast in bronze from paper painted with wax, and a fabricated brass "handle" is attached to the core structure. Finally, the biomorphic skeins of pale and royal blue were cast from sheet wax, which Graves cut and then had cast. The paper, polystyrene, and wax were cast in bronze, joined and then brilliantly patinated.

Bronze, with its inherent strength, allowed the translation of maps into a rigid form. Another step toward the archaeological-site pieces were bronzes such as *Aurignac*, 1978 (cat. no. 34), a richly modeled polychrome bronze whose green and brown patinas suggested Graves's growing interest in more intense coloring. In the next seven years the surface colors of her bronzes would move in the direction of ever-increasing intensity.

In 1978, for the first time, Graves directly cast ropes, which she found at a boat yard in Rhode Island, into bronze. The cast forms of the ropes were the basis for a rather brightly patinated work entitled *Quipu*, 1978 (cat. no. 38), whose title refers to a Peruvian system for counting. *Quipu*'s construction from cast ropes suggested how limp objects could, once cast, have great structural potential, and again evoked the persistent *trompe l'oeil* aspect of Graves's work. While this was the first piece to be directly cast, the artist had no idea of the importance that the direct-casting technique would subsequently have for her work nor, for that matter, the role that brilliant patinas would continue to play in it.

Quipu was also the first instance in which the artist integrated the bronze gates used in the casting process into the sculpture itself. Just as her sculpture *Bones and Their Containers* comments on the mold-making process in sculpture, the inclusion of gates—the avenues by which bronze enters and exits molds—as structural elements continued Graves's sculptural commentary on sculpture making. *Quipu*, with its red, blue, green, and yellow patinas, with its directly cast pieces of rope and its permanent gates, is another seminal sculpture, like the camels, whose elements would be amplified in her later pieces. It was at this point that the colored surfaces of the sculptures became a salient characteristic of Graves's style. While Ron Young at Johnson Atelier, Princeton, New Jersey, had first developed a white patina for Graves, it was the artist Toni Putnam at Tallix Foundry who developed the intensely colored ones.

Graves has now harnessed the benefits and risks of direct casting to her own aesthetic and has become the most devoted contemporary advocate of the technique. Her collaboration with Polich at Tallix has resulted, since 1980, in nearly two hundred bronze sculptures that have been constructed of directly cast objects welded together and patinated.

To find the raw materials for these directly cast sculptures, Graves collects, at home and on her travels, rare and mundane examples of plant life, fish, and paper or wooden objects whose structural potential and images will complement her inventory of cast-bronze forms. She often prunes the plants and crops the objects into forms that interest her and then transports them to Tallix. At the foundry, she subverts the "model-making" aspect of bronze casting, the procedures by which preliminary models may be enlarged, reduced, or altered, and from which multiple bronze casts may be made. The found objects she uses are fully formed and, by the bronze-casting process, are directly translated into structural components. At most, Graves will reinforce these elements before casting by adding wax.

In preparation for direct casting, each plant and object is covered with shellac, gated, and vented. The gates are wax rods that provide avenues of entry for the molten bronze, and the vents form channels for the escape of gases. Once it is shellacked, gated, and vented, the form to be cast is dipped into a slurry solution, which hardens

Aurignac (cat. no. 34).

Quipu (cat. no. 38).

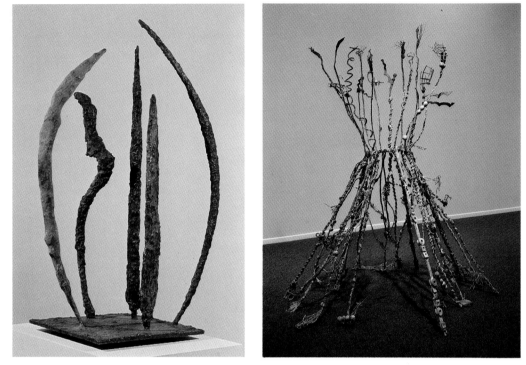

into the relatively thin and porous mold known as a ceramic shell. When the form is placed within a furnace, the intense heat vaporizes the object, the wax gates, and the vents, and leaves an empty shell. After the ceramic shell is removed from the furnace and cooled, air may be blown through the mold to make sure it is empty of all ash and particulate matter. When the empty mold is returned to the furnace for casting, molten bronze is poured into it, filling the negative space left by the object. After casting, the shell is broken open to reveal a metal form that literally reproduces the original object. The gates and vents—now bronze—must be filed off, and any irregularities in the bronze's surface may be chased, eliminated by craftsmen using files and rasps.

After casting and chasing, the unpatinated bronze object is added to Graves's stockpile of hundreds of directly cast objects, From this inventory she eventually selects pieces to be assembled into a sculpture. In selecting pieces, the artist works improvisationally, without preparatory drawings, searching for unlikely juxtapositions and formal linkages among directly cast forms. As the various plant, fish, and other elements are selected, they are welded together at as few points as possible. The results are airy assemblages in which metal replicas of forms of organic origin defy gravity to float, touch, and intertwine with one another. After welding, the final step is the application of luminous patinas, which Graves applies by brushing chemicals onto a surface heated with a gas torch. The brilliant coloration camouflages the original identity of the cast forms and enhances the peculiar and primeval unity of her work. While the sculptures synthesize Graves's interests in anthropology and botany with theories of assemblage and found objects, the active agent in this bonding process is direct casting after nature.

Identifying the constituent cast parts of one of Graves's sculptures, *Cantileve*, 1983 (cat. no. 113), demonstrates the role of direct casting in her art. *Cantileve* is supported by two raffia fans (a), which have been directly cast, and by the directly cast spears of a *Monstera* leaf stem (b). The once-fragile paper fans and tuberous stems defy their original nature by becoming the weight-bearing base of the metal sculpture, and are joined to a core of horizontally and vertically hatched openings made from a piece of baffling or soundproofing material (c). Wax positives, which were cast at the foundry from the original baffling material, were combined and melted together to create a core and then cast in bronze. From this nucleus springs the backbone of the piece, an archlike form produced by welding together three types of directly cast plants: Hupua ferns (d), dried leaf ferns (e), and sections of *Trevisa palmata* (f). The red, yellow, and gray patinated ferns and the pink *Trevisa* appear like nerve endings running through a huge spine. They connect the backbone with the head of the piece: the flat, torch-cut forms of directly cast lotus leaves (g) and the open calligraphy of sand-cast lines, made by drawing in a sand mold with a high-speed tool (h). The pocked surface of this calligraphic bronzework is made from bubble-wrap that has

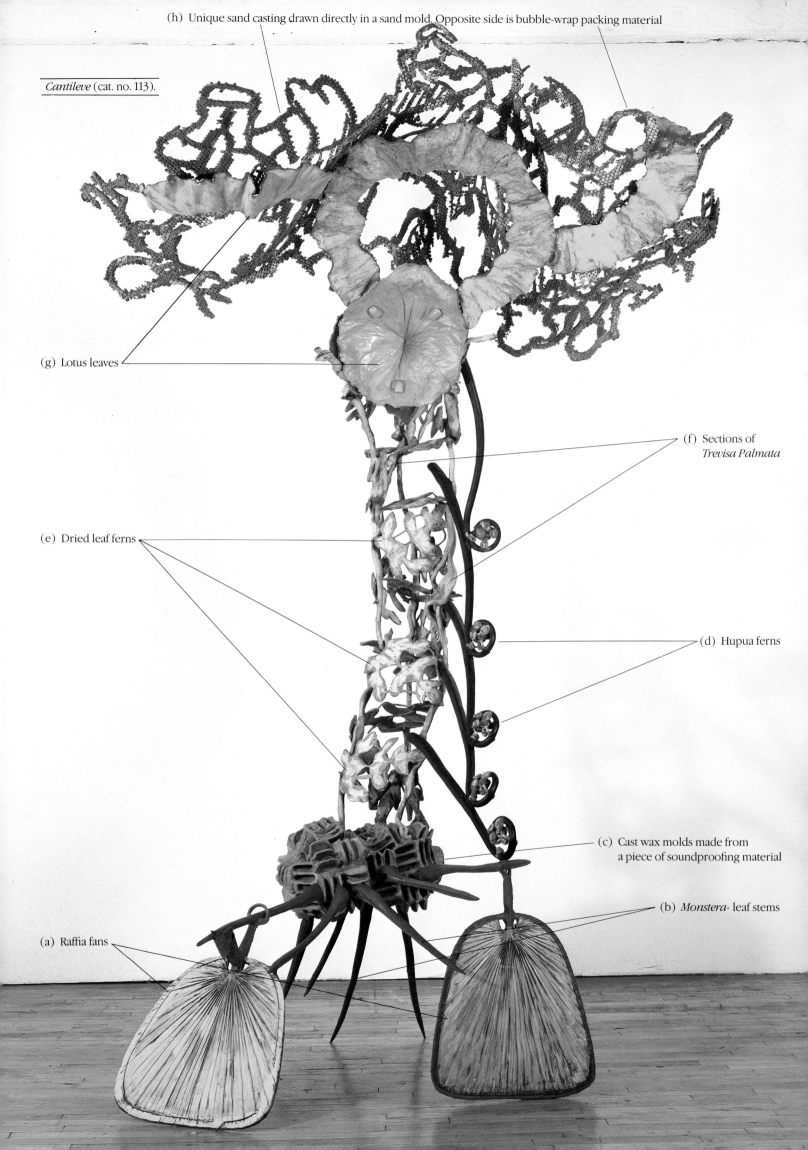

(h) Unique sand casting drawn directly in a sand mold. Opposite side is bubble-wrap packing material

Cantileve (cat. no. 113).

(g) Lotus leaves

(f) Sections of *Trevisa Palmata*

(e) Dried leaf ferns

(d) Hupua ferns

(c) Cast wax molds made from a piece of soundproofing material

(b) *Monstera-* leaf stems

(a) Raffia fans

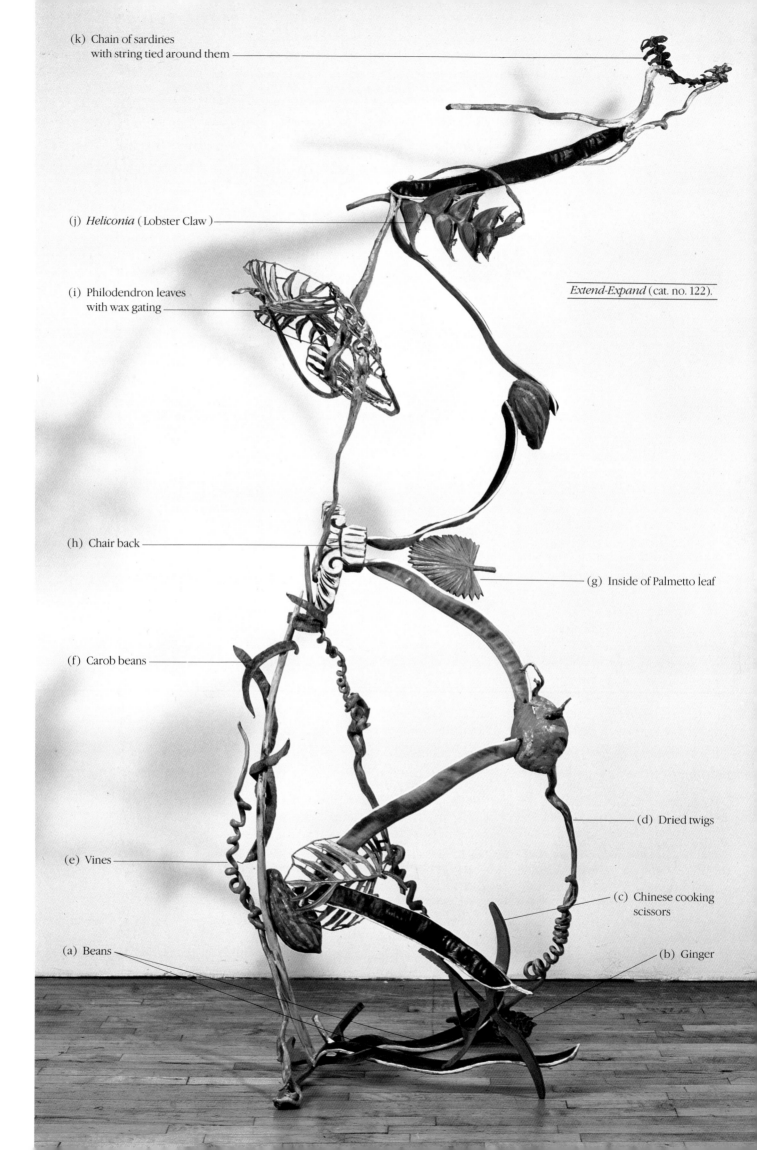

(k) Chain of sardines
 with string tied around them

(j) *Heliconia* (Lobster Claw)

(i) Philodendron leaves
 with wax gating

Extend-Expand (cat. no. 122).

(h) Chair back

(g) Inside of Palmetto leaf

(f) Carob beans

(d) Dried twigs

(e) Vines

(c) Chinese cooking
 scissors

(a) Beans

(b) Ginger

Penda (cat. no. 135).

been cast in sand. Thus, more traditionally sand-cast as well as directly cast elements are united in a single sculpture. Once we know the previous life of the sculpture's elements, we see the completed object both as a whole and as a mosaic of directly cast natural forms whose combination embodies modernist principles of assemblage, Surrealist juxtaposition, and abstract coloration.

If we turn to another sculpture, *Extend-Expand*, 1983 (cat. no. 122), we can see the continuing importance of directly cast plants in Graves's vigorous sculpture. From the base constructed of cast beans (a), ginger (b), and a pair of Chinese cooking scissors (c), the sculpture rises in a series of connections among twigs (d), vines (e), carob beans (f), a palmetto leaf (g), a chair back (h), *Philodendron* leaves with gating still attached (i), Heliconia (j), and, at the very top, a chain of sardines with string tied around them (k). While destroying Graves's original models, direct casting preserves their forms faithfully and transforms them into solid bronze structural units.

One limitation of Graves's special polychrome patinas has been their vulnerability to weather. This, combined with her interest in making larger outdoor works, led her and Polich to look for a safe, weatherproof, and brilliantly colored patina. Their search ended in the selection of polyurethane paint, which has now become her preferred method of patination for outdoor sculpture. The intensity of its pigmentation and its glossy, reflective qualities make the previous colored patinas seem muted. Not since Augustus Saint-Gaudens and other turn-of-the-century French and American sculptors favored gilded bronzes has an American sculptor pushed the limits of coloration in sculpture to this extreme.

At the same time Graves has explored baked-enamel patinas as well. Her first sculpture to which an enameled surface was applied was *Penda*, 1983 (cat. no. 135). In this piece, which consists of brightly patinated, directly cast elements, the ground and the base are the enameled elements. A number of the smaller pieces are entirely enameled, while some of the medium-size pieces combine bright patinas with enameled elements. The enamels are much more sonorous, gemlike, and reflective than the painted parts and are applied in powder form to the surface of the sculpture, along with gum arabic, and baked in a kiln in the artist's studio.

One effect of this coloration has been to draw her sculpture and painting more closely together. The sculptures, with the brilliantly, almost harshly colored polyurethane, have a dripped-on, nervous quality to them, while her recent paintings have cast and painted aluminum appendages projecting from them. Since 1977 her painting and sculpture have evolved simultaneously, and the two media appear on the brink of merging.

The sculpture comes close to the constructivist mode of step-by-step building. The use of wheels and silhouetted forms is reminiscent of David Smith's works, and the

Over Under (cat. no. 204).

introduction of moving parts refers to Alexander Calder's stabiles; nevertheless, Graves's sculptures remain strikingly similar to the "bone" sculptures she made almost fifteen years ago. Her sculptures—whether *Inside-Outside* of 1970 (cat. no. 16) or *Over Under* of 1985 (cat. no. 204)—still relate to the *écorché* or, more generally, to meditations on the notions of support and armature for sculpture. The bony armatures of her sculptures are themselves meditations on natural structures, human, animal, and vegetal, and observations on possible and seemingly impossible blendings among these genres.

Formally these inventive combinations also play with the physical limits of the materials of which they are made. Visually they move beyond the precedents set by previous painted bronzes. Technically they revive the abandoned and little-thought-of technique of direct casting and use it in a new and shocking way. Is it real? Is it art? These questions are contained in Nancy Graves's motivation for making sculpture. And the sculptures themselves provide the answer: a resounding "yes."

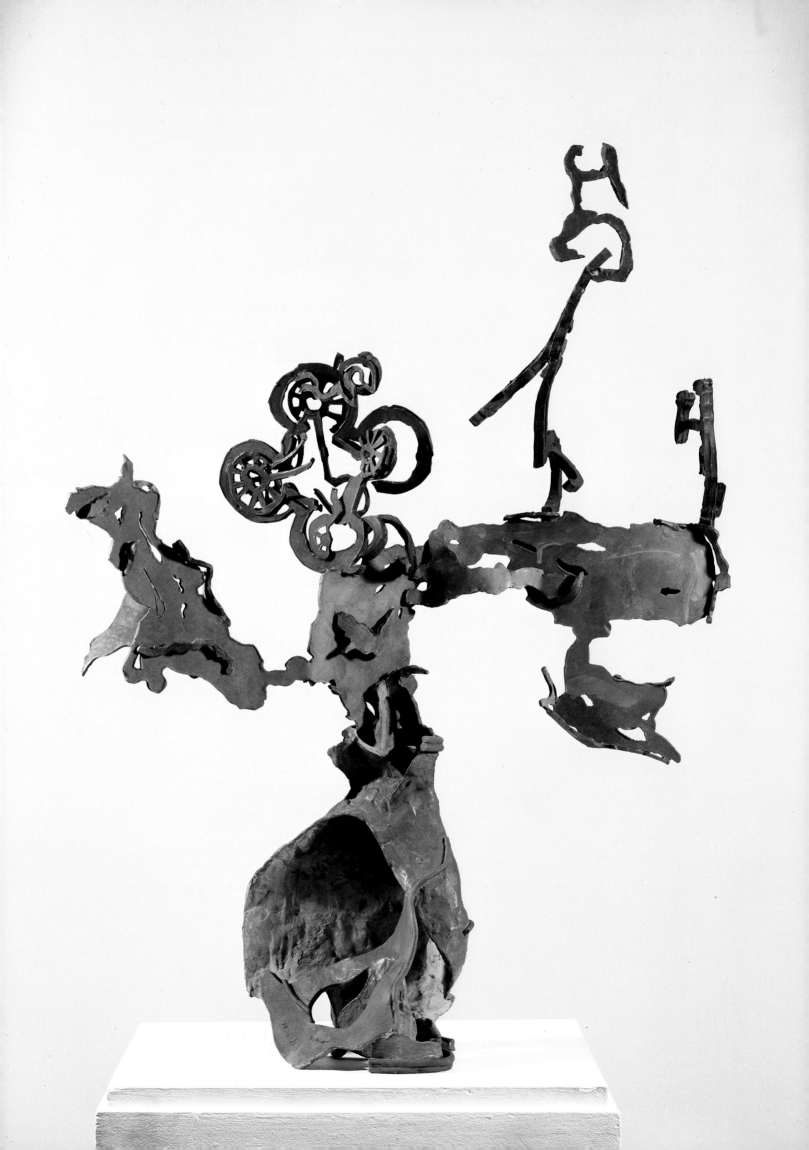

Nancy Graves

Sculpture for the Eye and Mind

LINDA L. CATHCART

Director, Contemporary Arts Museum, Houston

Nancy Graves emerged as an artist in the late 1960s, when she exhibited in New York, after studies at Yale and two years abroad in Paris and Florence. While in Paris on a Fulbright-Hayes grant for painting in 1964, the artist, who had trained as a painter, started to explore three-dimensionality and the possibilities of using various materials that were not usually associated with sculpture. She also experimented with composing in nontraditional ways. It was when living in Florence in 1965 that she began to realize a personal style of making sculpture. Her initial efforts reflected her powerful interests in naturalism and, in particular, in paleontology. In Europe she was not so deeply influenced by contemporary European art as she had been by American art at Yale—specifically by the sculptures of Alexander Calder and David Smith, and in general by the atmosphere she had experienced there. Important also was the sharing of ideas with her contemporaries, the artists Claes Oldenburg, Bruce Nauman, Richard Serra, and the composer Philip Glass.

In Florence, Graves discovered the waxworks of the eighteenth-century anatomist Clemente Susini in a natural-history museum. Susini's work had a profound impact on her thinking. His life-size wax forms were of animals and human anatomy, and Graves felt they had a visual completeness with which she was in sympathy. In Italy she made two experimental life-size camel sculptures of wood, raffia, and pelts, based upon his model. She destroyed these before returning to New York.

There was a personal reverberation in this analytical work. Perhaps because Graves was accustomed to looking at nature—she had grown up in the country, in Pittsfield, Massachusetts, where her father worked at the Berkshire Museum, which displayed art and natural history—she sought an animal form to convey her ideas. She chose the enigmatic camel originally because she felt it could be interpreted as a metaphor for the secret life of sculpture. In her later work she has used symbolic metaphor frequently, and with developing sophistication.

Graves is a relentless observer of art, as well as of natural forms, and when she established her studio in New York City in 1966, she continued to travel to Europe, where she spent as much time in museums of natural history and science as in art museums.

Of the twenty-five full-scale camel sculptures Graves made between 1965 and 1970, three were exhibited at the Whitney Museum of American Art in New York in 1969 (cat. nos. 2, 3, and 4). (Many of the others were subsequently destroyed by the artist.) This show marked her beginnings as an artist who would explore a tremendous range of media to get her ideas across, using natural forms as her starting point and modernist sculpture as her touchstone. Hers was a unique approach: she combined natural forms with formal and abstract information toward a unique end. This was based on a concept of an emotional and mysterious nature balanced by abstract and formal structures. Graves's camels were a prosaic interpretation of this concept; they functioned as a starting point for her sculptural investigations and had an emotional weight for the viewer. (The camel seems to be a beast whose personality is quirky and difficult.)

Archaeologue (cat. no. 43).

Graves's next works were camel "fossils" of wax. It was with these that she began to learn about sculptural techniques. Over time, fascination with techniques would grow and develop into a major influence on her work.

Throughout the 1970s, Graves made a group of works that dissected camel forms, skeleton forms, and referred by association to fossils, skins, feathers, shadows, prehistoric cave paintings, mummies, and shamanistic forms. In several dozen static works, and in five films (made between 1970 and 1974), she explored the relationship between the motionless observer and the single object, as well as between the small object and the larger, using variability and repetition of forms. These methods have come to characterize her work as a whole. She used wax, fired clay, latex, plaster, wood, steel, and acrylic and oil paint, and the resultant work contained the decisive elements found in her later sculpture. Of particular interest to her was the possibility of unconventional relationships among forms. Working with microcosm and macrocosm, and moving from the particular to the general, her ultimate aim came to be the abstract—an abstraction that comes out of a specific and concrete context.

In 1970 Graves made the seminal *Variability of Similar Forms* (cat. no. 23), a sculpture composed of thirty-six life-size wax, steel, marble dust, and acrylic camel legs—a forest of dissociated yet recognizable shapes. Each leg has three elements, separated by joints. The lower elements are all similar. The top two-thirds of each leg vary: some are fore, some hind legs. The variations of placement, angle, and positioning were of great interest to the artist. *Variability of Similar Forms* indicates some of Graves's developing concerns: the legs are not made in sets; each is a unique sculpture, yet they read as parts of a whole; like images on film, they are gestures of movement, perhaps equivalent to paint strokes on a canvas. Graves was at this time acknowledging the influence of the experimental photographer Eadweard Muybridge on her thinking about motion, perception, and recognition, and she began also to explore notions of measurement and scale. This piece refuses to offer the viewer a single vantage point; instead, the eye travels around it, accumulating a total, unified vision. In addition it has achieved a sense of mystery: the viewer may not initially understand these forms as animal legs, or may be struck by their cryptic, perhaps symbolic quality.

In making the camel and fossil pieces, Graves explored the logic of traditional sculptural formulas, making a careful study of space, armature, weight, and gravity. At the same time she began to realize the possibilities of other, less conventional methods of presentation, such as propping, hanging, and scattering. These were formal ideas about abstraction applied to specific natural phenomena in order to cause dysfunction of the familiar—to make it abstract. This work generated new ideas, which Graves organized as sets of oppositions: internal versus external forms, placement versus displacement, the perception of familiar images versus that of abstracted ones. At this time she made a number of works that hang from the ceiling or lie directly on the floor, thus eliminating the traditional base. In *Fossils*, 1969–70 (cat. no. 14), bones are scattered in a logical sequence, and the floor itself is used as a base. Each of these early sculptures stresses the importance of seeing a sculpture from various positions and experiencing it in time. Often the skeletal forms are segmented, broken down into parts, as in *Inside-Outside*, 1970 (cat. no. 16), so that the eye must reassemble the skeleton and re-form the original animal shape.

Among the most abstract and complex of Graves's early works is *Calipers*, 1970 (cat. no. 11), which consists of quarter-inch steel rods scattered and overlapping on the floor. This is an early instance of the use of overlapping and layering, so important in Graves's later work. The rods, previously used only as armatures for her sculpture, now become the sculpture itself. As the title indicates, each rod refers to a measurement. In this case, according to the artist, what is being measured is the distance between the ribs of a camel. With time, the rods rusted, leaving their outlines on the floor. The resultant marks reminded Graves of shadows, which could also function as measurements or as a drawing.

Another large and important early work is *Shaman*, 1970 (cat. no. 20). It is among the most ambitious of her works at this time. It consists of multiple elements of latex, gauze, metals, and other materials, each highly colored and fragile. Shadowy, anthropomorphic forms hover against a wall, creating a drawing in space. This work prefigures the delicate linear style of sculpture that was to come in the 1980s. The curved forms of the camels and the linear qualities of sculptures such as *Shaman*, together with her

Calipers (cat. no. 11).

Shaman (cat. no. 20).

Camouflage Series #4, 1971, acrylic on canvas, 96 × 72 (243.8 × 182.9). Private collection.

films of animals in motion, showed that Graves was studying drawing in time and in three dimensions.

In 1972 Graves returned to painting, which she then felt was the appropriate vehicle for her current ideas. Her new paintings were informed by the way she had colored her first sculptures. In these color had been naturalistic and dictated by the subject. The Camouflage Series of paintings (1972), based on sea animals, was a reassessment of figure-ground relationships. Using a pointillist technique to suggest natural camouflage, Graves explored methods of coloration that have their origin in natural phenomena. These paintings in turn had a profound influence on her subsequent sculpture. Camouflage, like shadow, appealed to Graves because it implied an abstraction derived from natural forms. At this point Graves began to remove images from their naturalistic context in order to allow the viewer to form a deeper relationship with the underlying information they offered. Her concern was not to examine them in isolation, but to re-evaluate the way the viewer sees and how the mind understands complex images.

In the Camouflage Series and the 1972 Ocean Floor Series (paintings based on bathymetric and marine topographic maps), Graves used a dense pattern of almost-connected dots forming curved lines around the canvas, tracing a topography. Maps

that translate three-dimensional information into two dimensions provided her with a foundation for her painting. Later she would use maps, as well as more general images of architecture and city planning, as a starting point for sculpture. These provided a new possibility for the play between drawing and sculpture, in that architectural plans are two-dimensional ideas that are realized in three dimensions.

By the late 1970s, Graves had begun to develop her increasingly complex subject matter through associative thinking. For example, she might reason that camels exist in nature, their bones are fossilized in the ground, the ground holds archaeological evidence as well as geological information, the ocean floor is a record of geological history, and the ocean itself is a natural environment for animals. The ocean, like the earth and the other planets, is a subject of maps. In 1979 Graves explained:

> One of the logical points in the early sculpture is that the content had to do with prehistoric forms, such as fossils and archaeological evidence, and used this as a line from which to extend three-dimensional forms into two dimensions. I was thinking about the Ocean Floor Series, which meant I was thinking about the earth as a prehistoric form. The earth contains fossil information and the ocean floors are one source.[1]

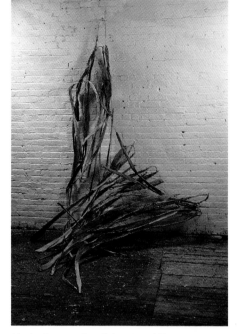

Evolutionary Graph (cat. no. 13).

A number of influences and precedents can be cited for Graves's nature sculptures made after the camels and related pieces. She followed David Smith's example in exploring natural images, using nature, as Smith had, for inspiration, for humor, and as a source of endlessly suggestive forms. From Pablo Picasso, Smith, Calder, and the post-Cubist sculptors she learned to create tension through shape and color, and to assemble her sculptures out of forms that barely touched, as opposed to pierced or built structures. Calder's work in particular taught her about balance and about the engineering of shapes into new forms and structures. Graves's Pendula Series, of which *Pendula*, 1983 (cat. no. 136), is the first, is an homage to Calder's genius for engineering and fabrication. The sculptures *Zag* and *Zaga*, both 1983 (cat. nos. 153 and 154), are tributes to Smith's Zig Series.

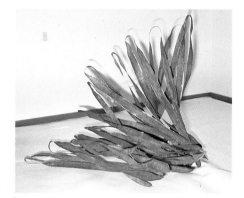

Graph (Evolutionary Graph II) (cat. no. 35).

In 1977 Graves was commissioned by Dr. Peter Ludwig, for the Museum Ludwig in Cologne, to create a permanent outdoor piece, *Ceridwen, out of Fossils* (cat. no. 33), based on an early sculpture, *Fossils*, 1969–70 (cat. no. 14). She made prototype parts for the sculpture, made wax molds of them, and transferred these into unique cast-bronze forms. To make this piece, she worked at the Tallix Foundry in Peekskill, New York, where she learned the lost-wax process and a method of patinating bronze by painting it with chemicals and sealing the coating with fire. This commission was thus an opportunity for her to develop techniques for new forms and a new sense of color.

In the first bronze sculptures, Graves used her early works as a point of departure for her subjects, but not as a source for replication. For example, *Evolutionary Graph*, 1970 (cat. no. 13), which had originally hung from the wall and rested on the floor, became *Graph (Evolutionary Graph II)*, 1978 (cat. no. 35), a floor piece fabricated from bronze sheets that were cut, bent, welded, and patinated. Elements used for *Column*, 1979 (cat. no. 46), were cast in bronze using *Variability of Similar Forms*, 1970 (cat. no. 23), as a prototype. Following these early experiments in bronze, Graves began a group of sculptures based on drawings she had made in the library of the American Academy in Rome in the spring of 1979, taken from books of drawings of ancient archaeological sites in the Mediterranean. The drawings included geographic maps (the "bones" of civilization), charts, architectural renderings, and sketches of artifacts. The notebook of drawings she compiled became the source for the set of sculptures beginning with *Bathymet-Topograph*, 1978–79 (cat. no. 45). *Bathymet-Topograph* demonstrates clearly how Graves moves from vertical information to horizontal and back again. It is, as the title implies, a combination of bathymetric and topographic information—the same kind as that which had informed Graves's 1972–73 paintings.

The necessity of transforming two-dimensional drawings into three-dimensional forms presented Graves with structural problems she had not encountered in her earlier sculpture. The drawings provided the inspiration for three-dimensional elements which Graves could make and join together. The principal problem was, as she said, "how to realize the third dimension without having seen it." In the sculpture of the late 1970s she began to expand her vocabulary, to "translate forms in as many ways as

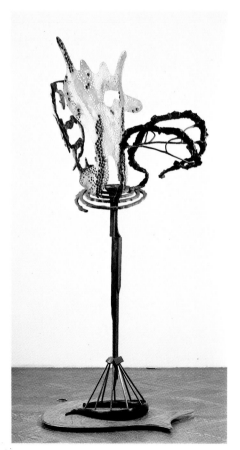

Bathymet-Topograph (cat. no. 45).

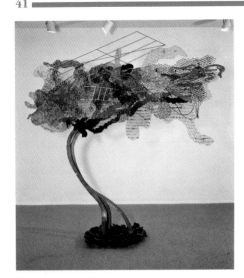

Trace (cat. no. 60).

possible into a sculpture solution." To do this, she became deeply involved in technique. She connected inspiration to technique. By using familiar forms, she was able to experiment freely with the elements of color and surface and to achieve monumentality in bronze for the first time. She began to use color as an element in itself and to apply it in increasingly vivid and painterly ways. *Quipu*, 1978 (cat. no. 38), is an important sculpture of this period, for it was made of rope cast directly in bronze. Also, it is the first bronze to use disjunctive color. Color had always been an important element in Graves's sculpture, used to distinguish one part from another and to give them greater three-dimensionality. In this work, and in all of the later sculpture, each of the elements is structural and necessary. Only occasionally after this does one see a small addition that might be purely decorative, but it usually functions as an indication of scale. From this point on, Graves's sense of visual and structural economy became an element of her aesthetics.

Archaeologue, 1979 (cat. no. 43), combines three separate archaeological sources from the Rome notebooks, with content ranging from the general to the specific: two Mediterranean city plans of varied scale and a fragmented vase, which introduces into the work the concept of container and contained. Graves abstracts the information taken from these sources, changing the scale relationship among the parts. She further uses color to emphasize those changes in scale. A related sculpture, *Archaeoloci*, 1979 (cat. no. 42), is also based on studies of a Mediterranean archaeological site. Blue, curvilinear shapes depict the sea, and the steplike forms that act as the support are the renderings of a breakwater found at the site. The base is a topographic rendering of another archaeological dwelling site. Graves says:

> The base is fabricated of sheets of wax which were punched out, shaped, bent, and fused. I brought a prototype in wax to the foundry that was close to the image made to scale from the drawings. There were two things going on in these pieces, as I continued to work. The choices of materials, surfaces, and processes of forms expanded and . . . as I increased the complexity of sculptural parts, the solutions became more open.

Each of the sculptures from the late 1970s depended upon a preliminary drawing. But by the end of the decade, Graves had stopped drawing or diagramming her sculptures and had begun to assemble directly in bronze from an inventory of cast forms, building pieces that were about balance, weight, and counterbalance. After 1979, when she began to feel she had a vocabulary in bronze, she became freer with it, using some shapes in repetition. For example, in the sculpture *Kariatae*, 1981 (cat. no. 69), she incorporated cast-bronze fans. These directly cast shapes gave the piece a rhythm that had been accomplished less fluidly in earlier sculptures with shapes that were drawn and then cast.

From the important sculptures of 1979, Graves moved to new works characterized by disparate elements, forms, and objects joined together. She began to abandon thematic treatment of her subject for the freedom to juxtapose. She started to mix her sources—camels, maps, artifacts—as she did in her paintings. Her use of line grew more flexible: it could now represent or enclose. Pattern could signify something particular or merely unify or disperse a color area. A shift in plane could direct the point of view or indicate how certain information was to be read. Forms were lazy or energetic, vertical or horizontal, realistically rendered or fancifully colored, related or not. In 1980 Graves was beginning to develop in her abstractions a method of working directly from intellectual material. She began to exercise her pleasure in mental gymnastics, knowing the viewer's initial disorientation would eventually result in a new visual experience. *Trace*, 1979–80 (cat. no. 60), measuring nine-and-one-half feet tall, represents the transition from the Archaeology Series, dependent mostly upon two-dimensional imagery, to sculptures in which Graves once again dealt with large scale and big volume, as she had in her earliest camels, but in a visual language that had been transformed.

As Graves continued both painting and sculpture, the two began to interact in an immediate and sophisticated way. She extracted a new identity for them by pushing each toward a combination of the strengths she found in both. Thus, in the 1980s, her methods of composing paintings could now be used as means for arranging forms in her sculptures. The initial inspiration for both was an instinctive response to a shape,

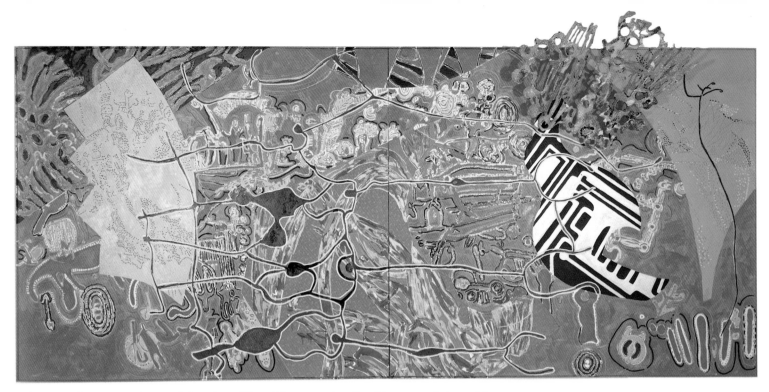

Raukken (Australia Series), 1985, oil and acrylic on canvas with painted aluminum sculpture (diptych), 83 × 173 × 11 (210.8 × 439.5 × 28). Private collection.

subject, color, or quality and density of line. The use of unfamiliar materials and images in her sculptures placed Graves's work in a new context. Her absorption of ancient as well as modern information—archaeology and technology—increased the possibilities for her art while decreasing its most simplistic interpretation. Rather than merely documenting, she studied and reconstructed visual information of various sorts.

Graves's sculptural vocabulary has evolved for over two decades. She began using animal forms, then made use of the vocabulary of bones to explore structure. Later she employed maps and archaeological and architectural shapes, and currently she integrates organic shapes and man-made, largely geometric elements into her sculptures. Graves has found that by working with direct casting she is able to eliminate the need to design and model each element needed for a sculpture. Because Tallix Foundry is able to cast highly complex objects directly (a method usually avoided because of the high risk of failure, and thus waste of material), in the 1980s Graves has been able to produce a body of sculpture that is truly unique.

Graves's sculpture of the 1980s maintains the same rationality as her earlier work but is much more complex. At first glance, the works seem unidentifiable. However, despite decorative and sometimes humorous elements, they come, upon scrutiny, to appear extremely logical and intellectual, even formal and precise. There is a serious side to the pieces that dominates their lyrical element. They are about experimentation in building processes, about tension and weight and extension into space, about support and balance. Structurally, each sculpture predicts and prompts the next. In 1981, using cast pleated lampshades, and in 1982, with the sculptures *Catepelouse, Columnouveau,* and *Conjunctive* (cat. nos. 83, 85, and 87), Graves began to use palm fans as open bases that touch the floor at three points. Successful bases allowed her to try more adventurous building techniques above the floor. For example, in *Closed-Open-Down,* 1985 (cat. no. 186), Graves conceived that hinging, which permitted more than one position of a given part, might be a way to build. She went on to make several more pieces exploring the idea of hinged joints. Hinging gives a sculpture a kind of mobility—that is, a range of static positions—not found in the more traditional kinetic methods, such as hanging. Graves has often explored possibilities related to the fulcrum. *Closed-Open-Down* extends ideas first developed in the 1960s and pursued in the Pendula Series, in which each sculpture has one movable element. As its title suggests, each appended part of *Closed-Open-Down* has three possible positions—none superior to the others. Three arms are hinged to a central element, together forming a new kind of sculptural base. The work is built from the base upward. Here, as in much of Graves's recent sculpture, development of the base is crucial: the construction and addition of each piece depend upon how many supporting elements are necessary. She tends to avoid large bases and to be conservative of space. Graves rarely builds horizontally and almost all of her work is made to human scale and human proportions. She says that this is for practical reasons. She is not, however, without a sense of humor. For example, the wedges, or two bronze ingots, attached to the circular sprues

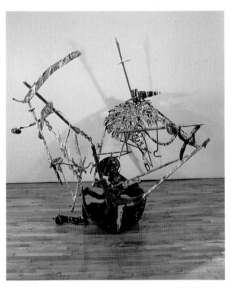

Closed-Open-Down (cat. no. 186).

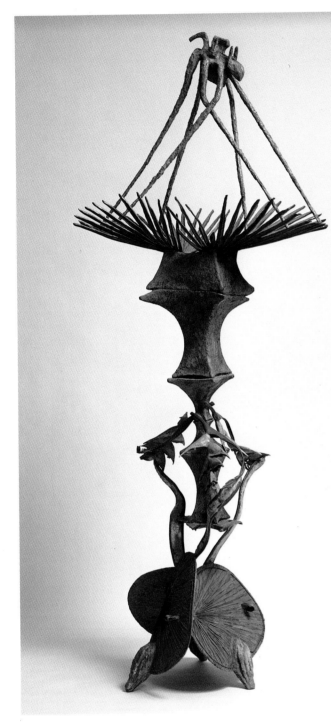

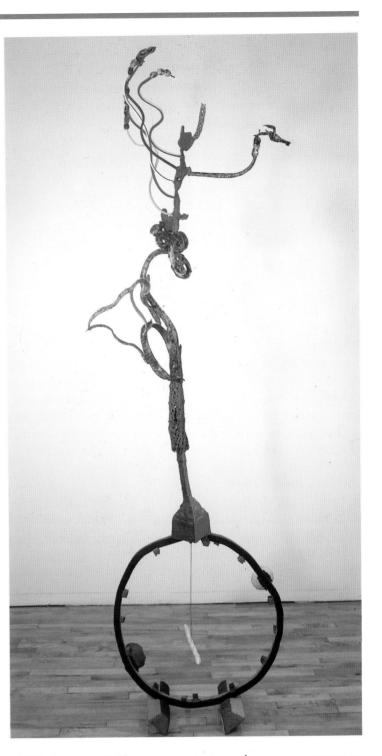

Columnouveau (cat. no. 85).

Pinocchio (cat. no. 172).

at the base of *Pinocchio*, 1984 (cat. no. 172), are amusing: wedges are a common device to compensate for poorly stabilized sculpture or poorly laid floors. (As ingots they are quintessential to the casting process, as they would be melted down and poured into molds.) Graves likes the observer's surprised recognition of this violation of good taste.

When Graves began *Closed-Open-Down*, she thought it was bound to be a structural failure because of the torque on the hinges. Trying to find new ways of securing and new ways of building at the same time, she often faces failure. She was able to save this particular sculpture, she says, by welding firm a number of hinges. Each decision prompts other decisions and the result is perhaps more conservative than what Graves might initially have wanted. This reality causes the artist to press on and make new work.

She finds modeling and working in wax tedious, although she has a great facility for it. It was in order to avoid such work that she first developed the notion of working with materials that could be cast in molds, using the lost-wax process. Originally she molded or drew each shape by hand, with wax or on paper. It was then cut out and formed into an element that could be directly cast. Eventually Graves found that this process could accommodate organic forms, such as plant leaves and vegetables. The technique thus abetted her already profound interest in natural forms and structures

and the shapes they can take. She combined this with casting inorganic objects, such as plastic bubble-wrap packing material, paper fans, and tools. The tools may have been inspired by her surroundings at the foundry, and may also serve as a reminder of the sculptural process; similarly, the packing material is the sort used for wrapping paintings and sculptures. Now she uses fabrication only as an adjunct to the assemblage of directly cast organic and geometric forms. *Span Link Cross*, 1985 (cat. no. 212), uses ropes fashioned into diamond shapes and then cast. Their function is to span, and they allow for flexibility in the movement of the sculpture. By extending the diamonds into a large zigzag-shaped piece, she increases its structural capabilities as well as its visual interest. This illustrates one of the basic principles of Graves's work: the sculpture remains open, yet it has bulk; it is stable because it is spanned, and it has a torque that can be read as a lyrical drawing in space. The bronze braided hose in this piece houses a hidden steel rod that enables it to support a solid-bronze stalk of brussels sprouts weighing about seventy-five pounds. The hose, in turn, is held by a scissors shape that forms one part of the delicate, open base.

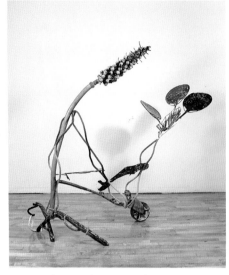

Span Link Cross (cat. no. 212).

Graves likes forms that have rhythm, such as the pleated-lampshade and fan shapes in *Bridged*, *Cantileve*, and *Chimera*, all 1983 (cat. nos. 111, 113, and 115); each uses a different kind of folding. The recognizable found objects are what Graves refers to as the "come-on" for each piece. The viewer begins by identifying elements that are recognizable or familiar; this recognition is quickly followed by the realization that they are bronze and weigh five to ten times more than their originals. Finally, one realizes that each element is in fact structural and, in addition, that each image combines, or flows, with the next, bringing about a total sculptural rhythm that embraces odd and startling conjunctions. The juxtaposition of, for example, fans with a rope of sardines, as in *Bridged*, is characteristic and surprisingly lyrical.

The sculptures follow a system of duplicated and permutated forms. The viewer can thus identify a form in its various permutations. This is where the painted surface becomes particularly important. Paint is applied by brushing, skeining, and dripping, a random process that defies control; or color is added in delicate glass enameling, unusual in large-scale bronze sculpture. That paint and patina have different viscosities can be seen in the way they drip and run when applied to three-dimensional forms. Paint in particular drips to follow a sculpture's contours—behavior very different from that which would occur on a canvas. A chromatic structure is created by the artist over the organic, volumetric structure of the form. This dripping over three dimensions provides a more random method of drawing than that possible on a flat surface.

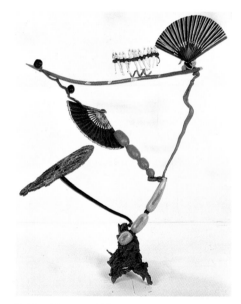

Bridged (cat. no. 111).

The artist takes advantage of the various processes involved in making each sculpture to do the unexpected. Sometimes this is a matter of balance, weight, and counterbalance, the pushing of elements into illogical positions. Frequently there is an element of humor, as is found in her use of camels, sardines, and crayfish, and sometimes there is even an element of danger. For example, the stiletto tips of a large palmetto leaf or dried weed cast in bronze may project sharply from a sculpture. These three techniques of surprise, humor, and risk create an emotional tension that is added to the physical tension of the sculpture. Each sculpture is as structurally spare as possible, with all its elements well placed and visible. Graves aims not for needless decoration but for a functional structure whose decorative elements have a purpose and carry meaning.

Her intention is to allow all the elements to reveal themselves while keeping the whole sculpture open, so that no one element obscures another. The aim is for each piece to be easily read from different points of view. In order to achieve this complex and difficult work in heavy material, Graves must placate the metal. She has to adapt it to her needs and herself to it, to achieve harmony among the materials, working methods, and subject matter. It is clear that she has done so. There is no sense of strain, of the difficulty of the machinery or the hardness of the metal. In fact, to make such sculptures is a rough and aggressive task. They appear, however, deliberate and lacy, full of loose, compound curves, rather than the sharp edges or hard, solid forms more commonly associated with bronze. In the recent sculptures especially there is an increased emphasis on the dynamics involved in their creation. Even the titles—*Extend-Expand*, 1983 (cat. no. 122), *Span-Spun*, 1984 (cat. no. 174), *Closed-Open-Down* and *Span Link Cross*, both 1985 (cat. nos. 186 and 212)—illustrate this. The use of dense objects such as big stalks of brussels sprouts, large gourds, steel rebar rods, and ingots at the bases contribute to the sense of unity and flow, being structur-

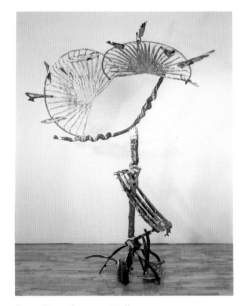

Span-Spun (cat. no. 174).

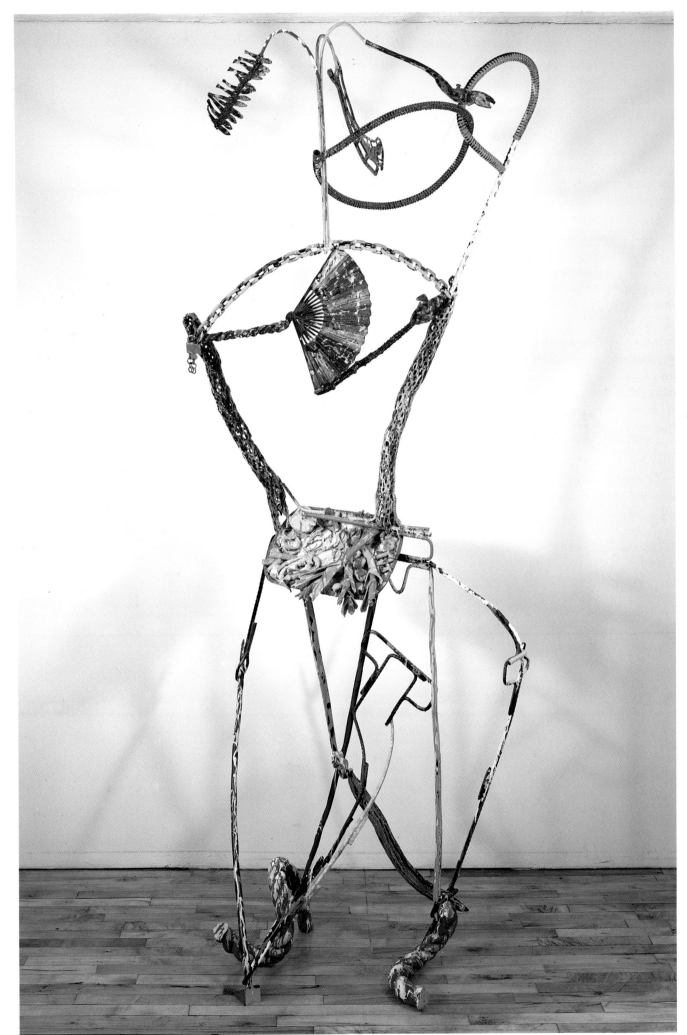

Looping
(cat. no. 199).

ally and aesthetically integrated, unlike traditional sculptural bases, whose forms are unrelated to the main body of the sculpture. She uses an object in the manner its shape suggests. She even uses the process of bronze casting itself to provide forms. Thus the gating used to pour molten metal into a delicate leaf shape is retained and becomes a structural device, as do the splashy metal spills retrieved from the foundry floor.

In *Looping*, 1985 (cat. no. 199), the central object, a plastic platter covered by a Woolworth's doily, upon which is placed an array of foods from a Korean food market, is a single piece directly cast. Its inspiration was a recipe photograph from *The New York Times*, but it evokes every classical still life ever made and comes to rest in modernism. The tray is tilted toward the viewer, flattened as if in a Cubist picture plane—a three-dimensional Hans Hofmann or Picasso. Defiant of gravity, flat and frontal, covered in color, it is painterly and modern. Symbolic with its halved apple, sensual with its breadsticks and baby corn, romantic with its unfurled fans, the piece dances in the air. Every object below the tray builds to it and everything above springs from it or circles back downward to focus upon it.

There is no reason to believe that Graves is near to concluding her sculptural investigations. The possible inventory of forms for her art is endless. She does not fight her materials; rather, she builds with them and allows the process itself to suggest new avenues. Each of her sculptures functions as an energetic abstraction, never remaining merely literal and never giving way to dead weight. She has the ability to amplify forms and to achieve for each individual one many possible readings. It is through this skill that she can make complex and multifaceted works of art. Unlike so many other sculptors in her media, she does not depend upon the aggressive force of machinery and metal. Rather, she structures her sculptures' parts so that clarity prevails and so that each element will reveal itself within the structural possibilities allowed by gravity. This requires an unusually subtle understanding of technique and structure, as well as of drawing and color.

Because she freely examines ideas, images, and history, and because she questions each assumption of both the intellect and the eye, Graves possesses a special sensibility, which she has turned equally upon the material and upon her own personal vision to continue opening up possibilities for new and original sculpture.

[1] The material included here on Graves's sculpture before 1979 is derived from my catalogue *Nancy Graves: A Survey, 1969–1979*, published by the Albright-Knox Art Gallery, Buffalo, New York, 1980. The material related to the subsequent sculpture was derived primarily from three tape-recorded, unpublished interviews with the artist in New York City and Peekskill, New York, in July 1985.

Catalogue Raisonné

RUTH J. HAZEL

Guide to the Catalogue Raisonné

Catalogue entries contain information under the following categories:

Catalogue number	Collection
Title	Provenance
Date	Exhibitions
Medium	References
Dimensions	Remarks
Inscription	

Information is as complete as possible through April 1986. The pieces of sculpture are numbered consecutively from 1A through 242. They are ordered chronologically by year and then alphabetically within each year. Works created over more than one year are catalogued under year of completion.

Titles and dates are those given by the artist. Dimensions are given in inches, followed by centimeters, and height precedes width precedes depth. Pieces with movable parts or various possibilities of assemblage may have variable dimensions. In such cases, they have been documented according to the artist's initial intention. Unsigned works are indicated as such. Placement and full wording of signatures and inscriptions are given for all other pieces.

The name and place of residence of each current owner are listed, unless the owner has restricted this information. Former owners and dealers involved in the transfer of ownership are listed, beginning with the earliest. M. Knoedler & Co., Inc., New York, the artist's dealer since 1977, was the main source in tracing provenance.

Exhibition records for each piece are listed chronologically, beginning with the earliest. Listings include city of exhibition, museum or gallery name, year, catalogue (if any), and illustration data. Circulating exhibitions are noted under city of origin and then as "traveling exhibition." Complete exhibition information can be found in the "Exhibition History."

References are in abbreviated form. They are listed chronologically by year and alphabetically by author within a single year. References by the same author within a single year are then listed chronologically according to day and month. Books and exhibition catalogues are cited by author's last name and date of publication, followed by the specific citation information. Magazine, journal, and newspaper articles include author's last name, title of periodical, date, month, year, and page number(s). Authorless articles are listed by abbreviated title; otherwise, titles are omitted, and can be found, together with full bibliographic data, in the bibliography. Since references often document reproductions, any that include comments in the text are noted with the abbreviation "comm." References are only as complete as the information available to the compiler.

All remarks are written by the artist. Information varies and may include explanations of titles, insights, processes, techniques, and materials used. Tallix Foundry, formerly in Peekskill, New York, now in Beacon, New York, is the place of fabrication of nearly all works. Only those cast at other foundries or locations are so noted.

LIST OF ABBREVIATIONS

bw	black-and-white illustration
cat.	catalogue
cat. no.	catalogue number
color	color illustration
comm.	commentary
front.	frontispiece
n.p.	no page
p., pp.	page, pages
pt.	part
sec.	section
ser.	series
supp.	supplement

1A Camel I, 1966
Wood, burlap, polyurethane, animal skin, wax, and oil paint.
96 × 60 × 144 (243.8 × 152.4 × 365.8). Unsigned. Destroyed by
the artist in Florence, 1966.

REFERENCES
Battcock, *The New York Free Press*, 2 May 1968, bw p. 8.

1B Camel II, 1966
Wood, burlap, polyurethane, animal skin, wax, and oil paint.
96 × 60 × 144 (243.8 × 152.4 × 365.8). Unsigned. Destroyed by
the artist in Florence, 1966.

REFERENCES
Battcock, *The New York Free Press*, 2 May 1968, bw p. 8.

1C Camel III, 1968
Wood, steel, burlap, polyurethane, animal skin, wax, acrylic, oil
paint, and fiber glass. 96 × 126 × 48 (243.8 × 320 × 121.9).
Unsigned. Destroyed by the artist in 1968.

EXHIBITIONS
New York: Graham Gallery, 1968

REFERENCES
Dienst, *Kunstwerk* 21 (April 1968), bw p. 33. "Reviews and Pre-
views," *Artnews* 67 (April 1968), bw. p. 11. Battcock, *The New York
Free Press*, 2 May 1968, comm. p. 8. Diamonstein, *Harper's Bazaar*,
January 1971, comm. p. 106.

REMARKS
The sculpture was destroyed by the artist, who did not wish *Camels
III, IV,* and *V* to be exhibited separately.

1D Camel IV, 1968
Wood, steel, burlap, polyurethane, animal skin, wax, acrylic, oil
paint, and fiber glass. 96 × 126 × 48 (243.8 × 320 × 121.9).
Unsigned. Destroyed by the artist in 1968.

EXHIBITIONS
New York: Graham Gallery, 1968

REFERENCES
Dienst, *Kunstwerk* 21 (April 1968), bw p. 33. "Reviews and Pre-
views," *Artnews* 67 (April 1968), bw. p. 11. Battcock, *The New York
Free Press*, 2 May 1968, comm. p. 8. Diamonstein, *Harper's Bazaar*,
January 1971, comm. p. 106.

REMARKS
The sculpture was destroyed by the artist, who did not wish *Camels
III, IV,* and *V* to be exhibited separately.

1E Camel V, 1968
Wood, steel, burlap, polyurethane, animal skin, wax, acrylic, oil
paint, and fiber glass. 96 × 126 × 48 (243.8 × 320 × 121.9).
Unsigned. Destroyed by the artist in 1968.

EXHIBITIONS
New York: Graham Gallery, 1968

REFERENCES
Dienst, *Kunstwerk* 21 (April 1968), bw p. 33. "Reviews and Pre-
views," *Artnews* 67 (April 1968), bw p. 11. Battcock, *The New York
Free Press*, 2 May 1968, comm. p. 8. Diamonstein, *Harper's Bazaar*,
January 1971, comm. p. 106.

REMARKS
The sculpture was destroyed by the artist, who did not wish *Camels
III, IV*, and *V* to be exhibited separately.

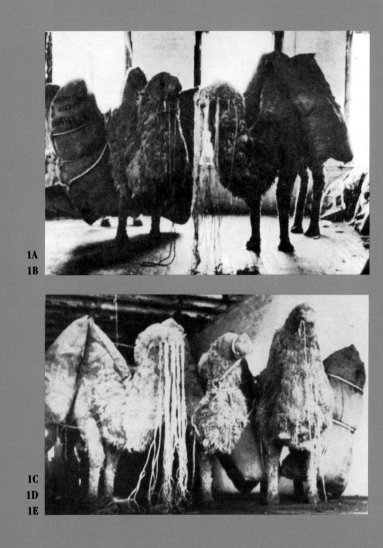

1A
1B

1C
1D
1E

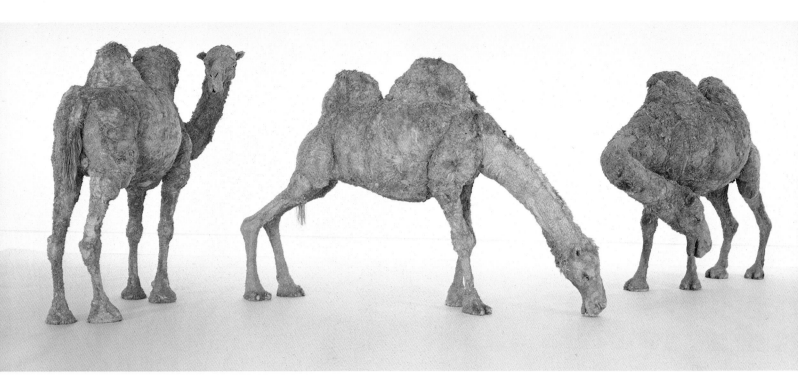

3, 2, 4

2 Camel VI, 1968–69

Wood, steel, burlap, polyurethane, animal skin, wax, acrylic, oil paint, and fiber glass. 96 × 126 × 48 (243.8 × 320 × 121.9). Unsigned.

COLLECTION

National Gallery of Canada, Ottawa

EXHIBITIONS

New York: Whitney Museum of American Art, 1969

New York: Whitney Museum of American Art (cat. no. 78; color p. 273), 1976

Buffalo: Albright-Knox Art Gallery (traveling exhibition; cat. no. 1; bw p. 12, color p. 37), 1980–81

REFERENCES

Frankenstein, *San Francisco Sunday Chronicle*, 6 April 1969, bw p. 39. *Time* 93 (4 April 1969), bw p. 70. Lord, *Artscanada* 27 (June 1970), bw p. 6. *Second Annual Review*, 1971, bw p. 6. Tuchman, 1971, bw n.p. Tuchman, Becker, and Strohmeyer, 1971, bw n.p. Lippard, *Art in America* 63 (November–December 1975), bw p. 78. Munro, 1979, bw p. 55. Bass, *The Berkshire Eagle*, 29 May 1980, bw p. 11. Carr, *Dialogue* (July–August 1980), bw p. 20. "Events and Openings," *The Buffalo News*, 2 May 1980, bw. Kalil, *Artweek* 11, 18 October 1980, bw p. 7. La Badie, *The Commercial Appeal* (Memphis), 11 November 1980, bw p. 26. Lindey, 1980, bw p. 142. Tennant, *Houston Chronicle*, 28 September 1980, color p. 12, color cover. Beals, *Weekend*, 13 February 1981, bw p. 13. Elliott, *Darien News*, 26 February 1981, bw sec. 3, p. 8. Schwartzman, *Vassar Quarterly* 77 (Winter 1981), bw p. 20. Smith, 1981, bw p. 11. Tulenko, *Art Voices* (July–August 1981), bw. Mulaire, 1985, comm. p. 24, bw p. 25. Berman, *Artnews* 85 (February 1986), color pp. 62–63.

REMARKS

Of twenty-five camels made between 1965 and 1969 only five remain extant. The original construction of the group was started in 1965 in Florence. Of the five, three are in the National Gallery of Canada, Ottawa, and two are in the Neue Galerie—Sammlung Ludwig, Aachen, West Germany (cat. nos. 6 and 8). A sixth work, *Head on Spear*, 1969 (cat. no. 5), in the collection of Janie C. Lee, Houston, is part of a destroyed work.

3 Camel VII, 1969

Wood, steel, burlap, polyurethane, animal skin, wax, acrylic, oil paint, and fiber glass. 96 × 126 × 48 (243.8 × 320 × 121.9). Unsigned.

COLLECTION

National Gallery of Canada, Ottawa, gift of Mr. Allan Bronfman, Montreal

EXHIBITIONS

New York: Whitney Museum of American Art (bw cover), 1969

REFERENCES

Andreae, *The Christian Science Monitor*, 17 April 1969, bw p. 10. *Time* 93 (4 April 1969), bw p. 70. Lord, *Artscanada* 27 (June 1970), bw p. 6. *Second Annual Review*, 1971, bw p. 6. Tuchman, 1971, bw n.p. Tuchman, Becker, and Strohmeyer, 1971, bw n.p. Lippard, *Art in America* 63 (November–December 1975), bw p. 78. Armstrong et al., 1976, color p. 237. Munro, 1979, bw p. 55. Cathcart, 1980, bw p. 12. Lindey, 1980, bw p. 142. Schwartzman, *Vassar Quarterly* 77 (Winter 1981), bw p. 20. Smith, 1981, bw p. 11. Tulenko, *Art Voices* (July–August 1981), bw. Mulaire, 1985, comm. p. 24, bw p. 25. Berman, *Artnews* 85 (February 1986), color pp. 62–63.

Study of "Head on Spear," 1969, gouache on graph paper, 18 × 14 (46 × 35.5). Collection Janie C. Lee Gallery, Houston.

4 Camel VIII, 1969
Wood, steel, burlap, polyurethane, animal skin, wax, acrylic, oil
paint, and fiber glass. 96 × 126 × 48 (243.8 × 320 × 121.9).
Unsigned.

COLLECTION
National Gallery of Canada, Ottawa, gift of Mr. Allan Bronfman,
Montreal

EXHIBITIONS
New York: Whitney Museum of American Art, 1969

REFERENCES
Lord, *The Five Cent Review* 1 (August 1969), bw p. 24. Lord,
Artscanada 27 (June 1970), bw p. 6. *Second Annual Review*, 1971,
bw p. 6. Tuchman, 1971, bw n.p. Tuchman, Becker, and Strohmeyer,
1971, bw n.p. Lippard, *Art in America* 63 (November–December
1975), bw p. 78. Armstrong et al., 1976, color p. 237. Munro, 1979,
bw p. 55. Cathcart, 1980, bw p. 12. Lindey, 1980, bw p. 142.
Schwartzman, *Vassar Quarterly* 77 (Winter 1981), bw p. 20. Smith,
1981, bw p. 11. Tulenko, *Art Voices* (July–August 1981), bw. Mulaire,
1985, comm. p. 24, bw p. 25. Berman, *Artnews* 85 (February 1986),
color pp. 62–63.

5 Head on Spear, 1969
Steel, wax, marble dust, acrylic, animal skin, and oil paint.
96 × 24 × 12 (243.8 × 61 × 30.5). Unsigned.

COLLECTION
Janie C. Lee, Houston

PROVENANCE
Wolfgang Hahn, Cologne

EXHIBITIONS
Philadelphia: Institute of Contemporary Art, University of Pennsylva-
 nia (bw p. 27), 1979–80
Buffalo: Albright-Knox Art Gallery (traveling exhibition; cat. no. 2; bw
 p. 38), 1980–81

REFERENCES
Tuchman, 1971, bw n.p. Tuchman, Becker, and Strohmeyer, 1971,
bw n.p. Bass, *The Berkshire Eagle*, 29 May 1980, bw p. 11.
Huntington, *Buffalo Courier-Express*, 11 May 1980, bw p. E3.
"Masks, Tents, Vessels, Talismans," *The Pennsylvania Gazette*,
February 1980, bw p. 26.

REMARKS
Head on Spear was made from the head of a previous, untitled
camel, the rest of which was destroyed by the artist.

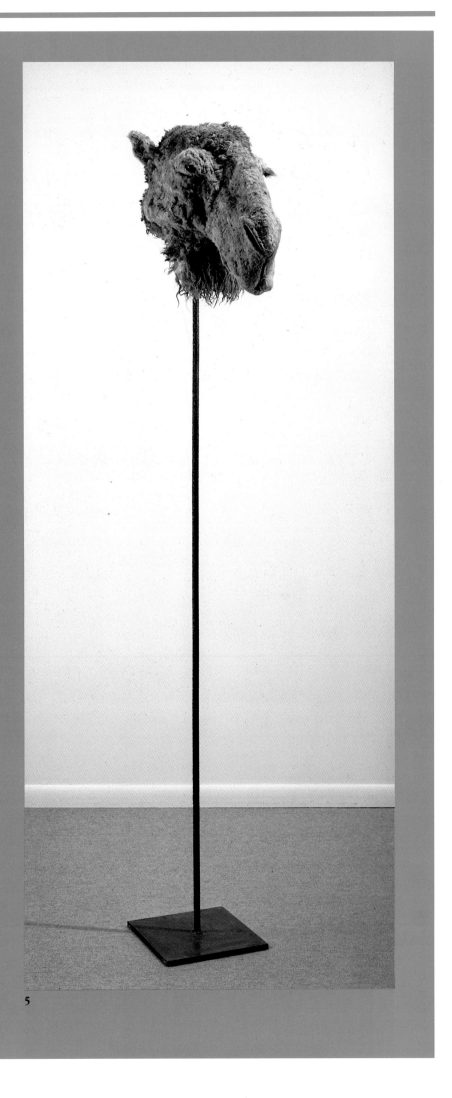

5

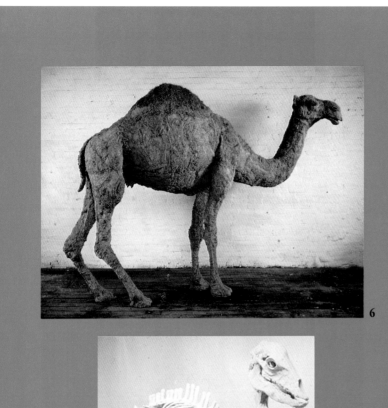

6

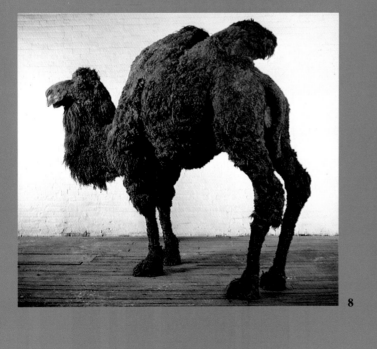

7

8

6 Kenya Dromedary (To Peter Ludwig), 1969

Wood, steel, burlap, polyurethane, skin, wax, and oil paint. 96 × 126 × 48 (243.8 × 320 × 121.9). Unsigned.

COLLECTION

Neue Galerie—Sammlung Ludwig, Aachen, West Germany

EXHIBITIONS

Aachen, West Germany: Neue Galerie im Alten Kurhaus (bw n. p.), 1970

Vienna: Kunstlerhaus Wien (cat. no. 28), 1977

REFERENCES

Tuchman, 1971, color n.p. Tuchman, Becker, and Strohmeyer, 1971, bw n.p. Becker, 1972, color n.p. *Ekstrem realisme*, 1973, bw p. 27. Becker, 1977, color n.p. Cortenova, 1978, bw p. 34. Malangre and Berger, 1980, color n.p.

7 Miocene Skeleton from Agate Springs, Nebraska (To David Schwendeman), 1969

Steel, wax, marble dust, acrylic, fiber glass, and aluminum. 78 × 96 × 36 (198.1 × 243.8 × 91.4). Unsigned. Destroyed by the artist in 1979.

PROVENANCE

Neue Galerie—Sammlung Ludwig, Aachen, West Germany

EXHIBITIONS

Aachen, West Germany: Neue Galerie im Alten Kurhaus (bw n.p.), 1970

West Berlin: Neue Nationalgalerie, 1976

REFERENCES

Tuchman, 1971, bw n.p. Tuchman, Becker, and Strohmeyer, 1971, bw n.p. Becker, 1972, color n.p. *Ekstrem realisme*, 1973, bw p. 27. Becker, 1977, bw n.p. Fillitz, 1979, color n.p.

REMARKS

This piece was used at the H. Noack foundry, West Berlin, to make a bronze version, *Miocene Skeleton*, 1979 (cat. no. 48), now in the Museum moderner Kunst—Sammlung Ludwig, Vienna.

This was the first sculpture in which fossil bones were the point of departure.

8 Mongolian Bactrian (To Harvey Brennan), 1969

Wood, steel, burlap, polyurethane, animal skin, wax, acrylic, oil paint, and fiber glass. 96 × 126 × 48 (243.8 × 320 × 121.9). Unsigned.

COLLECTION

Neue Galerie—Sammlung Ludwig, Aachen, West Germany

EXHIBITIONS

Aachen, West Germany: Neue Galerie im Alten Kurhaus (bw n.p.), 1970

Humlebaek, Denmark: Louisiana Museum Humlebaek, Cultural Center and Museum of Modern Art (cat. no. 16, bw p. 28), 1973

London: Serpentine Gallery (cat. no. 22, color n.p.), 1973

Vienna: Künstlerhaus Wien (cat. no. 27; bw n.p.), 1977

Tehran: Tehran Museum of Contemporary Art (color n.p.), 1978

REFERENCES

Dia-Serie, 1971, bw fig. 805. Becker, 1972, color n.p. *Die Kunst und das schöne Heim* (January 1972), bw p. 6. *Magazin Kunst* 47 (Fall 1972), color p. 2978. Nikolajsen, *Berlingske Tidende*, 10 February 1973, bw. Sager, 1973, fig. 82; bw p. 134. Becker, 1977, color n.p.; bw back cover. Cortenova, 1978, bw p. 34. Sakali, "First Exchange Plan Art Exhibition Opens in City," *Kayhan International*, 12 January 1978, bw. Russell, *The New York Times*, 26 January 1979, bw p. C16. Malangre and Berger, 1980, color n.p. Sello, *Brigitte* 19 (1981), bw p. 168. Zimmer, *Soho News*, 11 March 1981, bw p. 43.

9 Obviation of Similar Forms, 1969

Wax, marble dust, acrylic, steel, and aluminum. 36 × 36 × 36 (91.4 × 91.4 × 91.4). Unsigned. Destroyed by the artist in July, 1979.

PROVENANCE

Neue Galerie—Sammlung Ludwig, Aachen, West Germany

EXHIBITIONS

Aachen, West Germany: Neue Galerie im Alten Kurhaus (cat. no. 3, bw n.p.), 1971

REFERENCES

Wasserman, *Artforum* 9 (October 1970), bw p. 47. Tuchman, 1971, bw n.p. Becker, 1972, color n.p. Becker, 1977, comm. n.p. Metken, 1977, fig. 45; bw p. 82. Fillitz, 1979, color n.p. Berman, *Artnews* 85 (February 1986), comm. p. 62.

REMARKS

This is the first of three variations; the other two are in bronze and date from 1979 (cat. nos. 49 and 50). Graves used this original to make molds for the other two, thereby destroying it. Work was done in Germany, at the H. Noack foundry in West Berlin. The two bronze versions were commissioned by Peter Ludwig.

10 Bones, Skins, Feathers, 1970

Wax, latex, cotton, gauze, and oil paint. 144 × 120 × 120 (365.8 × 304.8 × 304.8). Unsigned.

COLLECTION

Private collection

EXHIBITIONS

Poughkeepsie, New York: Vassar College Art Gallery, 1971
New York: Gallery Reese Palley (checklist no. 6), 1971
Philadelphia: Institute of Contemporary Art, University of Pennsylvania (traveling exhibition; bw n.p.), 1972–73

REFERENCES

Rubenstein, *Poughkeepsie Journal*, 24 October 1971, bw. Tuchman, 1971, bw n.p. Tuchman, Becker, and Strohmeyer, 1971, bw n.p. "Alumnae Week," *Vassar Quarterly* 63 (Winter 1972), bw cover (detail); bw p. 8. Gross, *The Daily Pennsylvanian*, 28 September 1972, bw. McCaslin, *The Journal Herald*, 13 December 1972, bw p. 41.

REMARKS

Hanging Skin Bisected: Shadow Reflecting Itself, 1970 (cat. no. 15) was integrated into this piece.

11 Calipers, 1970

Quarter-inch hot-rolled steel. 12 × 120 × 180 (30.5 × 304.8 × 457.2). Unsigned.

COLLECTION

Private collection

EXHIBITIONS

Vancouver: The Vancouver Art Gallery (bw p. 6), 1977
Yonkers, New York: The Hudson River Museum (traveling exhibition; bw pp. 9, 23), 1979–80

REFERENCES

Wasserman, *Artforum* 9 (October 1970), bw p. 44. Tuchman, 1971, bw n.p. Tuchman, Becker, and Strohmeyer, 1971, bw n.p. Lippard, *Vanguard* 5–6 (October 1977), bw p. 17. Cathcart, 1980, bw p. 13.

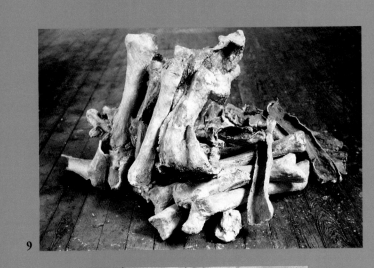

9

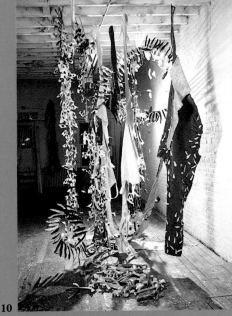

10

11

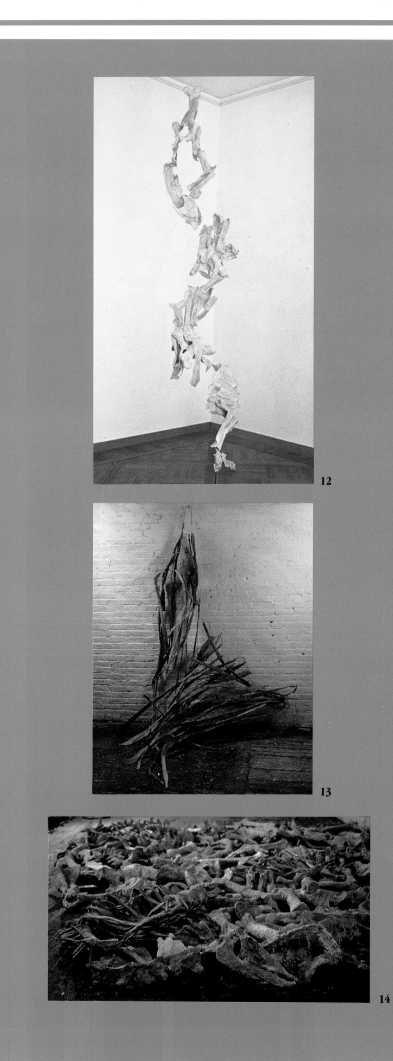

12

13

14

12 Cast Shadow Reflecting from Four Sides, 1970
Gauze, acrylic, and marble dust. 40 × 132 × 36 (101.6 × 335.3 × 91.4). Unsigned. Destroyed by the artist in 1981.

EXHIBITIONS
Cologne: Galerie Rolf Ricke, 1970
Aachen, West Germany: Neue Galerie im Alten Kurhaus (cat. no. 4; bw n.p.), 1971

REFERENCES
Wasserman, *Artforum* 9 (October 1970), bw p. 47. Tuchman, 1971, bw n.p. Cathcart, 1980, bw p. 18.

REMARKS
The work was created from four casts of *Obviation of Similar Forms*, 1969 (cat. no. 9). In 1981 it was destroyed in order to make a bronze version, also titled *Cast Shadow Reflecting from Four Sides* (cat. no. 63).

13 Evolutionary Graph, 1970
Latex, gauze, and aluminum. 84 × 72 × 36 (213.4 × 182.9 × 91.4). Unsigned. Destroyed by the artist in 1978.

EXHIBITIONS
New York: Gallery Reese Palley (checklist no. 2), 1971
Poughkeepsie, New York: Vassar College Art Gallery, 1971
Cleveland: The New Gallery, 1972
Philadelphia: Institute of Contemporary Art, University of Pennsylvania (traveling exhibition; bw n.p.), 1972–73

REFERENCES
Tuchman, 1971, bw n.p. Tuchman, Becker, and Strohmeyer, 1971, bw n.p.

REMARKS
This sculpture was destroyed in the process of making a bronze version, *Graph (Evolutionary Graph II)*, 1978 (cat. no. 35).

14 Fossils, 1969–70
Plaster, gauze, marble dust, acrylic, and steel. 36 × 300 × 300 (91.4 × 762 × 762). Unsigned.

COLLECTION
Private collection

EXHIBITIONS
New York: Gallery Reese Palley (checklist no. 3; referred to as *Fossil Bed*), 1971
Buffalo: Albright-Knox Art Gallery, 1971
Poughkeepsie, New York: Vassar College Art Gallery, 1971
Philadelphia: Institute of Contemporary Art, University of Pennsylvania (traveling exhibition; bw n.p.), 1972–73
Buffalo: Albright-Knox Art Gallery (traveling exhibition; cat. no. 3; bw p. 39), 1980–81

REFERENCES
Wasserman, *Artforum* 9 (October 1970), color p. 45 (entitled *Fossils Incorrectly Located*). Catoir, *Kunstwerk* 24 (May 1971), bw p. 14 (entitled *Fossils Incorrectly Located*). Tuchman, 1971, bw n.p. Tuchman, Becker, and Strohmeyer, 1971, bw n.p. Gablik, 1977, bw fig. 154. Graves, *Artscribe* (April 1979), bw p. 39. Hjort, *Paletten* (February 1980), bw p. 29. Osterwold and Vowinckel, 1982, bw p. 158. Bonenti, *The Berkshire Eagle*, 27 December 1984, bw p. 19. Rubin, 1984, bw p. 678. Berman, *Artnews* 85 (February 1986), comm. p. 62.

REMARKS
The sculpture consists of 176 parts, and relates to a later group of sculptures with a "fossil" theme (see cat. no. 33).

15 Hanging Skin Bisected: Shadow Reflecting Itself, 1970
Torn, cut, and folded sheet, painted with marble dust and acrylic.
120 × 8 × 48 (304.8 × 20.3 × 121.9). Unsigned.

REMARKS
This piece was incorporated into *Bones, Skins, Feathers*, 1970 (cat.
no. 10).

16 Inside-Outside, 1970
Steel, wax, marble dust, acrylic, fiber glass, animal skin, and oil paint.
48 × 120 × 120 (121.9 × 304.8 × 304.8). Unsigned.

COLLECTION
Private collection

EXHIBITIONS
New York: Gallery Reese Palley (checklist no. 1), 1971
Cleveland: The New Gallery, 1972
Philadelphia: Institute of Contemporary Art, University of Pennsylvania (traveling exhibition; bw n.p.), 1972–73

REFERENCES
Wasserman, *Artforum* 9 (October 1970), color p. 44. Tuchman,
1971, bw n.p. Tuchman, Becker, and Strohmeyer, 1971, bw n.p. Cathcart,
1980, fig. 3, bw p. 15. Kelly, 1981, fig. 52, bw p. 58. "Malerin mit
Köpfchen," *ZuriWoche*, 23 December 1982, bw p. 33. Hammond,
1984, bw p. 50.

17 Mummy, 1969–70
Latex, steel, wax, and gauze. 108 × 36 × 42 (274.3 × 91.4 × 106.7).
Unsigned.

COLLECTION
Anselm and Marjorie Talalay, Cleveland

PROVENANCE
The New Gallery, Cleveland

EXHIBITIONS
New York: Gallery Reese Palley (checklist no. 8), 1971
Cleveland: The New Gallery, 1972
Philadelphia: Institute of Contemporary Art, University of Pennsylvania (traveling exhibition; bw n.p.), 1972–73

REFERENCES
Linville, *Artforum* 9 (March 1971), bw p. 65. Tuchman, 1971, bw n.p.
Tuchman, Becker, and Strohmeyer, 1971, bw n.p.

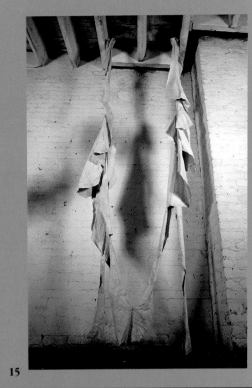

15

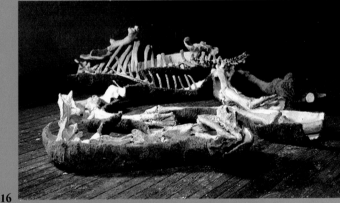

16

17

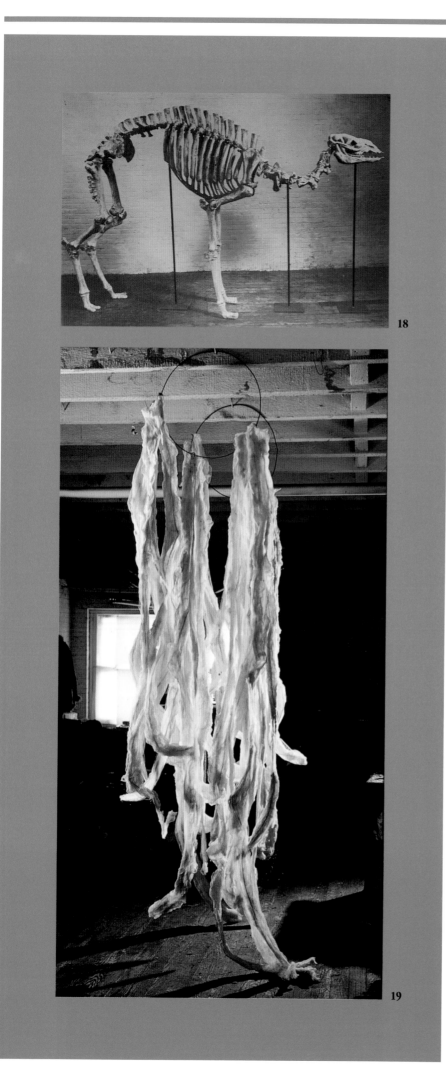

18

19

18 Pleistocene Skeleton, 1970

Steel, wax, marble dust, and acrylic. 84 × 120 × 36 (213.4 × 304.8 × 91.4). Unsigned.

COLLECTION
Private collection

EXHIBITIONS
New York: Gallery Reese Palley (checklist no. 7), 1971

REFERENCES
Keefe, *The Berkshire Eagle*, 29 January 1971, bw p. 5. Tuchman, 1971, bw n.p. Tuchman, Becker, and Strohmeyer, 1971, bw n.p.

19 Shadows Reflecting and Sun Disks, 1970

Steel, wax, and muslin. 108 × 36 × 36 (274.3 × 91.4 × 91.4). Unsigned.

COLLECTION
Private collection

EXHIBITIONS
New York: The School of Visual Arts, 1971
Philadelphia: Institute of Contemporary Art, University of Pennsylvania (traveling exhibition; bw n.p.), 1972–73

REFERENCES
Tuchman, 1971, bw n.p. Tuchman, Becker, and Strohmeyer, 1971, bw n.p.

REMARKS
The sculpture has thirty-six pendant cloth "shadows," eighteen on each disk.

20 Shaman, 1970

Latex over muslin; wax; steel, copper, and aluminum wire; gauze; oil paint; marble dust; and acrylic. 168 × 168 × 144 (426.7 × 426.7 × 365.8). Unsigned.

COLLECTION
Museum Ludwig, Cologne

EXHIBITIONS
New York: Whitney Museum of American Art (bw p. 43), 1970–71
Washington, D.C.: The Corcoran Gallery of Art (color cover), 1971
Ottawa: National Gallery of Canada (temporary loan), 2 September–31 October 1971
Kassel, West Germany: Neue Galerie (bw p. 16/30), 1972
Zurich: Kunsthaus Zurich (bw p. 84), 1979–80

REFERENCES
Baker, *Artnews* 69 (January 1971), bw p. 48. Chandler, *Artscanada* 28 (April 1971), bw p. 18. "Contemporary American Sculpture," *Kunstwerk* 24 (March 1971), bw p. 90. Frankenstein, *San Francisco Sunday Chronicle*, 7 February 1971, comm. p. 42. Henry, *Art International* 15 (February 1971), bw p. 78. Hughes, *Time*, 4 January 1971, color p. 51. Linville, *Arts Magazine* 45 (February 1971), bw p. 29. Masheck, *Artforum* 9 (February 1971), bw p. 70. Perreault, *The Village Voice*, 4 February 1971, comm. pp. 13–14. Rosenberg, 1971, bw p. 269. Thomas, 1971, bw fig. 173. Tuchman, 1971, bw n.p. Tuchman, Becker, and Strohmeyer, 1971, bw n.p. Von der Osten and Keller, 1971, color n.p. Celant, *Qui arte contemporanea* 9 (1972), bw p. 47. "Documenta 5—Slalom im Kassel," *Artis* 9 (September 1972), bw p. 25. "Documenta fünf," *Magazin Kunst* 47 (Fall 1972), bw p. 2954 (misidentified as by Eva Hesse). Richardson, *Arts Magazine* 46 (April 1972), color p. 58. Staber, *Art International* 16 (October 1972), bw p. 85. Townsend, *Artscanada* 29 (October–November 1972), bw p. 42. Budde and Weiss, 1973, bw fig. 49. Hess and Baker, 1973, bw p. 121. Rothenberg and Tedlock, *Artscanada* 184–87 (December 1973–January 1974), bw p. 180. Weiss, 1976, fig. 74; bw n.p. Thomas and de Vries, 1977, bw (detail) p. 170. Graves, *Artscribe* (April 1979), bw p. 39. Ruhrberg et al., 1979, color p. 256. Cathcart, 1980, fig. 7; bw p. 19. Daval, 1980, bw p. 127. Minaty, *Kunstwerk* 33 (January 1980), bw p. 82. *Pantheon* 38 (April 1980), bw p. 130. Wedewer, *Kunstwerk* 33 (May 1980), bw p. 19. Feldman, 1982, bw p. 15. Berman, *Artnews* 85 (February 1986), comm. p. 62.

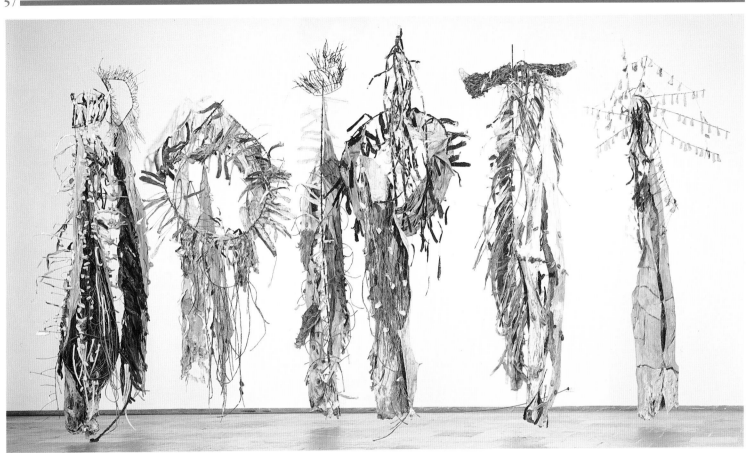

20

REMARKS

Shaman consists of ten separate hanging units, fourteen feet in height by fourteen feet in total width and depth. The materials employed are latex over muslin; oil paint; wax; marble dust; acrylic; gauze; and copper, steel, and aluminum wire. The forms created are camel skins, camel bones, beetles, cowrie shells, hoofs of small mammals, tree twigs, feathers used as headdresses, as wings of birds, as two eagles, and as an allusion to sun rays on the two circular hanging disks. The two circular units are centrally related to eight headdress forms with anthropomorphic hanging skins attached. The forms themselves articulate visual patterns and relationships found in the Pacific Northwest Indian Hall of the American Museum of Natural History in New York, but the symbolism bears a relationship to all primitive cultures.

The formal concerns address a problem apparent in the earlier camel pieces: how to develop a space greater than that a human being occupies, making it rich in incident and varied in texture. Latex and acrylic brushstrokes and three-dimensional forms made of wax, gauze, and paint are four to six inches long, the distance between a thumb and forefinger. These varied and repeated forms—beetles, shells, twigs of artificial materials—provide the scale for the eight hanging forms, which are themselves two and one-half times human scale.

The camel vertebrae, which are hung vertically giving scale to the ten-foot skins, refer to Graves's original decision to "go inside" (that is, to expose a work's internal supports), which had prompted her to make *Miocene Skeleton* (cat. no. 7) and subsequent, more abstract "bone" pieces. The "skins" were created over wires that remain intact to allow visual articulation of the armature as internal structural surface.

By repeating the hanging skins eight times it was possible to emphasize the difference between the relationship of large elements to each other and that of large to small elements. When Robert Hughes mentions Graves's interest in the relationship of elements in the displays at the American Museum of Natural History, New York (Hughes, 1971), he refers to a concern with our tendency to see a single object from different distances in terms of its context. This bears an inverse relationship to the two films, *Goulimine*, 1970, and *Izy Boukir*, 1971, in which the camel was considered as a unit of motion in opposition to the static observer. The artist's concern in the sculpture was with the relational problem of a two- or three-inch measure compared with one of fourteen feet, and she wished to explore the visual possibilities inherent in the ambulatory motions of a six-foot human being in relation to a fourteen-foot cubic space. She has concluded that it is impossible for the viewer to achieve total comprehension at any one point, and that individual repeated forms are of a complexity that denies the possibility of a gestalt, with the consequence that, in addition to becoming visually overwhelming, a great deal of the piece becomes a "head trip"; the translation of the outside to inside and the intellectual articulation of this formal premise become the subject matter of the sculpture.

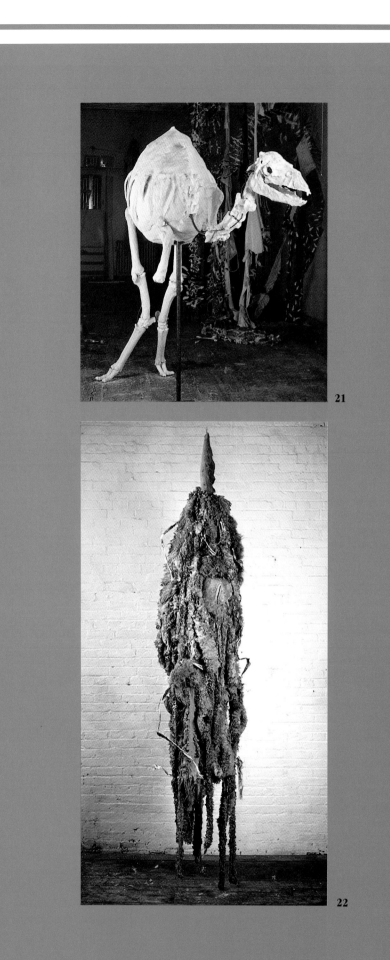

21

22

21 Taxidermy Form, 1970
Steel, wood, wax, marble dust, and acrylic. 108 × 120 × 48 (274.3 × 304.8 × 121.9). Unsigned. Destroyed by the artist in 1979.

PROVENANCE
Janie C. Lee Gallery, Houston
Mrs. John D. Murchison, Dallas

EXHIBITIONS
New York: Gallery Reese Palley (checklist no. 4), 1971

REFERENCES
Wasserman, *Artforum* 9 (October 1970), bw p. 43. Kramer, *The New York Times*, 19 January 1971, bw p. 30. Tuchman, 1971, bw n.p. Tuchman, Becker, and Strohmeyer, 1971, bw n.p.

REMARKS
The work represented a camel skeleton in the process of transformation into a fur-covered dromedary. It was a visual approximation of one stage in the taxidermy metamorphosis, but all the materials were fake. It was destroyed by the artist in July 1979, when the bronze version, commissioned by John D. Murchison, was made. See remarks for *Taxidermy Form*, 1979 (cat. no. 52).

22 Totem, 1970
Animal skin, gauze, wax, oil paint, latex, and acrylic on chicken-wire armature. 102 × 36 × 36 (259.1 × 91.4 × 91.4). Unsigned.

COLLECTION
Private collection

EXHIBITIONS
Cleveland: The New Gallery, 1972
Philadelphia: Institute of Contemporary Art, University of Pennsylvania (traveling exhibition; bw n.p.), 1972–73
Zurich: Kunsthaus Zurich (bw p. 85), 1979–80
New York: The Museum of Modern Art (traveling exhibition, New York only; color p. 679), 1984–85

REFERENCES
Tuchman, 1971, bw n.p. Tuchman, Becker, and Strohmeyer, 1971, bw n.p. Sundell, *Cleveland* 1 (June 1972), illus. p. 76. Ashton, *Arts Magazine* 59 (November 1984), bw p. 79. Rubin, 1984, color p. 679. Bois, *Art in America* 73 (April 1985), bw p. 189. Nadelman, *Artnews* 84 (February 1985), bw p. 95. Berman, *Artnews* 85 (February 1986), comm. p. 62.

REMARKS
Blue "shadows" made of steel wire, muslin, wax, and acrylic paint were remade by the artist in September 1984, in addition to minor restoration work done on the skin.

23 Variability of Similar Forms, 1970
Steel, wax, marble dust, and acrylic on wood base. 84 × 126 × 180 (213.4 × 320 × 457.2). Unsigned.

COLLECTION
Private collection

EXHIBITIONS
New York: Gallery Reese Palley (checklist no. 5), 1971
Philadelphia: Institute of Contemporary Art, University of Pennsylvania (traveling exhibition; bw n.p.), 1972–73
Buffalo: Albright-Knox Art Gallery (traveling exhibition; cat. no. 5, bw p. 41), 1980–81

REFERENCES
"At the Galleries," *The Village Voice*, 14 January 1971, bw p. 20. Henry, *Art International* 15 (March 1971), bw p. 51. Keefe, *The Berkshire Eagle*, 29 January 1971, bw p. 5. Perreault, *The Village Voice*, 4 February 1971, comm. pp. 13–14. Tuchman, 1971, bw n.p. Tuchman, Becker, and Strohmeyer, 1971, bw n.p. Donohoe, *The Philadelphia Inquirer*, 24 September 1972, bw p. H8. McCaslin, *The*

Journal Herald, 13 December 1972, bw p. 41. Stadnik, *Pennsylvania Voice*, 20 September 1972, bw. Arn, *Artscanada* 31 (Spring 1974), comm. p. 45. Lippard, *Art in America* 63 (November–December 1975), bw p. 78. Heinemann, *Arts Magazine* 51 (March 1977), bw p. 139. Carr, *Dialogue* (July–August 1980), bw p. 21. Daval, 1980, bw p. 126. Tennant, *Houston Chronicle*, 21 September 1980, bw p. 16. Beals, *Weekend*, 13 February 1981, bw p. 13. Kelly, 1981, fig. 60, bw p. 67. Morris, *Minneapolis Tribune*, 3 June 1981, bw p. 2B. Morrison, *The Minneapolis Star*, 29 May 1981, bw p. 3B. Raynor, *The New York Times*, 1 February 1981, bw p. 16. Smith, 1981, bw p. 11. Amaya, *Architectural Digest* 39 (February 1982), color p. 146. Rubinstein, 1982, fig. 9–19; bw p. 417. Berman, *Artnews* 85 (February 1986), bw p. 60, comm. p. 62.

REMARKS
Graves made drawings of the articulated Pleistocene camel skeleton at the Natural History Museum of Los Angeles County. She created thirty-six legs in wax over a steel armature based on her drawings and photographs of Pleistocene front and back legs, each a unique and separate freestanding sculpture. The illusion of motion is achieved while the viewer walks around the sculpture. The positioning of each wax fossil leg was influenced by Eadweard Muybridge's photographs of animals and the human body in sequential motion. *Variability* and Muybridge influenced her first film, *200 Stills at 60 Frames*, in which she segmented and repeated a single image while using the sixteen-millimeter motion picture as the vehicle.

24 Vertebral Column with Skull and Pelvis, 1970
Steel, marble dust, and acrylic. 108 × 12 × 60 (274.3 × 30.5 × 152.4). Unsigned. Destroyed by the artist in 1981.

PROVENANCE
Gallery Reese Palley, New York
Charles Cowles, New York

EXHIBITIONS
New York: Gallery Reese Palley (checklist no. 9), 1971

REFERENCES
Wasserman, *Artforum* 9 (October 1970), bw p. 42. Tuchman, 1971, bw n.p. Tuchman, Becker, and Strohmeyer, 1971, bw n.p.

REMARKS
From this sculpture, and with additional forms, in 1981 the artist made a floor piece for Charles Cowles, entitled *Phoenix* (cat. no. 73). Molds from *Vertebral Column with Skull and Pelvis* were used to make *Gravilev*, 1979–80 (cat. no. 57), and *Varilev*, 1981 (cat. no. 78).

25 Bone-Finger, 1971
Steel, acrylic, and gauze. 114 × 60 × 12 (289.6 × 152.4 × 30.5). Unsigned.

COLLECTION
Private collection

EXHIBITIONS
Aachen, West Germany: Neue Galerie im Alten Kurhaus (cat. no. 1; bw n.p.), 1971
Hamburg: Kunsthaus Hamburg (bw p. 44), 1972
Philadelphia: Institute of Contemporary Art, University of Pennsylvania (bw p. 15), 1979–80

REFERENCES
Wasserman, *Artforum* 9 (October 1970), bw p. 43. Tuchman, 1971, bw n.p.

REMARKS
As the sculpture turns, either by motion of the air or by touch, the steel wire extending to the floor draws a circle.

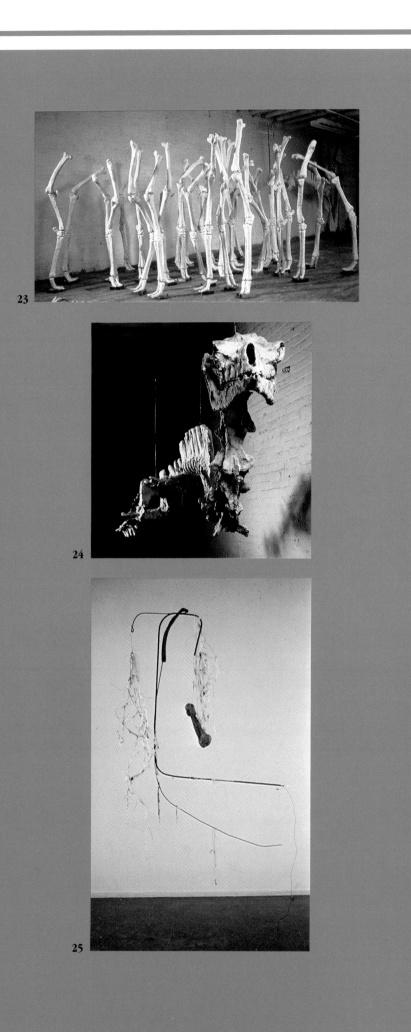
23
24
25

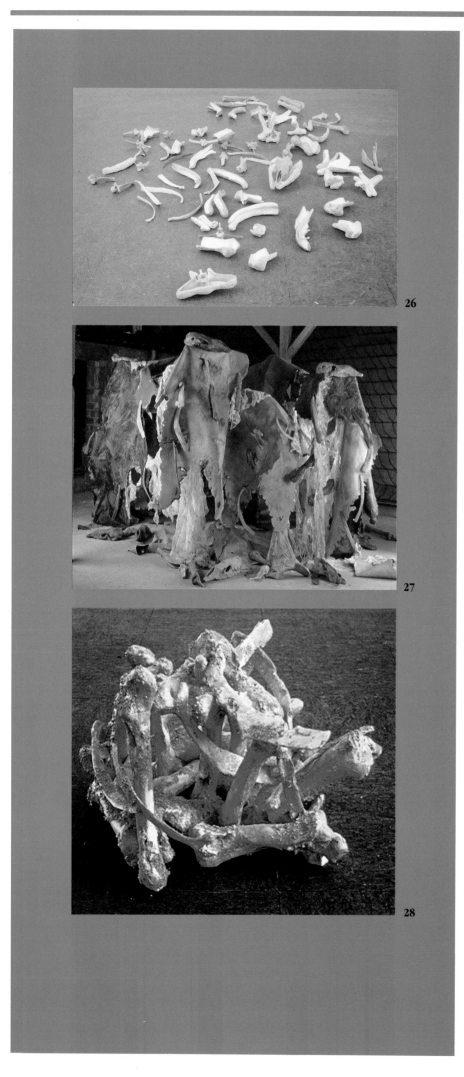

26

27

28

26 Bones and Their Containers (To Martin Cassidy), 1971
Steel, gauze, acrylic, plaster, burlap, and wax. 8 × 132 × 60
(20.3 × 335.3 × 152.4). Unsigned.

COLLECTION
Private collection

EXHIBITIONS
Aachen, West Germany: Neue Galerie im Alten Kurhaus (cat. no. 2; bw
n.p.), 1971
Philadelphia: Institute of Contemporary Art, University of Pennsylvania
(bw front.), 1979–80

REFERENCES
Tuchman, 1971, color n.p.

REMARKS
Martin Cassidy, who is in charge of casting in the Department of
Vertebrate Paleontology at the American Museum of Natural History,
New York, has on numerous occasions given of his technical expertise
to the artist. An excavated fossil is transported in a container of
plaster and burlap for protection. The "containers" in this sculpture
were made by placing plaster and burlap around the bone positives;
after the plaster casts hardened they were opened and reworked.

27 Bones, Skins, Membranes Overlayed, 1971
Steel, latex, gauze, oil paint, marble dust, acrylic, and cotton.
96 × 144 × 144 (244 × 366 × 366). Unsigned.

COLLECTION
Private collection

EXHIBITIONS
Aachen, West Germany: Neue Galerie im Alten Kurhaus (cat. no. 9; bw
n.p.), 1971
Philadelphia: Institute of Contemporary Art, University of Pennsylvania
(traveling exhibition; bw n.p.), 1972–73

REFERENCES
Tuchman, 1971, bw n.p. Forman, *The Sunday Bulletin* (Philadelphia),
24 September 1972, color.

28 Bones to Dust, 1971
Steel, marble dust, acrylic, and wax. 40 × 40 × 40 (101.6 ×
101.6 × 101.6). Unsigned.

COLLECTION
Private collection

EXHIBITIONS
Aachen, West Germany: Neue Galerie im Alten Kurhaus (cat. no. 5; bw
n.p.), 1971

REFERENCES
Tuchman, 1971, bw n.p.

REMARKS
This piece was made in Aachen, West Germany, as one of three
works: *Cast Shadow Reflecting from Four Sides*, 1970 (cat. no. 12),
and *Obviation of Similar Forms*, 1969 (cat. no. 9), are the
other two.

29 Fifty Hair Bones and Sun Disk (To the students of the Aachener Werkkunstschule, Aachen), 1971
Steel, plaster, glue, and acrylic. 132 × 156 × 156 (335.3 × 396.2 × 396.2). Unsigned.

COLLECTION
Museum moderner Kunst, Vienna; formerly Sammlung Hahn

PROVENANCE
Wolfgang Hahn, Cologne

EXHIBITIONS
Aachen, West Germany: Neue Galerie im Alten Kurhaus (cat. no. 7; bw n.p.), 1971

REFERENCES
Tuchman, 1971, color n.p. Richardson, *Arts Magazine* 46 (April 1972), bw p. 60. Cladders, 1979, no. 131; bw n.p. Drechsler et al., 1979, color n.p. Cathcart, 1980, fig. 5; bw p. 17.

REMARKS
The term ''hair bone'' is used by the Australian aborigines to refer to carved bones with a spiritual meaning. There are thirty-six forms in this sculpture, the same number as in *Variability of Similar Forms*, 1970 (cat. no. 23). Each has three visual divisions as in *Variability of Similar Forms*.

30 Hanging Skins, Bones, Membranes, 1971
Cotton, acrylic, glue, plaster, and steel. 108 × 276 × 60 (274.3 × 701 × 152.4). Unsigned. Destroyed by the artist in 1972.

EXHIBITIONS
Aachen, West Germany: Neue Galerie im Alten Kurhaus (cat. no. 8; bw n.p.), 1971

REFERENCES
Tuchman, 1971, color, n.p.

31 Paleo-Indian Cave Painting, Southwestern Arizona (To Dr. Wolfgang Becker), 1970–71
Steel, fiber glass, oil paint, acrylic, and three wood boards. 156 × 108 × 90 (396.2 × 274.3 × 228.6). Unsigned.

COLLECTION
Neue Galerie—Sammlung Ludwig, Aachen, West Germany, gift of the artist

EXHIBITIONS
Aachen, West Germany: Neue Galerie im Alten Kurhaus (cat. no. 6; bw n.p.), 1971
Humlebaek, Denmark: Louisiana Museum Humlebaek, Cultural Center and Museum of Modern Art (cat. no. 17), 1973
Cologne: Kunsthalle, 1974

REFERENCES
Wasserman, *Artforum* 9 (October 1970), bw p. 46. Tuchman, 1971, color n.p. Becker, 1972, color n.p. Ratcliff, *Artforum* 14 (November 1975), bw p. 59. Read, 1975, bw fig. 275. Becker, 1977, comm. n.p. Cortenova, 1978, bw p. 34. Cathcart, 1980, fig 4; bw p. 16.

REMARKS
This piece was made in Aachen, West Germany, with fifteen assistants from the Werkkunstschule, in 1970–71. Camel images hypothesize the presence of prehistoric camels in the southwestern United States at the time of the appearance of the first humans.

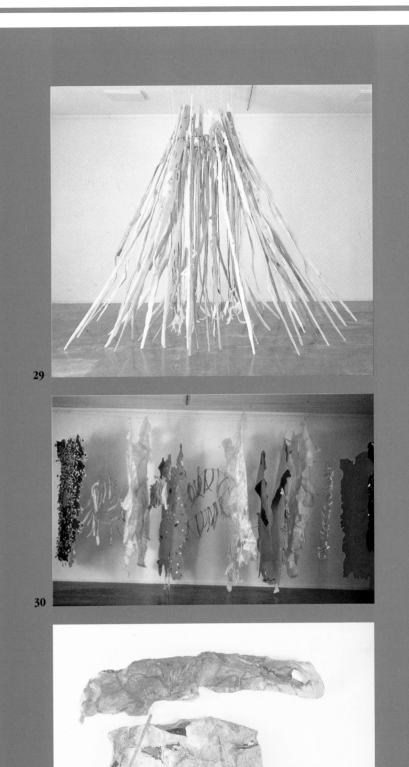

29

30

31

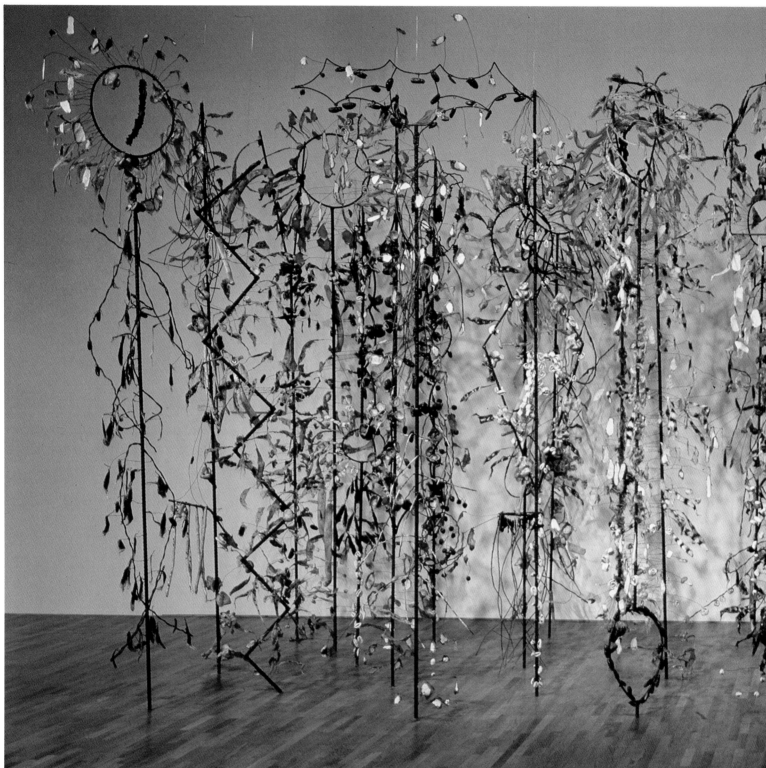

32

32 Variability and Repetition of Variable Forms, 1971
Steel, latex, gauze, wax, oil, and acrylic. 120 × 180 × 312
(304.8 × 457.2 × 792.5). Unsigned.

COLLECTION
National Gallery of Canada, Ottawa

EXHIBITIONS
San Francisco: Gallery Reese Palley, 1971
Chicago: Museum of Contemporary Art (bw n.p.), 1971
New York: The Museum of Modern Art, 1971–72
New York: The Museum of Modern Art (traveling exhibition, New
York only; color p. 678), 1984–85

REFERENCES
Artweek 32 (Oakland, California), 25 September 1971, p. 2. Auer,
Post Crescent, 14 November 1971, comm. p. E8. Frankenstein, *San
Francisco Sunday Chronicle*, 19 September 1971. Rice, *Artweek*,
2 October 1971, bw p. 2. Schjeldahl, *The New York Times*, 26 Decem-

ber 1971, bw p. 25. Schulze, *Chicago Daily News*, 6–7 November
1971, bw p. 11. Stiles, *Artforum* 10 (November 1971), bw p. 87.
Tarshis, *The San Francisco Fault*, 1971, bw p. 21. Borden, *Artforum*
10 (February 1972), comm. p. 90. Chandler, *Artscanada* 29 (October–
November 1972), bw p. 30. *Fourth Annual Review*, 1972, bw front.
Museum of Modern Art Annual Report, 1972, bw p. 14. Richardson,
Arts Magazine 46 (April 1972), bw p. 61. Schwartz, *Craft Horizons*
(April 1972), comm. p. 57. Kalavinka, *Artscanada* 30 (May 1973),
bw p. 50. Kelly, 1974, bw p. 99. Peterson and Wilson, 1978, bw
p. 130; fig. VII, 21. Cathcart, 1980, fig. 8; bw p. 20. *International
Sculpture Center Bulletin* (Fall–Winter 1980), bw. p. 10. *U.S. News
and World Report* 89 (1 September 1980), color p. 67. Kelly, 1981,
fig. 88, bw p. 89. Smith, 1981, bw p. 13. "Reviews," *New York Maga-
zine* (19 November 1984), comm. p. 63. Rubin, 1984, color p. 678.
Bourdon, *Vogue* (February 1985), bw p. 82. Berman, *Artnews* 85
(February 1986), comm. pp. 60, 62, 63. Frank, *Connoisseur* 216
(February 1986), comm. p. 59.

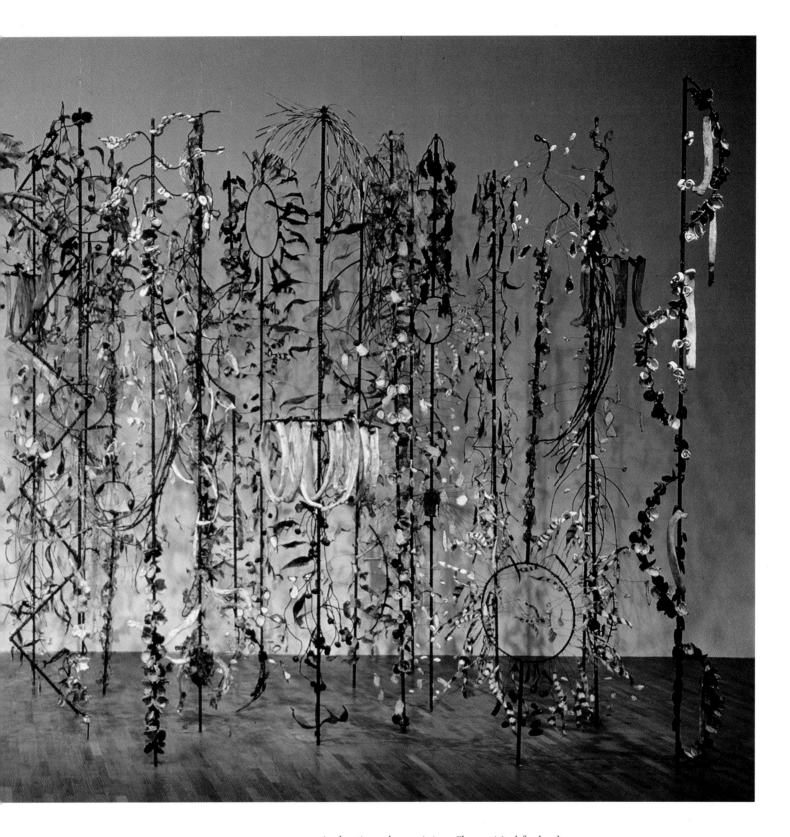

REMARKS

This piece was made with twenty-five assistants when Graves was teaching at the San Francisco Art Institute, during the summer of 1971. It was her first use of welding and glazed ceramics. The imagery was inspired by South Pacific island cultures. The tallest units vary in height between nine feet, four inches, and ten feet. Each of the thirty-eight units stands on the floor and is spaced at approximately a three-foot interval. The maximum weight of any one unit is thirty pounds. The installation varies slightly with the site.

The image of each single unit is totemic; that of the whole is an organic abstraction. The forms attached to the ten-foot structures range from one inch square to thirty-six inches in length. They are all taken from nature: butterflies, twigs, vines, berries, beetles, cowrie shells, bones, and feathers are simulated. The colors comprise the principal hues of the spectrum, and spatial overlay of the varied and repeated forms is infinitely variable. As the viewer moves around the static sculpture, he has any number of vantage points. Dedifferentiated

visual tension—the term is Anton Ehrenzweig's, defined as the complexity, placement, and number of parts that will permit an unspecialized scanning[1]—is established among individual units that are almost twice human scale, on which are hung and repeated multiples of forms fifty to sixty times smaller. This tension is developed as the viewer walks around the perimeter.

Objectness is deobjectified by its very complexity; total cognition is cumulative; and since it is impossible to "know" the whole at any one view, there is no gestalt, but instead a series of informed views. The object itself is a memory.

1. Anton Ehrenzweig, *The Hidden Order of Art: A Psychology of Artistic Imagination* (Berkeley: University of California Press, 1967), p. 19.

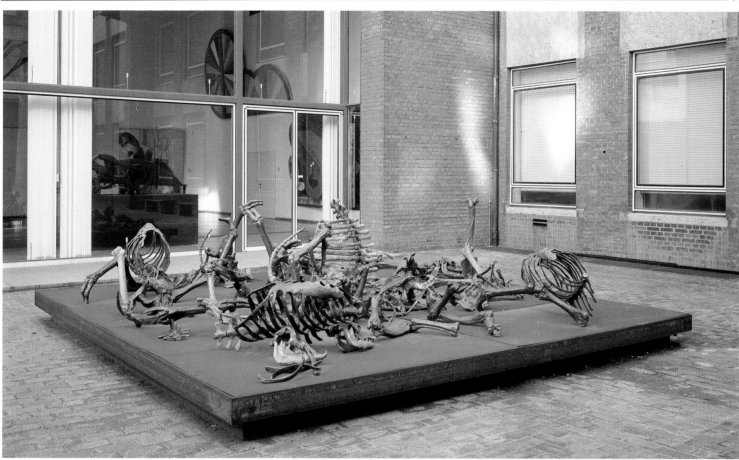

33

33 Ceridwen, out of Fossils, 1969–77

Bronze on Cor-ten steel base. 60 × 192 × 192 (152.4 × 488 × 488)
Inscribed on Cor-ten steel base: *N. S. Graves 1969–77 CERIDWEN, OUT OF FOSSILS TX.*

COLLECTION
Museum Ludwig, Cologne

EXHIBITIONS
New York: Hammarskjöld Plaza Sculpture Garden, 1978

REFERENCES
"Bronze aus New York." *Quer durch Köln,* 23 June 1978, bw p. K11.
Rubinfien, *Artforum* 16 (Summer 1978), bw p. 74. Vomm, *Bulletin,*
August 1978, bw cover. *Gazette des beaux-arts* 93, ser. 6 (April 1979),
fig. 126; bw supp. p. 25. Munro, 1979, comm. p. 390. Ruhrberg et
al., 1979, color p. 258. Shapiro, *Arts Magazine* 58 (December 1983),
bw p. 111; comm. p. 111. Berman, *Artnews* 85 (February 1986), comm.
p. 63.

REMARKS
This piece was the artist's first bronze sculpture; the lost-wax process
was used. It was commissioned by Peter Ludwig.

Ceridwen is the medieval Welsh name for the goddess of death and
immortality. "Out of fossils" refers to the prototype sculpture *Fossils,*
1969–70 (cat. no. 14). It is the second of three related works on the
fossils theme, each unique in terms of number and placement of
parts and color of patina. The third, made after *Ceridwen* was
completed, is *Phoenix,* 1981 (cat. no. 73). All three present notions
of variability, repetition, displacement, and scattering. Due to the num-
ber of its parts and the size of the original *Fossils* (twenty-five feet
square), comprehension of the detailed relationships of part to self,
part to part, and part to whole was impossible. Anton Ehrenzweig's
ideas on dedifferentiation were highly influential and should here be
noted.[1]

Graves is the first artist to concern herself with prehistory as a
point of departure for her work. In all three sculptures image refer-
ences are to paleontology. In the nineteenth century a bed of
Pleistocene camel fossils was discovered in the La Brea tar pits in Los
Angeles. This remains a point of scientific interest today while, through
carbon dating, developed in the 1960s, a highly specific means of
determining prehistoric time has been established.

In the bronze sculpture of 1977, the layering and thrust of part to
part, fossil bone to fossil bone, allude to geological movement, call-
ing into question our relationship both to our highly refined technol-
ogy and to prehistory, and examining its significance.

1. Anton Ehrenzweig, *The Hidden Order of Art: A Psychology of Artistic
Imagination* (Berkeley: University of California Press, 1967).

34 Aurignac, 1978

Bronze with polychrome patina. 43 × 20 × 27 (109.2 × 50.8 × 68.6). Inscribed on base: *N. S. Graves AURIGNAC 1978 TX.*

COLLECTION
Mr. Christopher Brumder, Darien, Connecticut

PROVENANCE
M. Knoedler & Co., Inc., New York

EXHIBITIONS
Seattle: Gallery Diane Gilson, 1978
Buffalo: Albright-Knox Art Gallery (traveling exhibition; cat no. 45; color p. 83), 1980–81

REFERENCES
Bass, *The Berkshire Eagle*, 29 May 1980, bw p. 11. Castaneda, *Rice Thresher*, September 1980, bw.

REMARKS
Additional waxes were made from the original molds for *Aurignac* and were used individually in several other sculptures; for example, in *Equipage*, 1982 (cat. no. 94). The waxes in *Aurignac* were then reworked by the artist and are consequently unique.

The title alludes to five carved-bone primal forms dating from the Aurignacian period (toward the end of the Pleistocene epoch, associated with the appearance of Cro-Magnon and other types of *Homo sapiens*).

A white patina developed especially for Graves, which was to be used in 1979 on *Variability and Repetition of Similar Forms II* (cat. no. 54), was tested for the first time here.

35 Graph (Evolutionary Graph II), 1978

Bronze with polychrome patina and fabricated wire. 51 × 54 × 67 (129.5 × 137.2 × 170.2). Inscribed along side: *N. S. Graves GRAPH (EVOLUTIONARY GRAPH II) 1978 TX.*

COLLECTION
Skinner Corporation, Seattle

PROVENANCE
Gallery Diane Gilson, Seattle

EXHIBITIONS
Seattle: Gallery Diane Gilson, 1978
Buffalo: Albright-Knox Art Gallery (traveling exhibition; cat no. 49; bw p. 87), 1980–81

REFERENCES
Robertson, *MPLS Saint Paul*, June 1981, bw p. 46.

REMARKS
The piece is made of sheet bronze fabricated at Tallix Foundry; it is the only bronze sculpture that did not require casting in some part at the foundry. The original version, *Evolutionary Graph*, 1970 (cat. no. 13), was used and destroyed subsequent to the creation of this bronze variation.

36 Measure, 1978

Bronze with polychrome patina. Seven parts: 1: 2¼ × 14½ × 11¾ (5.7 × 36.8 × 29.8); 2: 3¼ × 10¼ × 10¼ (8.2 × 26 × 26); 3: 3 × 13¼ × 13½ (7.6 × 33.7 × 34.3); 4: 4½ × 8 × 9½ (11.4 × 20.3 × 24); 5: 3 × 17 × 16½ (7.6 × 43.2 × 40.6); 6: 2¼ × 14¾ × 16 (5.7 × 37.5 × 40.6); 7: 5 × 14 × 15 (12.7 × 35.6 × 38). Inscribed on the back of one piece: *N.S. Graves*. Each part is numbered on the back.

COLLECTION
Private collection

EXHIBITIONS
Philadelphia: Institute of Contemporary Art, University of Pennsylvania (no illus.), 1979–80

REMARKS
This piece consists of seven parts and has its prototype in African sculpture. Sand and pebbles were placed over wax before casting, to heighten the texture. The relationships of part to part on the floor are interchangeable.

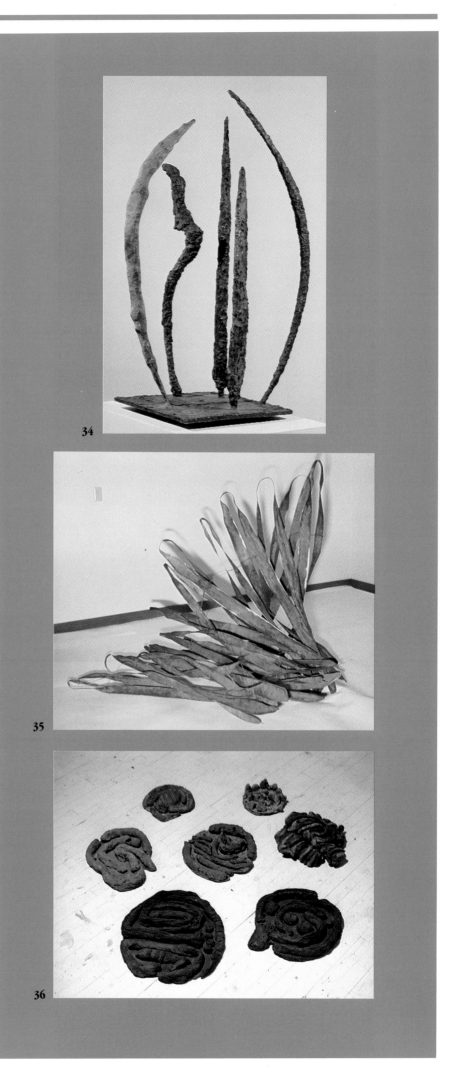

34

35

36

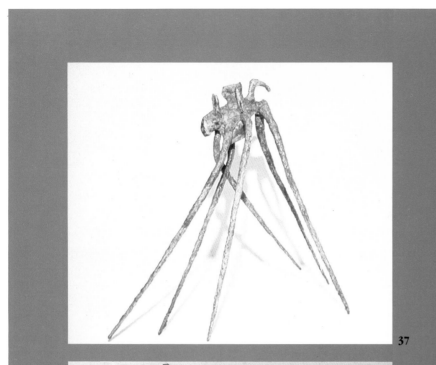

37

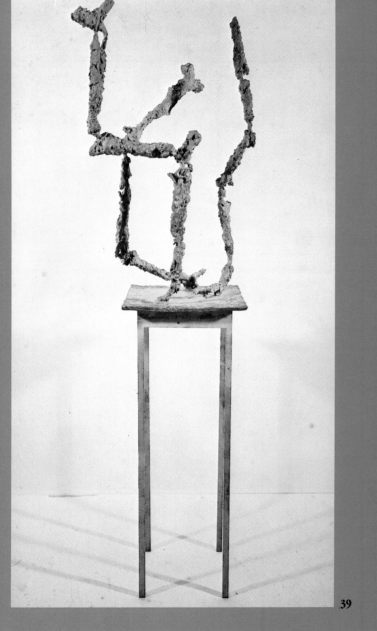

39

37 Ombre, 1978

Bronze with polychrome patina. 29 × 40 × 18 (73.7 × 101.6 × 45.7). Inscribed on central part, approximately 22½ in. high: *N. S. Graves "OMBRE" '78 TX.*

COLLECTION

Private collection

REMARKS

This piece is a variation of *Shadow Reflection*, 1978 (cat. no. 40).

38 Quipu, 1978

Bronze with polychrome patina. 70 × 60 × 58 (177.8 × 152.4 × 147.3). Inscribed on side: *N. S. Graves QUIPU 1978 TX.*

COLLECTION

Helen Elizabeth Hill Trust

PROVENANCE

Janie C. Lee Gallery, Houston

EXHIBITIONS

Houston: Janie C. Lee Gallery, 1978

Buffalo: Albright-Knox Art Gallery (traveling exhibition; cat. no. 54; color p. 92), 1980–81

REFERENCES

Crossley, *The Houston Post*, 24 November 1978, bw p. 9AA. Moser, *Houston Chronicle*, 15 November 1978, bw sec. 4, p. 1.

REMARKS

This sculpture is one of the earliest directly cast works by the artist. It was made by casting nautical ropes and strings of diverse lengths and widths. The small circular forms were made by direct casting out of sheet wax. The red, yellow, pink, and blue patinas are Graves's earliest experiments in nontraditional coloration.

39 Seven Legs, 1978

Bronze with polychrome patina. 69½ × 22 × 16 (176.5 × 55.9 × 40.6). Inscribed on side: *N. S. Graves SEVEN LEGS 1978 TX.*

COLLECTION

Margo Leavin Gallery, Los Angeles

PROVENANCE

M. Knoedler & Co., Inc., New York

EXHIBITIONS

Buffalo: Albright-Knox Art Gallery (traveling exhibition; cat. no. 57; bw p. 95), 1980–81

Santa Barbara: Santa Barbara Contemporary Arts Forum (no illus.), 1983

Houston: McIntosh/Drysdale Gallery, 1983

Williamstown, Massachusetts: Williams College Museum of Art (traveling exhibition; shown only at Newport Harbor Art Museum, Newport Beach, California; no illus.), 1984–85

Los Angeles: Margo Leavin Gallery, 1984

REFERENCES

Huntington, *Buffalo Courier-Express*, 11 May 1980, bw p. E3.

REMARKS

A white patina with a pearlescent color was first used on this piece. The "table," which provides four of the seven legs, is fabricated; the form of three legs on the top refers to *Variability of Similar Forms*, 1970 (cat. no. 23).

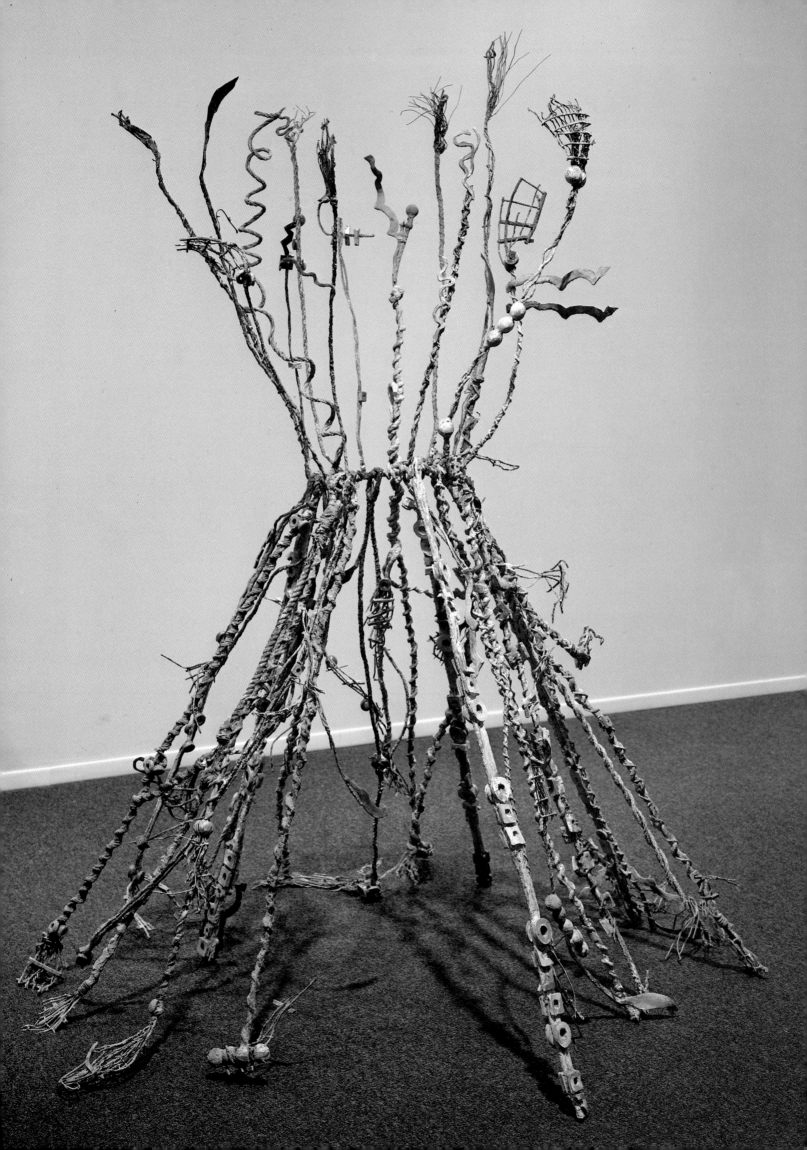

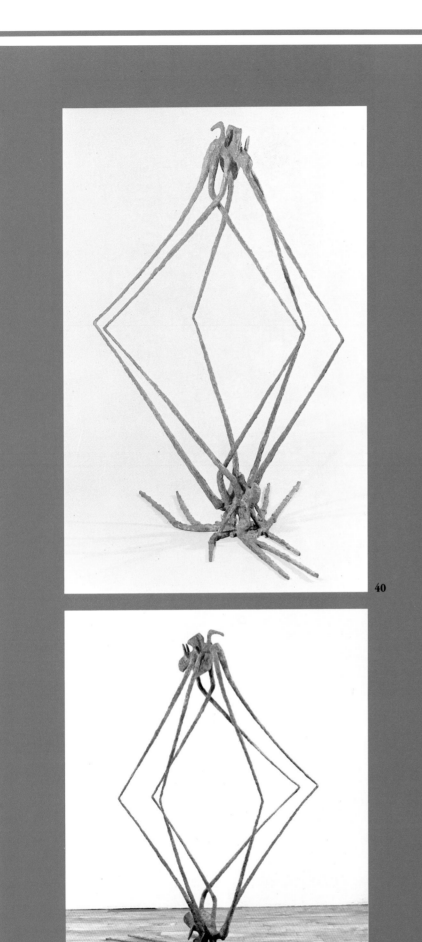

40

41

40 Shadow Reflection, 1978

Bronze with polychrome patina. 57¾ × 52 × 34 (146.7 × 132 × 86.4). Inscribed on bottom center: *N. S. Graves "SHADOW REFLECTION" '78.*

COLLECTION
Private collection

PROVENANCE
M. Knoedler & Co., Inc., New York

EXHIBITIONS
Houston: Janie C. Lee Gallery, 1978
Buffalo: Albright-Knox Art Gallery (traveling exhibition; cat. no. 58; bw p. 96), 1980–81

REFERENCES
Amaya, *Architectural Digest* 39 (February 1982), color p. 146.

REMARKS
This piece is a variation of *Ombre*, 1978 (cat. no. 37). Two waxes from the *Ombre* mold were abutted at the legs so that one is reversed and upside down. The base was the result of drawing the shadow cast from the two bronze forms welded at the legs; a three-dimensional replica of it in directly cast sheet wax was then made. A second version, *Shadow, Six Legs*, 1978 (cat. no. 41), was assembled separately and is not an exact duplicate. The patina on each version is unique.

41 Shadow, Six Legs, 1978

Bronze with polychrome patina. 60½ × 34 × 56 (153.7 × 86.4 × 142.2). Inscribed on left center of base: *N. S. Graves SHADOW, SIX LEGS 1978 TX.*

COLLECTION
Private collection

EXHIBITIONS
New Haven: Yale University Art Gallery (bw p. 43), 1981
Providence: Museum of Art, Rhode Island School of Design (checklist, mislabeled as *Shadow/Reflection*), 1982.

REMARKS
This piece is one of two related sculptures; the other is *Shadow Reflection*, 1978 (cat. no. 40).

42 Archaeoloci, 1979

Bronze and brass with polychrome patina and red oil color.
39½ × 30 × 27 (100.3 × 76.2 × 68.6). Inscribed on base:
N. S. Graves ARCHAEOLOCI 1979 TX.

COLLECTION
Barry and Gail Berkus, Santa Barbara

PROVENANCE
M. Knoedler & Co., Inc., New York

EXHIBITIONS
New York: M. Knoedler & Co., Inc. (checklist no. 1), 1980
Buffalo: Albright-Knox Art Gallery (traveling exhibition; cat. no. 59;
 color p. 97), 1980–81
San Francisco: Fuller Goldeen Gallery (fig. no. 3, bw), 1982
Santa Barbara: Santa Barbara Contemporary Arts Forum (bw n.p.),
 1983
Santa Barbara: Santa Barbara Museum of Art (color p. 46), 1984

REFERENCES
"New York Reviews," *Artnews* 79 (September 1980), color p. 247.
Saunders, *Art in America* 68 (Summer 1980), color p. 91. Tennant,
Houston Chronicle, 28 September 1980, *Texas Magazine*, color
p. 13. McVinney, *The Load*, February 1981, bw. Schwartzman, *Vassar
Quarterly* 77 (Winter 1981), bw p. 23. Timberman, *Artweek*, 5 March
1983, bw p. 16.

REMARKS
Archaeoloci was made by assembling forms directly cast in wax, made
to scale from a drawing. The title comes from the Latin: *archaeo +
loci*; that is, "places of archaeology," ancient sites or archaeological
maps. The sculpture is part of an archaeological series based on
drawings done during the artist's residency at the American Academy
in Rome. When placed on its side, it looks like an ancient Roman
port.

The steps were cast from folded paper painted with wax. The zig-
zag form rising next to them, like a breakwater for a Roman port, is
made of cast polystyrene packing material. All elements were directly
cast, except for the brass tube in a *c* shape, attached to the steps. The
blue waves were cast from wax cut and shaped with a hot tool. The
map on the base was cast from wax pieces placed on a sheet of
cut-out wax. Two city plans were cut out of sheet wax and layered
together to form the base.

43 Archaeologue, 1979

Bronze with polychrome patina and oil color. 32 × 25½ × 11 (81.3 ×
64.8 × 27.9). Inscribed on base: *N. S. Graves ARCHAEOLOGUE 1979 TX.*

COLLECTION
Mr. and Mrs. Myron Mendelson, Connecticut

PROVENANCE
M. Knoedler & Co., Inc., New York
Mr. William Zierler, Inc., New York
M. Knoedler & Co., Inc., New York
Irving Galleries, Palm Beach, Florida

EXHIBITIONS
New York: M. Knoedler & Co., Inc. (checklist no. 7), 1980

REFERENCES
Cathcart, 1980, fig. no. 13; bw p. 29. Frank, *Connoisseur* 216 (Feb-
ruary 1986), comm. p. 57.

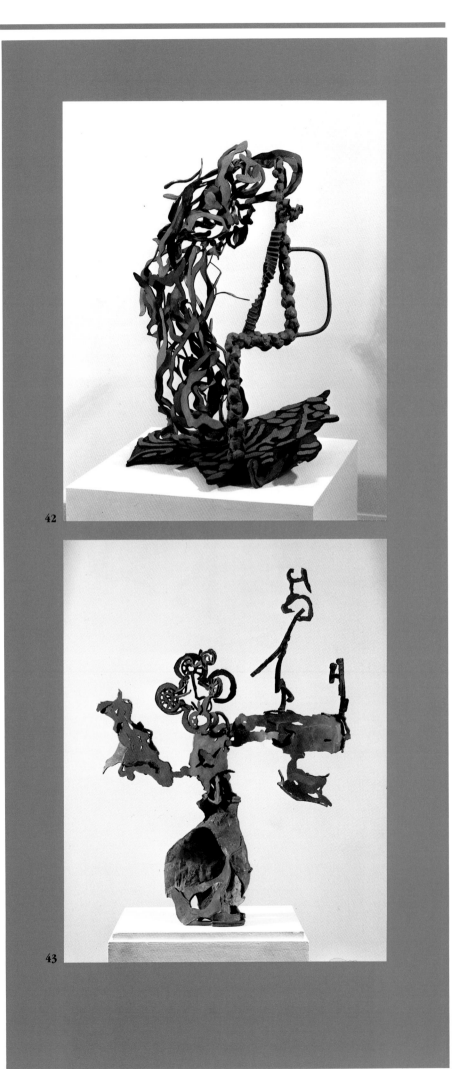

42

43

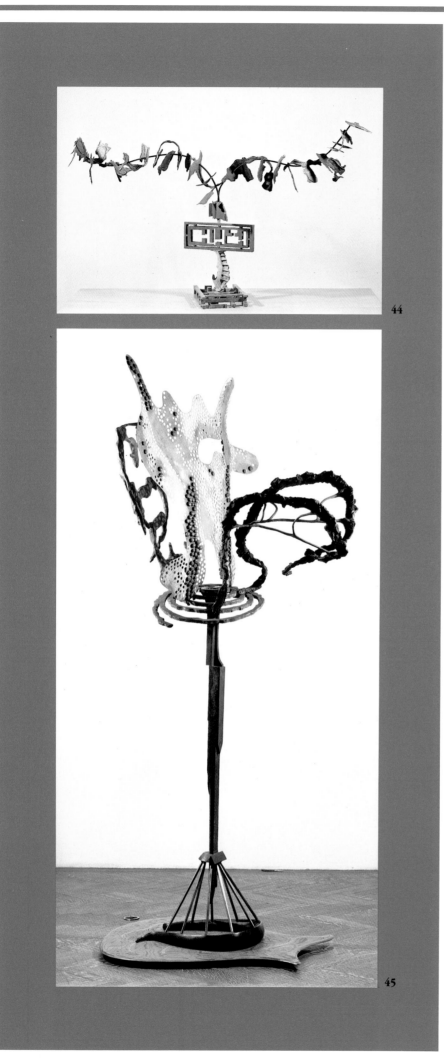

44

45

44 Aves, 1979
Bronze and steel with polychrome patina and oil paint. 46½ ×
82 × 30 (118.1 × 208.3 × 76.2). Inscribed on third vertical ele-
ment from bottom: *N. S. Graves AVES 1979 TX.*

COLLECTION
Private collection

EXHIBITIONS
New York: M. Knoedler & Co., Inc. (checklist no. 9), 1980
Buffalo: Albright-Knox Art Gallery (traveling exhibition; cat. no. 60;
 color p. 98), 1980–81

REFERENCES
Carr, *Dialogue* (July–August 1980), bw p. 21. Amaya, *Architectural
Digest* 39 (February 1982), color p. 146. Shapiro, *Arts Magazine* 58
(December 1983), bw p. 111; comm. p. 112.

REMARKS
All parts of *Aves* are directly cast. Moving from bottom to top, the first
element is a base made of square lengths of gating material. The
second is a vase made with gating material modeled by the artist in
wax (a task normally done by the foundry). Third is an archaeologi-
cal plan of a building, made of gating material. The fourth is cast
from dotted, stamped Cushion Craft paper of the kind used for wrap-
ping sculptures; a fragment of a building is depicted. The fifth ele-
ment is composed of wings and the profiles of prehistoric caves cast
from paper, with wax and gating materials on one side and poured
wax on the other.

45 Bathymet-Topograph, 1978–79
Bronze with polychrome patina. 82 × 36 × 30 (208.3 × 91.4 × 76.2).
Inscribed on side of vertical element: *N. S. Graves BATHYMET-
TOPOGRAPH 1978–79 TX.*

COLLECTION
Museum moderner Kunst, Vienna; on loan from the Sammlung Ludwig,
Aachen, West Germany

PROVENANCE
M. Knoedler & Co., Inc., New York

EXHIBITIONS
Rome: American Academy in Rome (bw n.p.), 1979

REFERENCES
Fillitz, 1979, color n.p. Graves, *Artscribe* (April 1979), bw p. 40.
Cathcart, 1980, fig. 12; bw p. 28. Daval, 1980, bw p. 127

REMARKS
This bronze sculpture was the first of a series that combined direct
casting (the spiral at the top was made of paper and wax that were
burned out after the spiral was put in a casting shell, and therefore
no mold was needed) with mold casting (the two topographical maps
that rest on top of the spiral were originally made in wire and wax)
and fabrication (the bathymetric section at the top and the first base
were cut out of sheet bronze).

Bathymet-Topograph is the first of a series of unique sculptures
made between 1979 and 1981 whose themes are anthropological and
archaeological mapping.

The forms in this sculpture are derived from engravings in Franz
Boas's book on the Eskimo. The patina is experimental in its combi-
nation of cadmium red, yellow, and purple with traditional browns,
greens, and black.

46 Column, 1979
Bronze with black patina on Cor-ten steel base. 72½ × 14 × 7
(184.2 × 35.6 × 17.8). Inscribed on side: *N. S. Graves COLUMN 1979 TX.*

COLLECTION
Mr. and Mrs. Irwin Meyer, New York

PROVENANCE
M. Knoedler & Co., Inc., New York

EXHIBITIONS
Buffalo: Albright-Knox Art Gallery (traveling exhibition; cat. no. 63;
 color p. 100), 1980–81

REMARKS
Column is one of two single Pleistocene camel legs; the second, *Col-
umn II* (cat. no. 47), has a brown patina and its constituent parts
are different.

47 Column II, 1979
Bronze with brown patina on painted Cor-ten steel base. 79 × 14 ×
6½ (200.7 × 35.6 × 16.5). Inscribed ten inches from top:
N. S. Graves COLUMN II 1979 TX.

COLLECTION
Private collection

EXHIBITIONS
New York: Grey Art Gallery and Study Center (bw p. 37), 1980
Providence: Museum of Art, Rhode Island School of Design (check-
 list), 1982

REFERENCES
Sozanski, *Providence Journal*, 27 August 1982, bw.

48 Miocene Skeleton, 1979
Bronze with green and black patina, steel rods; Cor-ten steel base.
76¾ × 94½ × 35½ (195 × 240 × 90). Inscribed on base:
N. S. Graves MIOCENE SKELETON 1979.

COLLECTION
Museum moderner Kunst, Vienna; on loan from the Ludwig Foundation

REFERENCES
Ronte, *L'Art et le temps*, 1984, bw p. 243.

REMARKS
Miocene Skeleton was made at the H. Noack foundry in West Berlin
while Graves was in residence at the American Academy in Rome. It
was a commission. The vertical rod supporting the piece was added
by the foundry. Molds were taken from *Miocene Skeleton*, 1969
(cat. no. 7), the original "bone" sculpture in which fossil forms are
synonymous with armature.

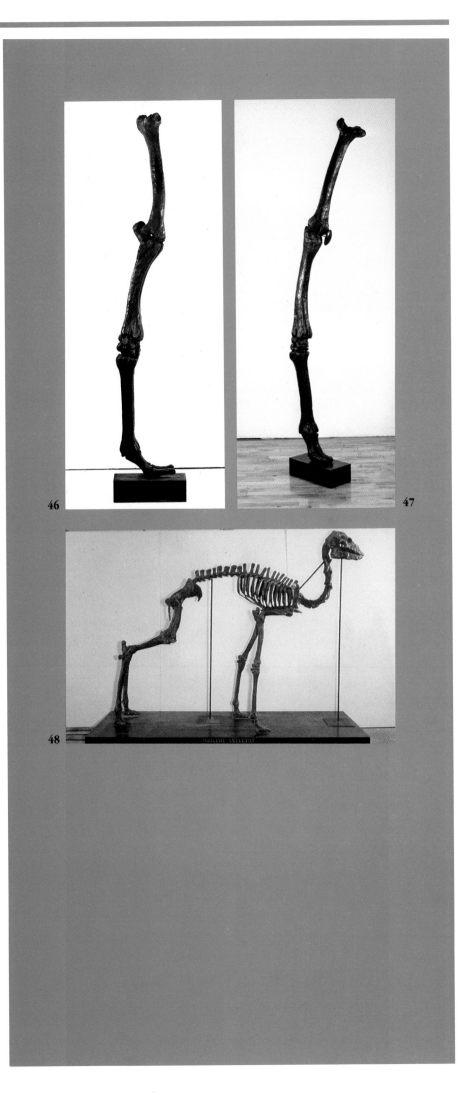

46
47
48

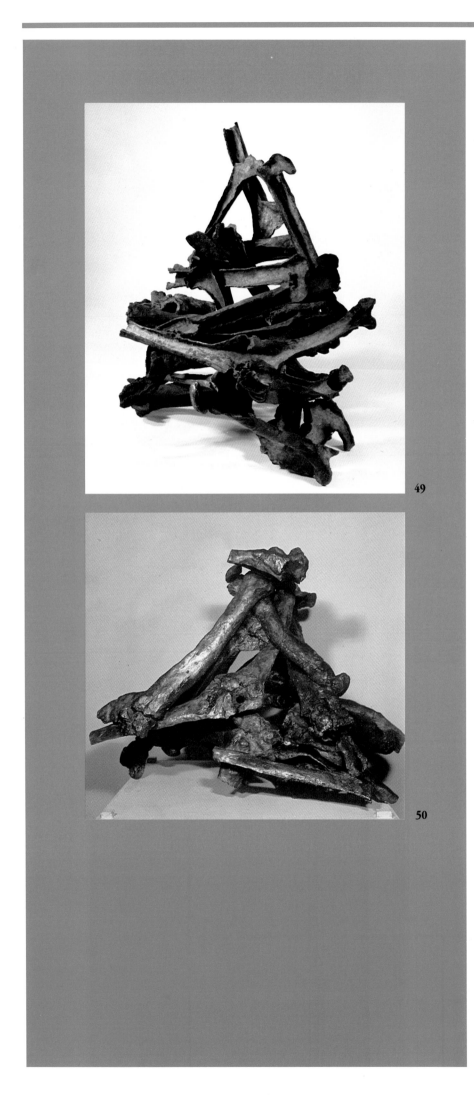

49

50

49 Obviation of Similar Forms, Second Variation, 1979
Bronze with liver of sulphur and green patina. 36 × 36 × 36 (91.4 × 91.4 × 91.4). Inscribed on side: *N. S. Graves 1979 OBVIATION OF SIMILAR FORMS, second variation.*

COLLECTION
Musuem moderner Kunst, Vienna; on loan from the Ludwig Foundation.

EXHIBITIONS
Stuttgart: Württembergischer Kunstverein (bw p. 159), 1982

REFERENCES
"Neuerwerbungen der Sammlung Ludwig (2)." *Aachener Nachrichten*, 19 July 1980, bw.

REMARKS
This work, a commission, was produced at the H. Noack foundry in West Berlin, using molds made from the earlier *Obviation of Similar Forms*, 1969 (cat. no. 9). The first version, consisting of wax, marble dust, acrylic, steel, and aluminum, was destroyed in the process of making molds for the two commissioned bronze versions in 1979 (cat. nos. 49 and 50).

50 Obviation of Similar Forms, Third Variation, 1979
Bronze with black and green patina. 36 × 36 × 36 (91.4 × 91.4 × 91.4). Inscribed on side: *N. S. Graves 1979 OBVIATION OF SIMILAR FORMS, third variation.*

COLLECTION
Neue Galerie—Sammlung Ludwig, Aachen, West Germany

REMARKS
The piece, a commission, was made at the H. Noack foundry in West Berlin. See remarks to cat no. 49.

51 Optic, 1979

Bronze with black patina and silver nitrate. 34½ × 20 × 15½
(87.6 × 50.8 × 39.4). Inscribed on base: *N. S. Graves 9 '79 TX.*

COLLECTION

Private collection

EXHIBITIONS

New York: M. Knoedler & Co., Inc. (checklist no. 8), 1980
New York: Hamilton Gallery, 1981

REMARKS

This piece was made from directly cast, cut-out sheet wax. The forms
are an archaeological city plan *in toto*.

52 Taxidermy Form, 1979

Bronze with white, brown, and green patina on Cor-ten steel base.
88 × 30 × 138 (223.5 × 76.2 × 350.5). Inscribed: *N. S. Graves*
TAXIDERMY FORM 1979 TX.

COLLECTION

Mrs. John D. Murchison, Dallas

PROVENANCE

Janie C. Lee Gallery, Houston

REMARKS

The molds for this piece were made from *Taxidermy Form*, 1970
(cat. no. 21), which was destroyed in the process. This is a unique
bronze version, different from the original because the artist made
changes in the wax molds and in the patina. It was commissioned by
Mrs. Murchison through the Janie C. Lee Gallery, Houston.

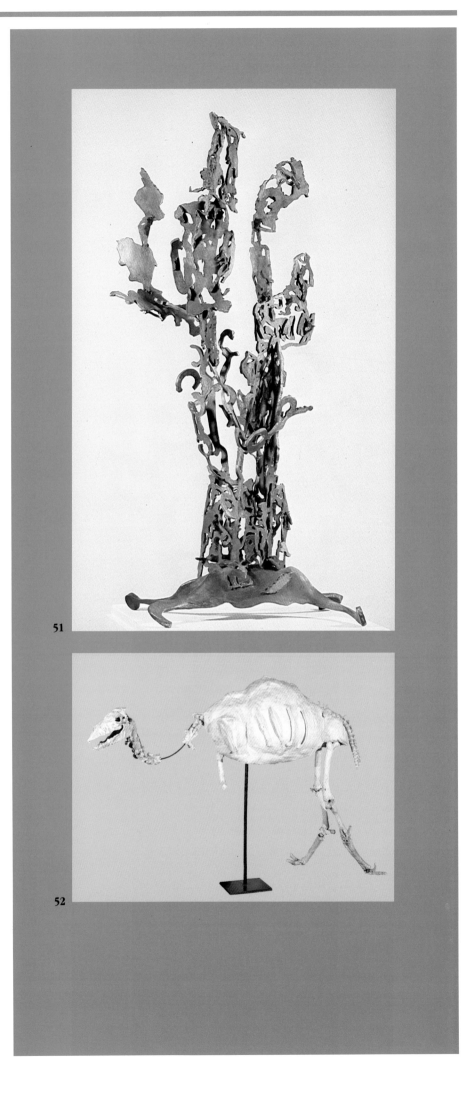

51

52

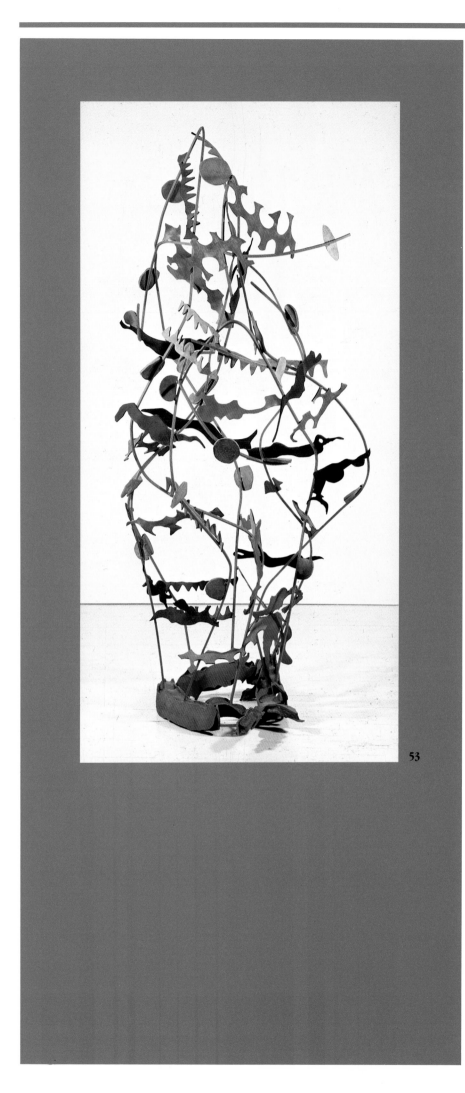

53

53 Variability and Repetition, 1979

Bronze with polychrome patina and red and cobalt violet oil paint.
62 × 36 × 40 (157.5 × 91.4 × 101.6). Inscribed on base: *N. S. Graves*
VARIABILITY AND REPETITION X 1979 TX.

COLLECTION
Mr. and Mrs. Louis S. Myers

PROVENANCE
M. Knoedler & Co., Inc., New York

EXHIBITIONS
New York: M. Knoedler & Co., Inc. (checklist no. 3), 1980

REFERENCES
Schwartzman, *Vassar Quarterly* 77 (Winter 1981), bw p. 21.

REMARKS
This piece is the first of Graves's sculptures to combine fabricated
square bronze rods with directly cast forms, which are topographical
and bathymetric.

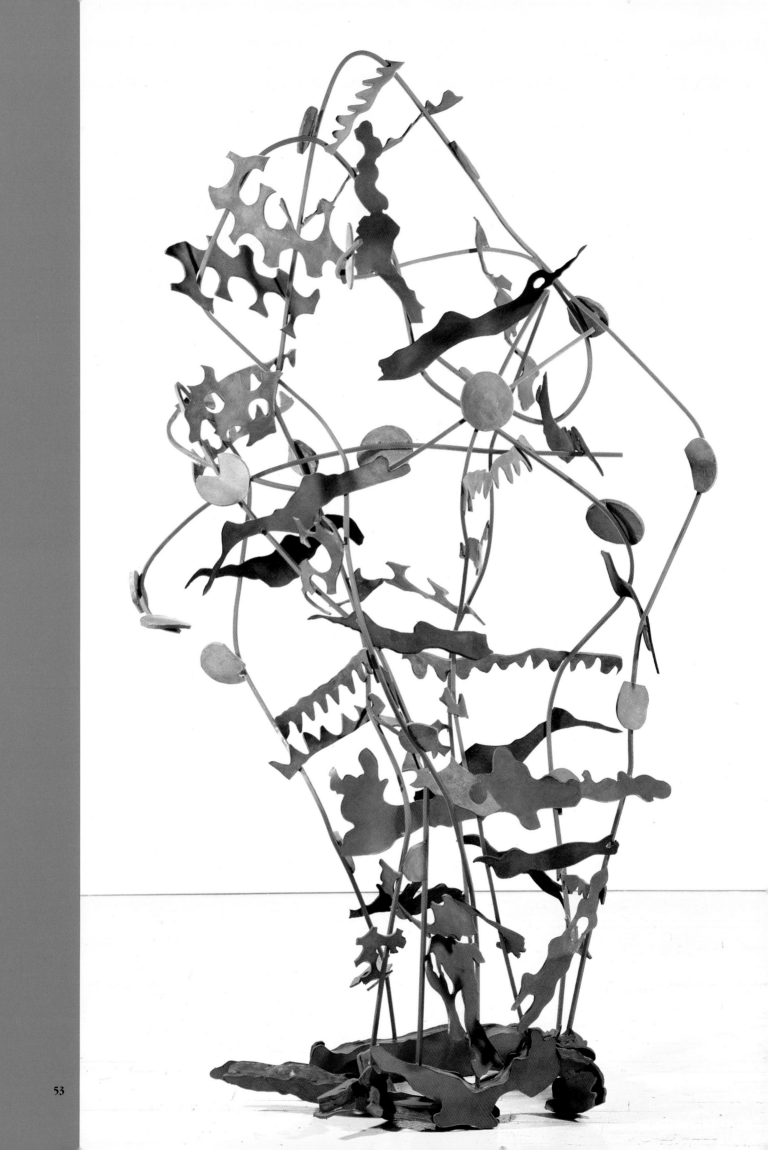

53

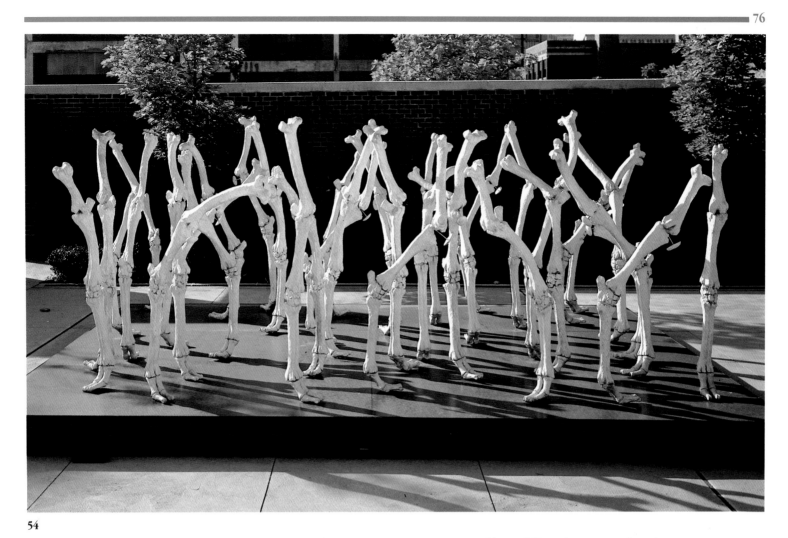

54

54 Variability and Repetition of Similar Forms II, 1979
Bronze with white patina with Cor-ten steel base. 72 × 144 × 192
(182.9 × 365.8 × 487.7). Inscribed on base: *N. S. Graves VARIABILITY
AND REPETITION OF SIMILAR FORMS II 1979.*

COLLECTION
Akron Art Museum, purchased with the aid of the Museum
Acquisition Fund, the Mary and Louis S. Myers Foundation, the Fire-
stone Foundation, and the National Endowment for the Arts

PROVENANCE
M. Knoedler & Co., Inc., New York

EXHIBITIONS
Washington, D.C.: Forrestal Office Building, 1980
Akron: Akron Art Museum (checklist), 1985

REFERENCES
American Institute of Architects Journal 69 (July 1980), bw p. 32.

REMARKS
This piece was made at Johnson Atelier, Princeton, New Jersey, the
only one of Graves's works created at this foundry. Thirty-six front
and rear camel-skeleton legs, consisting of upper, middle, and lower
parts, were made from six prototype forms. Each of the waxes was
varied by the artist, so that it is a unique piece, visually related to the
1970 version (cat. no. 23) but not an exact replica. Of note is the
white patina, which was devised by Ron Young and applied to the
sculpture in up to thirty layers.

55 Arachna, 1980

Bronze. 10½ × 7½ × 16 (26.7 × 19.1 × 40.6). Inscribed on side: *N. S. Graves ARACHNA 1980 TX.*

COLLECTION
Dr. Luther W. Brady, Philadelphia

PROVENANCE
M. Knoedler & Co., Inc., New York

REMARKS
Arachna was one of three versions. The other two were made in 1981, and each version has a unique patina (see cat. nos. 61 and 62).

56 Archaeolem, 1980

Bronze with polychrome patina. 67 × 38 × 44 (170.2 × 96.5 × 111.8). Inscribed 30 in. from top: *N. S. Graves 11/80 ARCHAEOLEM TX.*

COLLECTION
Private collection

EXHIBITIONS
New York: M. Knoedler & Co., Inc. (checklist no. 10), 1981
Providence: Museum of Art, Rhode Island School of Design (bw n.p.), 1982
Williamstown, Massachusetts: Williams College Museum of Art (traveling exhibition; bw n.p.), 1984–85

REFERENCES
Sozanski, *Providence Journal*, 27 August 1982, bw. Wallach, *Newsday*, 4 November 1984, bw p. 4, part II.

REMARKS
This was one of a series of sculptures made following Graves's 1979 residency at the American Academy in Rome, based on archaeological mapping of juxtaposed, varying scales.

57 Gravilev, 1979–80

Bronze with polychrome patina on steel base. 88 × 143 × 32 (223.5 × 363.2 × 81.3). Inscribed on third vertebra from skull: *N. S. Graves GRAVILEV 1979–80 TALLIX.*

COLLECTION
Dr. J. H. Sherman, Baltimore

PROVENANCE
M. Knoedler & Co., Inc., New York

EXHIBITIONS
New York: M. Knoedler & Co., Inc. (checklist no. 4), 1981
Baltimore: The Baltimore Museum of Art (temporary loan), 16 November 1984–26 June 1985

REMARKS
Gravilev is the first of two variations, the other being *Varilev*, 1981 (cat. no. 78). Both were made from molds of an earlier sculpture, *Vertebral Column with Skull and Pelvis*, 1970 (cat. no. 24), which was destroyed in the process.

55

56

57

58

59

58 Locomorph, 1980
Bronze with polychrome patina. $44 \times 26 \times 17$ ($111.8 \times 66 \times 43.2$).
Inscribed on side: *N. S. Graves LOCOMORPH II 1980 TX.*

COLLECTION
Mr. and Mrs. Graham Gund

PROVENANCE
M. Knoedler & Co., Inc., New York

EXHIBITIONS
New York: M. Knoedler & Co., Inc. (checklist no. 8), 1981
Boston: Museum of Fine Arts (color p. 26; mislabeled as *Motolo*),
 1982
Providence: Museum of Art, Rhode Island School of Design
 (checklist), 1982
Pittsfield, Massachusetts: The Berkshire Museum (traveling
 exhibition; color n.p.), 1983
Poughkeepsie, New York: Vassar College Art Gallery (traveling
 exhibition; color p. 6), 1986

REFERENCES
Tulenko, *Art Voices*, July–August 1981, bw. Sozanski, *Providence
Journal*, 27 August 1982, bw.

REMARKS
Locomorph is the first sculpture in a series of five that are character-
ized by a base made of a directly cast lampshade, a caryatid figure as
the third element from the bottom, and, at the top, fanlike configura-
tions. Other sculptures in this series include *Relocomorph*, 1981
(cat. no. 74), and *Acordia* (cat. no. 79), *Fanne Figura* (cat. no.
96), and *Five Fans, Lampshades and Lotus* (cat. no. 98), all 1982.

59 Motolo, 1980
Bronze with polychrome patina and oil paint. $10 \times 26 \times 5\frac{1}{4}$
($25.4 \times 66 \times 13.3$). Inscribed along top: *N. S. Graves MOTOLO VII
1980 TX.*

COLLECTION
Mr. and Mrs. Graham Gund

PROVENANCE
M. Knoedler & Co., Inc., New York

EXHIBITIONS
Boston: Museum of Fine Arts (no illus.; title incorrectly given to
 Locomorph, 1980), 1982
Poughkeepsie, New York: Vassar College Art Gallery (traveling
 exhibition; no illus.), 1986

REMARKS
Motolo is the first of three versions. *Motolo II* and *Motolo III* (cat.
nos. 71 and 72) were made in 1981. Each has a different patina and
slightly different construction.

60 Trace, 1979–80
Bronze and steel with polychrome patina and Ronan superfine Japan
colors. $107 \times 59 \times 115$ ($271.8 \times 150.8 \times 292.1$). Inscribed on
base: *N. S. Graves TRACE 1979–80 TX.*

COLLECTION
Mr. and Mrs. Graham Gund

PROVENANCE
M. Knoedler & Co., Inc., New York

EXHIBITIONS
New York: M. Knoedler & Co., Inc. (checklist no. 5), 1980
Buffalo: Albright-Knox Art Gallery (traveling exhibition; cat. no. 64;
 color p. 101), 1980–81
Boston: Museum of Fine Arts (color p. 27), 1982
South Hadley, Massachusetts: Mount Holyoke College Art Museum
 (color p. 41), 1985

60

REFERENCES

Contemporary Arts Museum, Houston, Texas, Annual Report, 1980, color cover, comm. p. 8. Crossley, *The Houston Post*, 21 September 1980, color p. 1AA. La Badie, *The Commercial Appeal* (Memphis), 16 November 1980, bw p. 27. Rose, *Vogue* 170 (June 1980), color p. 202. Russell, *The New York Times*, 1 June 1980, bw p. D25. Balwin, *Des Moines Register*, 19 April 1981, bw p. 5C. Larson, *The Village Voice*, 24 March 1980, bw p. 81. McVinney, *The Load*, February 1981, bw. Russell, 1981, color p. 397. Lauzon, *The Berkshire Eagle*, 11 March 1982, bw p. 21.

REMARKS

Trace is part of the Archaeology Series inspired by the artist's residency at the American Academy in Rome. First in the series was *Archaeoloci*, 1979 (cat. no. 42). A second version of *Trace*, 1981 (cat. no. 75), is sixteen feet tall. It was fabricated by Lippincott, Inc., North Haven, Connecticut.

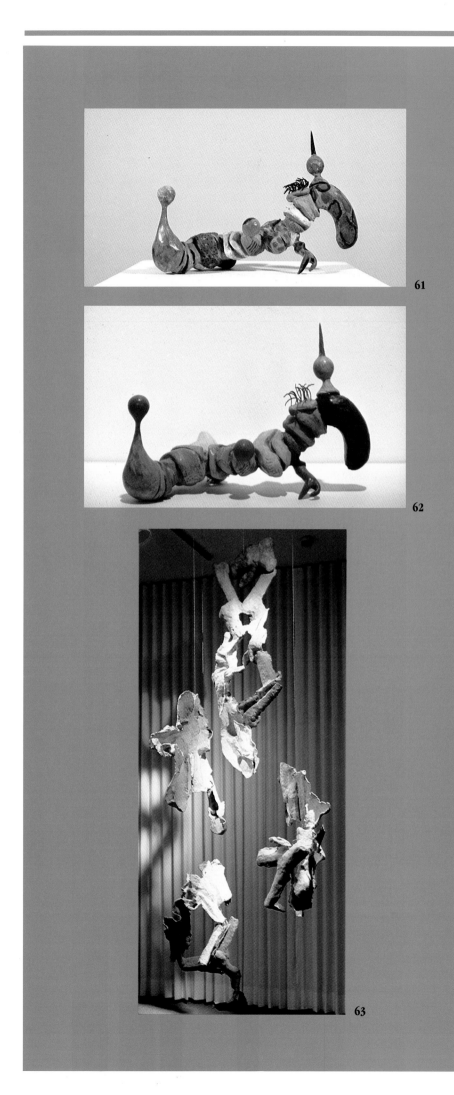

61

62

63

61 Aracn, 1981
Bronze with polychrome patina. 10½ × 16 × 7 (26.7 × 40.6 × 17.8).
Inscribed on green sausage shape: *N. S. Graves ARACN 1981 TX.*

COLLECTION
Private collection

REMARKS
This is one of a series of three: *Arachna*, 1980 (cat. no. 55), and
Arachnai, 1981 (cat. no. 62), are the other two. Each of these works
has a unique patina and assembly of bronze elements made from
plant stalks and chair caning, found objects that were cast directly.

62 Arachnai, 1981
Bronze with polychrome patina. 16 × 10½ × 7 (40.6 × 26.7 × 17.8).
Inscribed on side: *N. S. Graves ARACHNAI 1981 TX.*

COLLECTION
Diane Fuller, San Francisco

PROVENANCE
M. Knoedler & Co., Inc., New York
Fuller Goldeen Gallery, San Francisco

EXHIBITIONS
San Francisco: Fuller Goldeen Gallery (cat. no. 11), 1982
Rohnert Park, California: University Art Gallery, Sonoma State
 University (traveling exhibition; bw p. 37), 1984–86

63 Cast Shadow Reflecting from Four Sides, 1970–81
Bronze with white patina. Four parts, top to bottom: 1: 56 × 22 × 10
(142.2 × 55.9 × 25.4); 2: 34 × 24 × 15 (86.4 × 61 × 38.1); 3:
39 × 20 × 17 (99 × 51 × 43.2); 4: 43 × 22 × 13 (109.2 × 56
× 33). Inscribed: *N. S. Graves CAST SHADOW REFLECTING FROM FOUR
SIDES TX.*

COLLECTION
Mr. and Mrs. Harvey Walner, Highland Park, Illinois

PROVENANCE
M. Knoedler & Co., Inc., New York
Richard Gray Gallery, Chicago

EXHIBITIONS
Chicago: Richard Gray Gallery (checklist no. 11), 1981

REMARKS
The sculpture is a cast variation of *Cast Shadow Reflecting from
Four Sides,* 1970 (cat. no. 12), which was destroyed in the process.

64 Columniary, 1981
Bronze with polychrome patina. 113 × 23 × 23 (287 × 58.4 × 58.4).
Inscribed on side: *N. S. Graves COLUMNIARY III–1981 TX.*

COLLECTION
Dr. J. H. Sherman, Baltimore

PROVENANCE
M. Knoedler & Co., Inc., New York

EXHIBITIONS
New York: M. Knoedler & Co., Inc. (checklist no. 7), 1981

REMARKS
Columniary is part of a series that includes *Urbscolumna*, 1981
(cat. no. 77), *Columnouveau*, 1982 (cat. no. 85), and *Corinthia*,
1982 (cat. no. 90).

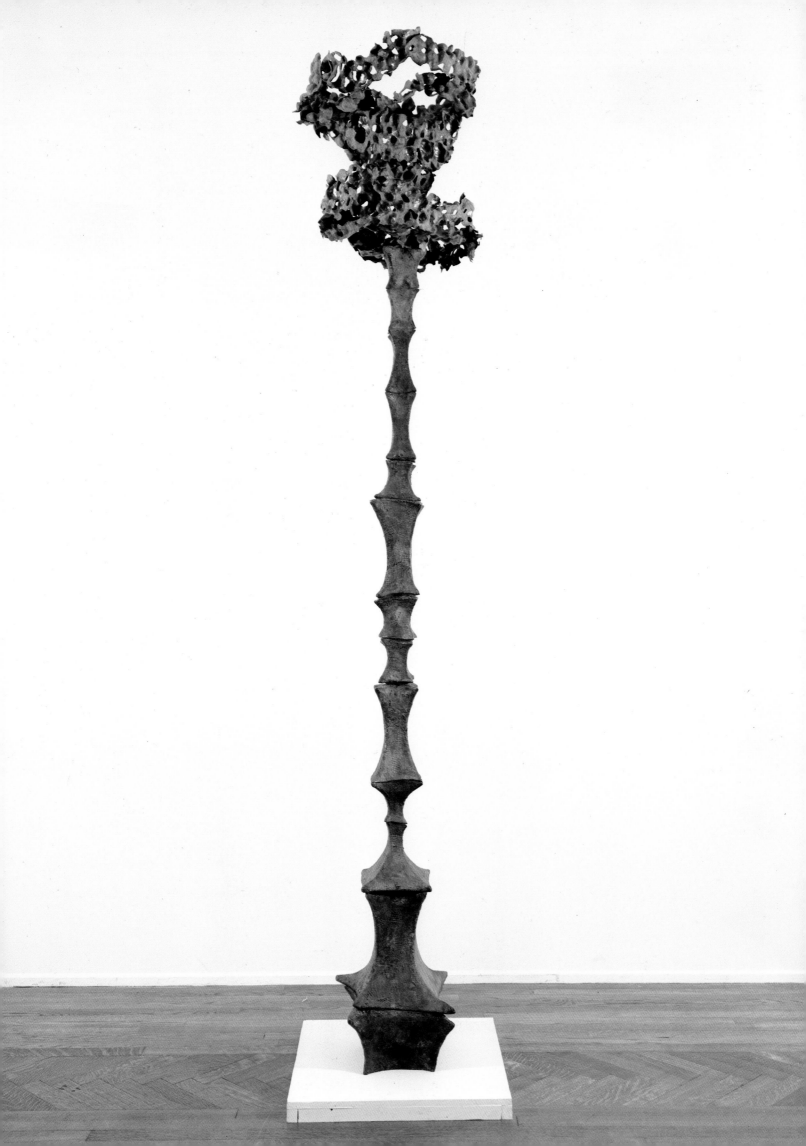

65

66

67

65 Combinate, 1981

Bronze with polychrome patina. 84 × 95 × 58 (213.4 × 241.3 × 147.3). Inscribed on side: *N. S. Graves COMBINATE 1981 TX.*

COLLECTION
The Ludwig Collection, Aachen, West Germany

PROVENANCE
M. Knoedler & Co., Inc., New York

EXHIBITIONS
Chicago: Richard Gray Gallery (checklist no. 5), 1981
Santa Barbara: Santa Barbara Contemporary Arts Forum (bw n.p.), 1983
Aachen, West Germany: Neue Galerie—Sammlung Ludwig (traveling exhibition; bw n.p.), 1984
Stockholm: Liljevalchs Konsthall (bw p. 71), 1985–86

REFERENCES
Amaya, *Architectural Digest* 39 (February 1982), color p. 155.

REMARKS
This scupture is the most important of the American Academy Archaeological Series, begun in 1979. It is the last sculpture not to use directly cast organic forms.

66 Fayum, 1981

Bronze with polychrome patina. 77½ × 78 × 57 (196.9 × 198.1 × 144.8). Inscribed on side: *N. S. Graves FAYUM XII–1981 TX.*

COLLECTION
Private collection, San Francisco

PROVENANCE
M. Knoedler & Co., Inc., New York

EXHIBITIONS
New York: M. Knoedler & Co., Inc. (checklist no. 5), 1982

REFERENCES
Walker, *Artscribe*, no. 38 (December 1982), bw p. 44. Storr, *Art in America* 71 (March 1983), bw p. 120; comm. p. 120. Frank, *Connoisseur* 216 (February 1986), color p. 61.

REMARKS
Fayum is part of the American Academy Archaeological Series begun in 1979. A second version is entitled *Fayum-Re*, 1982 (cat. no. 97).

67 Five Legs, 1981

Bronze. 70 × 52 × 83 (177.8 × 132.1 × 210.8). Inscribed under each toe: *NG '81 #1, #2, #3, #4, #5 TX.*

COLLECTION
Balene and Sanford McCormick

PROVENANCE
M. Knoedler & Co., Inc., New York
Janie C. Lee Gallery, Houston

REFERENCES
Ennis, *House and Garden* 156 (May 1984), color p. 179.

REMARKS
This is a five-part outdoor sculpture with footings sunk into the ground. It was commissioned by Mrs. Balene McCormick through the Janie C. Lee Gallery, Houston, and M. Knoedler & Co., Inc., New York.

68 Kariata, 1981

Aluminum, Cor-ten steel, brass, copper, and polyurethane paint. 51½ × 50 × 65 (130.8 × 127 × 165.1). Inscribed on base: *N. S. Graves 2/81 KARIATA LIPPINCOTT INC.*

COLLECTION
Peg Yorkin and Bud Yorkin, Los Angeles

PROVENANCE
M. Knoedler & Co., Inc., New York

EXHIBITIONS
New York: M. Knoedler & Co., Inc. (checklist no. 2), 1981

REMARKS
Kariata was made at Lippincott, Inc., North Haven, Connecticut. It is part of a series that originated with *Locomorph*, 1980 (cat. no. 58) and includes *Kariatae*, 1981 (cat. no. 69), *Kariate*, 1981 (cat. no. 70), *Relocomorph*, 1981 (cat. no. 74), *Acordia*, 1982 (cat. no. 79), *Fanne Figura*, 1982 (cat. no. 96), and *Five Fans, Lampshades and Lotus*, 1982 (cat. no. 98).

69 Kariatae, 1981

Steel, copper, bronze, brass, aluminum, and polyurethane paint. 138 × 108 × 126 (350.5 × 274.3 × 320). Inscribed on base: *N. S. Graves KARIATAE 1981 LIPPINCOTT INC.*

COLLECTION
Private collection

EXHIBITIONS
Toledo, Ohio: Downtown Toledo, The Toledo Museum of Art, and Crosby Gardens (cat. no. 2; bw p. 14), 1984
Chicago: State Street Mall (cat. bw p. 17), 1985
Saint Louis: Laumeier Sculpture Park (temporary loan), 1985–86

REFERENCES
Amaya, *Architectural Digest* 39 (February 1982), color p. 151. Miro, *Free Press*, 11 September 1984, bw.

REMARKS
See remarks to cat. no. 68.

70 Kariate, 1981

Bronze, steel, aluminum, copper, brass, and polyurethane paint. 30½ × 42 × 38 (77.5 × 106.7 × 96.5). Inscribed on base: *N. S. Graves KARIATE 6/81 LIPPINCOTT & TX.*

COLLECTION
Mr. and Mrs. Lawrence Rubin, New York

PROVENANCE
M. Knoedler & Co., Inc., New York

REFERENCES
Fell, *Architectural Digest* 38, pt. 4 (December 1981), color p. 129. Amaya, *Architectural Digest* 39 (February 1982), color p. 150. Hunter and Jacobus, 1985, illus. p. 386.

REMARKS
See remarks to cat. no 68.

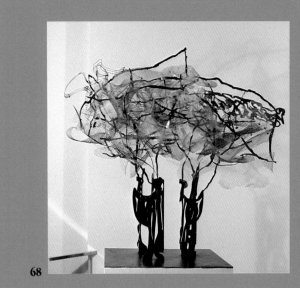

68

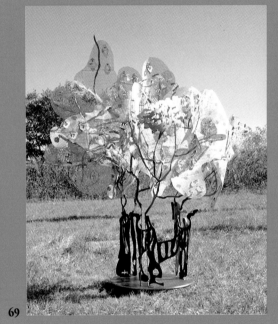

69

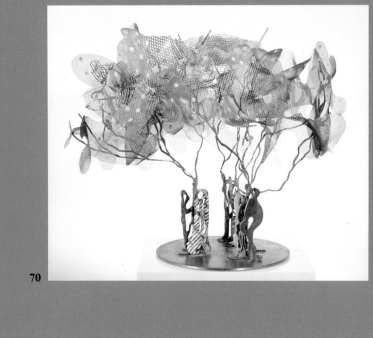

70

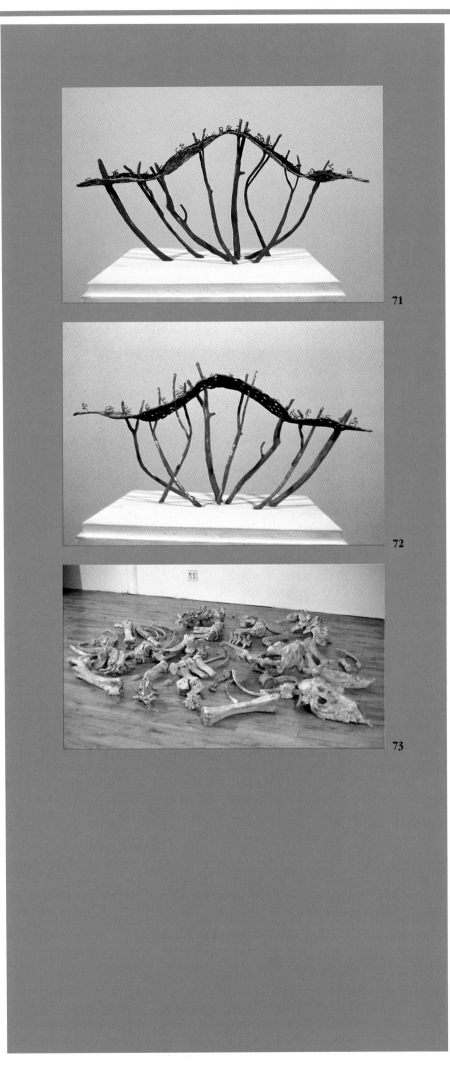

71

72

73

71 Motolo II, 1981

Bronze with polychrome patina and oil paint. 10 × 5 ¼ × 26 (25.4 × 13.3 × 66). Inscribed on top undulating element: *MOTOLO 1–81 N. S. Graves TX.*

COLLECTION
Private collection

REMARKS
Motolo II is the second of three versions. The first (cat. no. 59) was begun in 1980; the third version (cat. no. 72) also dates from 1981. Each version has a different patina and slightly different placement of plant legs.

72 Motolo III, 1981

Bronze with polychrome patina and oil paint. 10 × 5¼ × 26 (25.4 × 13.3 × 66). Inscribed on side: *N. S. Graves MOTOLO III 1–1981 TX.*

COLLECTION
Ann and Robert Freedman, New York

PROVENANCE
M. Knoedler & Co., Inc., New York

73 Phoenix, 1970–81

Vertebral column, skull, pelvis, wax, marble dust, steel, aluminum, and acrylic. 8 × 72 × 96 (20.3 × 182.9 × 243.9). Unsigned.

COLLECTION
Charles Cowles, New York

REMARKS
The artist made the present floor piece in 1981 from Charles Cowles's *Vertebral Column with Skull and Pelvis*, 1970 (cat. no. 24). Additional "bone" sculptures were added.

74 Relocomorph, 1981

Bronze with polychrome patina. 58 × 36 × 43 (147.3 × 91.4 × 109.2). Inscribed on side: *N. S. Graves RELOCOMORPH 1981 TX.*

COLLECTION
Aron and Phyllis Katz

PROVENANCE
M. Knoedler & Co., Inc., New York

REMARKS
Relocomorph is the second in a series of sculptures begun in 1980. See remarks to cat. no. 58.

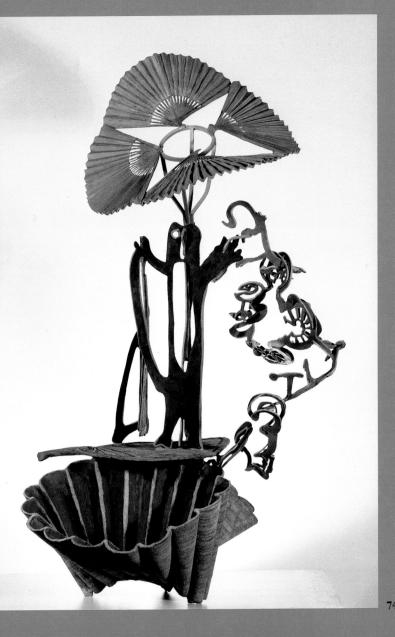
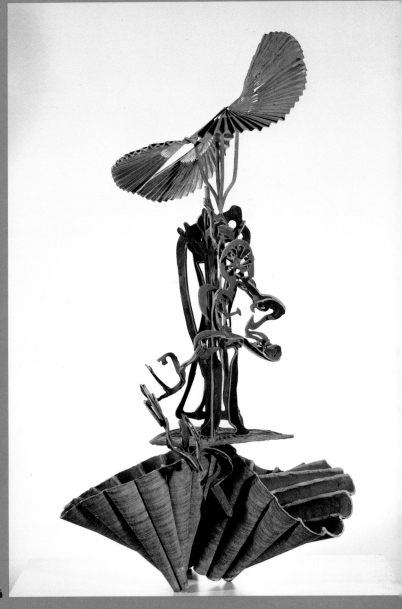

74

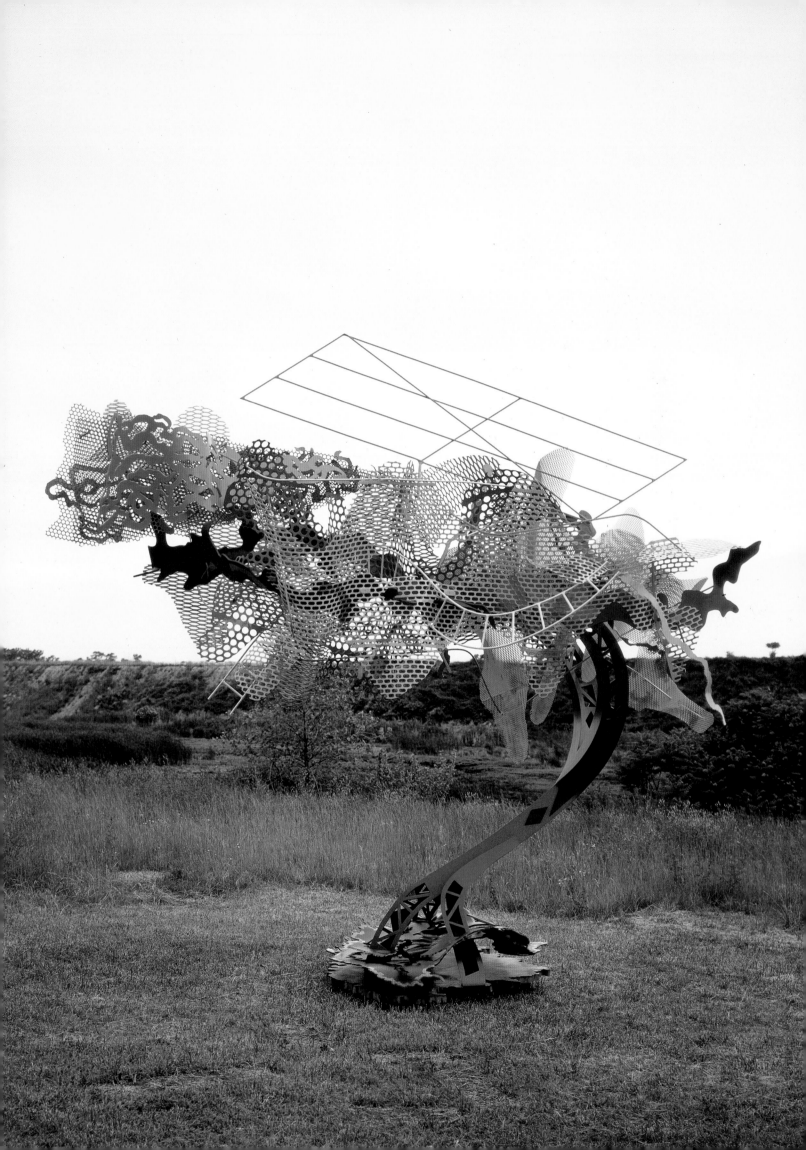

75 Trace, 1981

Cor-ten steel, aluminum, and polyurethane paint. 192 × 214 × 120
(487.7 × 543.6 × 305). Inscribed on base: *N. S. Graves TRACE 1981
LIPPINCOTT.*

COLLECTION

Los Angeles County Museum of Art, promised gift of Jaye and Joseph
Haddad

PROVENANCE

M. Knoedler & Co., Inc., New York
Jaye and Joseph Haddad, Beverly Hills

EXHIBITIONS

Los Angeles: Los Angeles County Museum of Art (checklist), 1984

REFERENCES

Frank, *Art in America* 68 (May 1980), color p. 155.

REMARKS

The original *Trace*, 1979–80 (cat. no. 60), is in the collection of Mr.
and Mrs. Graham Gund. This 1981 version is the first sculpture by
Graves fabricated at Lippincott, Inc., North Haven, Connecticut. The
sculpture is in three parts.

76 Urbscaleum, 1981

Bronze with polychrome patina. 63 × 26 × 44 (160 × 66 × 111.8).
Inscribed on side: *N. S. Graves URBSCALEUM 2/81 TX.*

COLLECTION

Mr. and Mrs. Irwin Meyer, New York

PROVENANCE

M. Knoedler & Co., Inc., New York

EXHIBITIONS

New York: M. Knoedler & Co., Inc. (checklist no. 9), 1981

REMARKS

The top element of the sculpture is based on an archaeological city
plan. The research for it was completed in 1979 at the American
Academy in Rome.

77 Urbscolumna, 1981

Bronze with polychrome patina. 107 × 47 × 36 (271.8 × 119.4 ×
91.4). Inscribed on side: *N. S. Graves URBSCOLUMNA 5/81 TX.*

COLLECTION

Albright-Knox Art Gallery, Buffalo, New York. George B. & Jenny R.
Mathews Fund, 1982

PROVENANCE

M. Knoedler & Co., Inc., New York

EXHIBITIONS

Chicago: Richard Gray Gallery (checklist no. 9), 1981
Poughkeepsie, New York: Vassar College Art Gallery (traveling exhibi-
 tion; color front.), 1986

REFERENCES

Amaya, *Architectural Digest* 39 (February 1982), color p. 154. Raye,
Albright-Knox Art Gallery Calendar, November 1982, comm. p. 5,
bw front. *Gazette des beaux-arts*, ser. 6, vol. 101 (March 1983), fig.
270, bw supp. p. 48.

REMARKS

The sculpture is part of a series that includes *Columniary*, 1981
(cat. no. 64), *Columnouveau*, 1982 (cat. no. 85), and *Corinthia*,
1982 (cat. no. 90).

78 Varilev, 1981

Bronze with polychrome patina on steel base. 88 × 143 × 32 (223.5 ×
363.2 × 81.3). Inscribed on side: *N. S. Graves VARILEV 1981 TX.*

COLLECTION

Private collection

EXHIBITIONS

Zurich: M. Knoedler Zurich AG (checklist no. 1), 1982–83

REMARKS

Varilev is the latter version of a pair, *Gravilev*, 1980 (cat. no. 57),
being the other; both were made from molds of an earlier sculpture,
Vertebral Column with Skull and Pelvis, 1970 (cat. no. 24).

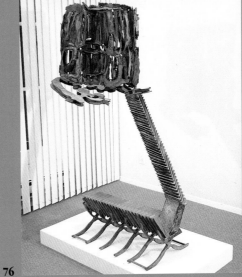

76

77

78

79

79 Acordia, 1982
Bronze with polychrome patina. 92¼ × 48 × 23½ (234.3 × 121.9 × 59.7). Inscribed on lotus: *N. S. Graves 7 '82 ACORDIA TX.*

COLLECTION
The Rivendell Collection

PROVENANCE
M. Knoedler & Co., Inc., New York

EXHIBITIONS
New York: M. Knoedler & Co., Inc. (checklist no. 3), 1982
New York: Whitney Museum of American Art (bw p. 27), 1983
Stratford, Ontario: The Gallery (traveling exhibition; no illus.), 1983–85

REFERENCES
Glueck, *The New York Times*, 22 October 1982, bw p. c22. Hall, *House and Garden* 155 (April 1983), color p. 8.

REMARKS
See remarks to cat. no. 58.

80 Agni, 1982
Bronze with polychrome patina. 73½ × 59 × 51 (186.7 × 149.9 × 129.5). Inscribed on black patina at bottom: *N. S. Graves 4 '82 AGNI TX.*

COLLECTION
Mr. and Mrs. Bagley Wright, Seattle

PROVENANCE
M. Knoedler & Co., Inc., New York

EXHIBITIONS
New York: M. Knoedler & Co., Inc. (checklist no. 18), 1982
Seattle: Seattle Art Museum (checklist), 1984–85

REFERENCES
"New York: Graves at M. Knoedler," *The Art Gallery Scene*, 16 November 1982, bw p. 5. Tully, *Art World*, November 1982, bw p. 6.

REMARKS
The artist made this piece after a trip to India.

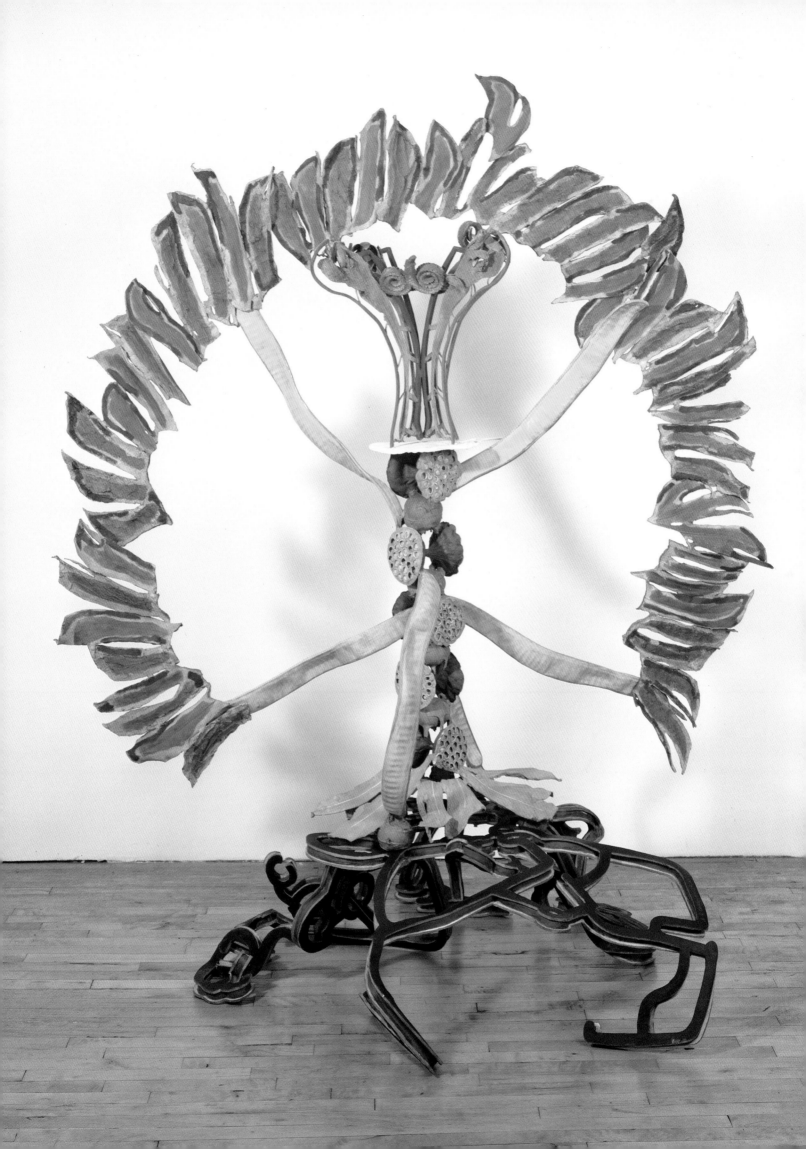

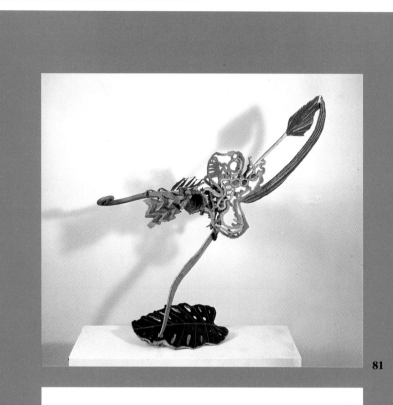

81

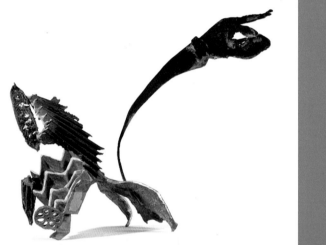

82

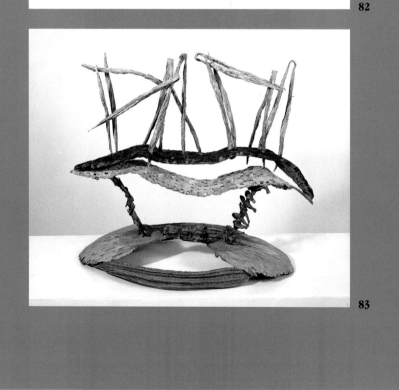

83

81 Bilanx, 1982

Bronze with polychrome patina. 41½ × 41 × 17½ (105.4 × 104.1 × 44.5). Inscribed on yellow column: *BILANX N. S. Graves 12–82 TX.*

COLLECTION
Private collection

EXHIBITIONS
New York: Barbara Toll Fine Arts Gallery, 1983
Stratford, Ontario: The Gallery (traveling exhibition; bw n.p.), 1983–85

REFERENCES
Friedman, *Arts Magazine* 58 (September 1983), comm. p. 9. Frank, *Connoisseur* 216 (February 1986), color p. 55.

REMARKS
Bilanx is one of the four original pieces in which sand casting is combined with direct casting. Graves made the sand-cast elements by cutting into a block of glue-hardened sand with a rotary drill and various drill bits.

82 Boss, 1982

Bronze with polychrome patina. 15 × 18½ × 10 (38.1 × 47 × 25.4). Inscribed on leaf: *BOSS N. S. Graves 6–'82 TX.*

COLLECTION
Mr. and Mrs. Wil J. Hergenrader, Memphis

PROVENANCE
M. Knoedler & Co., Inc., New York

EXHIBITIONS
New York: M. Knoedler & Co., Inc. (checklist no. 22), 1982

83 Catepelouse, 1982

Bronze with polychrome patina. 21 × 25 × 16½ (53.3 × 63.5 × 41.9). Inscribed on yellow horizontal element: *CATEPELOUSE N. S. Graves 6 '82.*

COLLECTION
Sally Sirkin Lewis, Beverly Hills

PROVENANCE
M. Knoedler & Co., Inc., New York

EXHIBITIONS
New York: M. Knoedler & Co., Inc. (checklist no. 20), 1982
Santa Barbara: Santa Barbara Contemporary Arts Forum (bw n.p.), 1983

REFERENCES
Storr, *Art in America* 71 (March 1983), color p. 121.

REMARKS
The caning in the sculpture's horizontal element is similar to that in *Motolo*, 1980 (cat. no. 59).

84 Colubra, 1982

Bronze with polychrome patina. 35¾ × 28 × 22½ (90.8 × 71.1 × 57.1). Inscribed on gourd: *N. S. Graves 8–82 COLUBRA TX.*

COLLECTION
Barry and Gail Berkus, Santa Barbara

PROVENANCE
M. Knoedler & Co., Inc., New York

EXHIBITIONS
New York: M. Knoedler & Co., Inc. (checklist no. 13), 1982
Santa Barbara: Santa Barbara Contemporary Arts Forum (bw n.p.), 1983
Santa Barbara: Santa Barbara Museum of Art (color, p. 48), 1984

REFERENCES
Storr, *Art in America* 71 (March 1983), color p. 118.

REMARKS
The title is a variation of the word "cobra." The sculpture was made after the artist's India trip.

Nancy Graves

A Sculpture Retrospective
February 19–April 26, 1987

Seed pods and crayfish claws, a chain of sardines, palmetto leaves and carob beans, bubble wrap, a chair back, baby corn, and Chinese cooking scissors—these are a few of the numerous cast-bronze elements Nancy Graves (American, b. 1940) uses to create sculpture. Although Graves has worked as a painter, printmaker, stage designer, and filmmaker, sculpture has been her primary focus in recent years. This exhibition of forty-eight works concentrates on sculpture done since 1979, a particularly prolific period for the artist in this medium.

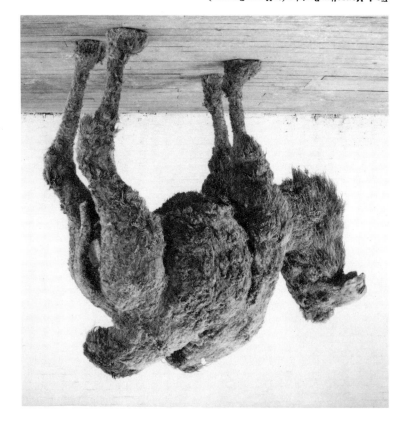

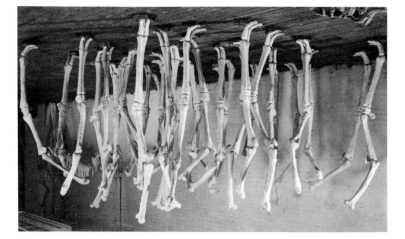

A s a child, Nancy Graves spent many hours in the Berkshire Museum in Pittsfield, Massachusetts, where her father served as director. That museum's diverse collection, which ranges from art to the natural sciences, engendered the many and varied interests that inform her works of art. After studying at Vassar and Yale, Graves spent a year in Paris on a Fulbright-Hayes grant in painting. She then went to Florence where she photographed wax models of animals and humans by an 18th-century Italian anatomist. These models and her investigations of taxidermy in the museum of natural history in Florence stimulated Graves to move from two-dimensional work to sculpture.

With her return to the United States came gallery shows in New York. But it was the life-size camels made of wood, steel, burlap, animal skins, and wax that announced Graves to the art world in a one-person exhibition at the Whitney Museum of American Art in 1969. She subsequently destroyed most of the more than twenty camels she made, as she had her first efforts in Florence. *Mongolian Bactrian*, 1969 (fig. 1), is one of the few that remains. Next came works simulating skeletons, bone fragments, and fossils. *Variability of Similar Forms*, 1970 (fig. 2), is a grouping of thirty-six life-size camel legs made of wax and steel. Although the lower part of each leg is similar, the two top elements vary. In these early works Graves was exploring sculptural forms and varied materials to express her concerns with anatomy, biology, paleontology, and anthropology.

From 1972 to 1976 Graves stopped making sculpture to concentrate on painting and filmmaking. One series of paintings based on topographic maps of the ocean floor led her to archaeology and urban planning as a basis for sculpture. Spurred by a commission to produce one of her earlier works in bronze, in the late 1970s she turned to making bronze sculptures, using forms derived from her skeletal pieces.

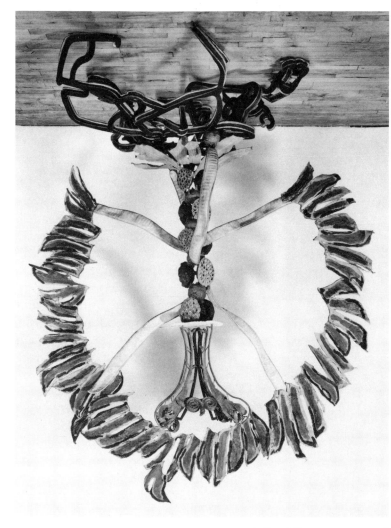

Archaeologue and *Archaeoloci*, both from 1979, combine information from specific Mediterranean sites. Graves reduced her source material to its basic components, changed the scale of the elements, and added color to underline those new relationships. The base of *Archaeoloci* is a town plan with dwelling sites in low relief, the steplike support is abstracted from a breakwater, and the blue curvilinear shapes represent the sea.

Direct casting became Graves's preferred working method after 1979 when she began to work with bronze duplicates of actual objects, many from nature. The process of direct casting, which is undergoing a renaissance of sorts among contemporary artists, involves encasing an object—a leaf, for example—in a ceramic shell and then firing it. The object burns away and liquid bronze takes its place. When cool, the bronze cast is an exact copy of the original form. By 1980 Graves had stopped making preliminary sketches for sculpture and she began to assemble works improvisationally, actually drawing in space by welding the cast pieces together at as few points as possible. Color, an important element, is applied last. The technicians at Tallix Foundry in Peekskill, New York, where all her casting is done, developed new patinas that gave Graves a wide range of colors—not just the browns and greens usually associated with bronze sculpture. For even brighter color she began using polyurethane paint in 1981. And in 1983 another new technique using powdered glass allowed her to create her first enameled sculptures.

Graves has lived in New York for the past twenty years but travels regularly, having visited northern Africa, Peru, India, Australia, and China; the philosophies and artifacts of other cultures stimulate her thoughts about sculpture. The cast ropes of *Quipu*, 1978, with their bright red, blue, green, and yellow patinas, are based on an ancient Peruvian system of counting. *Fayum*, 1981, is a direct reference to the excavated villages of a prehistoric Egyptian society that gave the region south of

Cairo its name. *Agni*, 1982 (fig. 3), a bronze structure with six yellow seed-pod arms that holds an arc of blue-patinated flames, is Graves's tribute to the Vedic fire deity and mediator between the gods and men.

Among the artists to whom Graves pays homage in her work are Alexander Calder and David Smith. The palmetto-leaf pendulum in *Penda*, 1983 (fig. 4), is balanced on the right with a crazed, airy bronze line in a colorful sculpture that recalls the delicate equilibrium in Calder's mobiles and stabiles. *Wheelabout*, 1985 (fig. 5), is a bronze construction of C-clamps and a raffia fan welded to a three-wheeled cart that holds an S-shaped ladder. This work joins disparate parts into a whole whose title describes its ability to move, acknowledging the half-toy, half-work tool sculptures from David Smith's Voltri and Wagon series.

From a stockpile of hundreds of directly cast objects, Graves selects pieces, searching for unlikely juxtapositions and formal links between shapes. In many of her recent sculptures, the bronze elements serve structural and decorative purposes at the same time. The open and lacelike *Extend-Expand*, 1983 (cover), whose curves and brilliant color camouflage the material with which it was made, is only one recently evolved species in Graves's new version of nature. Her studies in the physical and natural sciences, her experience of other cultures, and her appreciation of the work of other artists give Nancy Graves a special sensibility evident in the inventive sculpture on view in this exhibition.

This exhibition was organized by the Fort Worth Art Museum, Fort Worth, Texas.

Fig. 4. *Penda* (Pendula Series), 1983. Bronze with polychrome patina and baked enamel. Private collection.

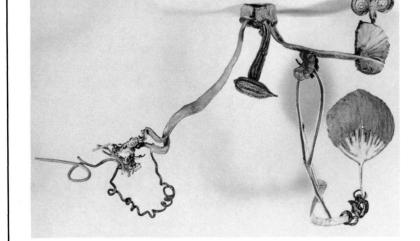

Fig. 5. *Wheelabout*, 1985. Bronze and steel with polyurethane paint. The Fort Worth Art Museum, gift of Mr. and Mrs. Sid R. Bass.

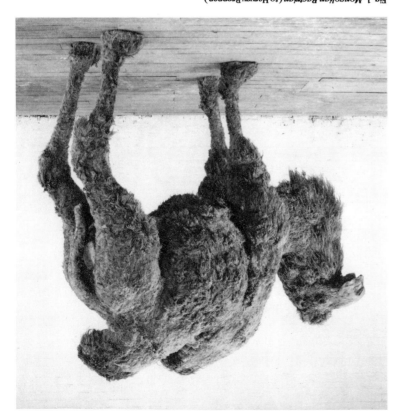

Fig. 1. *Mongolian Bactrian* (to Harvey Brennan), 1969. Wood, steel, burlap, polyurethane, animal skin, wax, acrylic, oil, and fiberglass. Neue Galerie-Sammlung Ludwig, Aachen.

Fig. 2. *Variability of Similar Forms*, 1970. Steel, wax, marble dust, and acrylic on wood base. Private collection.

As a child, Nancy Graves spent many hours in the Berkshire Museum in Pittsfield, Massachusetts, where her father served as director. That museum's diverse collection, which ranges from art to the natural sciences, engendered the many and varied interests that inform her works of art. After studying at Vassar and Yale, Graves spent a year in Paris on a Fulbright-Hayes grant in painting. She then went to Florence where she photographed wax models of animals and humans by an 18th-century Italian anatomist. These models and her investigations of taxidermy in the museum of natural history in Florence stimulated Graves to move from two-dimensional work to sculpture.

With her return to the United States came gallery shows in New York. But it was the life-size camels made of wood, steel, burlap, animal skins, and wax that announced Graves to the art world in a one-person exhibition at the Whitney Museum of American Art in 1969. She subsequently destroyed most of the more than twenty camels she made, as she had her first efforts in Florence. *Mongolian Bactrian*, 1969 (fig. 1), is one of the few that remains. Next came works simulating skeletons, bone fragments, and fossils. *Variability of Similar Forms*, 1970 (fig. 2), is a grouping of thirty-six life-size camel legs made of wax and steel. Although the lower part of each leg is similar, the two top elements vary. In these early works Graves was exploring sculptural forms and varied materials to express her concerns with anatomy, biology, paleontology, and anthropology.

From 1972 to 1976 Graves stopped making sculpture to concentrate on painting and filmmaking. One series of paintings based on topographic maps of the ocean floor led her to archaeology and urban planning as a basis for sculpture. Spurred by a commission to produce one of her earlier works in bronze, in the late 1970s she turned to making bronze sculptures, using forms derived from her skeletal pieces.

Nancy Graves

A Sculpture Retrospective
February 19–April 26, 1987

S eed pods and crayfish claws, a chain of sardines, palmetto leaves and carob beans, bubble wrap, a chair back, baby corn, and Chinese cooking scissors—these are a few of the numerous cast-bronze elements Nancy Graves (American, b. 1940) uses to create sculpture. Although Graves has worked as a painter, printmaker, stage designer, and filmmaker, sculpture has been her primary focus in recent years. This exhibition of forty-eight works concentrates on sculpture done since 1979, a particularly prolific period for the artist in this medium.

Extend-Expand, 1983. Bronze with polychrome patina. The Museum of Modern Art, New York, gift of Mr. and Mrs. Sid R. Bass.

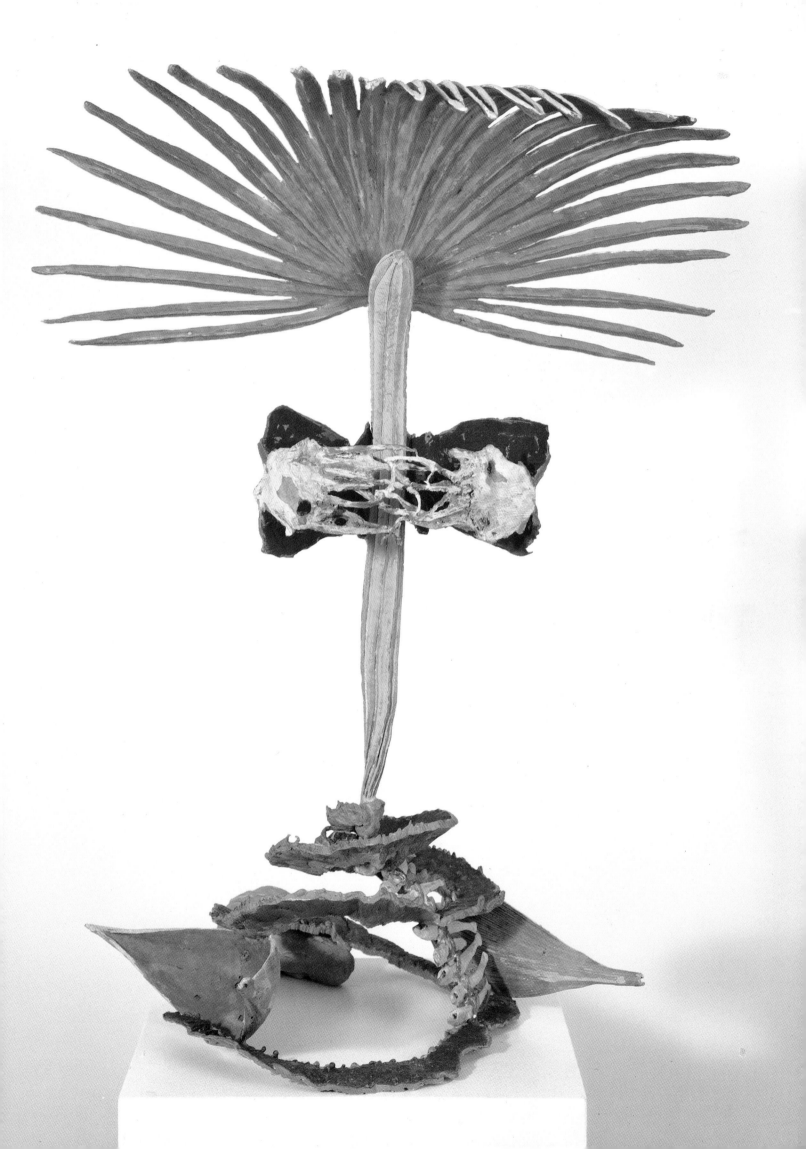

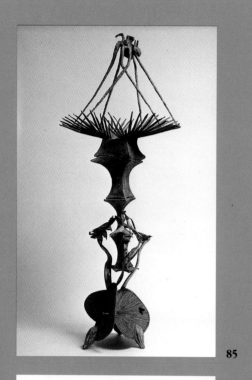

85

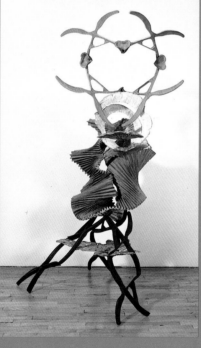

86

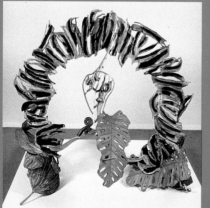

87

85 Columnouveau, 1982
Bronze with polychrome patina. 98 × 42 × 24 (248.9 × 106.7 × 61). Inscribed on white flower: *COLUMNOUVEAU N. S. Graves 7 '82 TX.*

COLLECTION
Private collection, Fort Worth, Texas

PROVENANCE
M. Knoedler & Co., Inc., New York

EXHIBITIONS
New York: M. Knoedler & Co., Inc. (checklist no. 7), 1982

REFERENCES
Storr, *Art in America* 71 (March 1983), comm. p. 120.

REMARKS
The sculpture is part of a series including *Columniary* (cat. no. 64) and *Urbscolumna* (cat. no. 77), both 1981, and *Corinthia*, 1982 (cat. no. 90).

86 Conjugate, 1982
Bronze with polychrome patina. 64 × 50 × 55 (162.6 × 127 × 139.7). Inscribed on bottom leg: *N. S. Graves 5 '82 TX CONJUGATE.*

COLLECTION
Mr. and Mrs. Werner Dannheisser, New York

PROVENANCE
M. Knoedler & Co., Inc., New York

EXHIBITIONS
New York: M. Knoedler & Co., Inc. (checklist no. 4), 1982

REFERENCES
Berman, *Artnews* 85 (February 1986), comm. p. 63.

87 Conjunctive, 1982
Bronze with polychrome patina. 42½ × 50 × 42 (108 × 127 × 106.7). Inscribed on bottom leaf: *CONJUNCTIVE N. S. Graves 8 '82 TX.*

COLLECTION
Norna Sarofim, New York

PROVENANCE
M. Knoedler & Co., Inc., New York

EXHIBITIONS
New York: M. Knoedler & Co., Inc. (checklist no. 2), 1982
New York: Whitney Museum of American Art (no illus.), 1983

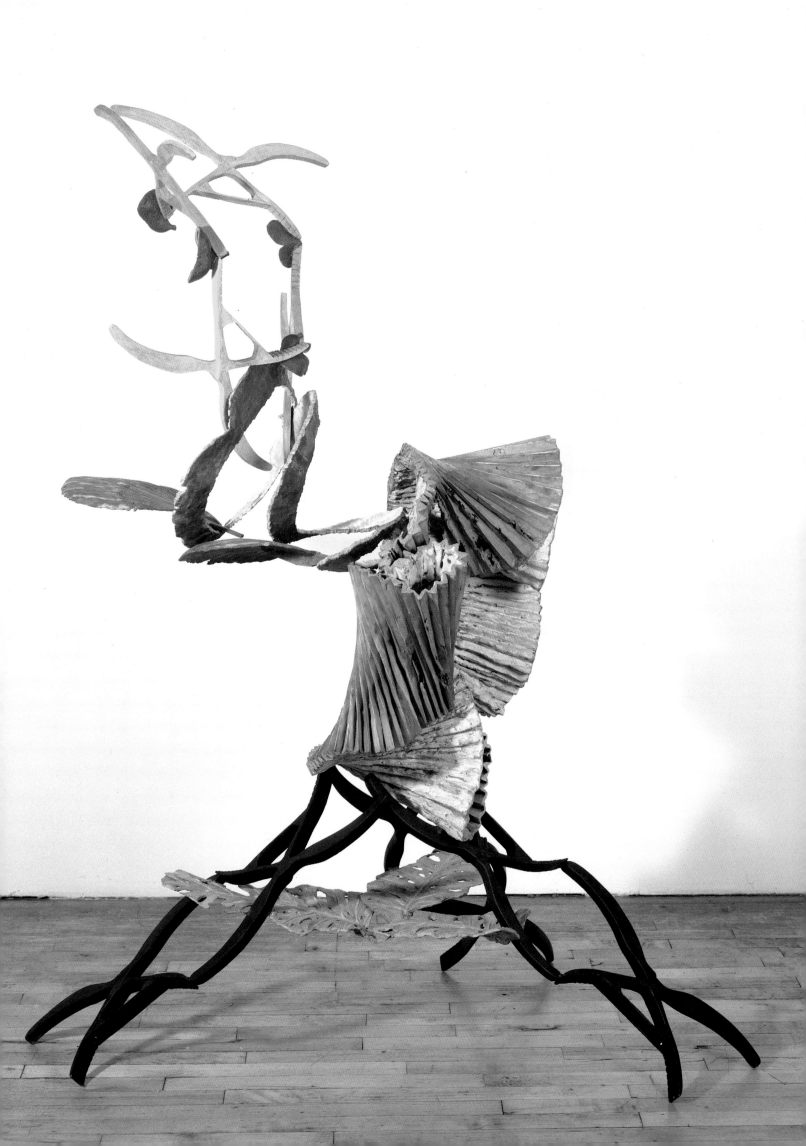

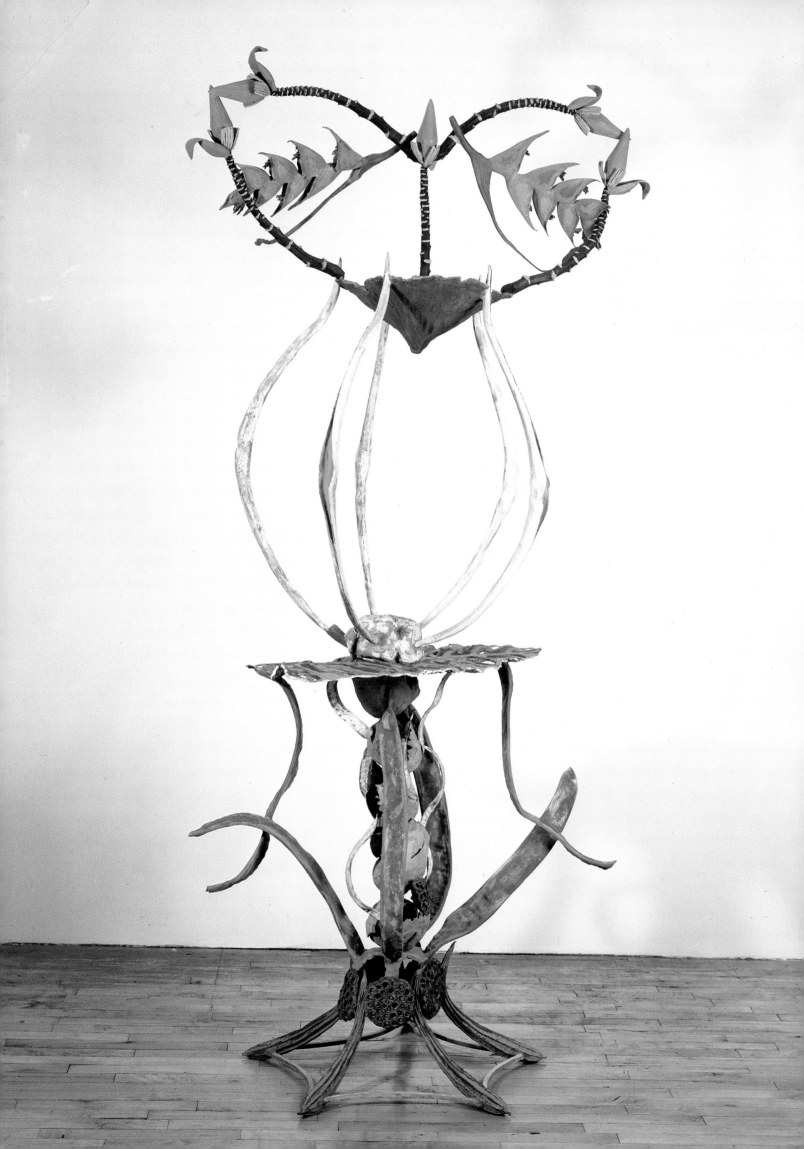

88 Conjuncture, 1982

Bronze with polychrome patina. 75 × 28 × 25 (190.5 × 71.1 × 63.5). Inscribed on leaf: *N. S. Graves CONJUNCTURE TX.*

COLLECTION
Mr. and Mrs. Myron Mendelson, Connecticut

PROVENANCE
M. Knoedler & Co., Inc., New York

EXHIBITIONS
New York: M. Knoedler & Co., Inc. (checklist no. 12), 1982
New York: Whitney Museum of American Art (no illus.), 1983

89 Convolute-Concave, 1982

Bronze with polychrome patina. 35½ × 30 × 32 (90.2 × 76.2 × 81.3). Inscribed on side: *N. S. Graves CONVOLUTE-CONCAVE VIII–1982 TX.*

COLLECTION
John and Mary Pappajohn, Des Moines

PROVENANCE
M. Knoedler & Co., Inc., New York

EXHIBITIONS
New York: M. Knoedler & Co., Inc. (checklist no. 15), 1982

REMARKS
The sculpture is a variation of *Colubra*, 1982 (cat. no. 84).

90 Corinthia, 1982

Bronze with polychrome patina. 104 × 26 × 25 (264.2 × 66 × 63.5). Inscribed on gourd: *N. S. Graves 6 '82 TX CORINTHIA.*

COLLECTION
Private collection

EXHIBITIONS
Zurich: M. Knoedler Zurich AG (checklist no. 12), 1982–83
Katonah, New York: The Katonah Gallery (checklist no. 3), 1984
New York: The Mendick Company & 909 Third Avenue (checklist), 1984–85
Poughkeepsie, New York: Vassar College Art Gallery (traveling exhibition; no illus.), 1986

REMARKS
Corinthia is part of a series begun in 1981 with *Columniary* (cat. no. 64) and also including *Urbscolumna* (cat. no. 77) and *Columnouveau* (cat. no. 85), both dating from 1982.

91 Cyme, 1982

Bronze with polychrome patina. 26 × 26 × 15 (66 × 66 × 38.1). Inscribed on side: *N. S. Graves CYME VI–1982 TX.*

COLLECTION
Private collection

EXHIBITIONS
Houston: Contemporary Arts Museum (no. illus.), 1982–83
Pittsfield, Massachusetts: The Berkshire Museum (traveling exhibition; bw n.p.), 1983

REFERENCES
Houston Arts 6 (First Quarter 1983), color cover.

REMARKS
The sculpture was one of four initial pieces done with sand casting and direct casting, made as a series. The other three are *Bilanx* (cat. no. 81), *Proboscid* (cat. no. 106), and *Visage* (cat. no. 108), all 1982.

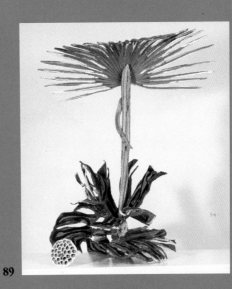

89

90

91

92

94

92 Discoid, 1982
Bronze with polychrome patina. 37¾ × 45 × 37½ (95.9 × 114.3 × 95.3). Inscribed on side: *N. S. Graves DISCOID 1982 TX.*

COLLECTION
Rita and Toby Schreiber

PROVENANCE
M. Knoedler & Co., Inc., New York

EXHIBITIONS
New York: M. Knoedler & Co., Inc. (checklist no. 17), 1982

REFERENCES
Rose, *Vogue* 173 (January 1983), color p. 222.

93 Equebrate, 1982
Bronze with polychrome patina. 60 × 30½ × 29 (152.4 × 77.5 × 73.7). Inscribed on leaf: *N. S. Graves 7 '82 EQUEBRATE TX.*

COLLECTION
Rebecca Smith, New York

PROVENANCE
M. Knoedler & Co., Inc., New York

EXHIBITIONS
New York: M. Knoedler & Co., Inc. (checklist no. 11), 1982
Poughkeepsie, New York: Vassar College Art Gallery (traveling exhibition; bw p. 47), 1986

REMARKS
This was the first sculpture with spring movement—in this case, the lotus leaf was torch-cut into a spiral.

94 Equipage, 1982
Bronze with polychrome patina. 53 × 42 × 53½ (134.6 × 106.7 × 135.9). Inscribed on scoop: *N. S. Graves 6–82 TX EQUIPAGE.*

COLLECTION
Michael C. Burrows, Palm Beach, Florida

PROVENANCE
M. Knoedler & Co., Inc., New York

EXHIBITIONS
New York: M. Knoedler & Co., Inc. (checklist no. 6), 1982

REFERENCES
Anderson, *Portfolio* 5 (March–April 1983), color p. 82.

REMARKS
The green, patinated area, made of directly cast sheet wax, was assembled to represent a Chinese archaeological grave site.

95 Etruria, 1982
Bronze with polychrome patina. 19½ × 52 × 19 (49.5 × 132.1 × 48.3). Inscribed on leaf: *ETRURIA N. S. Graves 5 '82 TX.*

COLLECTION
Mrs. Martin Tycher, Dallas

PROVENANCE
M. Knoedler & Co., Inc., New York

EXHIBITIONS
New York: M. Knoedler & Co., Inc. (checklist no. 10), 1982

REMARKS
The title refers to the source for the sculpture's imagery, an Etruscan vase.

93

95

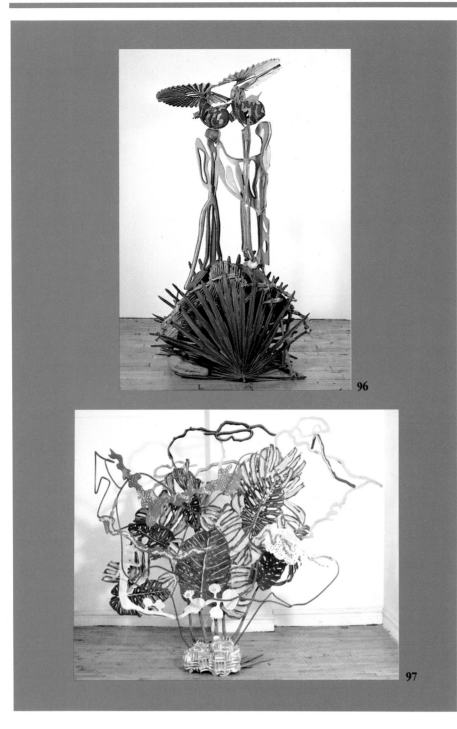

96

97

96 Fanne Figura, 1982
Bronze with polychrome patina. 54½ × 28 × 21½ (138.4 × 71.1 × 54.6). Inscribed on middle column: *N. S. Graves 4–82 FANNE FIGURA TX.*

COLLECTION
Ann and Robert Freedman, New York

PROVENANCE
M. Knoedler & Co., Inc., New York

EXHIBITIONS
New York: M. Knoedler & Co., Inc. (checklist no. 9), 1982

REFERENCES
Walker, *Artscribe*, no. 38 (December 1982), bw p. 44.

REMARKS
See remarks to cat. no. 58.

97 Fayum-Re, 1982
Bronze with polychrome patina. 77½ × 78 × 57 (196.9 × 198.1 × 144.8). Inscribed on pale pink form approximately 18½ in. high: *N. S. Graves 5 '82 FAYUM-RE TX.*

COLLECTION
Private collection

EXHIBITIONS
Williamstown, Massachusetts: Williams College Museum of Art (traveling exhibition; bw n.p.), 1984–85

REFERENCES
Brenson, *The New York Times*, 4 November 1984, bw p. H9.

REMARKS
The open blue fabricated forms refer to bathymetric mapping, as in *Trace*, 1979–80 (cat. no. 60), and in Graves's *Ocean Floor* paintings of 1972. The pink forms refer to the Fayum delta region of Egypt, which the artist visited in 1981. All these elements represent geographic features, as on a map. Directly cast *Monstera* leaves are the central element. Bases similar to that seen here are found in *Fayum*, 1981 (cat. no. 66), *Krater*, 1982 (cat. no. 100), and *Cantileve*, 1983 (cat. no. 113).

98 Five Fans, Lampshades and Lotus, 1982
Bronze with polychrome patina. 81 × 34 × 35 (206 × 86.4 × 89). Inscribed on side: *N. S. Graves FIVE FANS, LAMPSHADES AND LOTUS 1–1982 TX.*

COLLECTION
Private collection

EXHIBITIONS
New York: Center for Inter-American Relations and Kouros Gallery, 1982
Stratford, Ontario: The Gallery (traveling exhibition; color n.p.), 1983–85

REFERENCES
Edinburgh, *The Financial Post*, 25 June 1983, bw p. 21.
Geldzahler, *Artmagazine* 14 (Summer 1983), bw p. 15.

REMARKS
See remarks to cat. no. 58.

Pacific Ocean Floor II (Ocean Floor Series), 1972, acrylic on canvas, 90 × 72 (228.6 × 182.9). Collection Mrs. John D. Murchison, Dallas.

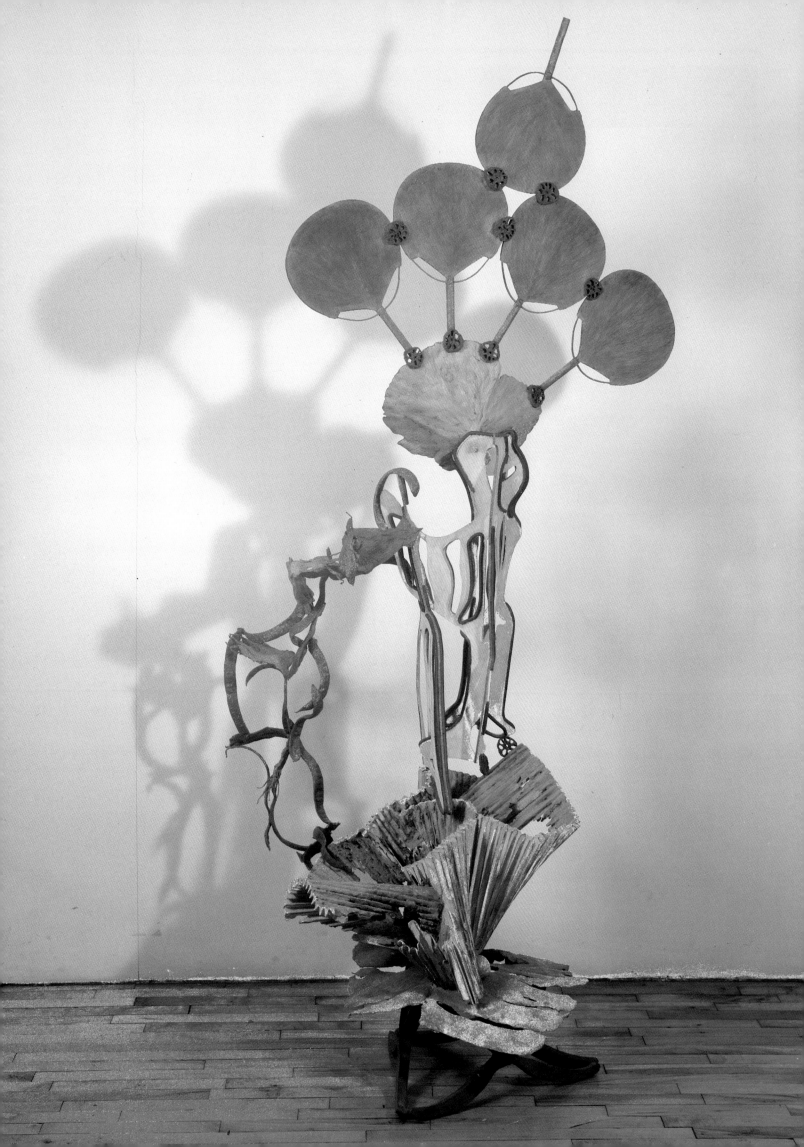

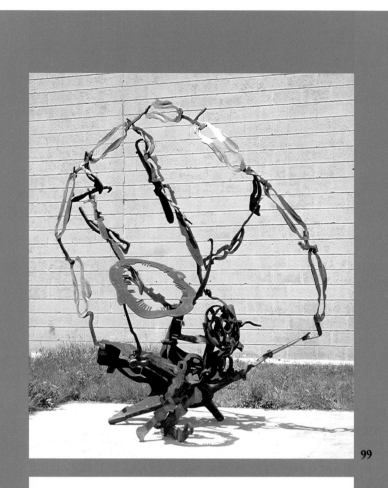

99

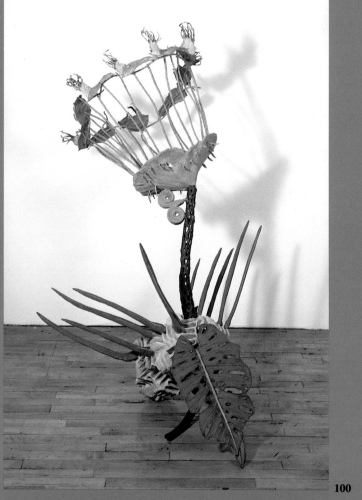

100

99 Indicate, 1982

Cast iron and Cor-ten steel. 114 × 9 × 90 (289.6 × 22.9 × 228.6).
Inscribed on side: *N. S. Graves INDICATE 1982 LIPPINCOTT INC.*

COLLECTION
Private collection

EXHIBITIONS
Greenvale, New York: Long Island University / C. W. Post Campus,
 "Program for Public Art," indefinite loan from 2 December 1985

REMARKS
Indicate was made at Lippincott, Inc., North Haven, Connecticut.
Parts of an offset lithography press were welded to cut and fabricated
Cor-ten steel parts made from drawings by the artist. Cor-ten steel was
rusted and acrylic lacquer was applied to preserve the surface.

100 Krater, 1982

Bronze with polychrome patina. 57½ × 41 × 40 (146 × 104.1 ×
101.6). Inscribed on leaf: *N. S. Graves KRATER 1982 TX.*

COLLECTION
Irving Galleries, Palm Beach, Florida

PROVENANCE
M. Knoedler & Co., Inc., New York

EXHIBITIONS
New York: M. Knoedler & Co., Inc. (checklist no. 14), 1982
Zurich: M. Knoedler Zurich AG (checklist no. 8), 1982–83

REMARKS
The sculpture's base was made from the same mold as those in *Fayum*,
1981 (cat. no 66), and *Fayum-Re*, 1982 (cat no. 97).

101 Kyathis, 1982

Bronze with polychrome patina. 12¼ × 18 × 10 (31.1 × 45.7 ×
25.4). Inscribed on pink shell: *N. S. Graves 7–2 '82 KYATHIS.*

COLLECTION
Mr. and Mrs. Michael Hecht, New York

PROVENANCE
M. Knoedler & Co., Inc., New York

EXHIBITIONS
New York: M. Knoedler & Co., Inc. (checklist no. 16), 1982
Williamstown, Massachusetts: Williams College Museum of Art (trav-
 eling exhibition; color n.p.), 1984–85
Poughkeepsie, New York: Vassar College Art Gallery (traveling exhibi-
 tion; no illus.), 1986

REFERENCES
Rose, *Vogue* 174 (February 1984), color p. 172.

102 Kylix, 1982

Bronze with polychrome patina. 19 × 22 × 19 (48.3 × 55.9 × 48.3).
Inscribed on leaf: *N. S. Graves 6– '82 KYLIX TX.*

COLLECTION
Bob and Linda Gersh, Los Angeles

PROVENANCE
M. Knoedler & Co., Inc., New York

EXHIBITIONS
New York: M. Knoedler & Co., Inc. (checklist no. 19), 1982
Santa Barbara: Santa Barbara Contemporary Arts Forum (color n.p.),
 1983
Williamstown, Massachusetts: Williams College Museum of Art
 (traveling exhibition; shown only at Newport Harbor Art Museum,
 Newport Beach, California; no illus.), 1984–85

REFERENCES
Myers, *Artforum* 21 (March 1983), color p. 49. "New York
Reviews," *Artnews* 82 (January 1983), bw p. 144. Russell,
The New York Times, 24 July 1983, bw sec. 2, p. 1. Berman,
Artnews 85 (February 1986), comm. p. 63.

REMARKS
The form, as the title suggests, was one of a series inspired by
Etruscan and Greek vase prototypes.

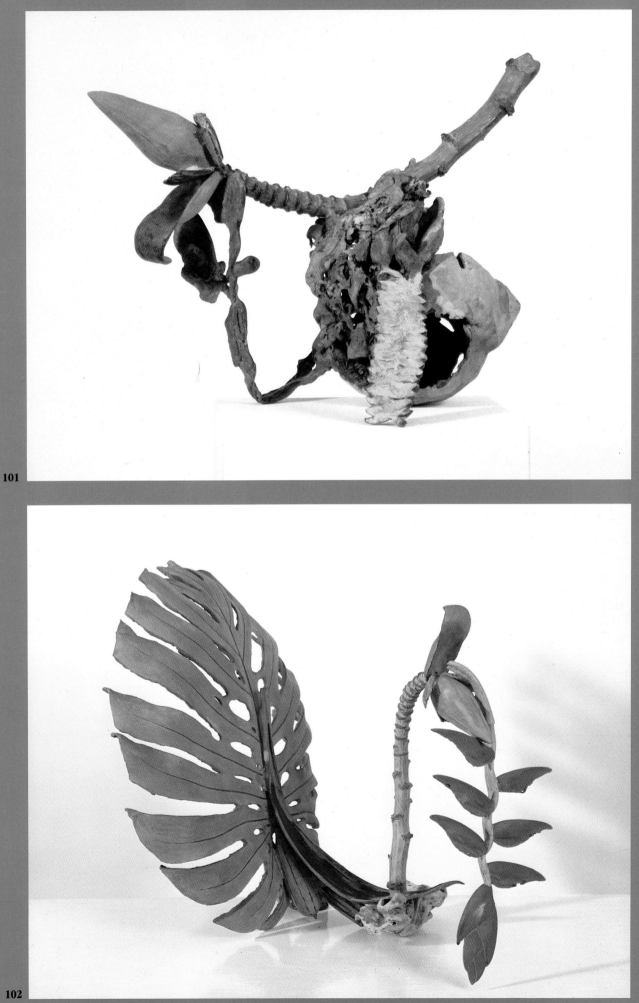

101

102

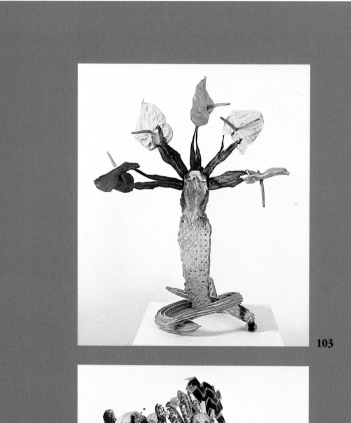

103

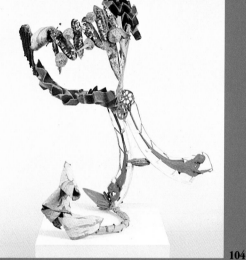

104

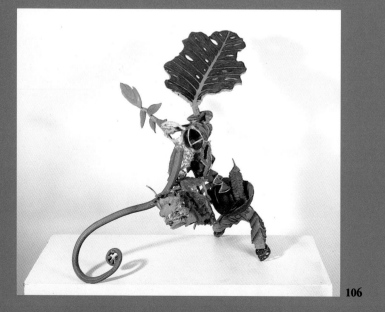

106

103 Naga, 1982
Bronze with polychrome patina. 31 × 24 × 16 (78.7 × 61 × 40.6).
Inscribed on column: *NAGA N. S. Graves 5 '82 TX.*

COLLECTION
Ann and Donald Brown, Washington, D.C.

PROVENANCE
M. Knoedler & Co., Inc., New York

EXHIBITIONS
New York: M. Knoedler & Co., Inc. (checklist no. 8), 1982

REMARKS
The vertical element in *Naga* also appears in *Motolo*, 1980 (cat. no. 59),
and *Catepelouse* (cat. no. 83) and *Scylla* (cat. no. 107), both 1982.

104 Pendulate, 1982
Bronze with polychrome patina. 31 × 29 × 15½ (78.7 × 73.7 ×
39.4). Inscribed on leaf: *N. S. Graves 7 '82 TX PENDULATE.*

COLLECTION
Mr. and Mrs. Stanley Hirsch, Great Neck, New York

PROVENANCE
M. Knoedler & Co., Inc., New York

EXHIBITIONS
New York: M. Knoedler & Co., Inc. (checklist no. 1), 1982

REMARKS
Like *Bilanx*, 1982 (cat. no. 81), this piece verges on imbalance.

105 Pilot, 1982
Bronze with polychrome patina. 57½ × 41 × 40 (146 × 104.1 ×
101.6). Inscribed on column: *N. S. Graves PILOT 1982 TX.*

COLLECTION
Holly Hunt Tackbary, Winnetka, Illinois

PROVENANCE
M. Knoedler & Co., Inc., New York

EXHIBITIONS
New York: M. Knoedler & Co., Inc. (checklist no. 21), 1982

REMARKS
The title refers to the fact that the top section of the sculpture rotates.
The base is an archaeological map cast directly from plastic bubble-
wrap packing material.

106 Proboscid, 1982
Bronze with polychrome patina. 28¼ × 28 × 16 (71.8 × 71.1 ×
41). Inscribed on green leg: *PROBOSCID N. S. Graves 11–82 TX.*

COLLECTION
Private collection

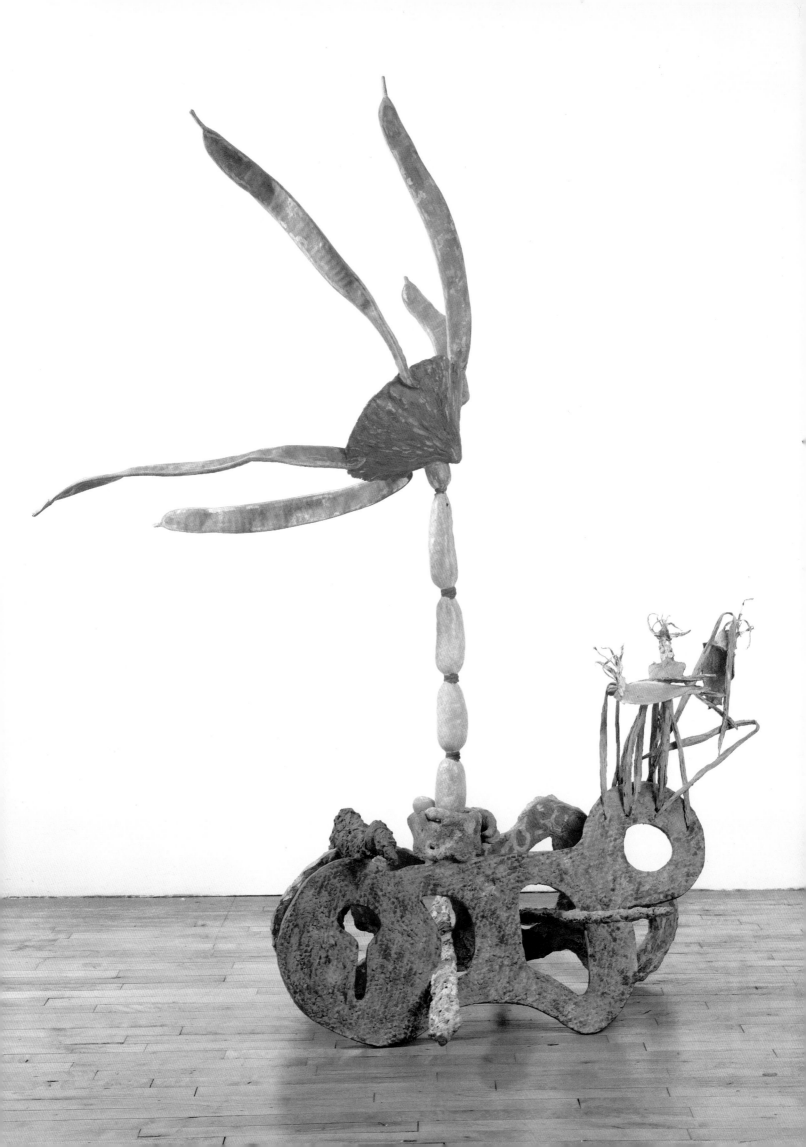

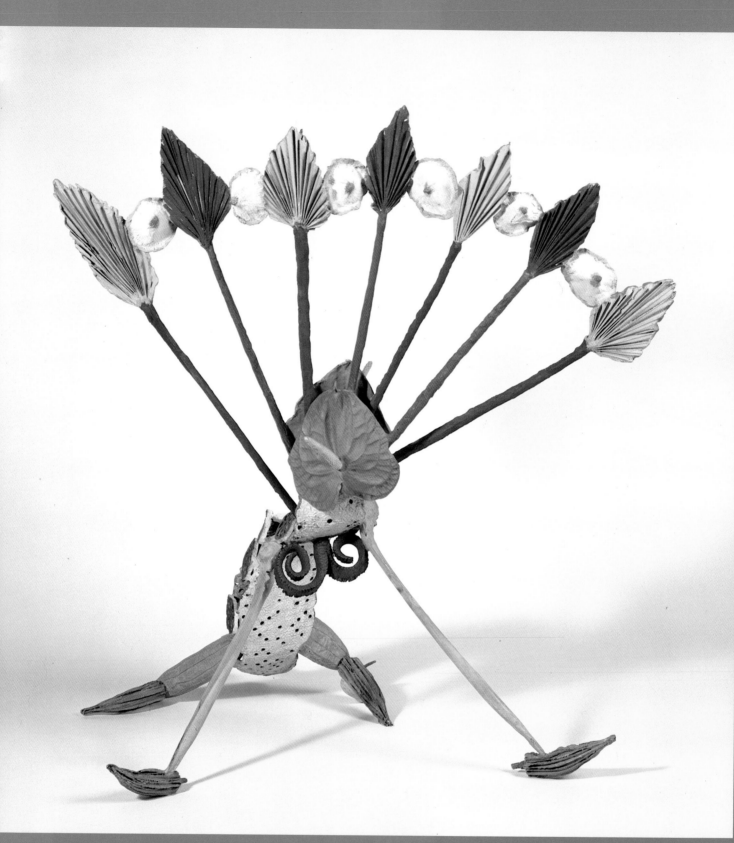

107 Scylla, 1982
Bronze with polychrome patina. 31½ × 30 × 28 (80 × 76.2 × 71.1). Inscribed on side: *N. S. Graves SCYLLA 1982 TX.*

COLLECTION
Brett Mitchell Collection, Cleveland

PROVENANCE
M. Knoedler & Co., Inc., New York

EXHIBITIONS
Basel: Basel Art Fair, 1982
Zurich: M. Knoedler Zurich AG (checklist no. 15), 1982–83

REMARKS
Motolo, 1980 (cat. no. 59), *Catepelouse*, 1982 (cat. no. 83), and *Naga*, 1982 (cat. no. 103), each also contains a caning element.

108 Visage, 1982
Bronze with polychrome patina. 19 × 17½ × 16 (48.3 × 44.5 × 40.6). Inscribed on base of scissors: *N. S. Graves 11–82 VISAGE TX.*

COLLECTION
Private collection

REMARKS
One of the first four directly sand-cast partite sculptures; the others are *Bilanx* (cat. no. 81), *Cyme* (cat. no. 91), and *Proboscid* (cat. no. 106), all from 1982.

109 Abacus, 1983
Bronze with polychrome patina and baked enamel. 20¼ × 23 × 20 (51.4 × 58.4 × 50.8). Inscribed on yellow pod: *ABACUS N. S. Graves 10–83 TX.*

COLLECTION
Holly Hunt Tackbary, Winnetka, Illinois

PROVENANCE
M. Knoedler & Co., Inc., New York

EXHIBITIONS
New York: M. Knoedler & Co., Inc. (checklist no. 26), 1984

REMARKS
The sculpture has one movable part: the circular element on the horizontal fern.

110 Append, 1983
Bronze with polychrome patina. 65 × 38 × 36 (165.1 × 96.5 × 91.4). Inscribed on bottom rim: *APPEND N. S. Graves 1–83 TX.*

COLLECTION
Barbara and Avram A. Jacobson

PROVENANCE
M. Knoedler & Co., Inc., New York

EXHIBITIONS
New York: M. Knoedler & Co., Inc. (checklist no. 20), 1984

108

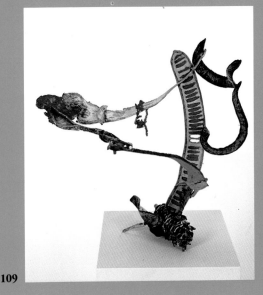

109

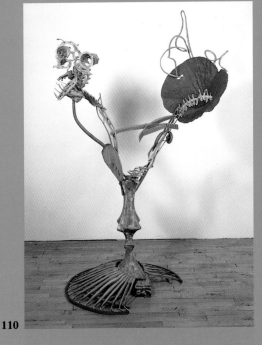

110

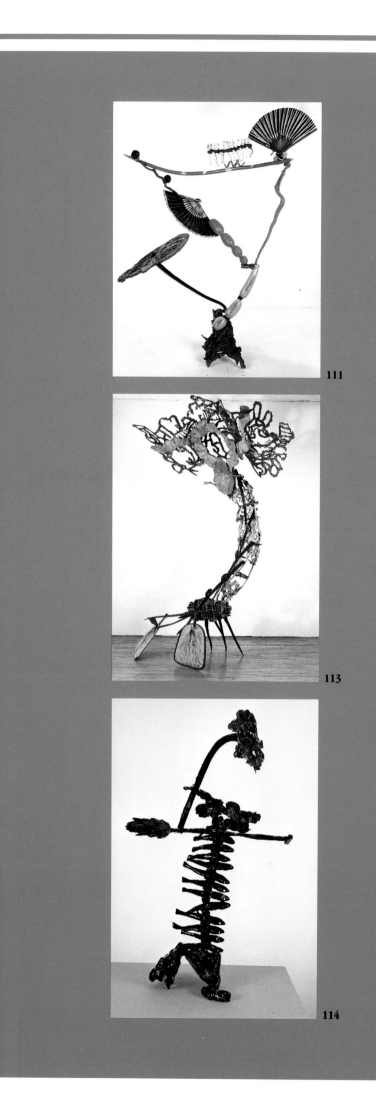

111

113

114

111 Bridged (Spill Series), 1983
Bronze with polychrome patina. 56½ × 39½ × 19 (143.5 × 100.3 × 48.3). Inscribed on yellow gourd: *N. S. Graves 11–83 TX BRIDGED.*

COLLECTION
Private collection

PROVENANCE
M. Knoedler & Co., Inc., New York

EXHIBITIONS
New York: M. Knoedler & Co., Inc. (checklist no. 14), 1984

REMARKS
Bridged was made with direct casting and bronze spills.

112 Byrd, 1983
Bronze with polychrome patina. 20½ × 7 × 9 (52 × 17.8 × 22.9). Inscribed on yellow leaf: *BYRD N. S. Graves 7–'83 TX.*

COLLECTION
Cathy Colman Dater

PROVENANCE
M. Knoedler & Co., Inc., New York
Ochi, Boise, Idaho

113 Cantileve, 1983
Bronze with polychrome patina. 98 × 68 × 54 (248.9 × 172.7 × 137.2). Inscribed on black fern (third from top): *N. S. Graves CANTILEVE 8 '83 TX.*

COLLECTION
Whitney Museum of American Art, New York. Purchase, with funds from the Painting and Sculpture Committee. Acquisition no. 83.39

PROVENANCE
M. Knoedler & Co., Inc., New York

EXHIBITIONS
New York: M. Knoedler & Co., Inc. (checklist no. 5), 1984
Fort Lauderdale, Florida: The Museum of Art (bw p. 24), 1986

REFERENCES
Freeman et al., 1984, bw n.p. Phillips, 1984, fig. 45; bw p. 43. Shapiro, *Arts Magazine* 59 (November 1984), color p. 94. Frank, *Connoisseur* 216 (February 1986), comm. p. 58. Watson-Jones, 1986, color p. 237.

REMARKS
The same base appears in *Fayum*, 1981 (cat. no. 66), and *Fayum-Re* (cat. no. 97) and *Krater* (cat. no. 100), both 1982.

114 Caveat (Glass Series), 1983
Baked enamel on bronze. 21 × 15½ × 12¼ (53.3 × 39.4 × 31.1). Inscribed on orange area near bottom: *N. G. 12–83 CAVEAT.*

COLLECTION
Mr. and Mrs. Stephen M. Kellen

PROVENANCE
M. Knoedler & Co., Inc., New York

EXHIBITIONS
New York: M. Knoedler & Co., Inc. (checklist no. 9), 1984

REMARKS
Caveat was made with direct casting, molten-bronze spills, and baked enamel on bronze.

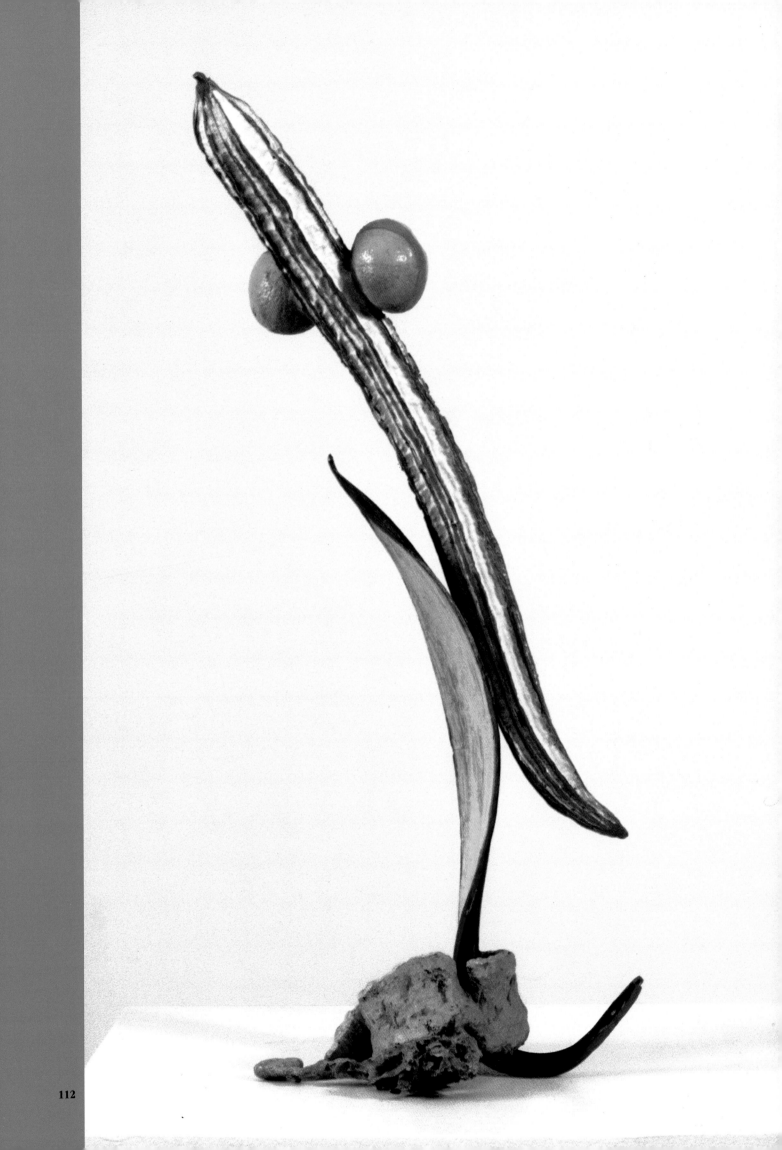

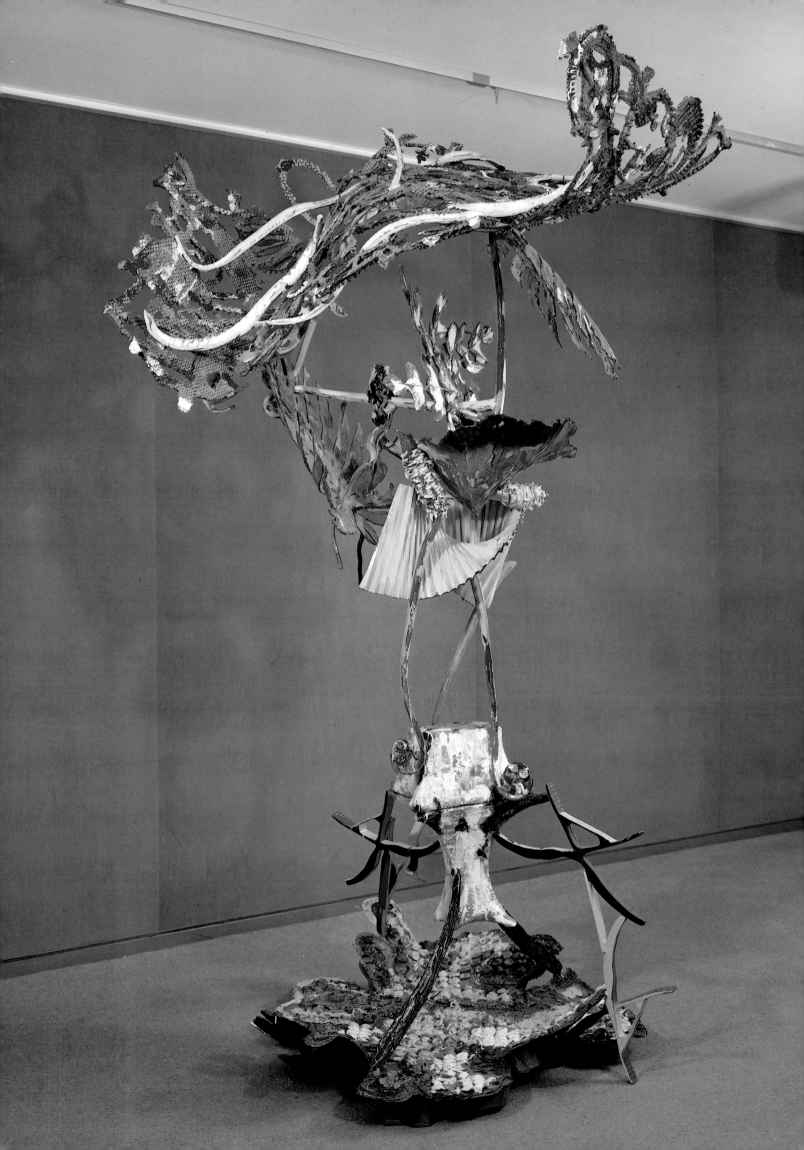

115 Chimera, 1983
Bronze with polyurethane paint. 84 × 68 × 63 (213.4 × 172.7 × 160). Inscribed on scissors: *N. S. Graves CHIMERA XII–1983 TX.*

COLLECTION
Barry and Gail Berkus, Santa Barbara

PROVENANCE
M. Knoedler & Co., Inc., New York

EXHIBITIONS
New York: M. Knoedler & Co., Inc. (checklist no. 18), 1984
Santa Barbara: Santa Barbara Museum of Art (color p. 47), 1984

REMARKS
Chimera was made with casts.

116 Ciliate (Spill Series), 1983
Bronze with polychrome patina and baked enamel. 40¾ × 42 × 20¾ (103.5 × 106.7 × 52.7). Inscribed on pink scissors shape: *N. S. Graves 11–83 CILIATE TX.*

COLLECTION
Private collection

REMARKS
Ciliate was made with direct casting, molds, molten-bronze spills, and baked enamel on bronze. The enamel paint drips on the spills are reminiscent of Jackson Pollock.

117 Circumfoliate, 1983
Bronze with polychrome patina. 46½ × 44½ × 32½ (118.1 × 113 × 82.5). Inscribed on pink rim: *CIRCUMFOLIATE N. S. Graves 1–'83 TX.*

COLLECTION
Ms. Gloria Luria, Bay Harbor Island, Florida

PROVENANCE
M. Knoedler & Co., Inc., New York

EXHIBITIONS
Fort Lauderdale, Florida: The Museum of Art (color p. 234), 1986

REMARKS
Circumfoliate was made with direct and sand casting.

118 Counter, 1983
Bronze with polychrome patina. 25½ × 41 × 8 (64.8 × 104.1 × 20.3). Inscribed on scissors shape at left: *N. S. Graves 8 '83 TX COUNTER.*

COLLECTION
Bruce and Judith Eissner, Marblehead, Massachusetts

PROVENANCE
M. Knoedler & Co., Inc., New York

EXHIBITIONS
New York: M. Knoedler & Co., Inc. (checklist no. 2), 1984

REMARKS
Counter relates to *Quipu*, 1978 (cat. no. 38). In ancient Peru *Quipu* was a counting system using ropes. In *Counter* the horizontal bamboo poles with fern integers attached relate visually to the abacus, the ancient Chinese "adding machine" still in use today. The two sculptures thus share conceptual roots.

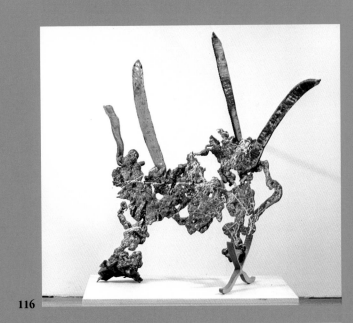

116

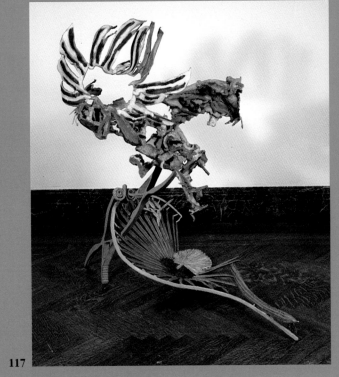

117

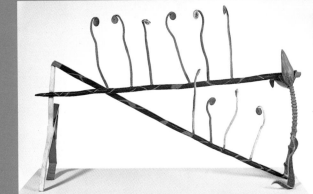

118

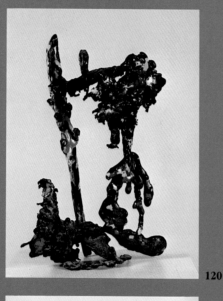

119

120

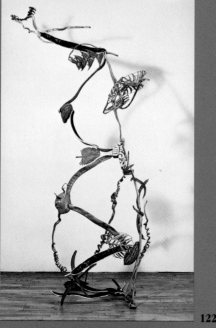

122

119 Elacinate (Glass Series), 1983
Baked enamel on bronze. 25 × 10¾ × 13 (63.5 × 27.3 × 33).
Inscribed on bottom: *N. G. 12–83 ELACINATE TX.*

COLLECTION
The Honorable Herbert A. Fogel, Philadelphia

PROVENANCE
M. Knoelder & Co., Inc., New York

EXHIBITIONS
New York: M. Knoedler & Co., Inc. (checklist no. 10), 1984

REMARKS
Direct casting, baked enamel on bronze, and molten-bronze spills
were used in the sculpture's construction.

120 Enameled, Spill (Glass Series), 1983
Baked enamel on bronze. 12 × 8¼ × 5 (30.5 × 21 × 12.7).
Inscribed on bottom: *TO DICK MERRY CHRISTMAS 12–25–83 N. Graves.*

COLLECTION
Mr. Richard Polich, Garrison, New York

REMARKS
Enameled, Spill was made with direct casts, molten-bronze spills, and
baked enamel on bronze. Richard Polich is the owner and director of
Tallix Foundry.

121 Et Sec, 1983
Bronze with polychrome patina. 24¼ × 30½ × 12 (61.6 × 77.5
× 30.5). Inscribed on blue scissors: *N. S. Graves 7 '83 ET SEC TX.*

COLLECTION
Helen Elizabeth Hill Trust

PROVENANCE
M. Knoedler & Co., Inc., New York

EXHIBITIONS
New York: M. Knoedler & Co., Inc. (checklist no. 23), 1984

REMARKS
In 1984–85 *Et Sec*, made of directly cast organic forms and one form
cast from a mold, was the point of departure for *Sequi* (cat. no.
208), which stands in front of the Crocker Bank in Los Angeles. Prior
to this time, enlarging of small sculptures into outdoor-scale versions
was done at Lippincott by fabrication. *Trace*, 1981 (cat. no. 60), for
example, was originally nine feet tall and was enlarged to sixteen feet
by this method. In the traditional casting method of enlargement
subsequently used for Graves's work, molds are made of enlarged
clay positives, and these are cast in parts.

Casting provides greater detail, variation in texture, and compound
and complex curves. It is appropriate to the enlarging of organic
forms, whereas fabrication is a process appropriate to geometric
shapes, such as the scissors in *Sequi*.

122 Extend-Expand, 1983
Bronze with polychrome patina. 85 × 51 × 33⅜ (215.7 × 129.5 ×
85.4). Inscribed on black bean pod near base: *N. S. Graves 4 '83
EXTEND-EXPAND TX.*

COLLECTION
The Museum of Modern Art, New York. Gift of Mr. and Mrs.
Sid R. Bass

PROVENANCE
M. Knoedler & Co., Inc., New York

EXHIBITIONS
New York: M. Knoedler & Co., Inc. (checklist no. 21), 1984

REFERENCES
Shapiro, *Arts Magazine* 59 (November 1984), color p. 95.

REMARKS
Extend-Expand is open and linear, like *Indicate*, 1982 (cat. no. 99),
and *Caveat Emptor* (cat. no. 160) and *Rebus* (cat. no. 173), both
1984.

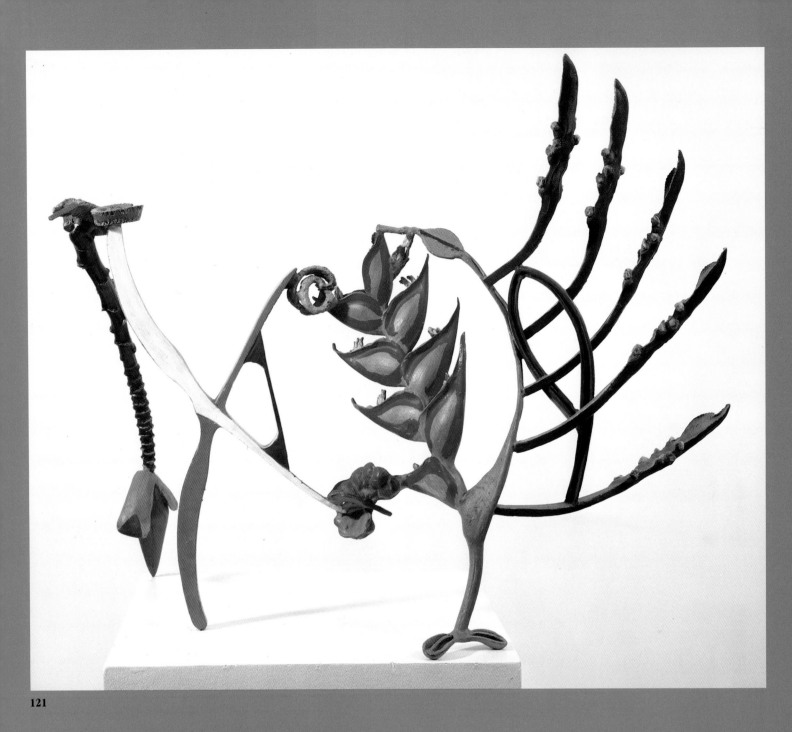

121

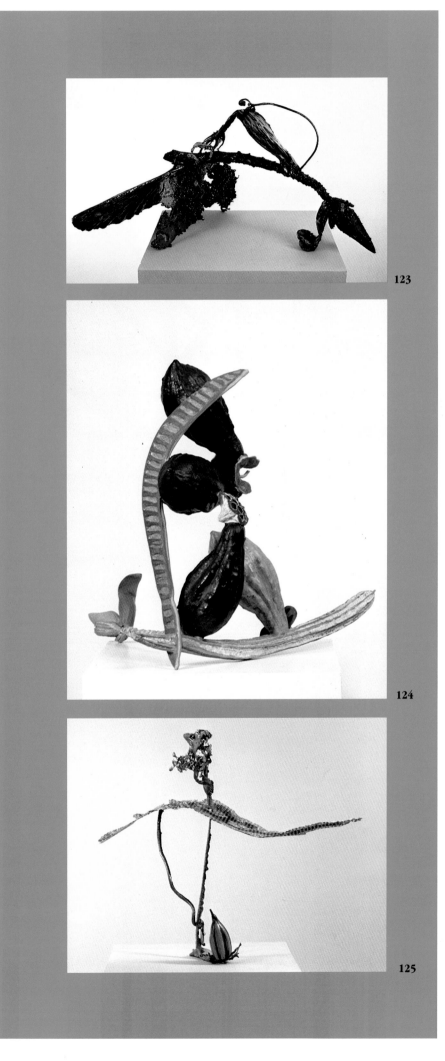

123

124

125

123 Fanning (Glass Series), 1983
Baked enamel on bronze. 11¾ × 24½ × 17¾ (29.8 × 62.2 × 45).
Inscribed on edge of fan: *N. Graves 12–15–83 FANNING TX.*

COLLECTION
Private collection

EXHIBITIONS
New York: Marilyn Pearl Gallery, 1985

REMARKS
Direct casts, molten-bronze spills, and baked enamel on bronze were
used in the sculpture.

124 Ferre Femme, 1983
Bronze with polychrome patina. 18¾ × 19½ × 20½ (47.6 × 49.5 ×
52). Inscribed on violet flower: *FERRE FEMME N. S. Graves VII–'83 TX.*

COLLECTION
Mr. Byron Meyer, San Francisco

PROVENANCE
M. Knoedler & Co., Inc., New York

REMARKS
The sculpture's title and configuration refer to prehistoric carved
fertility objects.

125 Fungibla, 1983
Bronze and stamped steel. 20¼ × 26 × 10 (51.4 × 66 × 25.4).
Inscribed on gourd: *N. S. Graves 8 '83 TX. FUNGIBLA.*

COLLECTION
Private collection

REMARKS
Fungibla was the first sculpture to combine direct casting with
fabrication and spills.

126 Fungible, 1983
Bronze with polychrome patina. 33¾ × 20 × 21¼ (88.7 × 50.8 ×
54). Inscribed on yellow leaf: *N. S. Graves 1–83 FUNGIBLE TX.*

COLLECTION
Dr. J. H. Sherman, Baltimore

PROVENANCE
M. Knoedler & Co., Inc., New York

EXHIBITIONS
Poughkeepsie, New York: Vassar College Art Gallery (traveling exhibi-
tion; bw p. 32), 1986

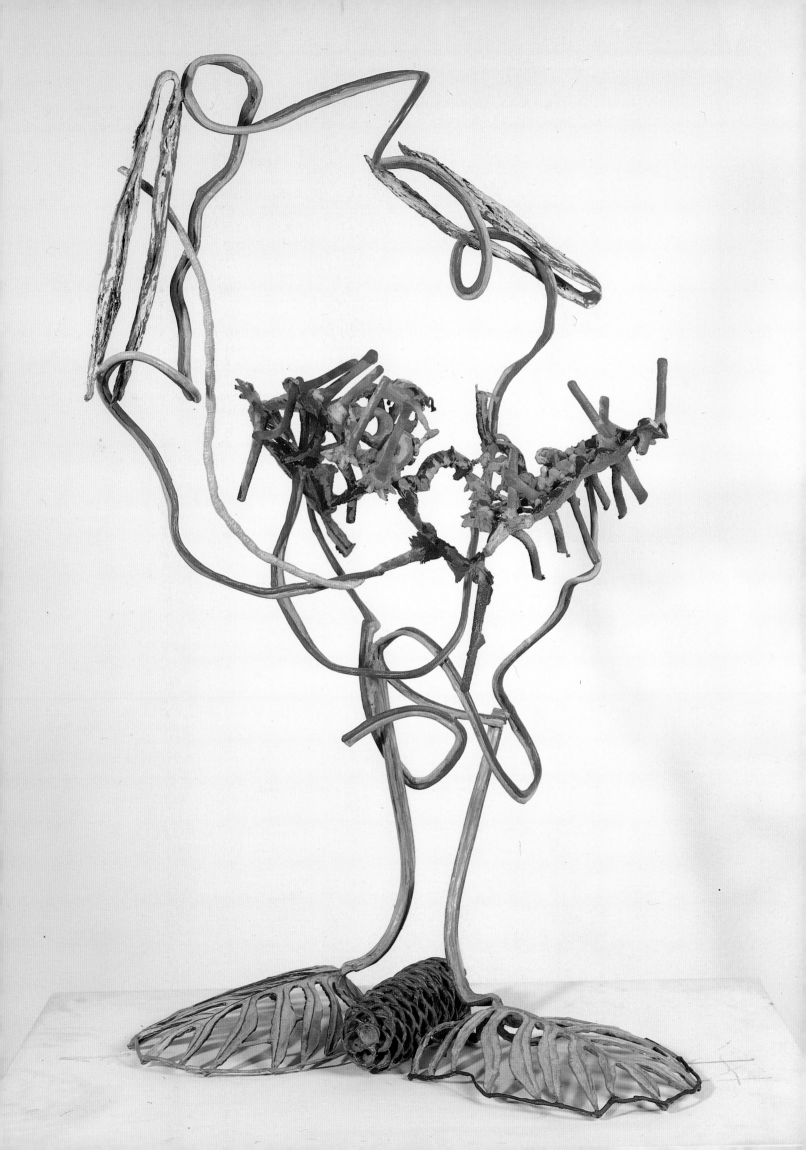

127

128

129

127 Lacinate, 1983
Bronze with polychrome patina. 54 × 48 × 41 (137.2 × 121.9 × 104.1). Inscribed on red-oxide bean pod: *LACINATE N. Graves 4 '83 TX.*

COLLECTION
Edna S. Beron, New Jersey

PROVENANCE
M. Knoedler & Co., Inc., New York

EXHIBITIONS
New York: M. Knoedler & Co., Inc. (checklist no. 1), 1984
Newark, New Jersey: The Newark Museum (cat. no. 83; bw p. 65), 1984–85

128 Landed (Glass Series), 1983
Baked enamel on bronze. 22¼ × 28 × 13 (56.5 × 71.1 × 33). Inscribed on red leaf: *N. Graves 12–83 TX LANDED.*

COLLECTION
Private collection

EXHIBITIONS
Williamstown, Massachusetts: Williams College Museum of Art (traveling exhibition; shown only at the Brooklyn Museum, New York; no illus.), 1984–85

REMARKS
Landed was made with direct casting, using molds, molten-bronze spills, and baked enamel. It is a variation of *Et Sec*, 1983 (cat. no. 121).

129 Landscape (Spill Series), 1983
Bronze with polychrome patina and baked enamel. 18½ × 20 × 8 (47 × 50.8 × 20.3). Inscribed on maroon area near base: *–83 TX N. S. Graves LANDSCAPE.*

COLLECTION
Mr. and Mrs. Jay Bennett, New York

PROVENANCE
M. Knoedler & Co., Inc., New York

EXHIBITIONS
New York: M. Knoedler & Co., Inc. (checklist no. 25), 1984
Poughkeepsie, New York: Vassar College Art Gallery (traveling exhibition; color p. 34), 1986

REFERENCES
Frank, *Connoisseur* 216 (February 1986), color p. 57, comm. p. 59.

REMARKS
Landscape was made with direct casting, lost-wax casting, baked enamel, and molten-bronze spills.

130 Lyra, 1983
Bronze with polychrome patina. 30½ × 26 × 11 (77.5 × 66 × 28). Inscribed on green arm: *LYRA N. S. Graves 6–'83 TX.*

COLLECTION
Private collection, Fort Worth, Texas

PROVENANCE
M. Knoedler & Co., Inc., New York

EXHIBITIONS
New York: M. Knoedler & Co., Inc. (checklist no. 17), 1984

REMARKS
Lyra is composed of two Hupua ferns, sardines, the back of a chair, and vines with pods at the ends.

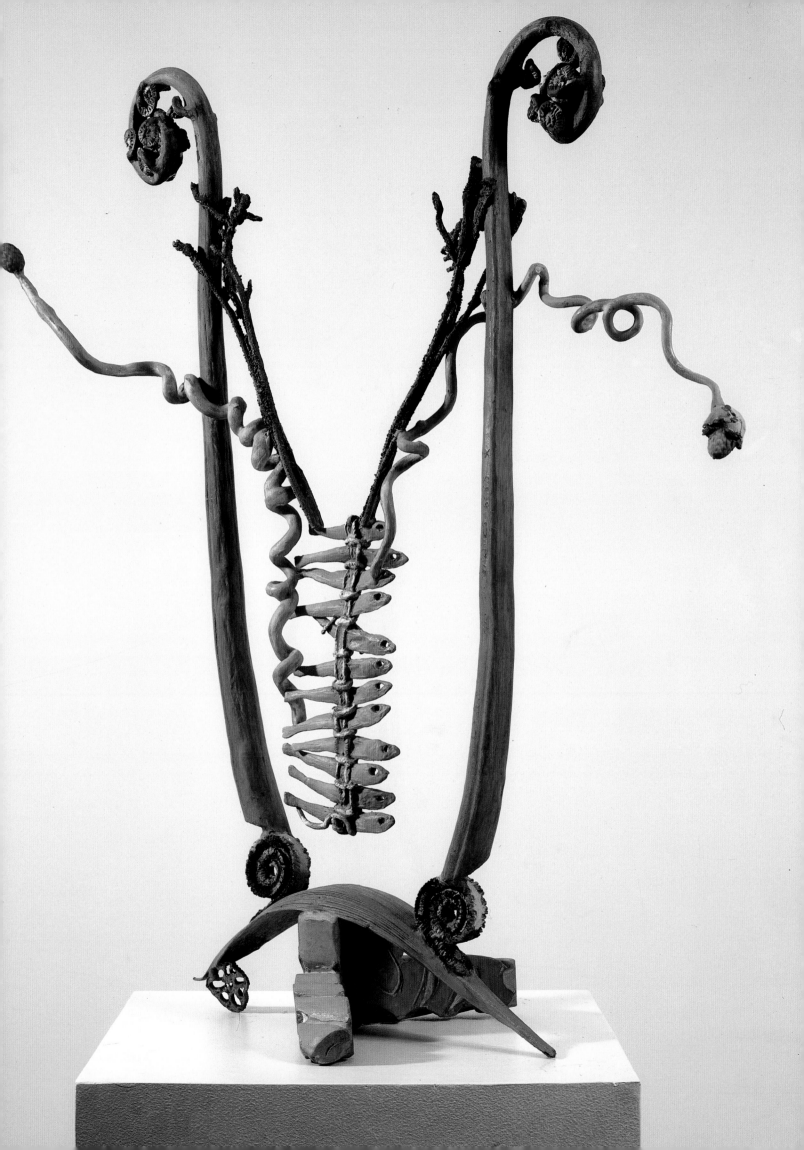

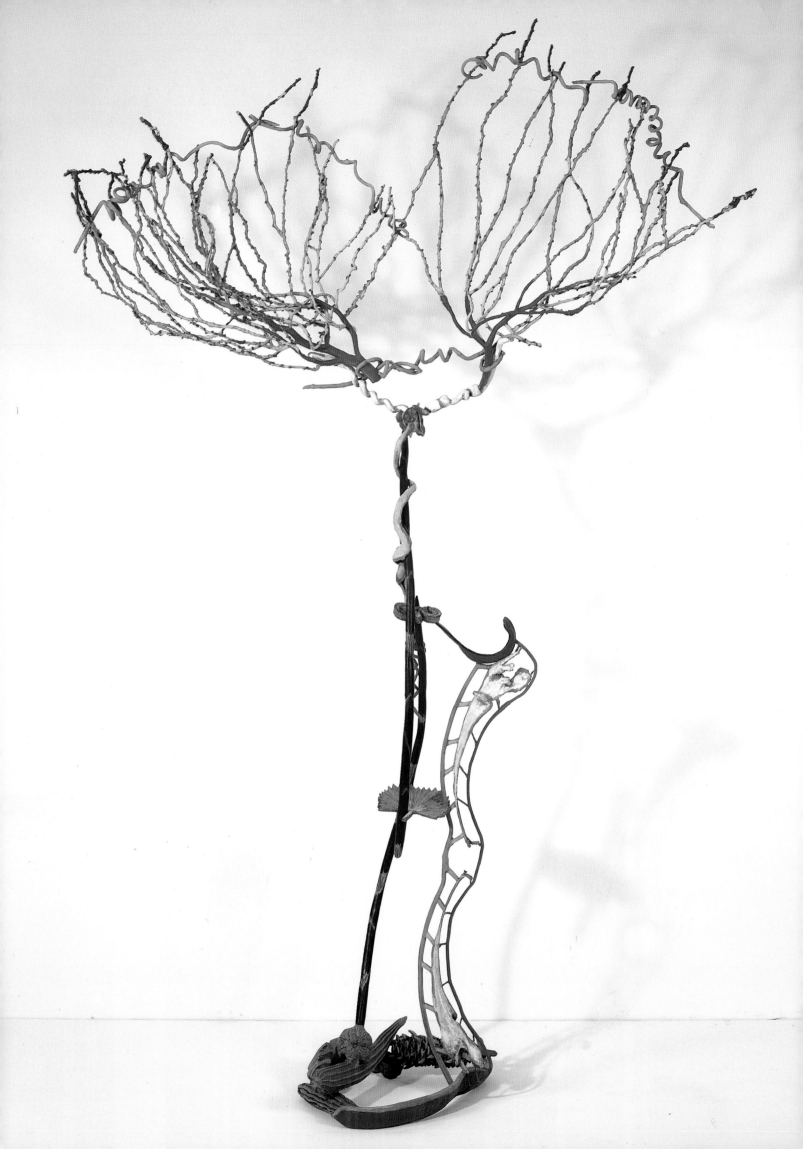

131 Medusa, 1983

Bronze with polychrome patina. 92¾ × 61¼ × 17½ (235.6 × 155.6 × 44.5). Inscribed on lower black pole: *N. S. Graves 7 '83 TX MEDUSA.*

COLLECTION

Private collection, Fort Worth, Texas

PROVENANCE

M. Knoedler & Co., Inc., New York

EXHIBITIONS

New York: M. Knoedler & Co., Inc. (checklist no. 6), 1984

REFERENCES

Brenson, *The New York Times*, 16 March 1984, bw p. C21.

REMARKS

The sculpture's top is a directly cast palm blossom with other directly cast forms.

132 Nike, 1983

Bronze with polychrome patina. 67½ × 64½ × 58¼ (171.5 × 163.8 × 148). Inscribed on long blue arm: *NIKE N. S. Graves 6–'83 TX.*

COLLECTION

Mr. and Mrs. Harold Price, Laguna Beach, California

PROVENANCE

M. Knoedler & Co., Inc., New York

EXHIBITIONS

New York: M. Knoedler & Co., Inc. (checklist no. 7), 1984

REMARKS

A directly cast lotus leaf, cut into three sections, together with sections of *Monstera*, comprise the upper third of the sculpture.

133 Pacifica, 1983

Bronze with polychrome patina. 61½ × 40½ × 36¼ (156.2 × 102.9 × 92.1). Inscribed on yellow scissors at lower left: *PACIFICA N. S. Graves 12–83 TX.*

COLLECTION

Private collection, Fort Worth, Texas

PROVENANCE

M. Knoedler & Co., Inc., New York

EXHIBITIONS

New York: M. Knoedler & Co., Inc. (checklist no. 19), 1984

REMARKS

Pacifica was made by direct casting, using some molds and molten-bronze spills. The upper section is a Polynesian map made of directly cast polyurethane bubble-wrap packing material. The base is a spill, selected by the artist from the foundry floor after a bronze pour.

131

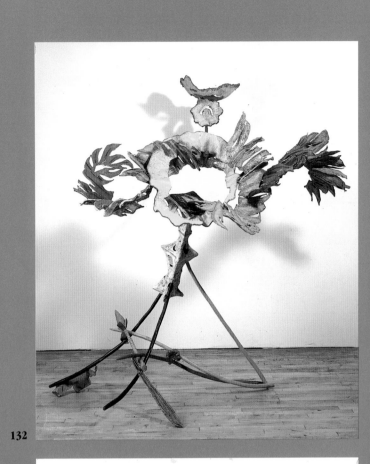

132

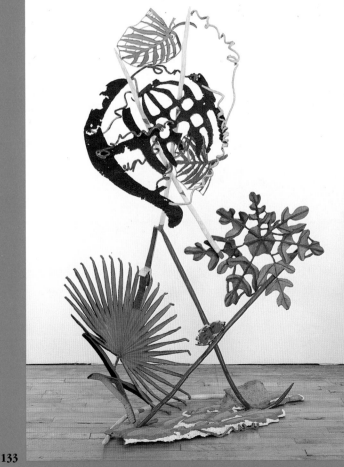

133

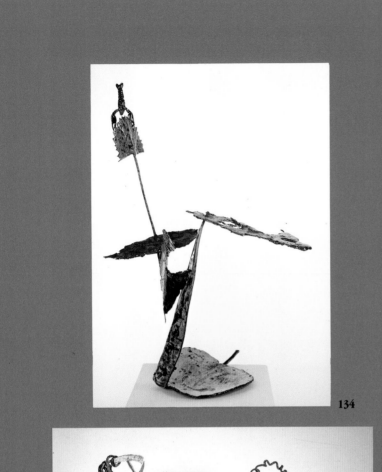

134

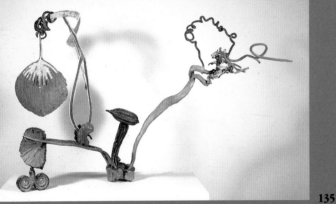

135

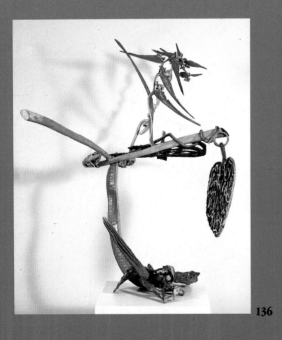

136

134 Paragone (Glass Series), 1983
Baked enamel on bronze. 33½ × 21½ × 18 (85.1 × 54.6 × 45.7).
Inscribed on edge of pod: *N. G. 12–83 PARAGONE TX.*

COLLECTION
Mrs. and Mrs. Harold Tanner, New York

PROVENANCE
M. Knoedler & Co., Inc., New York

EXHIBITIONS
New York: M. Knoedler & Co., Inc. (checklist no. 12), 1984

REMARKS
Paragone was made with direct casts, molten-bronze spills, and
baked enamel on bronze.

135 Penda (Pendula Series), 1983
Bronze with polychrome patina and baked enamel. 29¼ × 43 × 18
(74.3 × 109.2 × 45.7). Inscribed on lotus leaf: *N. S. Graves PENDA
9 '83 TX.*

COLLECTION
Private collection

EXHIBITIONS
New York: Sidney Janis Gallery (cat. part II; cat. no. 12; bw n.p.),
 1984

REMARKS
Penda was the first sculpture in which Graves combined baked
enamel on bronze with patinated bronze. To prevent the glass enamel
from burning during welding, attachments were made by drilling and
threading a swivel into the enameled bronze.

136 Pendula (Pendula Series), 1983
Bronze with polychrome patina. 41 × 37 × 30 (104.1 × 94 × 76.2).
Inscribed on pink and green arm, approximately 24 in. high:
N. S. Graves PENDULA 4 '83 TX.

COLLECTION
Private collection

EXHIBITIONS
New York: Hirschl & Adler Modern Gallery, 1984
Katonah, New York: The Katonah Gallery (checklist no. 4, bw n.p.),
 1984
Akron: Akron Art Museum (checklist), 1985

REMARKS
Pendula is the first in the Pendula Series.

137 Pendule (Pendula Series), 1983
Bronze with polychrome patina. 24 × 18 × 11½ (61 × 45.7 ×
29.2). Inscribed on green pod: *PENDULE N. S. Graves 6–83 TX.*

COLLECTION
The Greenberg Gallery, Saint Louis

PROVENANCE
M. Knoedler & Co., Inc., New York
Dr. and Mrs. Michael Neuwirth, New York
M. Knoedler & Co., Inc., New York

EXHIBITIONS
New York: M. Knoedler & Co., Inc. (checklist no. 22), 1984
Poughkeepsie, New York: Vassar College Art Gallery (traveling exhibi-
 tion; bw p. 22), 1986

REFERENCES
Buckvar, *The New York Times*, 14 October 1984, bw. sec. 22,
p. WC23.

REMARKS
The blue sardines are a movable part.

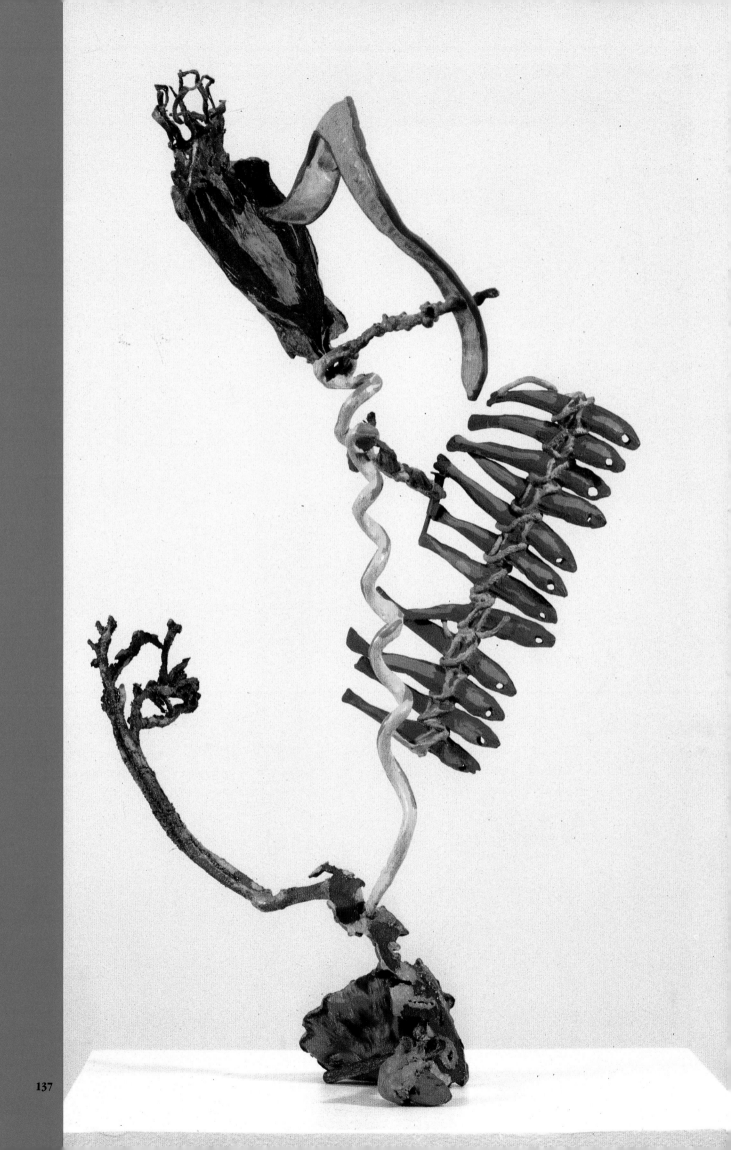

137

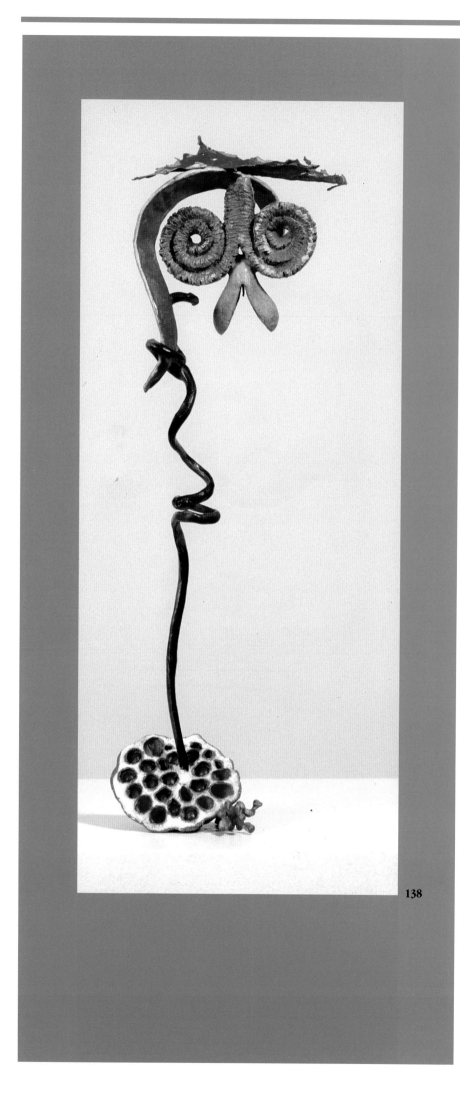

138

138 Perspek, 1983
Bronze with polychrome patina. 20 × 7 × 6 (50.8 × 17.8 × 15.2).
Inscribed on light-blue pod: *N. S. Graves 6–83 TX*, and on central
orange area, 12¾ in. high: *PERSPEK.*

COLLECTION
Mr. and Mrs. James Clarke, Pittsfield, Massachusetts

139 Rotota, 1983
Bronze with polychrome patina. 73½ × 44½ × 30 (186.7 × 113 ×
76.2). Inscribed on green fern: *ROTOTA N. S. Graves 12–83 TX.*

COLLECTION
Dr. J. H. Sherman, Baltimore

PROVENANCE
M. Knoedler & Co., Inc., New York

EXHIBITIONS
New York: M. Knoedler & Co., Inc. (checklist no. 3), 1984

REMARKS
Rotota was made with direct casting and molten-bronze spills. The
title alludes to the top element of vines and beans, which rotates. A
pin provides the possibility of stopping the rotation at three different
angles.

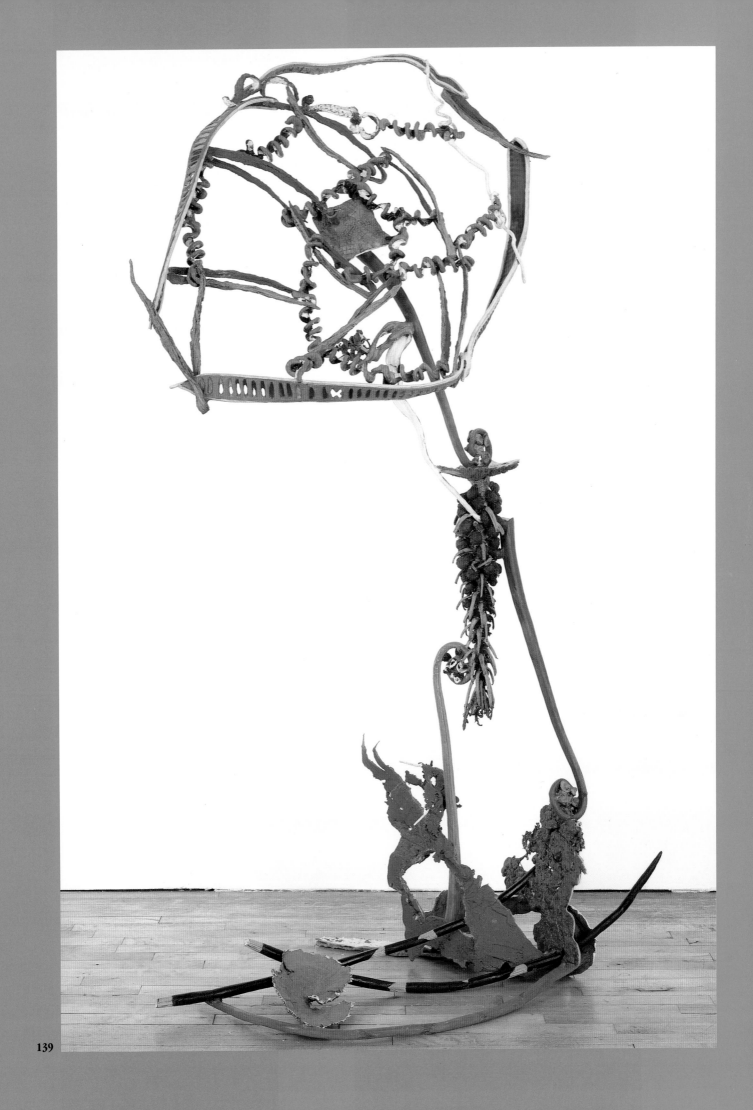

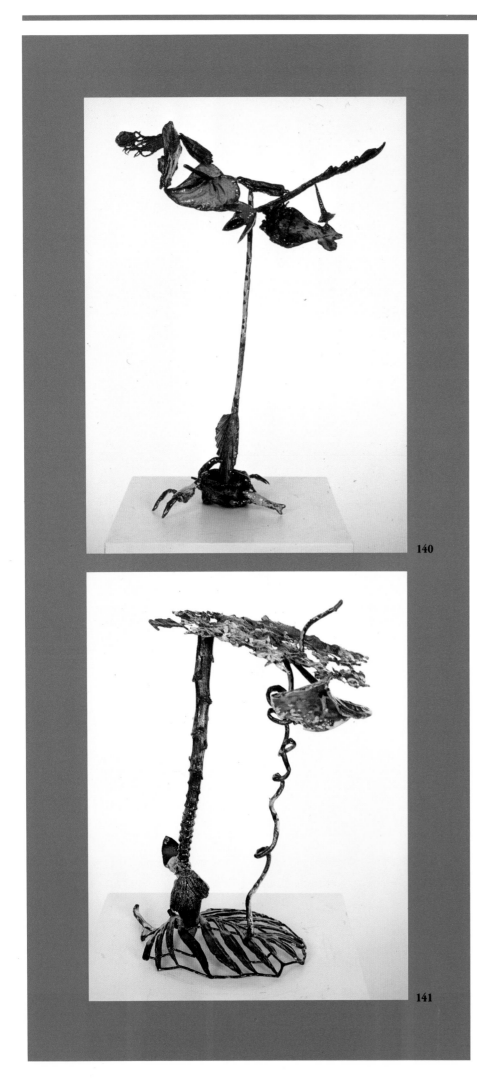

140 **Sine** (Glass Series), 1983
Baked enamel on bronze. 28⅞ × 21½ × 13½ (73.5 × 54.6 × 34.3). Inscribed on center of lower element: *SINE TX N. G. 11–83.*

COLLECTION
Private collection

REMARKS
Sine is one of eight baked-enamel-on-bronze sculptures all assembled on a single day in November. All eight titles begin with the letter *s*. These are the first sculptures in which enameled bronzes were welded.

141 **Slen** (Glass Series), 1983
Baked enamel on bronze. 21 × 9 × 16 (53 × 22.9 × 40.6). Inscribed on bottom: *SLEN TX N. G. 11–83.*

COLLECTION
John and Mary Pappajohn, Des Moines

PROVENANCE
M. Knoedler & Co., Inc., New York

REMARKS
See remarks to cat. no. 140.

140

141

142 Sote (Glass Series), 1983
Baked enamel on bronze. 17¾ × 14¼ × 17 (45.1 × 36.2 × 43.2).
Inscribed on bottom leaf: *N. G. 11–83 SOTE TX.*

COLLECTION
Mr. and Mrs. Sidney Singer, Mamaroneck, New York

PROVENANCE
M. Knoedler & Co., Inc., New York

EXHIBITIONS
Poughkeepsie, New York: Vassar College Art Gallery (traveling exhibition; no illus.), 1986

REMARKS
See remarks to cat. no. 140.

143 Spill (Glass Series), 1983
Baked enamel on bronze. 12 × 15 × 9 (30.5 × 38.1 × 22.9).
Inscribed near bottom: *SPILL N. Graves 12–83 TX.*

COLLECTION
Private collection

REMARKS
Spill was made with molten-bronze spills and baked enamel on bronze. It is the only sculpture by Graves made exclusively of enameled spills.

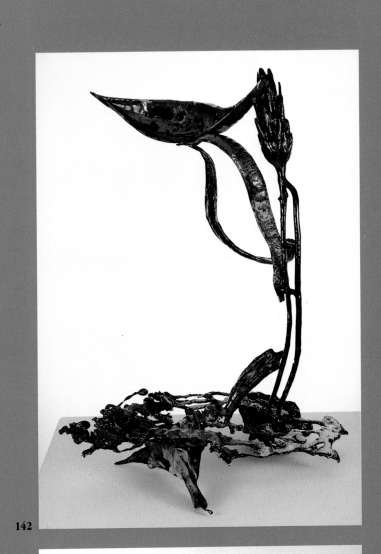

142

143

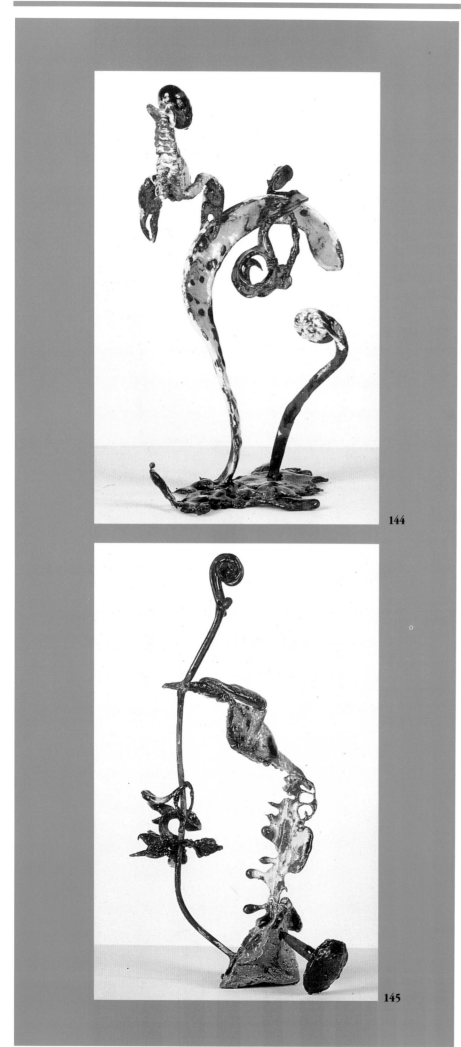

144

145

144 Spin (Glass Series), 1983
Baked enamel on bronze. 10½ × 7¼ × 5 (26.7 × 18.4 × 12.7).
Inscribed on bottom: *SPIN N. Graves TX 10–83.*

COLLECTION
Private collection

REMARKS
Spin is one of two very small works made on the same day of baked
enamel on bronze, each with one movable element. *Spun,* 1983 (cat.
no. 145), is the second work.

145 Spun, 1983
Baked enamel on bronze. 10¾ × 5¾ × 5 (27.3 × 14.6 × 12.7).
Inscribed on bottom: *N. G. '83 SPUN TX.*

COLLECTION
The Ludwig Collection, Aachen, West Germany

PROVENANCE
M. Knoedler & Co., Inc., New York

REMARKS
Spun has one movable element (see remarks to cat. no. 144).

146 Sron (Glass Series), 1983
Baked enamel on bronze. 20⅞ × 9¾ × 6 (53 × 24.8 × 15.2).
Inscribed on central area, approximately 15½ in. high: *N. G. 11–83 SRON TX.*

COLLECTION
Mr. Paul Heyer, New York

PROVENANCE
M. Knoedler & Co., Inc., New York

REMARKS
See remarks to cat. no. 140.

147 Stan (Glass Series), 1983
Baked enamel on bronze. 15⅝ × 10¼ × 8¼ (39.7 × 26 × 21).
Inscribed on bottom: *N. Graves STAN 11–83 TX.*

COLLECTION
Private collection

REMARKS
See remarks to cat. no. 140.

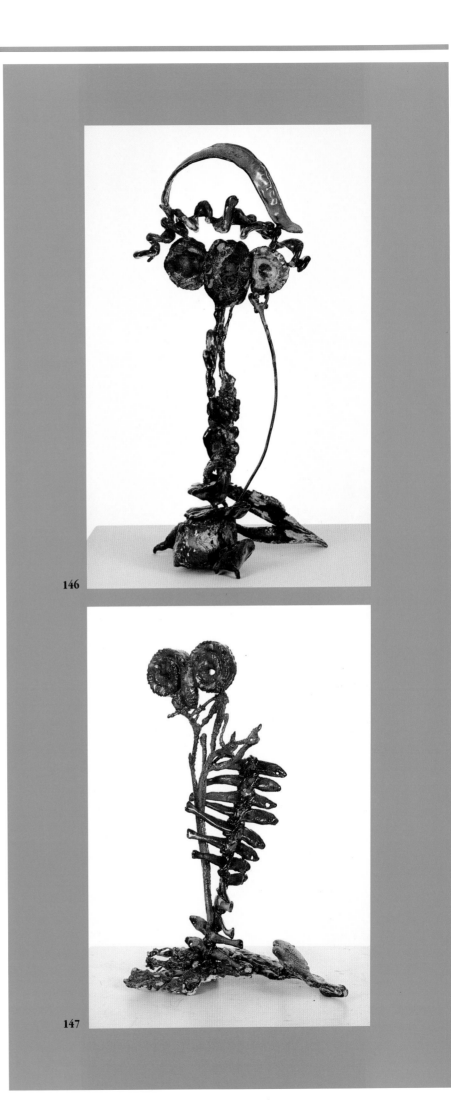

146

147

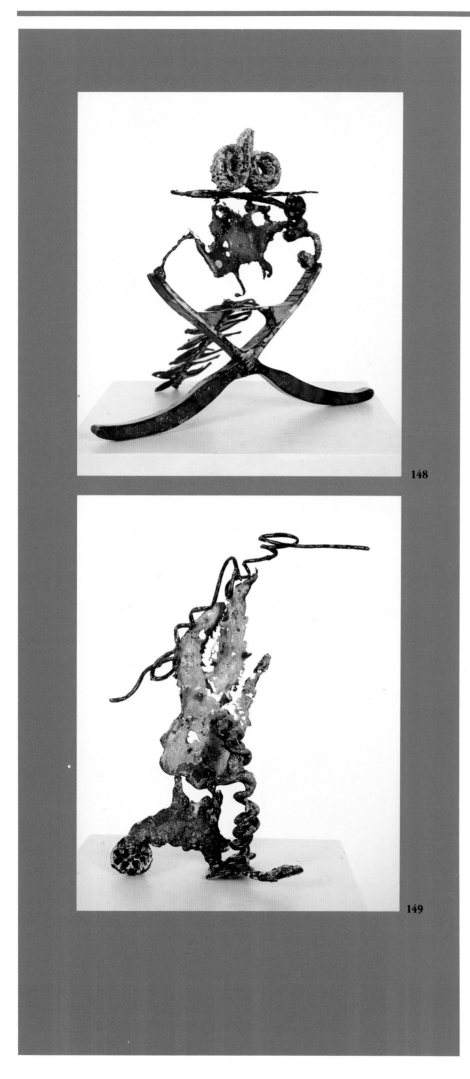

148

149

148 Stay (Glass Series), 1983
Baked enamel on bronze. 15¼ × 17⅞ × 9¼ (38.7 × 45.4 × 23.5).
Inscribed on central area of scissors: *N. Graves STAY 11–83 TX.*

COLLECTION
Private collection

REMARKS
See remarks to cat. no. 140.

149 Stur (Glass Series), 1983
Baked enamel on bronze. 19 × 15 × 8½ (48.3 × 38.1 × 21.6).
Inscribed on bottom: *N. G. 11–83 STUR TX.*

COLLECTION
Private collection

REMARKS
See remarks to cat. no. 140.

150 Swen (Glass Series), 1983
Baked enamel on bronze. 17¼ × 5⅝ × 7⅜ (43.8 × 14.3 × 18.2).
Inscribed on seed, approximately 6 in. high: *N. Graves 11–83 SWEN TX.*

COLLECTION
Private collection

REMARKS
See remarks to cat. no. 140.

151 Triped, 1983
Bronze with polychrome patina. 35 × 45 × 23 (88.9 × 114.3 × 58.4).
Inscribed on side: *N. S. Graves TRIPED III–1983 TX.*

COLLECTION
Ochi, Boise, Idaho

PROVENANCE
M. Knoedler & Co., Inc., New York

REFERENCES
Lucie-Smith, 1984, bw p. 267.

REMARKS
Lost-wax and sand-cast methods were used. The title refers to
the structure of the base, which touches the floor on three points.
This is essential in sculpture for stability.

152 Walk (Spill Series), 1983
Bronze with polychrome patina. 36 × 36½ × 12½ (91.4 × 92.7 ×
31.8). Inscribed on yellow scissors: *N. S. Graves 10–25–83 TX WALK.*

COLLECTION
Private collection, Topeka, Kansas

PROVENANCE
M. Knoedler & Co., Inc., New York

EXHIBITIONS
New York: M. Knoedler & Co., Inc. (checklist no. 15), 1984

REMARKS
Walk was made with direct casting, sand casting, and molten-bronze
spills. It was created from a spill with a manlike appearance, and has
allusions to Jean Dubuffet's work. Directly cast bronze elements and
gating material, together with a Chinese cooking scissors, comprise
the base.

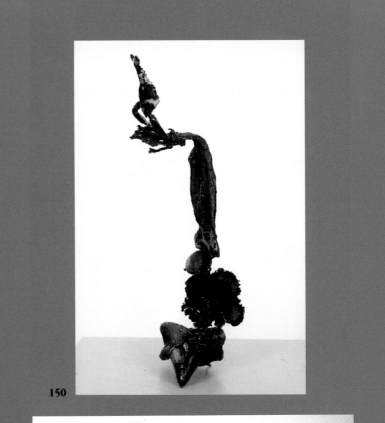

150

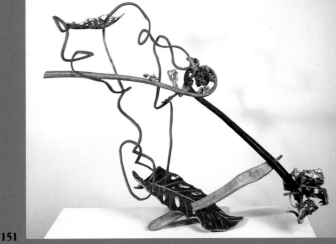

151

152

153

155

153 Zag, 1983
Bronze with polychrome patina. 80 × 37 × 27¼ (203.2 × 94 × 69.2).
Inscribed on circular pink rim: *N. S. Graves 5–'83 ZAG TX.*

COLLECTION
Private collection, Fort Worth, Texas

PROVENANCE
M. Knoedler & Co., Inc., New York

EXHIBITIONS
New York: M. Knoedler & Co., Inc. (checklist no. 4), 1984

REFERENCES
Shapiro, *Arts Magazine* 58 (December 1983), color p. 114.

REMARKS
Zag was inspired by David Smith's Zig Series. The base is a bronze
spill.

154 Zaga, 1983
Bronze with polychrome patina. 72 × 49 × 32 (182.9 × 124.5 ×
81.3). Inscribed on orange leaf: *N. S. Graves 10–17 '83 TX.*

COLLECTION
The Nelson-Atkins Museum of Art, Kansas City, Missouri. Gift of the
Friends of Art

PROVENANCE
M. Knoedler & Co., Inc., New York

EXHIBITIONS
New York: M. Knoedler & Co., Inc. (checklist no. 16), 1984

REFERENCES
Hughes, *Time*, 2 April 1984, color p. 80. Berman, *Artnews* 85
(February 1986), color p. 58, comm. p. 63. McTavish, *The Kansas
City Star*, 19 February 1986, comm. p. 12B.

REMARKS
Like it predecessor, *Zag, Zaga* rises vertically by means of a zigzag
format.

155 Zeeg (Spill Series), 1983
Bronze with polychrome patina. 28½ × 14 × 11 (73.4 × 35.6 ×
27.9). Inscribed on orange column: *N. S. Graves ZEEG 10–83 TX.*

COLLECTION
Private collection

PROVENANCE
M. Knoedler & Co., Inc., New York

EXHIBITIONS
New York: M. Knoedler & Co., Inc. (checklist no. 24), 1984

REMARKS
The top element of *Zeeg* is made with direct casting and a bronze
spill. The scale of parts and method of assembly predict the first
sculptures in the Glass Series.

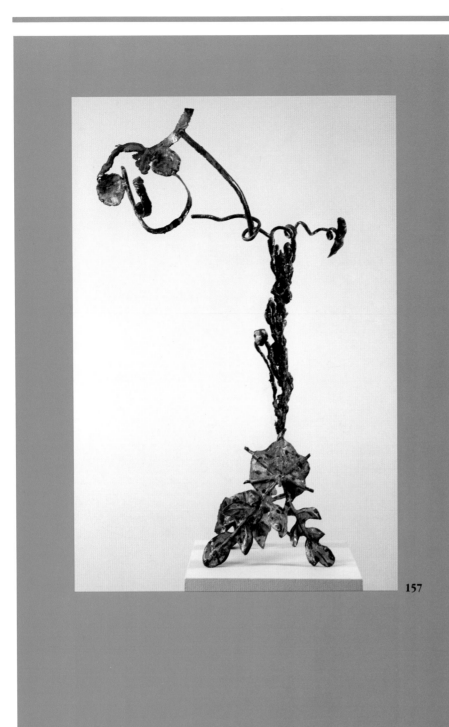

157

156 A Z, 1984
Bronze with polychrome patina and baked enamel. 22 × 29 × 21 (56 × 73.7 × 53.3). Inscribed on pink fern: *A Z N. S. Graves VI–84 TX.*

COLLECTION
Mr. and Mrs. H. Charles Price, Dallas

PROVENANCE
M. Knoedler & Co., Inc., New York

REFERENCES
Shantz, *The Alumnae Bulletin*, Spring 1985, bw p. 11.

REMARKS
A Z was made with casts, baked enamels, and molten-bronze spills.

157 Aspira (Glass Series), 1984
Baked enamel on bronze. 35½ × 21½ × 11 (90.2 × 54.6 × 27.9). Inscribed on seed-pod foot: *ASPIRA NG 4–84 TX.*

COLLECTION
The Frito-Lay Collection, Plano, Texas

PROVENANCE
M. Knoedler & Co., Inc., New York

EXHIBITIONS
Williamstown, Massachusetts: Williams College Museum of Art (traveling exhibition; shown only at the Brooklyn Museum, New York; no illus.), 1984–85

REFERENCES
"Frito-Lay Collection," *Horizons* 28 (October 1985), color p. 36.
Neff, 1985, color p. 24.

REMARKS
Aspira was made with casts, baked enamel on bronze, and molten-bronze spills. The work was assembled in twenty minutes, although the cast parts were made over an eight-week period.

158 Bel-Smelt, 1984
Bronze with polychrome patina and baked enamel. 44¾ × 96 × 19 (113.7 × 243.8 × 48.3). Inscribed on central diagonal bar: *BEL-SMELT N. S. Graves VIII–22 '84 TX.*

COLLECTION
Richard and Barbara Lane, New York

PROVENANCE
M. Knoedler & Co., Inc., New York

REFERENCES
Frank, *Connoisseur* 216 (February 1986), color p. 57.

REMARKS
Bel-Smelt was made with direct casting, molten-bronze spills, sand casting, and baked enamel on bronze. The title refers to the bronze ingots (each weighing twenty-five pounds) that were used on the right side of the sculpture as a counterweight or ballast to its thrust six feet in the opposite direction. The name "Belmont" (the name of the bronze smelter) appears on the ingots.

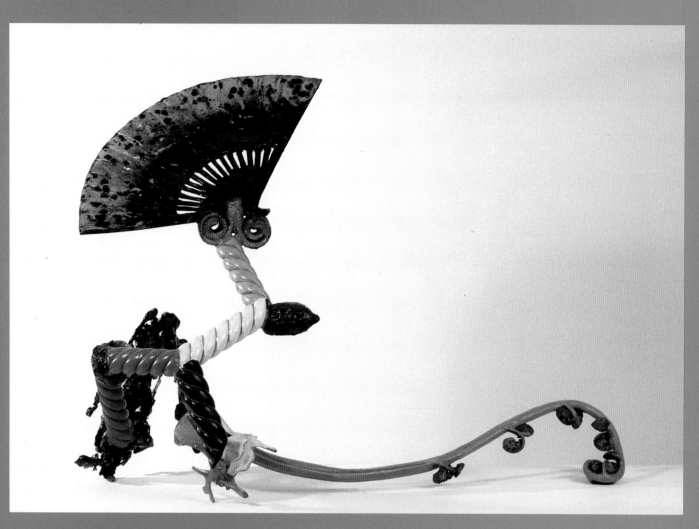

156

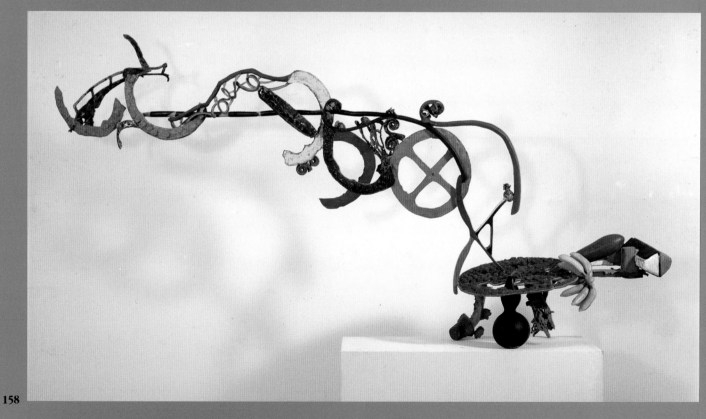

158

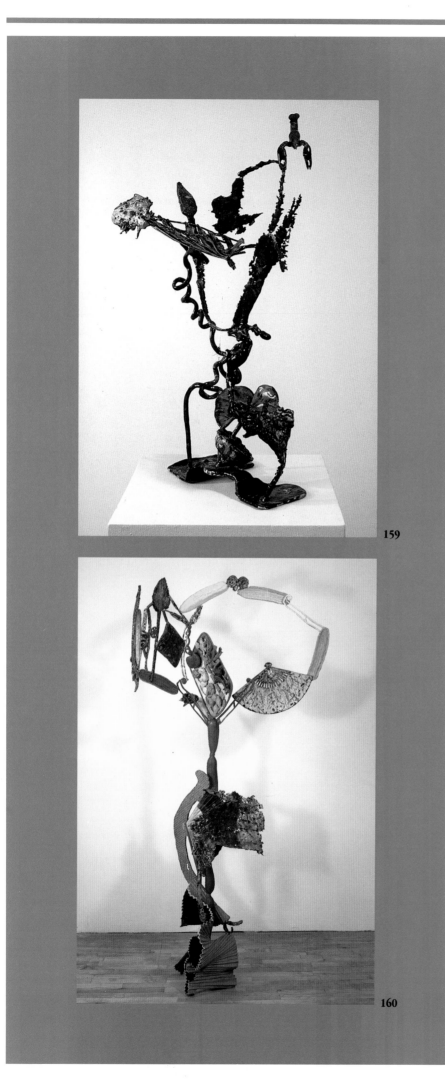

159

160

159 Bipe (Glass Series), 1984
Baked enamel on bronze. 28¾ × 15 × 16½ (73 × 38.1 × 41.9).
Inscribed on foot: *BIPE NG TX 4–84.*

COLLECTION
Nan and Gene Corman, Beverly Hills

PROVENANCE
M. Knoedler & Co., Inc., New York

REMARKS
Bipe was made with casts, molten-bronze spills, and baked enamel
on bronze. *B i p* and *e* are the first letters of the word "biped,"
referring to the *Monstera* leaves of which the sculpture's base is
made, which look like big feet.

160 Caveat Emptor, 1984
Bronze with polychrome patina and baked enamel. 82 × 42 × 22
(208.3 × 106.7 × 55.9). Inscribed on blue squash: *TX N. S. Graves 4–'84
CAVEAT EMPTOR.*

COLLECTION
The Ludwig Collection, Aachen, West Germany

EXHIBITIONS
Stockholm: Liljevalchs Konsthall (color p. 69), 1985–86

REMARKS
Caveat Emptor was made with casts, baked enamel on bronze, and
molten-bronze spills. A plastic tray with a cloth napkin and fresh
vegetables were directly cast to form the top center element. This is
one of a series of linear, open, large-scale indoor works—e.g.,
Indicate, 1982 (cat. no. 99), *Extend-Expand*, 1983 (cat. no. 122),
and *Rebus* (cat. no. 173) and *Span-Spun* (cat. no. 174), both 1984.

161 Counterfall, 1984
Bronze and steel with polychrome patina, polyurethane paint, and
baked enamel. 35 × 24 × 15 (88.9 × 61 × 38). Inscribed on base:
N. S. Graves COUNTERFALL 10–84 TX.

COLLECTION
Mrs. Michael Palin, New York

PROVENANCE
M. Knoedler & Co., Inc., New York

REMARKS
Counterfall was made of directly cast and sand-cast elements,
carbon-steel rebar and bronze spills, and colored with baked enamel
on bronze, polychrome patina, and paint.

162 Dallaleve (Pendula Series), 1984
Bronze with polychrome patina and baked enamel. 45 × 41½ × 30
(114.3 × 105.4 × 76.2). Inscribed on green leaf: *DALLALEVE N. S. Graves
VII–23–84 TX.*

COLLECTION
Private collection

REMARKS
Dallaleve has one movable part and is one of the Pendula Series;
Pendula (cat. no. 136), *Pendule* (cat. no. 137), and *Penda* (cat. no.
135), all 1983, are others; so, too, are *Moththe* (cat. no. 168),
Pendelance (cat. no. 171), and *Pinocchio* (cat. no. 172), all 1984;
and *Jato* (cat. no. 195), *Vertilance* (cat. no. 223), and *Whiffle Tree*
(cat. no. 227), all 1985.

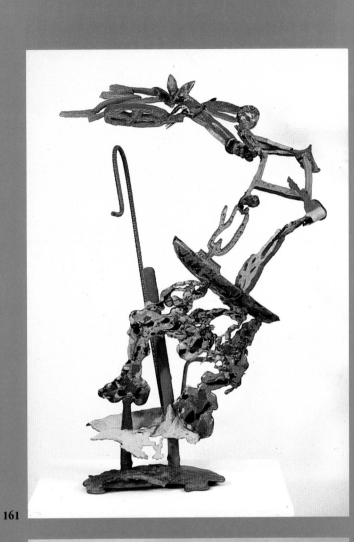

161

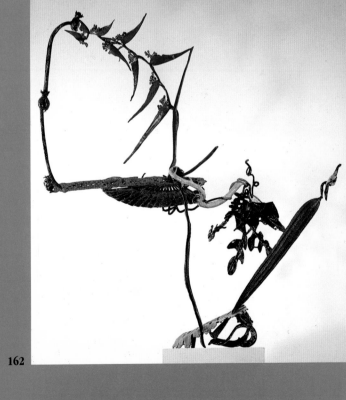

162

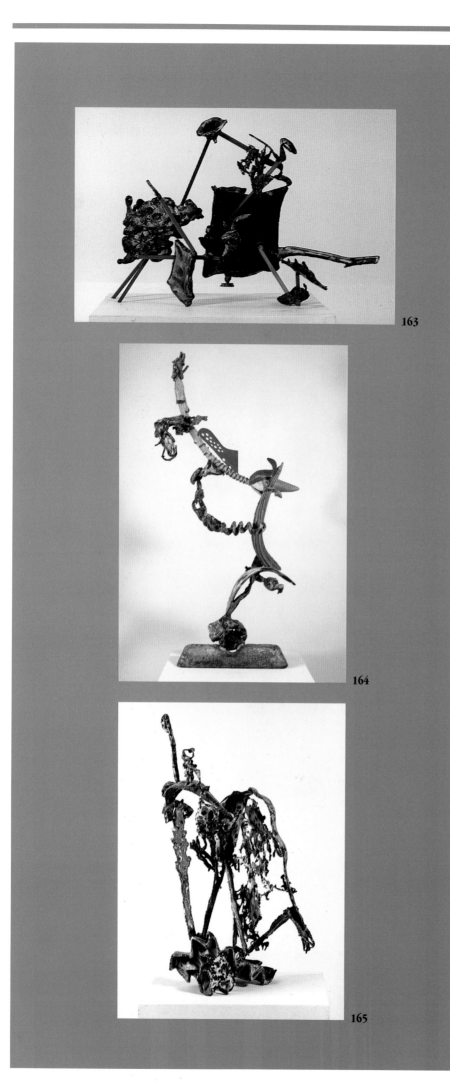

163

164

165

163 Drives (Stained-Glass Series), 1984
Bronze with polychrome patina and baked enamel. 13 × 27 × 14
(33 × 68.6 × 35.6). Inscribed on straight metal rod, 7¼ in. high:
N. S. Graves DRIVES VI–84 TX.

COLLECTION
Private collection

REMARKS
Drives was made with casts, molten-bronze spills, and baked enamel
on bronze. The sculpture has movable parts. "Stained-glass" refers to
bronze rods welded to baked enamel on bronze, which reminded the
artist of the lead filigree that holds the glass pieces in place in a
medieval cathedral window.

164 Fought Cight Cockfight, 1984
Bronze with polychrome patina and baked enamel. 34 × 12½ × 14
(86.4 × 31.8 × 35.6). Inscribed on lower horizontal side of ingot:
FOUGHT CIGHT COCKFIGHT N. S. Graves 8 25 '84 TX.

COLLECTION
The Saint Louis Art Museum, purchase: funds given by the Shoenberg
Foundation, Inc., Saint Louis

PROVENANCE
M. Knoedler & Co., Inc., New York

REMARKS
Fought Cight Cockfight was inspired by David Smith's sculpture
Cockfight, also in the Saint Louis Art Museum.

165 Janus (Glass Series), 1984
Baked enamel on bronze. 20¾ × 15¼ × 10 (52.7 × 38.7 × 25.4).
Inscribed on orange area, 7 in. high: *JANUS NG 1–84 TX.*

COLLECTION
Private collection

REFERENCES
Frank, *Connoisseur* 216 (February 1986), comm. p. 59.

REMARKS
Janus was made with direct casting, using molds, baked enamel on
bronze, and molten-bronze spills. The title refers to the two sections
that face each other, each containing elements that together form a
portrait.

166 Leif (Glass Series), 1984
Baked enamel on bronze. 23¾ × 19 × 9½ (60.3 × 48.3 × 24.1).
Inscribed on bean pod, 1 in. high: *LEIF NG 1 '84 TX.*

COLLECTION
Vassar College Art Gallery, Poughkeepsie, New York

EXHIBITIONS
Williamstown, Massachusetts: Williams College Museum of Art (traveling exhibition; shown only at the Brooklyn Museum, New York; no illus.), 1984–85

REMARKS
Leif was made with direct casting, using molds, baked enamel on bronze, and molten-bronze spills. A large spill, colored with baked enamel, is supported by the addition of directly cast baked-enameled forms.

167 Masque (Glass Series), 1984
Baked enamel on bronze. 21¼ × 20 × 10¾ (54 × 51 × 27.3).
Inscribed on side: *N. S. Graves MASQUE 1–84 TX.*

COLLECTION
Mr. and Mrs. Erwin P. Staller, Huntington, New York

PROVENANCE
M. Knoedler & Co., Inc., New York

EXHIBITIONS
New York: M. Knoedler & Co., Inc. (checklist no. 11), 1984

REMARKS
Masque was made with direct casting, using molds, baked enamel on bronze, and molten-bronze spills. The title refers to the image of a face comprising the horizontal element.

168 Moththe (Pendula Series), 1984
Bronze with polyurethane paint. 76¼ × 87 × 47 (193.7 × 221 × 119.4). Inscribed on small yellow scissors: *MOTHTHE N. S. Graves VII–84 TX.*

COLLECTION
Aron and Phyllis Katz

PROVENANCE
M. Knoedler & Co., Inc., New York

REMARKS
The title is an Old English form of "moth." The hanging fan relates this work to *Penda*, 1983 (cat. no. 135), *Pendula*, 1983 (cat. no. 136), *Dallaleve*, 1984 (cat. no. 162), and *Pendelance*, 1984 (cat. no. 171).

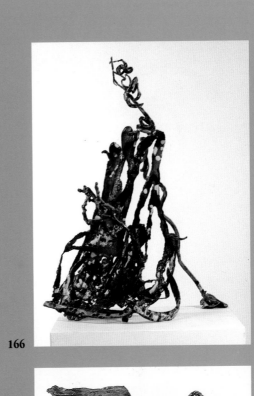

166

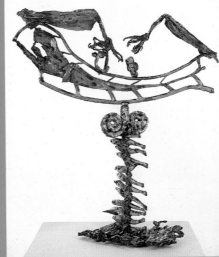

167

168

169

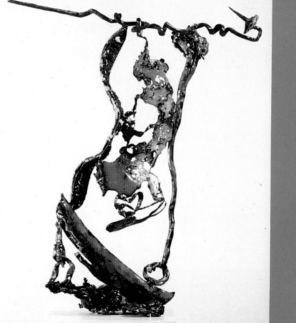

170

169 Nuda (Glass Series), 1984
Baked enamel on bronze. 29¼ × 14½ × 12¾ (74.3 × 36.8 × 32.4).
Inscribed on side: *N. S. Graves NUDA 1–84 TX.*

COLLECTION
Mrs. Seymour M. Klein, New York

PROVENANCE
M. Knoedler & Co., Inc., New York

EXHIBITIONS
New York: M. Knoedler & Co., Inc. (checklist no. 8), 1984

REMARKS
Nuda was made with direct casting, using molds, baked enamel on
bronze, and molten-bronze spills. The title alludes to a form reminis-
cent of an Henri Matisse nude that is the horizontal figure in this
sculpture.

170 Paindre (Glass Series), 1984
Baked enamel on bronze. 25 × 20¾ × 6 (63.5 × 52.7 × 15.2).
Inscribed on flat leaf, approximately 1½ in. high: *PAINDRE NG 1–84 TX.*

COLLECTION
Private collection

EXHIBITIONS
Williamstown, Massachusetts: Williams College Museum of Art (trav-
eling exhibition; shown only at the Brooklyn Museum, New York;
no illus.), 1984–85

REMARKS
Paindre was made with direct casting, using molds, enameled bronze,
and molten-bronze spills. The title is a pun on the French *peindre*,
"to paint." It thus refers to painting, or the painterly quality of these
assembled forms.

171 Pendelance (Pendula Series), 1984
Bronze and steel with polychrome patina. 51 × 41 × 24½ (129.5 ×
104.1 × 62.2). Inscribed on green bar: *N. S. Graves '84 PENDELANCE TX.*

COLLECTION
Candida N. Smith, New York

PROVENANCE
M. Knoedler & Co., Inc., New York

EXHIBITIONS
Poughkeepsie, New York: Vassar College Art Gallery (traveling exhibi-
tion; color p. 35), 1986

REMARKS
Pendelance was made with direct casts and sand casting. The
solid bronze, directly cast gourds act as counterweights. The sculpture
is unusual in that it rests on two bases.

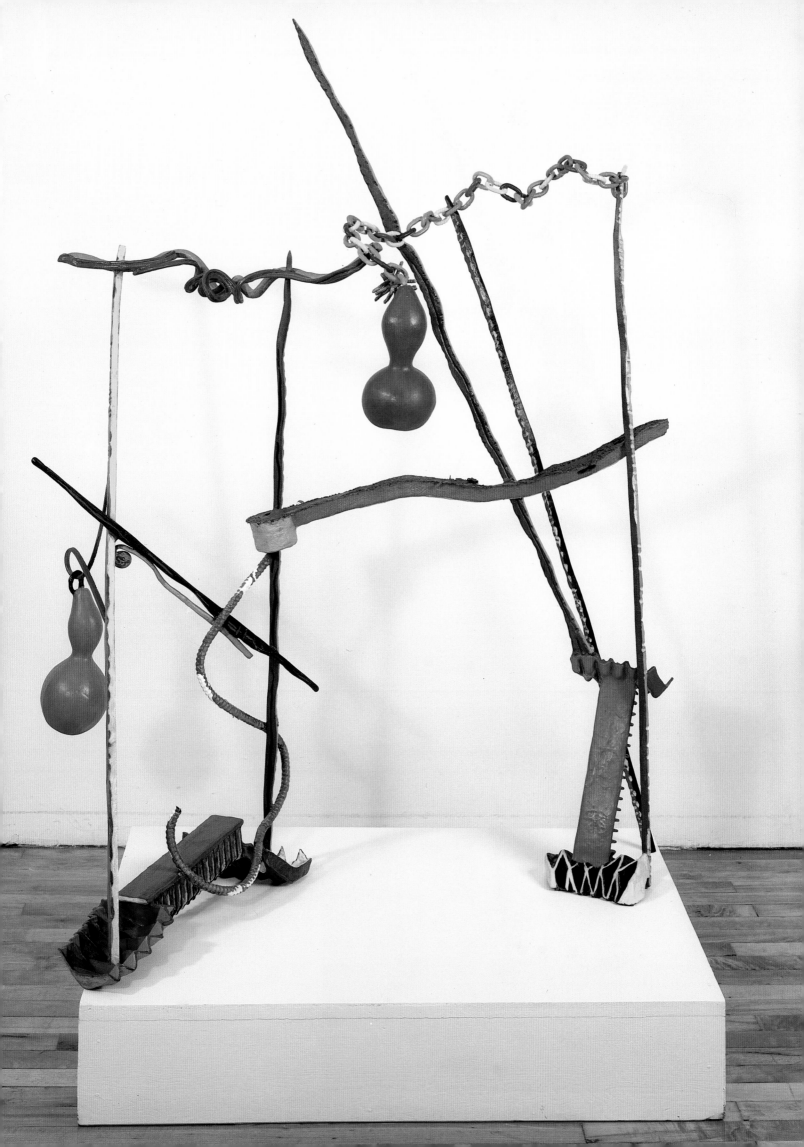

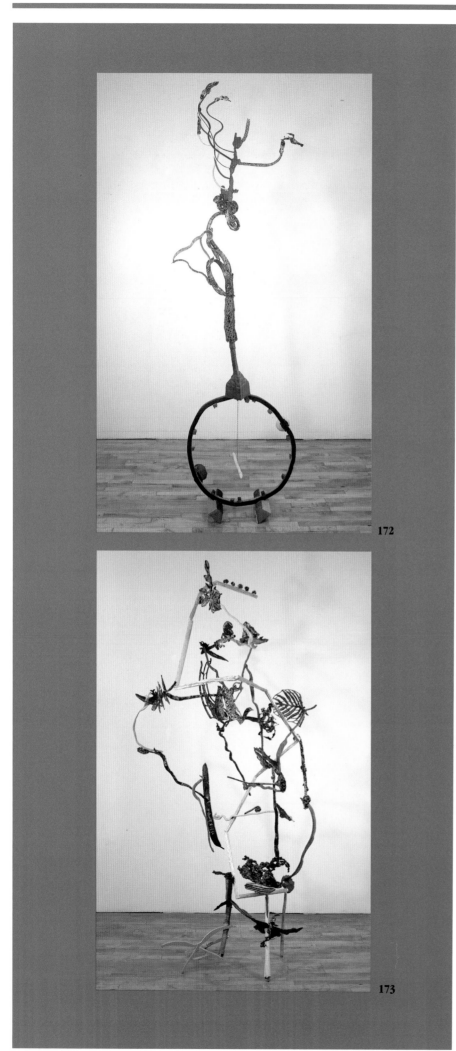

172

173

172 Pinocchio (Pendula Series), 1984
Bronze with polychrome patina and baked enamel. 92½ × 28 × 41 (235 × 71.1 × 104.1). Inscribed on red rim of circle: *N. S. Graves '84 PINOCCHIO TX.*

COLLECTION
Private collection

EXHIBITIONS
Houston: Janie C. Lee Gallery, 1986

REMARKS
Pinocchio was made with directs casts, glass enamels, and sand casting. The directly cast reed rod in a hanging position is reminiscent of the work of Alberto Giacometti. The circle is made of discarded gating material that normally would be melted down, the base is of two bronze ingots, and the figure is a spill.

173 Rebus, 1984
Baked enamel on bronze and stainless steel with polychrome patina and oil paint. 95 × 48½ × 43 (241.3 × 123.2 × 109.2). Inscribed on silver scissors: *REBUS N. S. Graves VI–84 TX.*

COLLECTION
Neuberger Museum, State University of New York at Purchase, museum purchase with funds from Friends of the Neuberger Museum and support from the Frances and Benjamin Benenson Foundation and Lois and Philip Steckler

PROVENANCE
M. Knoedler & Co., Inc., New York

EXHIBITIONS
Purchase, New York: Neuberger Museum, State University of New York at Purchase, 1984
Poughkeepsie, New York: Vassar College Art Gallery (traveling exhibition; bw p. 33), 1986

REMARKS
Rebus was made with casts, molten-bronze spills, and enamels. The sculpture is in one piece. Its height and openness can be attributed to the stainless-steel forms (directly cast corrugated cardboard), which provide greater strength than would bronze.

174 Span-Spun, 1984
Bronze with polyurethane paint. 93 × 62½ × 31 (236.2 × 158.8 × 78.7). Inscribed on pink scissors on base: *N. S. Graves SPAN-SPUN 84 TX.*

COLLECTION
Private collection

PROVENANCE
M. Knoedler & Co., Inc., New York

REMARKS
Span-Spun was made with direct and lost-wax casting, sand casting, and welding.

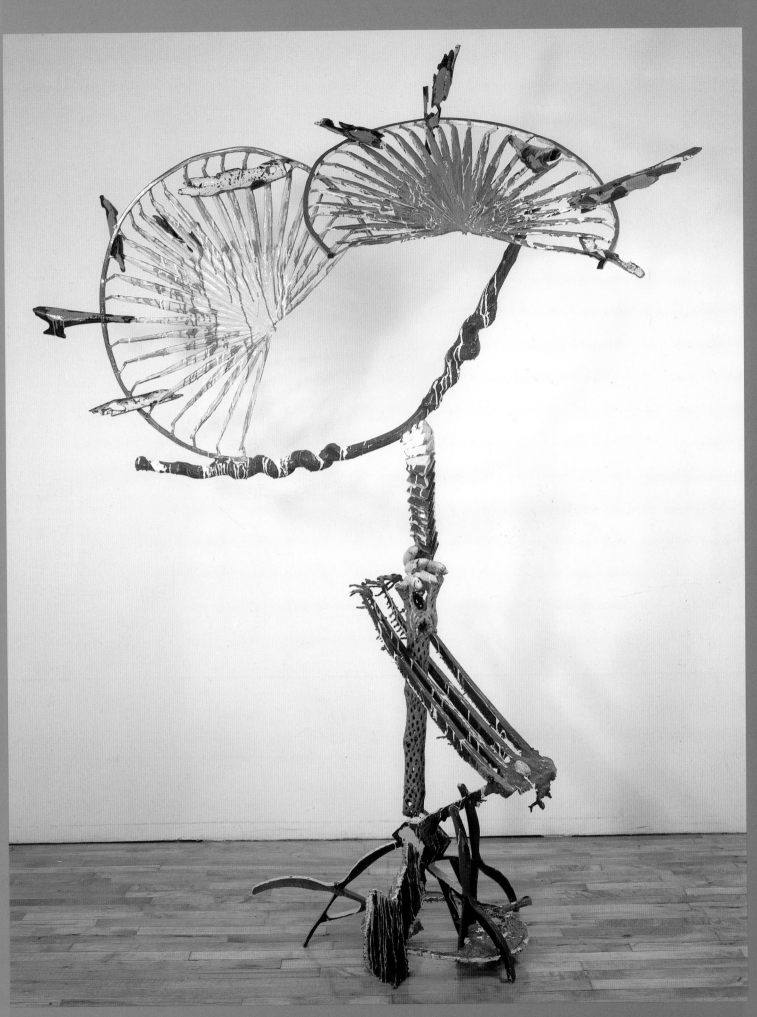

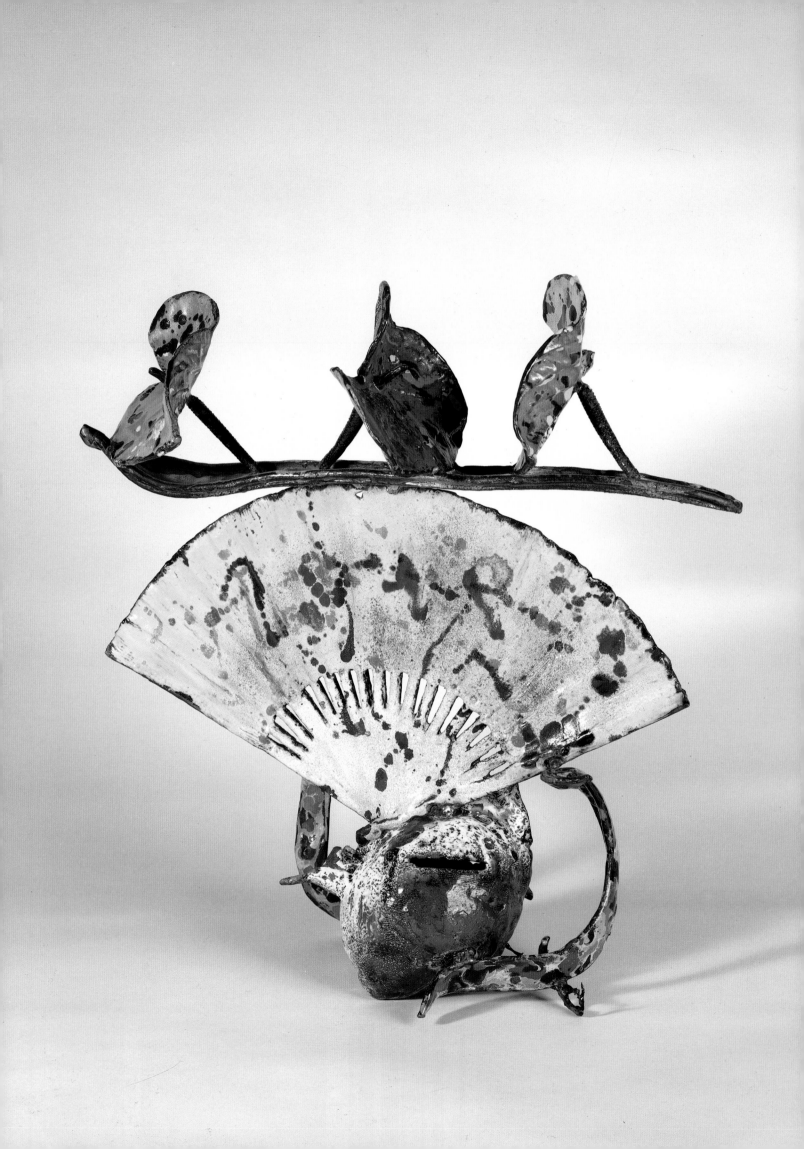

175 Tanz (Glass Series), 1984
Baked enamel on bronze. 19 × 19½ × 10 (48.3 × 49.5 × 25.4).
Inscribed on side: *N. S. Graves TANZ 1–84 TX.*

COLLECTION
Ann and Robert Freedman, New York

PROVENANCE
M. Knoedler & Co., Inc., New York

EXHIBITIONS
New York: M. Knoedler & Co., Inc. (checklist no. 13), 1984

REFERENCES
Shantz, *The Alumnae Bulletin*, Spring 1985, bw p.11.

REMARKS
Tanz was made with direct casting, enameled bronze, and
molten-bronze spills.

176 Tarot, 1984
Bronze with polychrome patina and baked enamel. 88 × 49 × 20
(223.5 × 124.5 × 50.8). Inscribed on pink scissors shape: *TAROT
N. S. Graves 3–'84 TX.*

COLLECTION
Private collection

EXHIBITIONS
New York: Holly Solomon Gallery, 1985
Pittsburgh: University of Pittsburgh Gallery (color p. 13), 1985
Cambridge: Massachusetts Institute of Technology, List Visual Arts
 Center, 1986

REFERENCES
Frank, *Connoisseur* 216 (February 1986), color p. 60.

REMARKS
Tarot was made with lost-wax and direct casting, enameled bronze,
and molten-bronze spills. It is one of a series of open, linear sculp-
tures begun in March and April 1984. The others are *Caveat Emptor*
(cat. no. 160) and *Rebus* (cat. no. 173); *Extend-Expand*, 1983
(cat. no. 122), is a related work.

177 Trambulate, 1984
Bronze and steel with polyurethane paint and baked enamel.
86½ × 71 × 38 (219.7 × 180.3 × 96.5). Inscribed on green lotus
root, approximately 27 in. high: *TRAMBULATE N. S. Graves 12 '84 TX.*

COLLECTION
Private collection

EXHIBITIONS
New York: M. Knoedler & Co., Inc. (checklist no. 9), 1985–86

REFERENCES
Frank, *Connoisseur* 216 (February 1986), comm. p. 60.

REMARKS
Trambulate was made with direct casts, sand casting, bronze gating
material, and prefabricated parts. This is an indoor sculpture and
does not come apart, but five objects on it move: two fans, two fungi,
and a Hupua fern with a turkey breastbone attached.

175

176

177

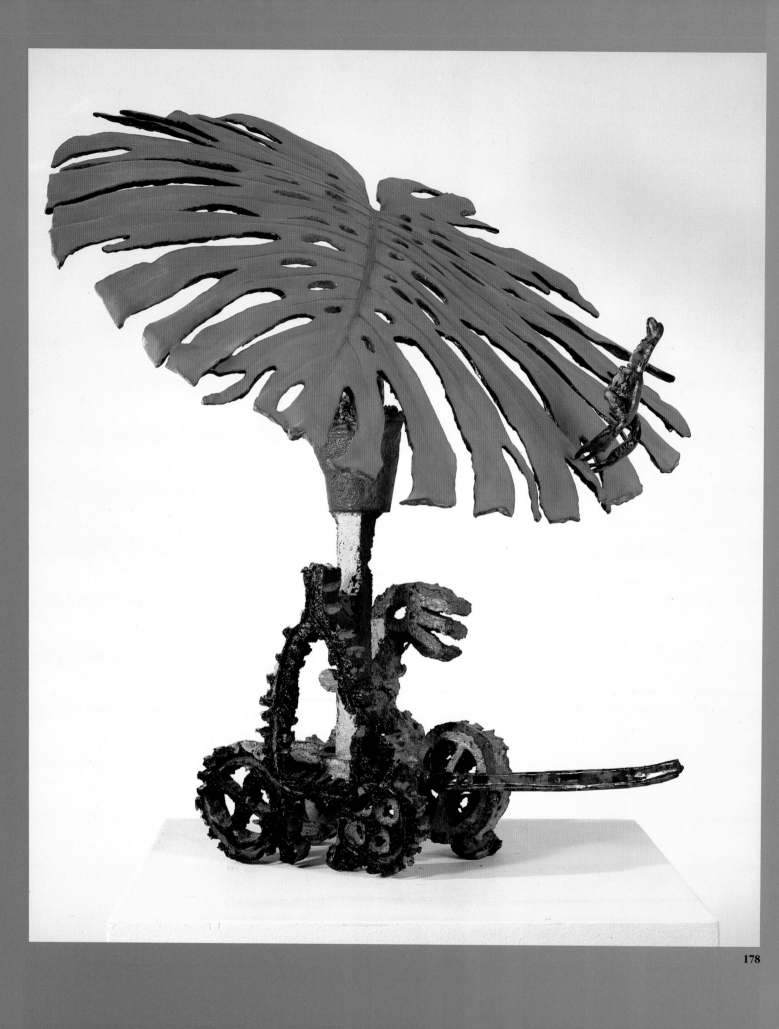

178 Trax, 1984
Bronze with polychrome patina and baked enamel. 24 × 23¼ × 20½ (61 × 59.1 × 52.1). Inscribed on pink leaf: *TRAX N. S. Graves V–9–84 TX.*

COLLECTION
Private collection

REMARKS
Trax was made with casts and enameled parts. The movable parts are the *Monstera* leaf, which turns 360 degrees, and the vine projecting from the base, which swivels up and down.

179 Trebuchet, 1984
Bronze with polychrome patina and baked enamel. 58½ × 33 × 14½ (148.6 × 83.8 × 36.8). Inscribed on orange area of antenna: *VII 10–84 TREBUCHET N. S. Graves TX.*

COLLECTION
Private collection

REFERENCES
Shapiro, *Arts Magazine* 59 (November 1984), color p. 93.

REMARKS
Trebuchet was made with direct casts, sand casting, enamels, spills, and molten bronze. The title refers to a medieval war machine comparable to a modern-day cannon. The string of directly cast forms from figure-eight polystyrene packing-material is movable: each object spins individually around a stainless-steel rod, reminiscent of children's colored play disks. The wooden Japanese temple clacker, directly cast, and the sardines cast by lost-wax process also move. The entire top horizontal element can be rotated 360 degrees.

180 Twind (Stained-Glass Series), 1984
Baked enamel on bronze. 16½ × 15 × 26 (41.9 × 38.1 × 66). Inscribed on bronze rod, 3½ in. high: *N. S. Graves 9 18 84 TWIND TX.*

COLLECTION
Mr. Bertil Hult, Santa Barbara

PROVENANCE
The Museum of Contemporary Art, Los Angeles, "Gala, Gala!," benefit auction

REMARKS
Twind was made with direct casts and enamels. Painted, fabricated rods were combined with directly cast, enameled-bronze objects. "Stained glass" refers to the use of lead as an armature for the colored-glass pieces comprising stained-glass windows in churches, from medieval times to the present (see also *Drives*, cat. no. 163).

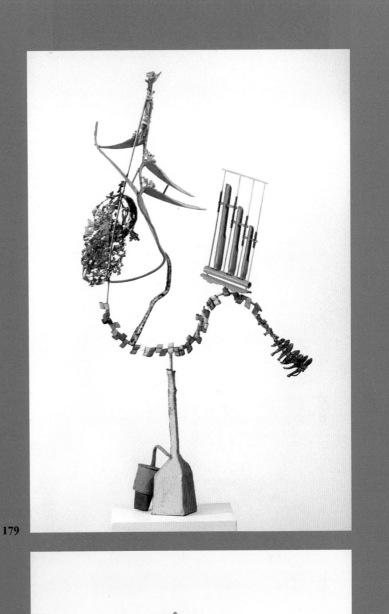

179

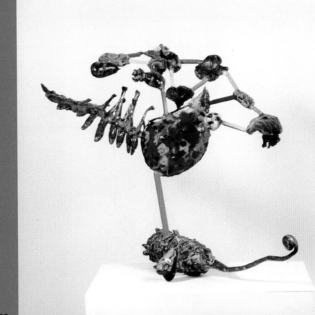

180

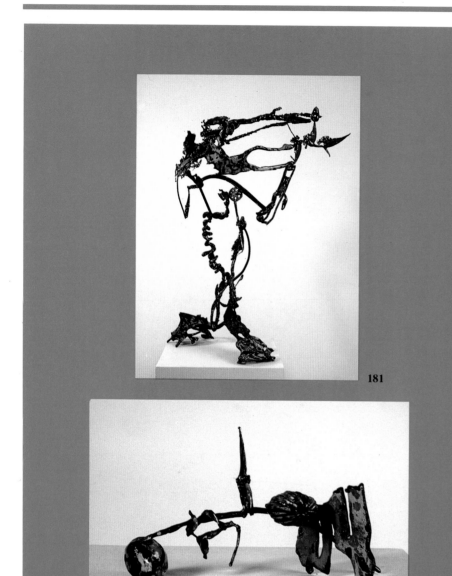

181

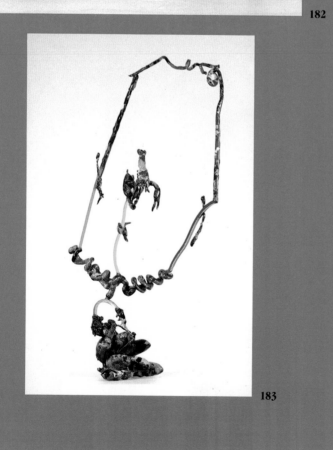

182

183

181 Wham (Glass Series), 1984
Baked enamel on bronze. 35 × 22 × 25½ (88.9 × 55.9 × 64.1).
Inscribed on metal rod, 15 in. high: *WHAM N. S. Graves V–84 TX.*

COLLECTION
Private collection

EXHIBITIONS
Williamstown, Massachusetts: Williams College Museum of Art (travel-
ing exhibition; shown only at the Brooklyn Museum, New York; no
illus.), 1984–85

REMARKS
Wham was made with casts, molten-bronze spills, and enamels.

182 XOXO, 1984
Baked enamel on bronze. 6½ × 12 × 5 (16.5 × 30.5 × 12.7).
Inscribed on bottom of ball: *NG XOXO '84 TX.*

COLLECTION
Mr. and Mrs. James Clarke, Pittsfield, Massachusetts

REMARKS
XOXO was made with direct casts and glass enamel. It has movable
parts.

183 XXXX (Glass Series), 1984
Baked enamel on bronze. 25 × 16 × 13½ (63.5 × 40.6 × 34.3).
Inscribed on bottom: *N. G. '84 TX XXXX.*

COLLECTION
Janie C. Lee, Houston

PROVENANCE
M. Knoedler & Co., Inc., New York

REMARKS
XXXX was made with casts, molten-bronze spills, glass enamel, and
prefabricated metal rods.

184 Catapult, 1985

Bronze and steel with baked enamel, polyurethane paint, and polychrome patina. 7 × 12½ × 8¼ (17.8 × 31.7 × 20.9). Inscribed on side of green wrench: *CATAPULT N. S. Graves X–85 TX.*

COLLECTION

Ann and Robert Freedman, New York

REMARKS

Catapult was made with direct casts and molten-bronze spills. The all-purpose steel wrench was purchased at a hardware store.

185 Chariot, 1985

Bronze with baked enamel and polychrome patina. 18 × 8¾ × 15½ (45.7 × 22.2 × 39.4). Inscribed on orange pretzel: *CHARIOT N. S. Graves X–85 TX.*

COLLECTION

Private collection

REMARKS

Chariot was made with direct casts. It was inspired by an Etruscan bronze sculpture seen at Yale University Art Gallery, New Haven.

186 Closed-Open-Down, 1985

Bronze and steel with polyurethane paint and baked enamel. 63 × 82 × 74½ (160 × 208.3 × 189.2). Inscribed on blue leaf, approximately 35 in. high: *CLOSED-OPEN-DOWN TX. N. S. Graves 2–85.*

COLLECTION

Private collection

EXHIBITIONS

New York: M. Knoedler & Co., Inc. (checklist no. 7), 1985–86

REMARKS

This piece has three sections that can be (1) unhooked and set on the floor, (2) hooked together, or (3) hooked and tilted into a vertical position.

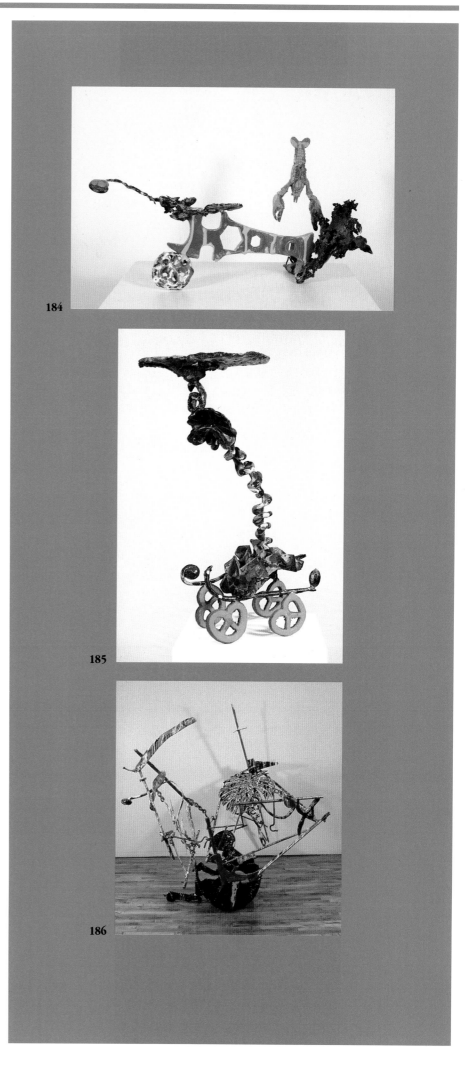

184

185

186

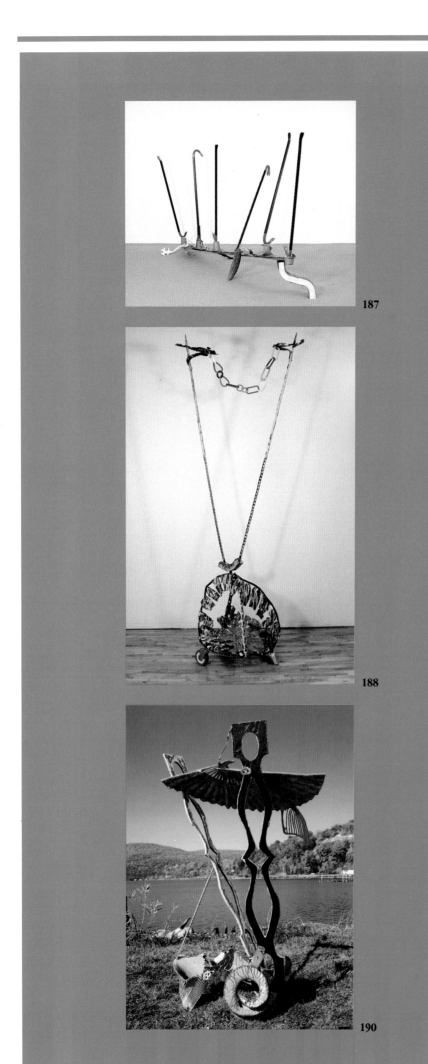

187

188

190

187 Crows at the Bar, 1985

Bronze and steel with polychrome patina. 47½ × 88 × 26 (120.7 × 223.5 × 66). Inscribed on horizontal green element, top center: *CROWS AT THE BAR N. Graves 8–85 TX.*

COLLECTION
Private collection

REMARKS
Six steel hardware-store crowbars are attached vertically to a seven-and-one-half-foot bronze sprue. The horizontal sculpture rests on four points: two welded-bronze gutter spouts that form an *s* curve, a Chinese wart cucumber, and two multiple-purpose wrenches directly cast in bronze. The repeated image of the crowbars is reminiscent of *Variability of Similar Forms*, 1970 (cat. no. 23). The undercoating of green cupric nitrate patina is partly exposed in juxtaposition with the polychrome patina.

188 Entomon, 1985

Bronze and steel with polyurethane paint and baked enamel. 104 × 43½ × 23½ (264.2 × 110.5 × 59.7). Inscribed on blue gating at top of leaf: *ENTOMON N. S. Graves 1–85 TX.*

COLLECTION
Private collection

EXHIBITIONS
New York: M. Knoedler & Co., Inc. (checklist no. 2), 1985–86

REMARKS
Entomon was made with direct casts, steel, polyurethane paint, and baked enamel. The top part, which separates from the *Monstera* leaf, swivels 360 degrees if touched.

189 Extent, 1985

Bronze and steel with polychrome patina and baked enamel 28 × 32 × 32 (71.1 × 81.3 × 81.3). Inscribed at end of bronze hose, approximately 17½ in. high: *EXTENT N. S. Graves TX 4-4-85.*

COLLECTION
Private collection, San Francisco

PROVENANCE
M. Knoedler & Co., Inc., New York

REMARKS
Extent was made with direct casts, baked enamel, and polychrome patina. The fan on the swivel is movable.

190 Fenced, 1985

Bronze and steel with polyurethane paint. 91 × 62 × 32½ (231.1 × 157.5 × 82.5). Inscribed on middle of pink outside edge of diagonal: *FENCED N. S. Graves IX–85 TX.*

COLLECTION
Mr. and Mrs. Roy O'Connor, Houston

REFERENCES
Berman, *Artnews* 85 (February 1986), color p. 61.

REMARKS
The juxtaposition of small and large elements (for example, the cast-bronze fan and fence, the latter originally made of wood covered with wax) provides variations in size that adapt well to an outdoor scale.

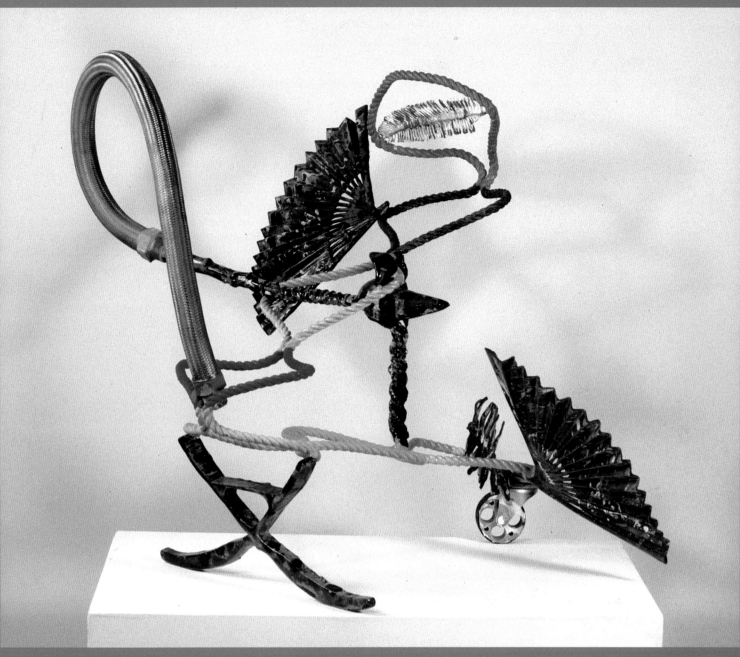

189

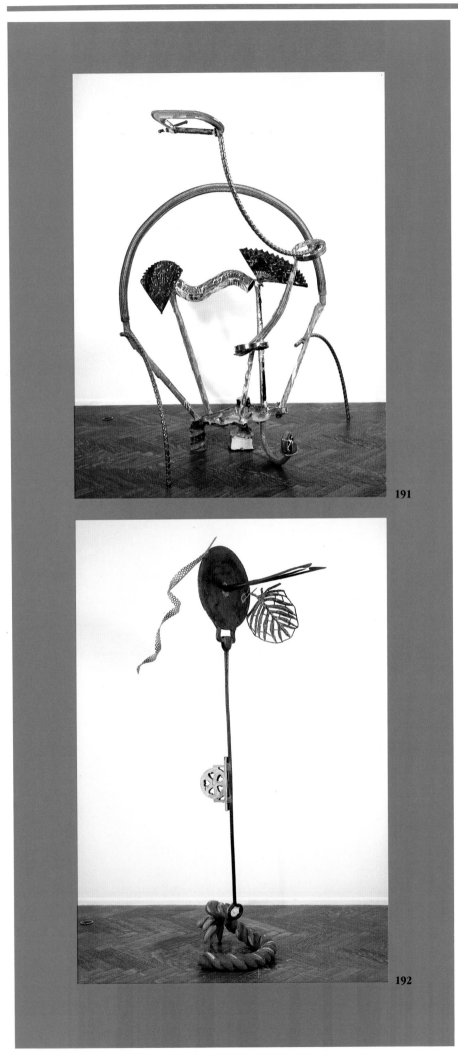

191

192

191 Five Arcs, 1985
Bronze and steel with baked enamel and polyurethane paint.
56 × 60 × 45½ (142.2 × 152.4 × 115.6). Inscribed on drain pipe
element: *FIVE ARCS N. S. Graves 5 '85 TX.*

COLLECTION
Private collection

REMARKS
Five Arcs has movable parts.

192 Griddle Man, 1985
Bronze and steel with polyurethane paint, polychrome patina, and
baked enamel. 65 × 40 × 26 (165.1 × 101.6 × 66). Inscribed on
round griddle element: *GRIDDLE MAN N. S. Graves IX–30–85 TX.*

COLLECTION
Bruce and Judith Eissner, Marblehead, Massachusetts

PROVENANCE
M. Knoedler & Co., Inc., New York

REMARKS
Griddle Man was inspired by Pablo Picasso's bronze *Pregnant Woman*
of 1949, in the Musée Picasso, Paris. An iron cooking griddle and an
iron eel spear, both nineteenth-century American antiques, are op-
posed at right angles to create a face.

193 Hay Fervor, 1985
Bronze and steel with polychrome patina, baked enamel, and polyurethane paint. 95¾ × 87 × 38½ (243.2 × 220.9 × 97.8).
Inscribed on column, approximately 60 in. high: *HAY FERVOR N. S. Graves IX 85 TX.*

COLLECTION
Private collection

EXHIBITIONS
New York: M. Knoedler & Co., Inc. (checklist no. 5), 1985–86

REMARKS
The cast-iron sickle bar is a turn-of-the-century farm implement. The gourd attached to the wrench is movable.

194 Intrecciata, 1985
Bronze and steel with baked enamel and polyurethane paint.
23½ × 40 × 17 (59.7 × 101.6 × 43.2). Inscribed on large bean pod: *INTRECCIATA N. S. Graves 5–85 TX.*

COLLECTION
The Greenberg Gallery, Saint Louis

PROVENANCE
M. Knoedler & Co., Inc., New York

REMARKS
Intrecciata was made with direct casts, bronze spills, fabricated parts, baked enamels, and polyurethane paint, and it has movable parts. The title is Italian for "braided," or "interwoven."

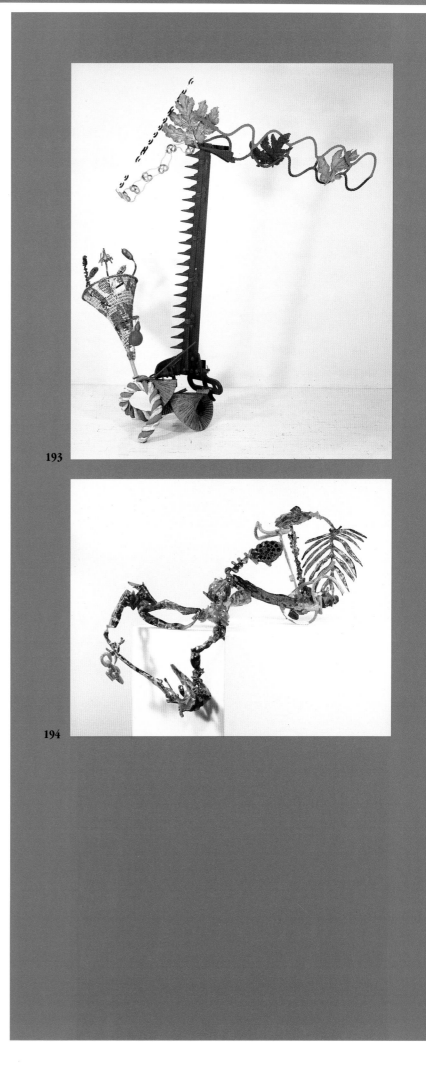

193

194

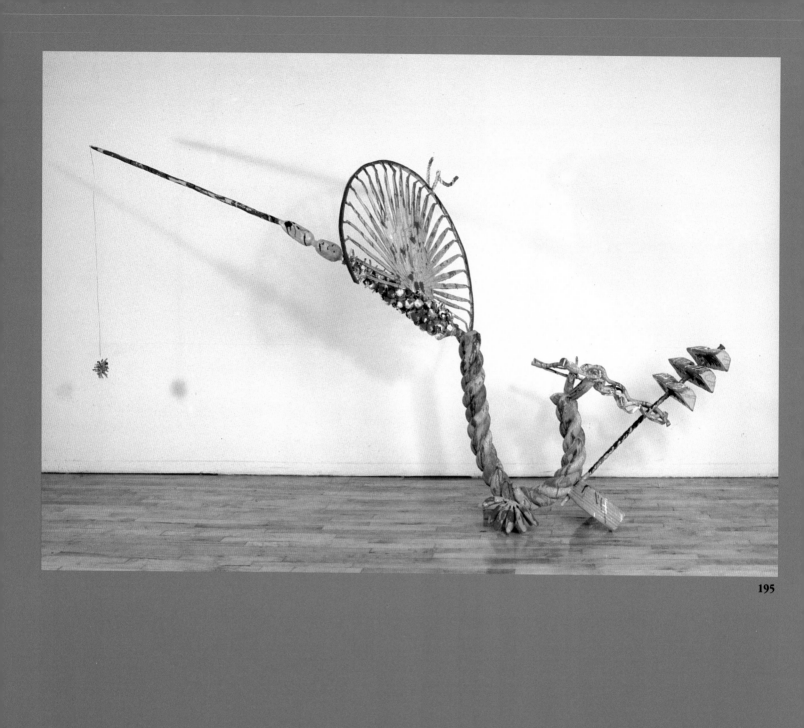

195 Jato (Pendula Series), 1985
Bronze and steel with polyurethane paint. 56 × 93½ × 40 (142.2 × 237.5 × 101.6). Inscribed on top of rope, approximately 27 in. high: *JATO N. S. Graves TX 3 '85.*

COLLECTION
Private collection

REMARKS
Jato was made with direct casts and polyurethane paint. Three of its parts rotate, and it has a hanging pendulum. It can be placed outdoors.

196 Lamp, 1985
Bronze, steel, and lead with polychrome patina, baked enamel, and polyurethane paint. 31 × 35 × 17 (78.7 × 88.9 × 43.2). Inscribed on neck of lamp: *LAMP N. S. Graves 10–'85 TX.*

COLLECTION
Dr. J. H. Sherman, Baltimore

PROVENANCE
M. Knoedler & Co., Inc., New York

REMARKS
Lamp has one movable part: a caster welded to the arched, braided-bronze hose allows the lotus leaf, which resembles a lampshade, to turn. The base is a cast jackfruit, brought from Hawaii in August 1985.

197 Landscape Tilt, 1985
Bronze, brass, aluminum, cast iron, and steel with polychrome patina, baked enamel, and polyurethane paint. 93½ × 44 × 28 (237.5 × 111.8 × 71.1). Inscribed on rim of jackfruit section, approximately 60 in. high: *LANDSCAPE TILT 11–13–85 N. S. Graves TX.*

COLLECTION
Private collection

REMARKS
Landscape Tilt was made with direct casts, molten bronze spills, ready-made parts, baked enamels, and sand casting. Double-circle bronze clips were used to join enameled bronze pieces to the aluminum structure; the whole was then mounted on a brass pole three and one-half inches in diameter. The patina has a cupric nitrate chemical base. The upper part of the sculpture is a landscape of aluminum vines, placed on a diagonal and combined with enameled organic forms. Two stainless-steel rings around the brass pole are welded to a bronze gutter pipe; the piece comes apart at the top of the brass pole. At the bottom a cast-iron swage block (used in blacksmithing), with bronze sand-cast runners and patches attached, is tilted by two steel casters.

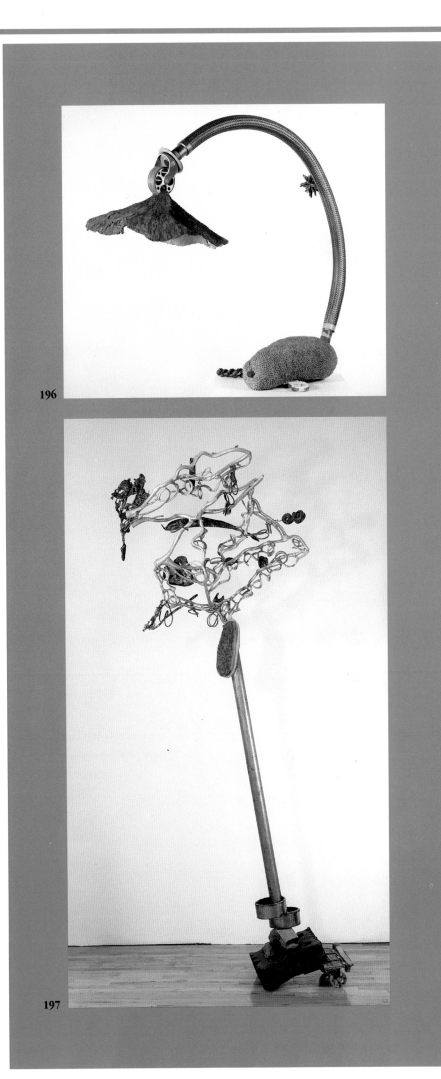

196

197

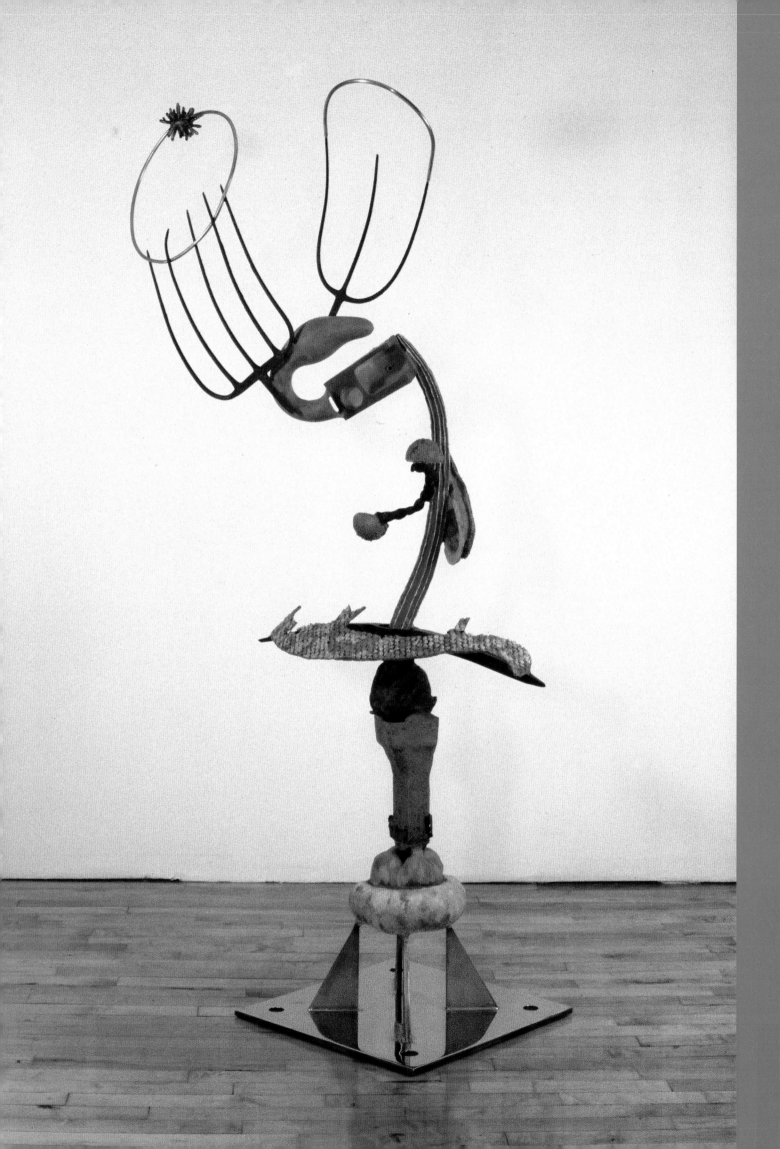

198 Leda, 1985
Bronze, iron, and steel with polychrome patina and baked enamel.
65½ × 30 × 21½ (166.4 × 76.2 × 54.6). Inscribed on ocher
gourd: *LEDA N. S. Graves XII 85 TX.*

COLLECTION
Private collection

REMARKS
Leda was made with direct casts, ready-made parts, baked enamels,
molten-bronze spills, and sand casting. The two iron forks are Ameri-
can farm tools. The carved gourd cut in half resembles the head of a
swan.

199 Looping, 1985
Bronze and steel with polyurethane paint and baked enamel.
106 × 41¾ × 29¼ (269.2 × 106 × 74.3). Inscribed on back of
red food platter: *1–85 N. S. Graves LOOPING TX.*

COLLECTION
Private collection

REMARKS
Looping was made with direct casts, baked enamel, and polyurethane
paint. Baked-glass enamel was used on the fern, sardines, fan,
banana blossom, and Chinese pastry rope. The sculpture comes apart
into two pieces.

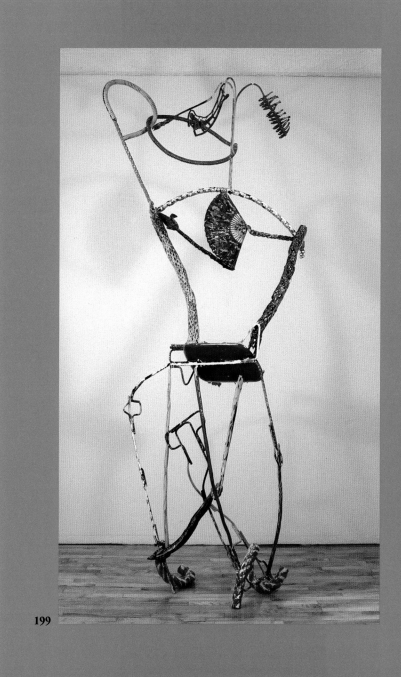

199

200

201

202

200 Mangonel, 1985

Bronze and steel with polychrome patina and baked enamel. 71 × 16 × 12 (180.3 × 40.6 × 30.5). Inscribed on brown clamp, approximately 24½ in. high: *MANGONEL N. Graves 8–22–85 TX.*

COLLECTION
Stewart and Judith Colton, Short Hills, New Jersey

PROVENANCE
M. Knoedler & Co., Inc., New York

REMARKS
Mangonel has movable parts.

201 Neolog, 1985

Bronze and steel with polyurethane paint, polychrome patina, and baked enamel. 118 × 43 × 32 (299.7 × 109.2 × 81.3). Inscribed on central horizontal element: *NEOLOG N. S. Graves IX '85 TX.*

COLLECTION
Mr. and Mrs. Richard Polich, Garrison, New York

REMARKS
Neolog has movable parts. The elements are parts of farm tools: the blade is from a sickle bar; the reel is from a lawn mower; the central steel element is part of a plowshare combined with two cultivating disks. The chain, welded link by link, comprises the two vertical elements.

202 Oiseau, 1985

Bronze, iron, and steel with polychrome patina. 32 × 25¼ × 9½ (81.3 × 64.1 × 24.1). Inscribed on right of bronze sprue: *OISEAU N. S. Graves XI–7–85 TX.*

COLLECTION
Mr. and Mrs. James Clarke, Pittsfield, Massachusetts

REMARKS
Oiseau ("bird" in French) was made with direct casts and ready-made parts. Among these are a pickax, two forged eel spears, a cooking whisk, and a turn-of-the-century cast-iron die for cutting shoes.

203 Osaurus, 1985

Bronze, steel, wood, and leather with polychrome patina and polyurethane paint. 63 × 84 × 51½ (160 × 213.4 × 130.8). Inscribed on large pink element: *OSAURUS N. S. Graves XII–11–85 TX.*

COLLECTION
Stephen Edlis, Chicago, Illinois

REMARKS
Osaurus has movable parts and was made using direct casts, sand casting, and polyurethane paint. The runners and down sprues (residues of the casting process) look like a centipede and are sand-cast. The artist made the fence element out of wood and added texture in the wax prior to sand casting. Found objects include a two-and-one-half-inch, directly cast rope; a steel caster three and one-half inches tall; forged eel spears; and a wood-and-leather snowshoe.

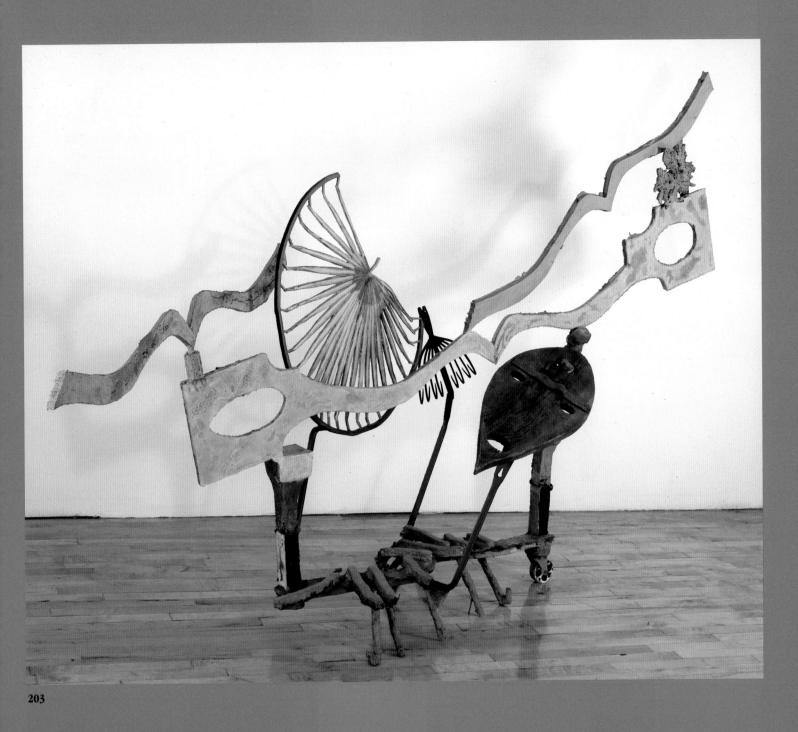

203

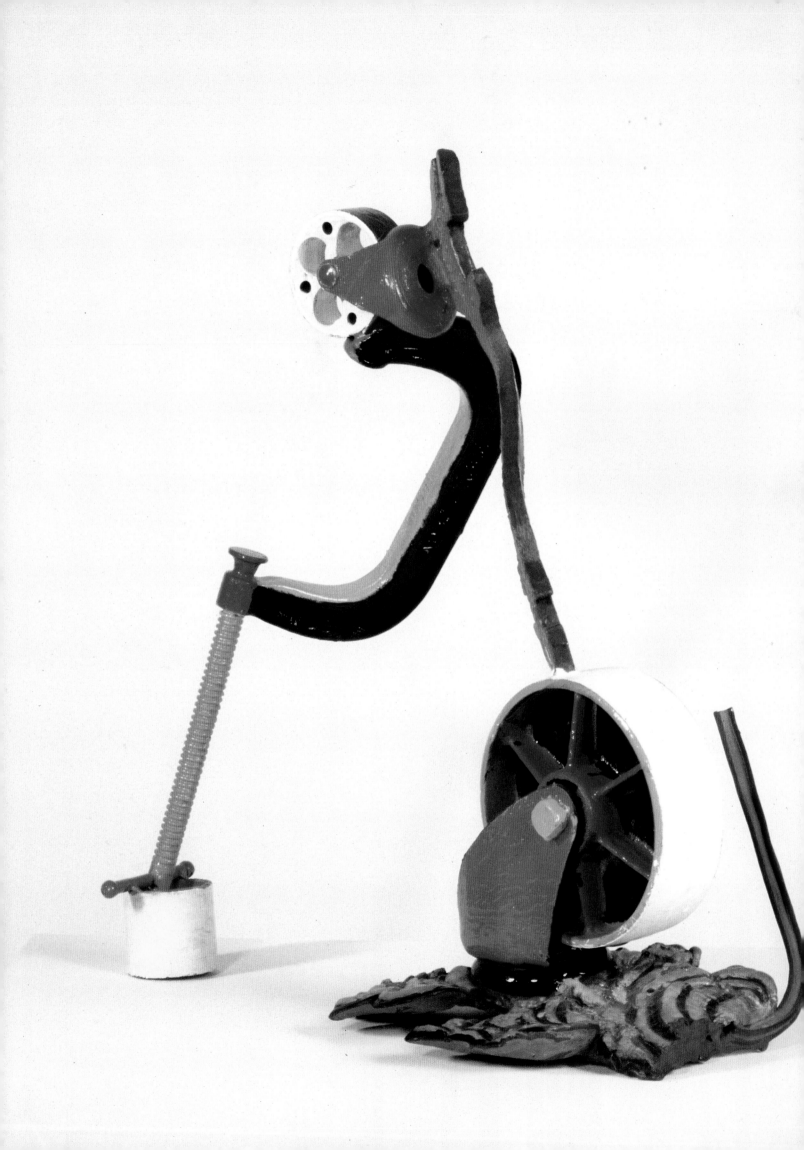

204 Over Under, 1985
Bronze and steel with polychrome patina, polyurethane paint, and baked enamel. 19½ × 21¼ × 13½ (49.5 × 54 × 34.3). Inscribed on wheel: *N. S. Graves OVER UNDER 6–30–85 TX.*

COLLECTION
Agnes Gund

PROVENANCE
M. Knoedler & Co., Inc., New York

EXHIBITIONS
Poughkeepsie, New York: Vassar College Art Gallery (traveling exhibition; bw p. 37), 1986

REMARKS
Over Under has movable parts with alternate positions.

205 Personate, 1985
Bronze with polychrome patina and baked enamel. 26 × 15¾ × 11¾ (66 × 40 × 29.9). Inscribed on side: *N. S. Graves PERSONATE '85 TX.*

COLLECTION
Dr. and Mrs. Marc Grossman

PROVENANCE
M. Knoedler & Co., Inc., New York

206 Post and Lintel, 1985
Bronze with polychrome patina. 106 × 82½ × 24½ (269.2 × 209.5 × 62.2). Inscribed on center of horizontal element: *POST AND LINTEL N. S. Graves 9 '85 TX.*

COLLECTION
Private collection

REMARKS
Here the normal order of post-and-lintel architecture is disrupted as the lintel forms the base. This reverses the expected location of support from above to below. The crayfish at the tops of the directly cast bronze bamboo poles (which are the nonsupporting "posts") accentuate their height to establish scale.

207 Rope Trap, 1985
Bronze with polyurethane paint. 56 × 65 × 38 (142.2 × 165.1 × 96.5). Inscribed on cylinder, approximately 13 in. high: *ROPE TRAP N. S. Graves 8–85 TX.*

COLLECTION
Mr. and Mrs. Robert Dubofsky, Kings Point, New York

PROVENANCE
M. Knoedler & Co., Inc., New York

EXHIBITIONS
New York: M. Knoedler & Co., Inc. (checklist no. 1), 1985–86

REMARKS
Rope Trap was made with direct casts, fabricated parts, sand casting, and polyurethane paint. This sculpture is an outdoor piece of one unit.

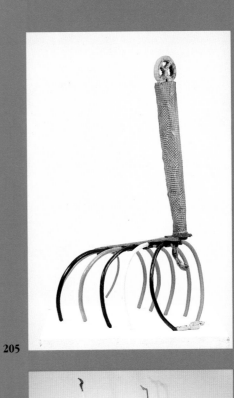

205

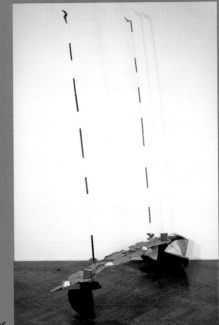

206

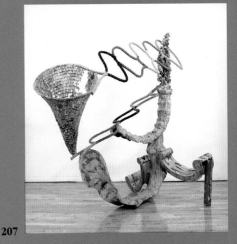

207

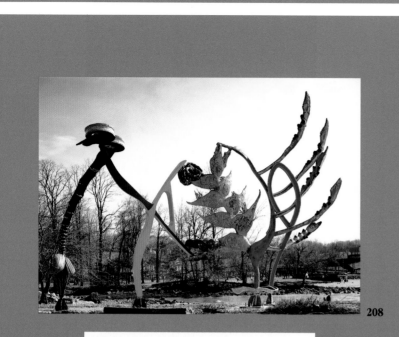

208

209

210

208 Sequi, 1984–85

Bronze with polyurethane paint. 156 × 224 × 96 (396.2 × 569 × 243.8). Inscribed on vine, near base: *N. S. Graves SEQUI 1984–85 TX.*

COLLECTION

Maguire—Thomas Partners-Crocker Bank, Los Angeles

PROVENANCE

M. Knoedler & Co., Inc., New York

REFERENCES

Frank, *Connoisseur* 216 (February 1986), color p. 61. Muchnic, *The Los Angeles Times*, 21 February 1986, bw p. VI1.

REMARKS

Sequi is made of cast and fabricated bronze with a polychrome weatherproof-paint surface. It is an open sculpture that touches the ground at four points and invites the viewer to walk through and around it. Elements include directly cast deerfoot fern, banana blossom, *Heliconia*, or lobster claw, a seed pod, and vines.

The sculpture is a visual contradiction in that it seems to defy gravity. Its apparent visual weightlessness is achieved by the delicate balance of the four base points and the fluid tapped joints, which appear to be nonsupporting.

209 The Singer, 1985

Bronze with polyurethane paint. 56 × 33½ × 25 (142.2 × 85.1 × 63.5). Inscribed, approximately 54 in. high: *THE SINGER N. S. Graves 6–85 TX.*

COLLECTION

Private collection

REMARKS

The Singer was made with direct casts, sand casts, braided-bronze tubing, and polyurethane paint. Individual hanging elements were directly cast from a venetian blind. This sculpture has many movable parts.

210 Snatch Load Block, 1985

Bronze and steel with polyurethane paint and polychrome patina. 73½ × 60 × 65 (186.7 × 152.4 × 165.1). Inscribed on top of bar attached to wheel: *SNATCH LOAD BLOCK N. S. Graves 11–85 TX.*

COLLECTION

Richard Ekstract, New York

PROVENANCE

M. Knoedler & Co., Inc., New York

EXHIBITIONS

New York: M. Knoedler & Co., Inc. (checklist no. 4), 1985–86

REMARKS

The disk cantilevered off the fan is movable. The cast-iron wheel was originally used for rolling sod. A cast-bronze six-holed form for holding bread dough, with the bronze sprues still attached, reaches from the floor to the top of the wheel.

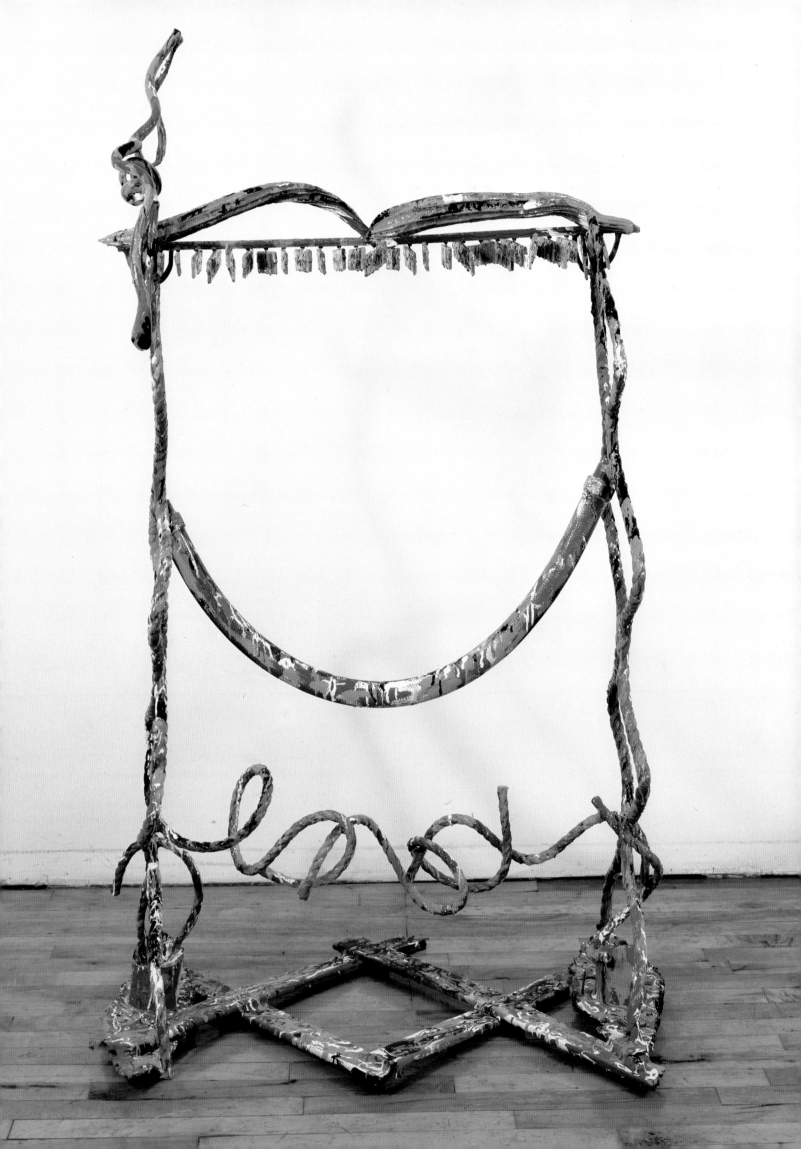

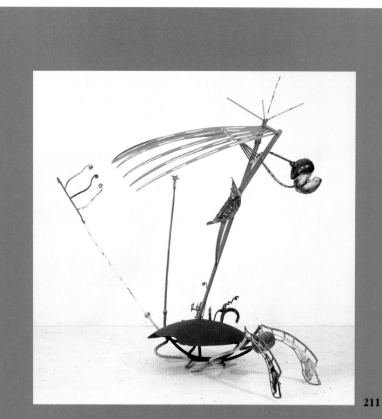

211

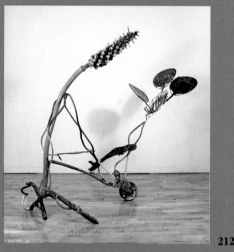

212

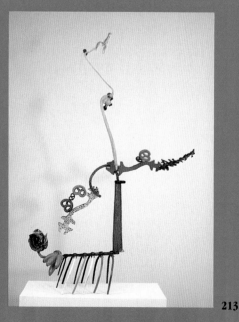

213

211 Le Sourire, 1985
Bronze and steel with polychrome patina, baked enamel, and polyurethane paint. 74¼ × 74¼ × 54¼ (188.6 × 188.6 × 137.8). Inscribed on green rim, approximately 50 in. high: *LE SOURIRE N. S. Graves IX '85 TX.*

COLLECTION
The Ludwig Collection, Aachen, West Germany

EXHIBITIONS
New York: M. Knoedler & Co., Inc. (checklist no. 3), 1985–86

REFERENCES
Berman, *Artneus* 85 (February 1986), color p. 56.

REMARKS
Le Sourire ("the smile" in French) has one movable part. The cast-iron sphere was part of a lawn mower. A Shaker rake was cast in bronze. Eight-inch nails form the hair at the top. The piece was inspired by Picasso's *Head of a Woman* (1929–30, Musée Picasso, Paris), from his brief Surrealist period.

212 Span Link Cross, 1985
Bronze and steel with polyurethane paint, polychrome patina, and baked enamel. 54½ × 56 × 31 (138.4 × 142.2 × 78.7). Inscribed on top of hose, approximately 42½ in. high: *SPAN LINK CROSS N. S. Graves 3–85 TX.*

COLLECTION
Private collection

REFERENCES
Frank, *Connoisseur* 216 (February 1986), color p. 56.

REMARKS
Span Link Cross was made with direct casts, molten-bronze spills, polyurethane paint, baked enamel, and polychrome patina. It has movable parts.

213 Spinner, 1985
Bronze with polychrome patina and baked enamel. 53½ × 25 × 31 (135.9 × 63.5 × 78.7). Inscribed on yellow wrench, approximately 26 in. high: *SPINNER N. S. Graves 8–85 TX.*

COLLECTION
National Gallery of Art, Washington, D.C., gift of the Lila Acheson Wallace Fund. No. 1986.19.1.

PROVENANCE
M. Knoedler & Co., Inc., New York

REMARKS
Spinner is made up of sixteen directly cast parts that were selected from the artist's foundry inventory and assembled in about an hour. From left to right and bottom to top the main parts are: a dried fish maw, directly cast and enameled; a tropical bean; a bunch of bananas; and a kind of fork used for night fishing (coated with pitch and ignited as a torch), with the prongs turned upside down. The handle of the fork is the main vertical shaft of the sculpture, which moves (or "spins") 360 degrees, and welded to it is a cast dried vine, painted pink; together these form the "spinner" element of the sculpture. To the right of the weld and perpendicular to it are a red and yellow multipurpose wrench, made from cast gating and packing materials, and three directly cast small and large pretzels. A swivel is attached between the pretzel and the handle of the fork and the vertical vine. The wrench rests on a pin which allows the top half to swivel. To the left are sardines that have been strung together in the traditional Japanese packing style, and an additional wrench and pretzels; the top element is a tiny yellow crayfish, perched at the sculpture's pinnacle to give the other elements a monumental scale.

The sculpture has an underlying anthropomorphic connotation: the crayfish can stand for a head, the right and left horizontal elements can be seen as arms, the handle as a torso, the semicircular prongs as legs, and the fish maw as a tail. The fork is made of cast gating wax, the neck of cast packing paper. The neck, spine, and legs were directly cast as a single unit.

The bronze is patinated, sealed with acrylic lacquer, and waxed, except where it is enameled.

214 Stupa, 1985
Bronze with polychrome patina and baked enamel. 17½ × 3¼ × 3¼ (44.5 × 8.3 × 8.3). Inscribed: *STUPA N. S. Graves 7–85 TX.*

COLLECTION
Kay, Collyer & Boose, New York

REMARKS
The title refers to the architectural form of the Hindu stupa, in which sphere tops sphere (in this case, pretzels directly cast in bronze) in a vertical progression seemingly *ad infinitum.*

215 Swivel Turn, 1985
Bronze and steel with baked enamel, polychrome patina, and polyurethane paint. 17¼ × 37 × 17½ (43.8 × 94 × 44.5). Inscribed on blue spatula: *SWIVEL TURN N. S. Graves X–16–85 TX.*

COLLECTION
Private collection

REMARKS
This piece is variable in placement and size, as the tip of each part is attached to the others by a swivel or hinge.

216 3 × 4, 1985
Bronze with baked enamel and polyurethane paint. 36¾ × 17½ × 12¾ (93.3 × 44.4 × 32.4). Inscribed on scissors, approximately 6 in. high: *3 × 4 N. S. Graves 6–18–85 TX.*

COLLECTION
Private collection

REMARKS
This is a proposal for an outdoor sculpture. Direct casts were used.

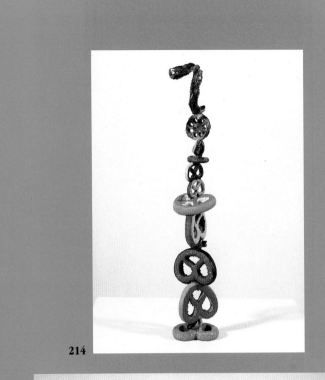

214

215

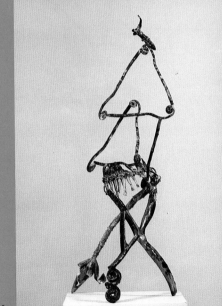

216

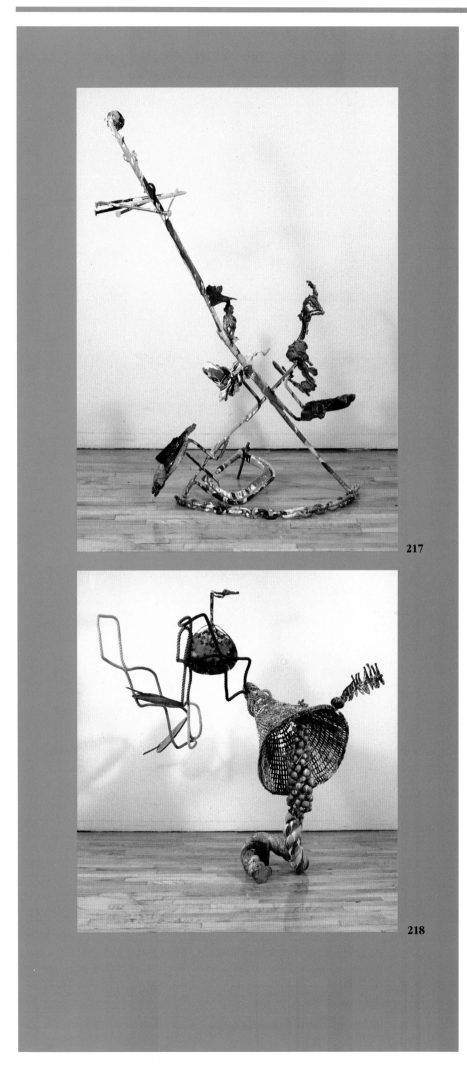

217

218

217 Torsional, 1985
Bronze and steel with polyurethane paint and baked enamel. 50 × 40½ × 26 (127 × 102.9 × 66). Inscribed on fern, approximately 35 in. high: *TORSIONAL N. S. Graves 5–85 TX.*

COLLECTION
Phyllis and William Mack

PROVENANCE
M. Knoelder & Co., Inc., New York

EXHIBITIONS
Poughkeepsie, New York: Vassar College Art Gallery (traveling exhibition, bw p. 36), 1986

REMARKS
Torsional was made with direct casts, molten-bronze spills, baked enamel, and polyurethane paint. The sculpture has movable parts.

218 Trap, 1985
Bronze and steel with polyurethane paint and baked enamel. 49½ × 42½ × 51¼ (125.7 × 107.9 × 130.2). Inscribed on end of heavy rope, approximately 2 in. high: *TRAP N. S. Graves 5–85 TX.*

COLLECTION
Private collection

EXHIBITIONS
Tokyo: Wacoal Art Center (color n.p.), 1985

REMARKS
Trap was made with direct casts, polyurethane paint, and baked enamel.

219 Twelve Spheres, 1985

Bronze and steel with polyurethane paint. 77¾ × 51 × 27 (197.5 × 129.5 × 68.6). Inscribed on vertical bronze ingot at base: *TWELVE SPHERES N. S. Graves 9 '85 TX.*

COLLECTION
Bill and Donna Nussbaum, Saint Louis

PROVENANCE
M. Knoedler & Co., Inc., New York

REMARKS
Twelve Spheres has one movable part: the caster welded to the rebar. The stainless-steel rings were cut from a pole six inches in diameter with an acetylene torch, leaving a jagged, beaded edge.

220 Unlimited, 1985

Bronze and steel with polychrome patina, polyurethane paint, and baked enamel. 26¼ × 28 × 23 (66.7 × 71.1 × 58.4). Inscribed on purple banana: *UNLIMITED N. S. Graves 6–27–85 TX.*

COLLECTION
Norman and Nancy Lipoff, Florida

PROVENANCE
M. Knoedler & Co., Inc., New York

REMARKS
Unlimited has movable parts that can take alternate positions.

221 Unnerve, 1985

Bronze and steel with polychrome patina, polyurethane paint, and baked enamel. 54¼ × 49 × 40 (137.8 × 124.5 × 101.6). Inscribed on top of salmon-colored pod: *UNNERVE N. S. Graves X '85 TX.*

COLLECTION
Private collection

219

220

221

222

222

222 Variable Forms, 1985
Bronze and steel with polyurethane paint and baked enamel. $20\frac{1}{2} \times 25 \times 27$ ($52.1 \times 63.5 \times 68.6$). Inscribed on drain elbow: *VARIABLE FORMS N. S. Graves '85 TX.*

COLLECTION
Mr. and Mrs. George M. Young, Fort Worth, Texas

PROVENANCE
M. Knoedler & Co., Inc., New York

223 Vertilance (Pendula Series), 1985
Bronze and steel with polyurethane paint and polychrome patina. $90 \times 45 \times 19\frac{1}{2}$ ($228.6 \times 114.3 \times 49.5$). Inscribed on pink and blue links, approximately 46 in. high: *VERTILANCE TX N. S. Graves 3–85.*

COLLECTION
Private collection

PROVENANCE
M. Knoedler & Co., Inc., New York

EXHIBITIONS
New York: M. Knoedler & Co., Inc. (checklist no. 10), 1985–86

REMARKS
Vertilance was made with direct casts and polyurethane paint. It has movable parts.

224 Vessel, 1985
Bronze with baked enamel and polychrome patina. $9\frac{1}{4} \times 35 \times 11\frac{1}{2}$ ($23.5 \times 88.9 \times 29.2$). Inscribed on bottom blue rim: *VESSEL N. S. Graves X–85 TX.*

COLLECTION
Private collection

REMARKS
Vessel was inspired by an Italic bronze fibula dating from the eleventh or tenth century BC at Yale University Art Gallery, New Haven.

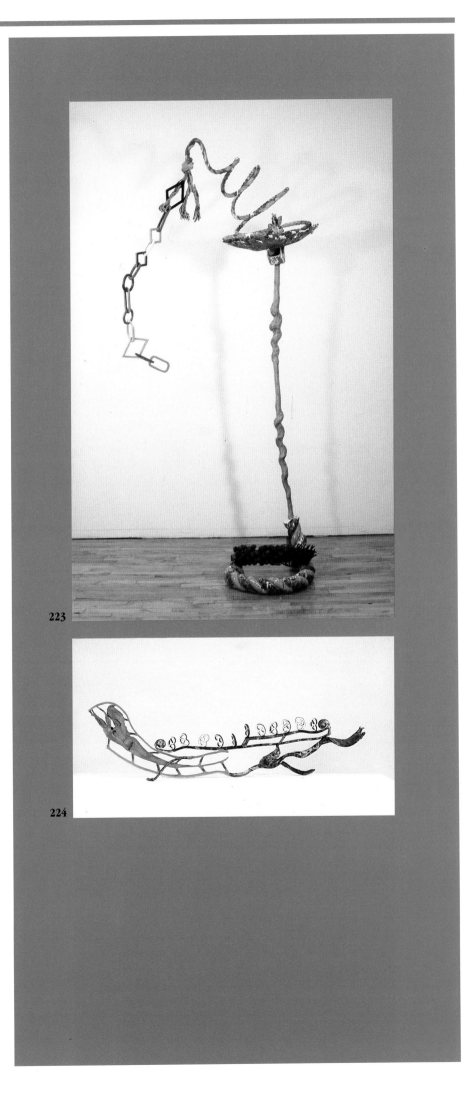

223

224

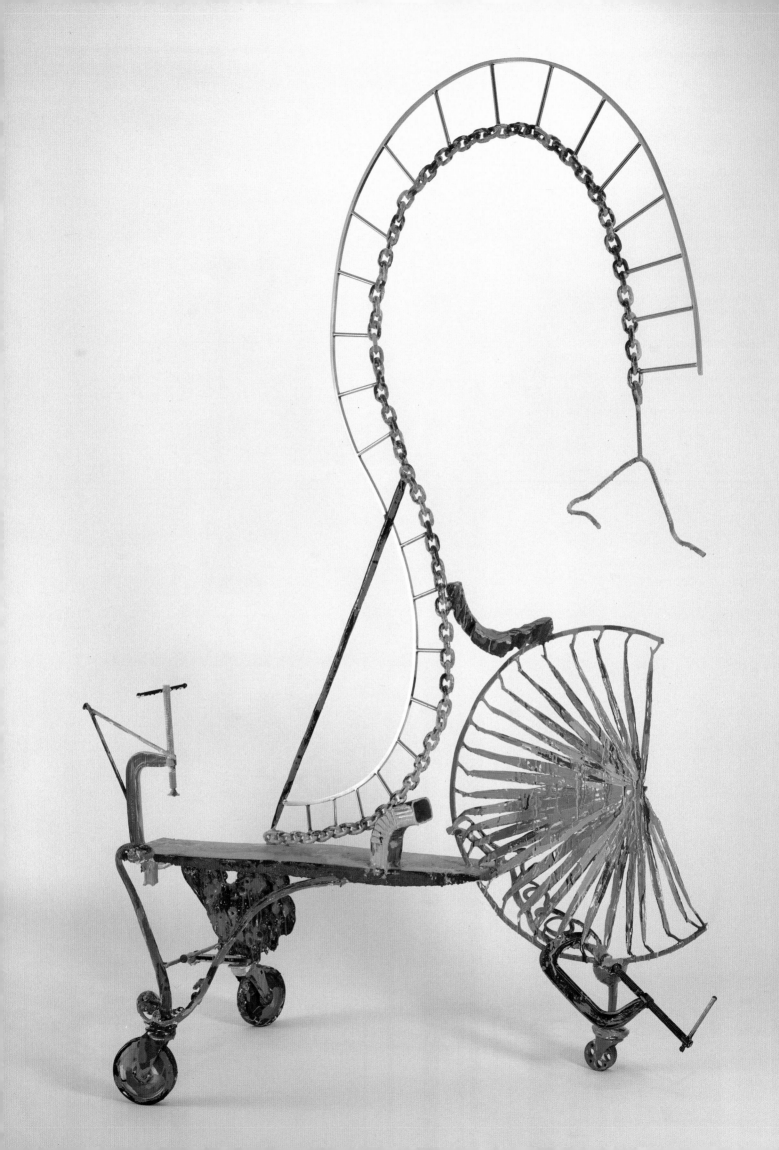

225 Wheelabout, 1985
Bronze and steel with polyurethane paint. 92½ × 70 × 32½ (235 × 177.8 × 82.6). Inscribed on diagonal pole, approximately 40 in. high: *WHEELABOUT N. S. Graves 7–85 TX.*

COLLECTION
The Fort Worth Art Museum, gift of Mr. and Mrs. Sid R. Bass

PROVENANCE
M. Knoedler & Co., Inc., New York

EXHIBITIONS
New York: M. Knoedler & Co., Inc. (checklist no. 6), 1985–86

REFERENCES
"Cover Story," *The Fort Worth Art Museum March–April Calendar*, 1986, color cover, comm. pp. 6–7. "FW Museum Acquires Eight Works," *The Dallas Times Herald*, 12 February 1986, bw. Kutner, *The Dallas Morning News*, 16 February 1986, bw p. 8C. Sewell, *The Fort Worth Star Telegram*, 12 February 1986, color p. 1.

REMARKS
Wheelabout was made with direct casts, fabricated and stainless steel, molten-bronze spills, sand casting, and polyurethane paint. The *s* curve is made of stainless steel. The sculpture has movable parts.

226 Wheeler, 1985
Bronze and steel with polyurethane paint and baked enamel. 77 × 63½ × 28 (195.6 × 161.3 × 71.1). Inscribed on orange rim, approximately 29½ in. high: *WHEELER N. S. Graves 5–85 TX.*

COLLECTION
Suzanne Usdan

PROVENANCE
M. Knoedler & Co., Inc., New York

REMARKS
Wheeler was made with direct casts, polyurethane paint, and baked enamel.

227 Whiffle Tree (Pendula Series), 1985
Bronze and steel with polyurethane paint. 97 × 60 × 65 (246.4 × 152.4 × 165.1). Inscribed approximately 31 in. high: *WHIFFLE TREE N. S. Graves 5–85 TX.*

COLLECTION
Mr. and Mrs. Jimmy Younger, Houston

PROVENANCE
M. Knoedler & Co., Inc., New York

EXHIBITIONS
New York: M. Knoedler & Co., Inc. (checklist no. 8), 1985–86

REFERENCES
Larson, *New York Magazine* 19 (13 January 1986), color p. 58.

REMARKS
Whiffle Tree was made with direct casts, sand-casting gates, stainless-steel rod, and polyurethane paint. This sculpture can be placed outdoors, and has movable parts.

228 Zick Zack (Stained-Glass Series), 1985
Baked enamel on bronze with acrylic paint. 19¼ × 19½ × 21 (48.9 × 49.5 × 53.3). Inscribed on red rod, approximately 14 in. high: *ZICK ZACK N. S. Graves 1–85 TX.*

COLLECTION
Dorry Gates Gallery, Kansas City, Missouri

PROVENANCE
M. Knoedler & Co., Inc., New York

REMARKS
Zick Zack was made with direct casts, molten-bronze spills, baked enamel, and acrylic paint. The sculpture has movable parts.

226

227

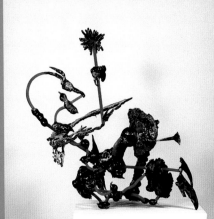

228

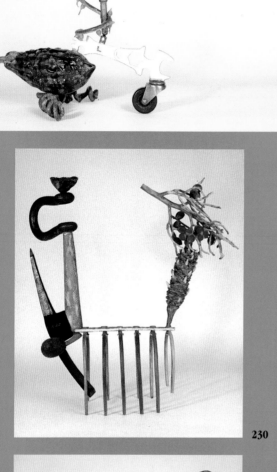

229

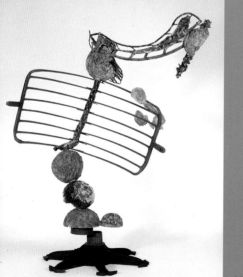

230

232

229 Cockatrice, 1986

Bronze, steel, zinc, tin, and plastic with baked enamel, polychrome patina, and polyurethane and oil paint. 14 × 17 × 8½ (35.6 × 43.2 × 21.6). Inscribed on wrench: *COCKATRICE N. S. Graves III–13–86 TX.*

COLLECTION

Laura Y. Taylor, Berwyn, Pennsylvania

PROVENANCE

M. Knoedler & Co., Inc., New York

REMARKS

Cockatrice was made with direct casts, baked enamels, and ready-made parts, including a zinc-and-tin funnel.

230 Contingence, 1986

Bronze and steel with polychrome patina and baked enamel. 27½ × 24½ × 10 (69.8 × 62.2 × 25.4). Inscribed on black pick: *CONTINGENCE N. S. Graves III–19–86 TX.*

COLLECTION

Dr. and Mrs. Paul Polydoran, Des Moines, Iowa

REMARKS

Contingence was made with direct casts, baked enamels, and ready-made parts.

231 Coptic, 1986

Bronze with baked enamel and polychrome patina. 25½ × 27 × 13 (64.8 × 68.6 × 33). Inscribed on bronze bar, approximately 10 in. high: *COPTIC N. S. Graves 1–29–86 TX.*

COLLECTION

Mr. and Mrs. Walter B. Ford II, Dearborn, Michigan

REMARKS

Coptic was made with direct casts, bronze spills, and baked enamels. The cut, cast-bronze Chinese cucumbers and glass-enameled objects are placed within a diamond shape made of quarter-inch-by-half-inch bronze bar. This creates a figure-ground tension related to the patterns in Coptic cloth. A so-called "decorative" border of cucumber sections fastened to the bar surrounds the "figurative" central elements in a typical Coptic format.

232 Diana, 1986

Bronze and iron with polychrome patina and baked enamel. 42 × 32½ × 20½ (106.7 × 82.5 × 52.1). Inscribed on iron handle, 27 in. high: *DIANA N. S. Graves II–15 86 TX.*

COLLECTION

Mr. and Mrs. Harold Blankenstein, Beverly Hills, California

REMARKS

Diana was made with direct casts, baked enamels, sand casting, and ready-made parts. In the center of the work two pitchforks are welded together at the tine tips.

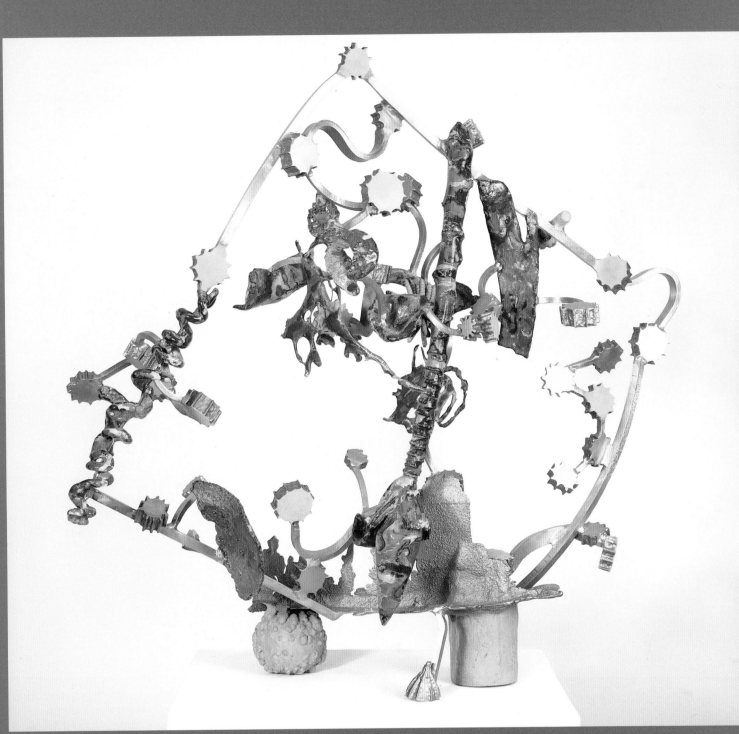

231

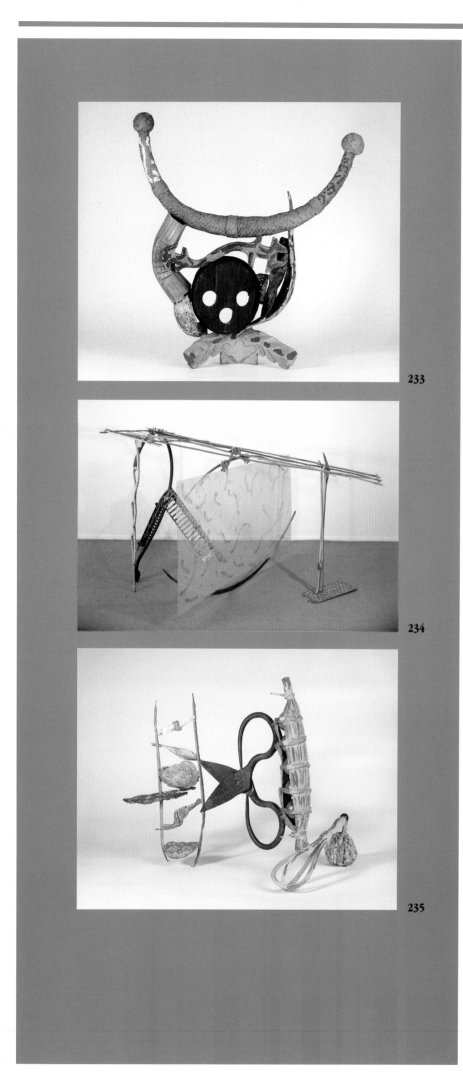

233

234

235

233 Ensor, 1986

Bronze and wood with polychrome patina and baked enamel. 24½ × 23 × 6½ (62.2 × 58.4 × 16.5). Inscribed on wrench: ENSOR N. S. Graves III–19–86 TX.

COLLECTION

Richard and Mary L. Gray, Chicago, Illinois

REMARKS

Ensor was made with direct casts, sand casting, and baked enamels. A turn-of-the-century circular wooden form for hauling rope becomes a face. A seaman's braid is cast in bronze. *Ensor* is based on Picasso's 1948 sculpture *Femme* in the Musée Picasso, Paris. The title acknowledges the paintings of masked figures of James Ensor and the piece also calls to mind *The Scream* of Edvard Munch, in the National Museum, Oslo.

234 Eye to Eye, 1986

Bronze, iron, and steel with polychrome patina and polyurethane paint. 82 × 71 × 52 (208.3 × 180.3 × 132.1). Inscribed on blue section of bamboo: EYE TO EYE N. S. Graves III–86 TX.

COLLECTION

Private collection

REMARKS

Eye to Eye was made with direct casts, sand casting, and found objects. Two elements of a cast-iron barbecue grill form one of the bases of this sculpture of three separate parts. A cast-bronze bamboo nautical star chart, inspired by a Melanesian artifact, a sheet of diamond-shaped expanded metal, a fifty-inch-tall, turn-of-the-century steel hook, a sand-cast bronze apple picker, and a sand-cast bronze wedge of wood comprise the most important elements.

235 Five Eggs, 1986

Bronze and iron with polychrome patina and baked enamel. 15½ × 18 × 12 (39.4 × 45.7 × 30.5). Inscribed on oyster shell: FIVE EGGS N. S. Graves III–12–86 TX.

COLLECTION

Ann and Robert Freedman, New York

PROVENANCE

M. Knoedler & Co., Inc., New York

REMARKS

Five Eggs was made with direct casts, bronze spills, baked enamels, and ready-made parts. The sculpture has movable parts: the five eggs as well as the enameled form pierced by the vertical bean. The title refers to the five directly cast eggs at the right, wrapped in the traditional Japanese manner.

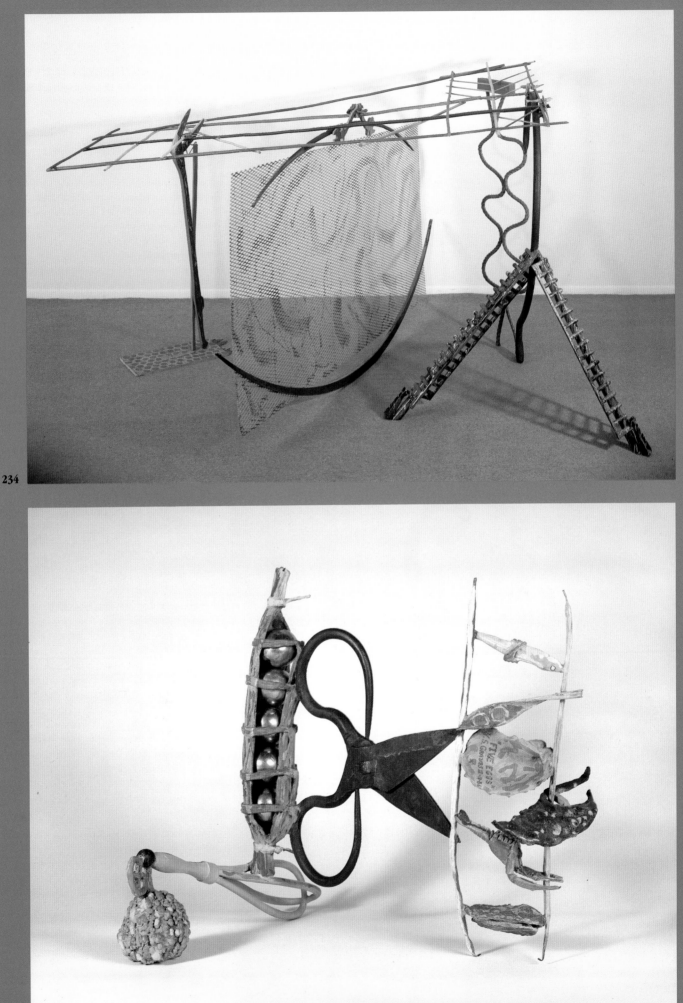

234

235

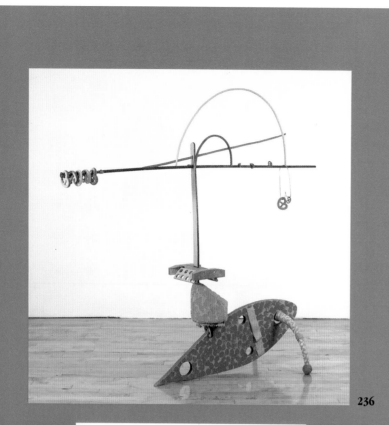

236

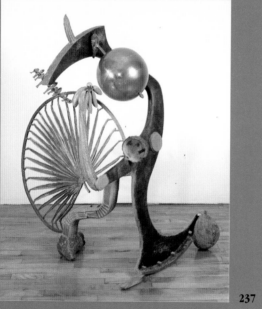

237

239

236 Mete-Point-Balance-Bound, 1986

Bronze with polychrome patina. 58½ × 72 × 22½ (148.6 × 182.9 × 57.2). Inscribed on red rim of bronze snowshoe: *METE-POINT-BALANCE-BOUND N. S. Graves 1–21–86 TX.*

COLLECTION
Private collection

REMARKS
Mete-Point-Balance-Bound was made with direct casts and sand casting. The two pretzels suspended on a wire from a bronze bamboo rod can be moved into any of three positions, and the five large pretzels on the other end of the rod can also be moved, to counter-balance it horizontally.

237 Morphose, 1986

Bronze and copper with polychrome patina and baked enamel. 54 × 39 × 39 (137.2 × 99.1 × 99.1). Inscribed on rim of gating on top of palmetto leaf, approximately 33 in. high: *MORPHOSE N. S. Graves 11–12–86 TX.*

COLLECTION
Private collection

REMARKS
Morphose was made with direct casts, sand casting, and baked enamels. Because the sculpture has a movable part, the float, its dimensions are variable. It is based on a Picasso sculpture of 1928, *Metamorphose I*, in the Musée Picasso, Paris. Elements include a sand-cast ship's rotor, a copper ball from a water tank that swirls and spins 360 degrees, a rope of sardines, several directly cast, bisected toy balls, and gourds.

238 Quincunx, 1986

Aluminum, wood, bronze, and steel with polychrome patina and polyurethane paint. 105 × 65 × 43 (266.7 × 165.1 × 109.2). Inscribed on large leaf: *QUINCUNX N. S. Graves III–86 TX.*

COLLECTION
Private collection

REMARKS
The title refers to the five vertical layers of the piece. The base is formed of sprues, pretzels, and a bronze wedge. A *Monstera* leaf is the horizontal second element. Above this, a long bar of wrought half-inch square aluminum forms a linear map and is the third layer. A wooden, diamond-patterned folding gate, such as is used to block off a stairway, is the topmost element, and is held in place by stainless-steel bamboo rods. A heat-rotated exhaust vent is the fifth element.

239 Trimote, 1986

Bronze, steel, and iron with polychrome patina. 11½ × 17 × 8 (29.2 × 43.2 × 20.3). Inscribed on steel circle: *TRIMOTE N. S. Graves III –19–86 TX.*

COLLECTION
Private collection

REMARKS
Trimote was made with direct casts, sand casting, and ready-made parts. It comprises only four elements: a stainless-steel, torch-cut ring, six inches in diameter, which is welded to a steel railroad clamp, a quarter section of bronze gourd, and a directly cast piece of ginger. The title refers to the three sections of the sculpture.

240

241

240 Uplift, 1986

Bronze and iron with polychrome patina. 81 × 50 × 23 (205.7 × 127 × 58.4). Inscribed, approximately 31 in. high: *UPLIFT N. S. Graves 1–24–86 TX.*

COLLECTION
Private collection

REMARKS
Uplift was made with direct casts, sand casting, and ready-made parts. A cast-iron wheel is supported by bronzed sailor's braid and a bronze sand casting of a wooden paddle. Above this is a hay shovel cut from sheet wax and directly cast. Movable fiddlehead ferns are attached by looped wires to the shovel and to a cockscomb blossom at the top of the piece.

241 Vanitas, 1986

Bronze and steel with polychrome patina and baked enamel. 9½ × 13 × 6 (24.1 × 33 × 15.2). Inscribed on inside of lid: *VANITAS N. S. Graves 1–3–86 TX.*

COLLECTION
Private collection

REMARKS
Vanitas was made with direct casts and baked enamel. This sculpture has a body made of a cast jackfruit with a movable, hinged lid and five elements that are attached to the inside of the fruit with quarter-inch steel-link chain. These are: a whisk, a crayfish, a doorknob, a piece of glass-enameled plantain bark, and a seedpod. It is possible to move them from the inside to the outside, and to arrange them in various positions.

242 Model for Harvester KC, 1986
Mixed media. 15 × 11 × 15 (38 × 28 × 38).

COLLECTION
Private collection

REMARKS
The model contains forms derived from topography and botany. It is a
maquette for a commissioned sculpture for the United Missouri Bank
in Kansas City, Missouri, and is the first sculptural paper model
Graves has done since the mid-1970s.

242

242

242

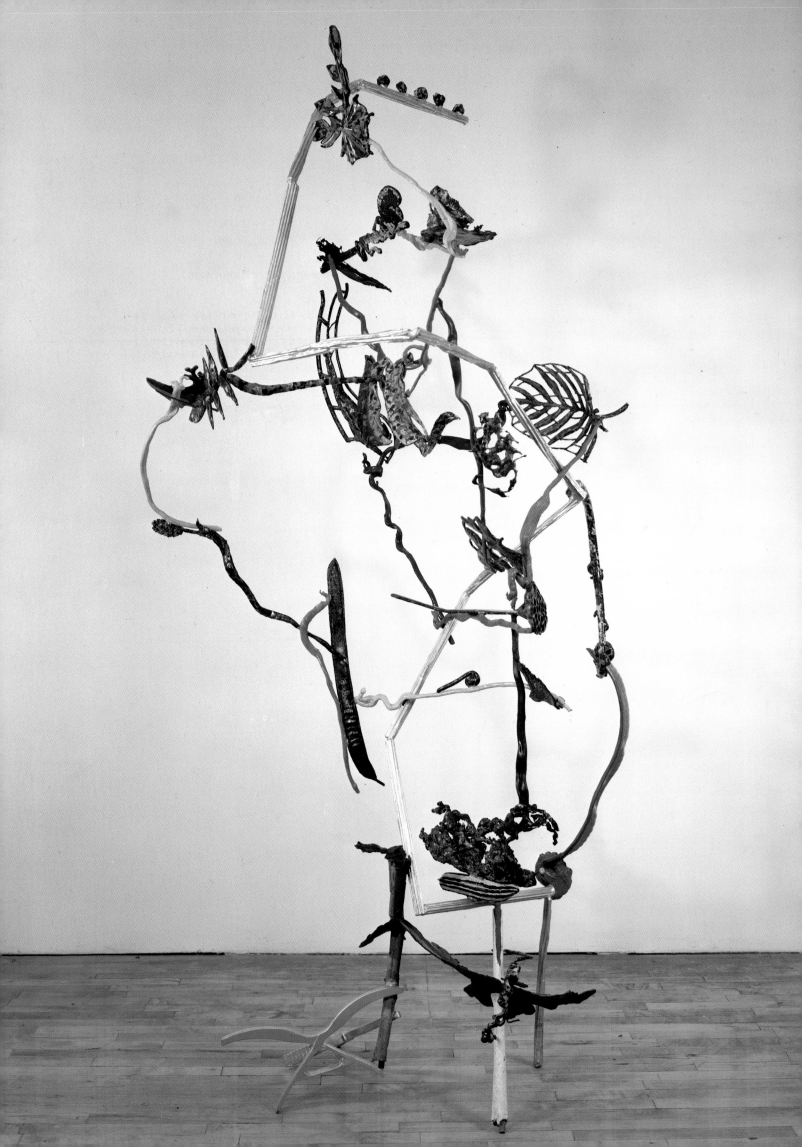

1940

Born Nancy Stevenson Graves on 23 December, in Pittsfield, Massachusetts.

1957–61

Studied at Vassar College, Poughkeepsie, New York. Received Bachelor of Arts degree in English literature in 1961.

1959

Awarded Fellowship in Painting to Yale-Norfolk Summer Art School.

1961–64

Studied at the School of Art and Architecture, Yale University, New Haven. Received Bachelor of Fine Arts degree in 1962 and Master of Fine Arts degree in 1964.

1964

Received a Fulbright-Hayes Grant in Painting to study in Paris for a year. Studied the paintings of Henri Matisse and Indian miniatures. Lived in an artist's studio duplex on rue d'Arsonval in the fifteenth arrondissement. Filled sketchbooks with charcoal drawings made in the Brancusi Room at the Musée d'Art Moderne de la Ville de Paris. Made prints with Maurice Beaudet. Made large oil paintings, which she later destroyed. Visited Spain, London, and the Netherlands. Studied work by Cézanne, Matisse, Picasso, and Fernand Léger in Aix-en-Provence and the Riviera.

1965

Lived and worked in Florence, Italy. Photographed the wax models of Clemente Susini, an eighteenth-century anatomist, and investigated taxidermy at La Specola, the Florence museum of natural history. Moved conceptually from painting to sculpture by experimentation in various modes and techniques. While making the first camel sculptures (which she destroyed before leaving Florence), collaborated with Richard Serra on sculptural assemblages incorporating live and stuffed animals, which became Serra's exhibition at Galleria La Salita, Rome.

1966

Moved in September to New York, where she continues to work and live. Established a studio in a loft at 164 Mulberry Street, in Little Italy. Met Robert Smithson and Eva Hesse. Taught for two years at Fairleigh Dickinson University, Madison, New Jersey. There she worked with a carpenter to devise armatures for the camel sculptures.

1968

Investigated anatomy, anthropology, and archaeology to develop better her ideas about sculpture. First one-artist sculpture exhibition at Graham Gallery, New York. Introduced to Yvonne Rainer.

1969

First artist given a one-woman exhibition at Whitney Museum of American Art, New York. Employed up to fifteen assistants in New York to work on early stages of "fossil" sculptures.

1970

With Linda Leeds as advisor and editor, started to make first of five films. Photographed *Goulimine, 1970* in Morocco. Met Trisha Brown at an Yvonne Rainer performance at Whitney Museum of American Art.

1971

Received Vassar College Fellowship. Filmed *Izy Boukir* in Morocco. Made drawings and six large sculptures in Aachen, West Germany, for a solo exhibition at the Neue Galerie. Taught at the San Francisco Art Institute, where, in August, *Variability and Repetition of Variable Forms* (cat. no. 32) was made.

1972

Ceased making sculpture and returned to painting. Made silkscreen prints, based on geologic maps of the moon, with Jack Lemon at Landfall Press in Chicago. Received a National Endowment for the Arts grant.

1974

Moved to present studio in Manhattan.

1976

Commissioned to create a bronze version of *Fossils* (cat. no. 14) for the Museum Ludwig, Cologne. Learned the lost-wax process of bronze casting at Tallix Foundry, then in Peekskill, New York, and began to work experimentally in bronze. Received the Skowhegan Medal for Drawing/Graphics.

1977

Created etchings, lithographs, and monotypes at Tyler Graphics, Bedford Village, New York.

1978

Traveled to India, Nepal, and Kashmir.

1979

Was a resident at the American Academy in Rome. Made prints, incorporating etching, aquatint, and drypoint, with Walter and Eleanora Rossi at 2RC, Rome. Created *Variability and Repetition of Similar Forms II* (cat. no. 54) at Johnson Atelier, Princeton, New Jersey.

1980

Visited Egypt. Fabricated outdoor sculptures at Lippincott, Inc., North Haven, Connecticut. A survey of her drawings, paintings, and sculpture, originated by the Albright-Knox Art Gallery, Buffalo, traveled nationally through 1981.

1982

Traveled to Peru; visited Machu Picchu and collected orchids as source material for paintings and drawings.

1983

Using a technique invented by Richard Polich of Tallix Foundry and the artists Babette Holland and Mark Loftin, applied powdered glass to bronze and assembled first enameled sculptures.

1984

Traveled to China. Noted especially the "post-Brancusi" garden sculpture in Beijing's Forbidden City. Created outdoor sculpture sited at Crocker Center, Los Angeles.

1985

In March traveled to Australia; visited Ayers Rock, a source of aboriginal oral history. Designed the sets for Trisha Brown's "Lateral Pass," for which she received a New York Dance and Performance Bessie Award (1986). Visited Hawaii in July. Received Yale Arts Award for Distinguished Achievement.

1986

Received Vassar College Distinguished Visitor Award. Visited the Dominican Republic; was visiting artist at the School of Design, Altos de Chavon. Brought back a selection of plants as future sculpture material. A traveling retrospective of drawings, paintings, and sculpture from 1980 to the present originated at Vassar College. Worked on outdoor sculpture commission for United Missouri Bank, Kansas City.

An asterisk denotes a one-person exhibition.

1968

*NEW YORK: Graham Gallery, "Nancy Graves: Camels," 6 April–4 May (3 works)

1969

*NEW YORK: Whitney Museum of American Art, "Nancy Graves: Camels," 24 March–30 April (brochure, 3 works)

1970

AACHEN, West Germany: Neue Galerie im Alten Kurhaus, "Klischee und Antiklischee: Bildformen der Gegenwart," opened 26 February (catalogue, 3 works)

COLOGNE: Galerie Rolf Ricke, "Program III," 26 June–10 September (1 work)

NEW YORK: Whitney Museum of American Art, "1970 Annual Exhibition: Contemporary American Sculpture," 12 December–7 February 1971 (catalogue, 1 work)

1971

*AACHEN, West Germany: Neue Galerie im Alten Kurhaus, "Nancy Graves," 25 September–20 November (catalogue, 9 works)

BUFFALO: Albright-Knox Art Gallery, "Kid Stuff?" 25 July–6 September (checklist, 1 work)

CHICAGO: Museum of Comtemporary Art, "Six Sculptors: Extended Structures," 30 October–12 December (catalogue, 1 work)

*NEW YORK: Gallery Reese Palley, "Nancy Graves," 9 January–3 February (checklist, 9 works)

*NEW YORK: The Museum of Modern Art, "Projects: Nancy Graves," 12 December–2 February 1972 (1 work)

NEW YORK: The School of Visual Arts, "Erasable Structures," 25 January–2 March (1 work)

*POUGHKEEPSIE: Vassar College Art Gallery, "Nancy Graves," 17 October–7 November (3 works)

*SAN FRANCISCO: Gallery Reese Palley, "Nancy Graves: Sculpture, Drawings, Films," 11 September–16 October (1 work)

WASHINGTON, D.C.: The Corcoran Gallery of Art, "Depth and Presence," 3–30 May (catalogue, 1 work)

1972

*CLEVELAND: The New Gallery, "Nancy Graves: Sculpture, Paintings, Drawings, Films," 19 May–15 June (4 works)

HAMBURG: Kunsthaus Hamburg, "American Woman Artist Show," 14 April–14 May (catalogue, 1 work)

KASSEL, West Germany: Neue Galerie, "Documenta 5," 30 June–8 October (catalogue, 1 work)

*PHILADELPHIA: Institute of Contemporary Art, University of Pennsylvania, "Nancy Graves: Sculpture and Drawings, 1970–1972," 22 September–1 November. Exhibition circulated to Cincinnati: Contemporary Arts Center, 1 December–7 January 1973 (catalogue, 9 works)

1973

HUMLEBAEK, Denmark: Louisiana Museum Humlebaek, Cultural Center and Museum of Modern Art, "Ekstrem realisme: Vaerker fra Neue Galerie der Stadt Aachen, Sammlung Ludwig," 10 February–25 March (catalogue, 2 works)

LONDON: Serpentine Gallery, "Photo-Realism: Paintings, Sculpture, and Prints from the Ludwig Collection and Others," 4 April–6 May (catalogue, 1 work)

1974

COLOGNE: Kunsthalle, "Project '74," 6 July–8 September (1 work)

1976

NEW YORK: Whitney Museum of American Art, "Two Hundred Years of American Sculpture," 16 March–26 September (catalogue, 1 work)

WEST BERLIN: Neue Nationalgalerie, "Amerikanische Kunst von 1945 bis Heute," 4 September–7 November (1 work)

1977

VANCOUVER: The Vancouver Art Gallery, "Strata: Nancy Graves, Eva Hesse, Michelle Stuart, Jackie Winsor," 9 October–6 November (catalogue, 1 work)

VIENNA: Kunstlerhaus Wien, "Kunst um 1970—Art around 1970," 8 March–12 June (catalogue, 2 works)

1978

*HOUSTON: Janie C. Lee Gallery, "Nancy Graves," 11 November–31 December (2 works)

*NEW YORK: Hammarskjold Plaza Sculpture Garden, "Nancy Graves: New Work," 6 February–30 April (1 work)

*SEATTLE: Gallery Diane Gilson, "Nancy Graves: New Sculpture, Recent Watercolors, Pastels, Etchings," 14 September–14 October (2 works)

TEHRAN: Tehran Museum of Contemporary Art (in affiliation with the Shahbanou Farah Foundation), "The Ludwig Collection," January (catalogue, 1 work)

1979

PHILADELPHIA: Institute of Contemporary Art, University of Pennsylvania, "Masks, Tents, Vessels, Talismans," 5 December–13 January 1980 (catalogue, 4 works)

ROME: American Academy in Rome, "Annual Exhibition, American Academy in Rome," 22 May–10 June (catalogue, 1 work)

YONKERS, New York: The Hudson River Museum, "Supershow," 20 October–9 December. (Organized by Independent Curators Incorporated, New York.) Exhibition circulated to Saint Paul, Minnesota: Landmark Center, 26 January–9 March 1980; Mesa, Arizona: The Center for Fine Arts, 12 April–4 June; and Cleveland: The New Gallery, 3–31 October (catalogue, 1 work)

ZURICH: Kunsthaus Zurich, "Weich und Plastisch—Soft Art," 16 November 1979–4 February 1980 (catalogue, 2 works)

1980

*BUFFALO: Albright-Knox Art Gallery, "Nancy Graves: A Survey, 1969–1980," 3 May–15 June. Exhibition circulated to Akron: Akron Art Institute, 5 July–31 August; Houston: Contemporary Arts Museum, 20 September–26 October; Memphis: Brooks Memorial Art Gallery, 15 November–6 January 1981; Purchase, New York: Neuberger Museum, State University of New York at Purchase, 25 January–15 March; Des Moines: Des Moines Art Center, 30 March–3 May; and Minneapolis: Walker Art Center, 31 May–12 July (catalogue, 13 works)

NEW YORK: Grey Art Gallery and Study Center, New York University, "Perceiving Modern Sculpture: Selections for the Sighted and Non-Sighted," 8 July–22 August (catalogue, 1 work)

*NEW YORK: M. Knoedler & Co., Inc., "Nancy Graves: New Paintings and Sculpture," 8–27 March (6 works)

WASHINGTON, D.C.: Forrestal Office Building, "Eleventh International Sculpture Center Conference," 4–7 June (1 work)

1981

*CHICAGO: Richard Gray Gallery, "Nancy Graves," 6 November–12 December (3 works)

NEW HAVEN: Yale University Art Gallery, "Twenty Artists: Yale School of Art, 1950–1970," 29 January–29 March (catalogue, 1 work)

NEW YORK: Hamilton Gallery, "Bronze," 30 January–28 February (1 work)

*NEW YORK: M. Knoedler & Co., Inc., "Nancy Graves: Recent Sculpture and Painting," 4–23 April (6 works)

1982

BASEL: Basel Art Fair, "Art 13 '82," 16–21 June (1 work)

BOSTON: Museum of Fine Arts, "A Private Vision: Contemporary Art from the Graham Gund Collection," 6 February–4 April (catalogue, 3 works)

HOUSTON: Contemporary Arts Museum, "In Our Time: Houston's Contemporary Arts Museum, 1948–1982," 22 October 1982–2 January 1983 (catalogue, 1 work)

NEW YORK: Center for Inter-American Relations and Kouros Gallery, "Women of the Americas, Emerging Perspectives," 15 September–17 October (1 work)

*NEW YORK: M. Knoedler & Co., Inc., "Nancy Graves: Recent Sculpture," 16 October–11 November (checklist, 22 works)

PROVIDENCE: Museum of Art, Rhode Island School of Design, "Metals: Cast-Cut-Coiled," 13 August–26 September (checklist, 4 works)

SAN FRANCISCO: Fuller Goldeen Gallery, "Casting: A Survey of Cast Metal Sculpture in the Eighties," 8 July–28 August (catalogue, 1 work)

STUTTGART: Württembergischer Kunstverein Stuttgart, "Vergangenheit Gegenwart Zukunft: Zeitgenössische Kunst und Architektur," 26 May–22 August (catalogue, 1 work)

*ZURICH: M. Knoedler Zurich AG, "Nancy Graves: Recent Sculpture and Paintings," 11 December 1982–15 January 1983 (4 works)

1983

HOUSTON: McIntosh/Drysdale Gallery, "Small Bronzes: A Survey of Contemporary Bronze Sculpture," 12 April–14 May (1 work)

NEW YORK: Barbara Toll Fine Arts Gallery, "Modern Objects," 2–23 April (1 work)

NEW YORK: Whitney Museum of American Art, "1983 Biennial Exhibition: Sculpture, Photography, Installations, Film, Video," 15 March–29 May (catalogue, 3 works)

PITTSFIELD, Massachusetts: The Berkshire Museum, "New Decorative Art," 4 June–31 July. Exhibition circulated to Albany: University Art Gallery, State University of New York at Albany, 6 September–23 October (catalogue, 2 works)

*SANTA BARBARA: Santa Barbara Contemporary Arts Forum, "Nancy Graves: Painting and Sculpture, 1978–82," 5 February–13 March (catalogue, 6 works)

STRATFORD, Ontario: The Gallery/Stratford, "American Accents," 6 June–7 August. Exhibition circulated to Toronto: College Park, 18 August–17 September; Parc des Champs de Bataille, Quebec: Musée du Quebec, 22 September–26 October; Halifax: Art Gallery of Nova Scotia, 5 January–6 February 1984; Windsor, Ontario: Art Gallery of Windsor, 23 February–25 March; Edmonton: The Edmonton Art Gallery, 5 April–13 May; Vancouver: Vancouver Art Gallery, 5 July–26 August; Calgary: Glenbow Museum, 13 September–30 October; and Montreal: Musée d'Art Contemporain, 29 November–30 January 1985 (catalogue, 2 works)

1984

AACHEN, West Germany: Neue Galerie—Sammlung Ludwig, "Aspekte amerikanischer Kunst der Gegenwart," 17 August–16 September. Exhibition circulated to Aalborg, Denmark: Nordjyllands Kunstmuseum; Hovikodden, Norway: Henie-Onstad Art Center; Mainz, West Germany: Mitterlrheinisches Landesmuseum; and Oberhausen, West Germany: Städtische Galerie Schloss Oberhausen (catalogue, 1 work)

KATONAH, New York: The Katonah Gallery, "Transformations," 21 August–14 October (checklist, 2 works)

LOS ANGELES: Margo Leavin Gallery, "American Sculpture," 17 July–15 September (1 work)

LOS ANGELES: Los Angeles County Museum of Art, "Olympian Gestures," 7 June–7 October (checklist, 1 work)

NEWARK: The Newark Museum, "American Bronze Sculpture: 1850 to the Present," 18 October–3 February 1985 (catalogue, 1 work)

NEW YORK: Hirschl & Adler Modern Gallery, "The Skowhegan Celebration Exhibition," 1-31 May (1 work)

NEW YORK: Sidney Janis Gallery, "American Women Artists: Part I, Twentieth Century Pioneers," 12 January–4 February (catalogue, 1 work)

*NEW YORK: M. Knoedler & Co., Inc., "Nancy Graves," 10–29 March (checklist, 26 works)

NEW YORK: The Mendick Company & 909 Third Avenue (organized by Modern Art Consultants), "Chromatics," 13 November–22 February 1985 (checklist, 1 work)

NEW YORK: The Museum of Modern Art, "'Primitivism' in Twentieth Century Art," 27 September–15 January 1985. Exhibition circulated to Detroit: The Detroit Institute of Arts, 27 February–19 May; and Dallas: Dallas Museum of Art, 23 June–1 September, but works were shown only in New York (catalogue, 2 works)

PURCHASE, New York: Neuberger Museum, State University of New York at Purchase, "Hidden Desires, Six American Sculptors," 30 September–23 December (checklist, 1 work)

ROHNERT PARK, California: University Art Gallery, Sonoma State University, "Works in Bronze: A Modern Survey," 2 November–16 December. Exhibition circulated to Redding, California: Redding Museum and Art Center, 1 May–2 June; Palm Springs, California: Palm Springs Desert Museum, 15 November–12 January 1986; Boise: Boise Gallery of Art, 21 February–30 March; and Spokane: Cheney Cowles Memorial Museum, 25 April–1 June (catalogue, 1 work)

SANTA BARBARA: Santa Barbara Museum of Art, "Art of the States: Works from a Santa Barbara Collection," 22 June–26 August (catalogue, 3 works)

SEATTLE: Seattle Art Museum, "American Sculpture: Three Decades," 15 November–27 January 1985 (checklist, 1 work)

TOLEDO: Downtown Toledo, The Toledo Museum of Art, and Crosby Gardens, "Citywide Contemporary Sculpture Exhibition," 15 July–14 October (catalogue, 1 work)

WILLIAMSTOWN, Massachusetts: Williams College Museum of Art, "Six in Bronze," 15 January–26 February. Exhibition circulated to Pittsburgh: Museum of Art, Carnegie Institute, 12 May–8 July; Columbus: Columbus Museum of Art, 18 August–30 September; Brooklyn, New York: The Brooklyn Museum, 26 October–6 January 1985; and Newport Harbor, California: Newport Harbor Art Museum, 7 February–14 April (catalogue, 10 works)

1985

AKRON: Akron Art Museum, "New Dimensions," 25 January–7 April (checklist, 2 works)

CHICAGO: State Street Mall, "Mile Four: Chicago Sculpture International," 9 May–9 June (loan extended to 1 September; catalogue, 1 work)

NEW YORK: Marilyn Pearl Gallery, "Between Abstraction and Reality," 5 February–2 March (1 work)

NEW YORK: Holly Solomon Gallery, "Innovative Still Life," 5 June–3 July (1 work)

NEW YORK: M. Knoedler & Co., Inc., "Nancy Graves: Recent Sculpture," 7 December 1985–8 January 1986 (checklist, 10 works)

PITTSBURGH: University of Pittsburgh Gallery, "Sculpture by Women in the Eighties," 6 November–15 December (catalogue, 1 work)

SOUTH HADLEY, Massachusetts: Mount Holyoke College Art Museum, "An Architect's Eye: Selections from the Collection of Graham Gund," 5 September–10 November (catalogue, 1 work)

STOCKHOLM: Liljevalchs Konsthall, "Amerikanskt 80–Tal: Maleri, skulptur och textil fran Neue Galerie—Sammlung Ludwig, Aachen," 15 November–6 January 1986 (catalogue, 2 works)

TOKYO: Wacoal Art Center, "Vernacular Abstractions," 18 October–29 December (catalogue, 1 work)

1986

CAMBRIDGE: Massachusetts Institute of Technology, List Visual Arts Center, "Natural Forms and Forces," 9 May–29 June (1 work)

FORT LAUDERDALE: The Museum of Art, "An American Renaissance: Painting and Sculpture since 1940," 11 January–30 March (catalogue, 2 works)

HOUSTON: Janie C. Lee Gallery, "Paintings, Sculpture, Collages, and Drawings," 7 March–14 May (1 work)

*POUGHKEEPSIE, New York: Vassar College Art Gallery, "Nancy Graves: Painting, Sculpture, Drawing, 1980–1985," 17 April–11 June. Exhibition circulated to Pittsfield, Massachusetts: The Berkshire Museum, 5 July–31 August; and Providence: The David Winton Bell Gallery, List Art Center, Brown University, 6 September–5 October (catalogue, 14 works)

Bibliography

1968

Battcock, Gregory. "Camels Today." *The New York Free Press*, 2 May 1968, pp. 8, 11

Dienst, R. G. "Ausstellungen im New York." *Kunstwerk* 21 (April 1968): 23–73

"Reviews and Previews." *Artnews* 67 (April 1968): 14

Simon, Rita. "Nancy Graves." *Arts Magazine* 43 (May 1968): 63

1969

Andreae, Christopher. "Review." *The Christian Science Monitor*, 17 April 1969, p. 10

———. "Review." *The Christian Science Monitor*, 14 July 1969, p. 8

Battcock, Gregory. "Art: Nancy Graves." *The Village Voice* (New York), 3 April 1969, p. 21

Feldman, Anita. "Nancy Graves." *Arts Magazine* 43 (May 1969): 58

Frankenstein, Alfred. "Art: Eight Odorless Camels." *San Francisco Sunday Chronicle*, 6 April 1969, *This World*, p. 39

Lord, Barry. "Five Cents Worth of Art." *The Five Cent Review* 1 (August 1969): 24–28

"Sculpture: The Camel as Art." *Time* 93 (4 April 1969): 70

Tucker, Marcia and Nancy Graves, *Nancy Graves: Camels*. New York: Whitney Museum of American Art, 1969

1970

Baur, John I. H. Foreword to *1970 Annual Exhibition: Contemporary American Sculpture*. New York: Whitney Museum of American Art, 1970

Becker, Wolfgang. *Die Neue Galerie, Aachen—Bilder und Berichte* 29 (1970): 12

Lord, Barry. "The Eleven O'Clock News in Colour." *Artscanada* 27 (June 1970): 4–29

Ludwig, Peter and Wolfgang Becker. *Klischee und Antiklischee: Bildformen der Gegenwart. Stadt Aachen: Neue Galerie im Alten Kurhaus*, vol. 1. Aachen, West Germany: Neue Galerie im Alten Kurhaus, 1970

Wasserman, Emily. "A Conversation with Nancy Graves." *Artforum* 9 (October 1970): 42–47

1971

"At the Galleries." *The Village Voice* (New York), 14 January 1971, p. 20

Auer, James. "Lucas Samaras' Whimsical Boxes." *Post Crescent* (Appleton, Wisconsin), 14 November 1971, p. E8

Artweek 32 (Oakland, California), 25 September 1971: 2

Baker, Edith C. "Sexual Art Politics." *Artnews* 69 (January 1971): 47–48, 60–62

Catoir, Barbara. "Interview mit Nancy Graves." *Kunstwerk* 24 (May 1971): 10–15

Chandler, John Noel, ed. "Symposium on the Sacred in Art." *Artscanada* 28 (April 1971): 17–25

"Contemporary American Sculpture." *Kunstwerk* 24 (March 1971): 90

Davis, Douglas. "The Invisible Woman Is Visible." *Newsweek* 78, pt. 2 (15 November 1971): 130–31

Diamonstein, Barbaralee. "One Hundred Women in Touch with Our Time." *Harper's Bazaar* (January 1971): 106

Dia-Serie: Kunst der Gegenwart IV: Neue Abstraktion und neuer Realismus. Garmisch-Partenkirchen: Kunst-Dia-Verlag Lubbert, 1971

Domingo, Willis. "New York Galleries." *Arts Magazine* 45 (March 1971): 55

Frankenstein, Alfred. "Art: Black Rock, Beams, and Bones." *San Francisco Sunday Examiner and Chronicle*, 7 February 1971, pp. 41–42

———. "The Lyrical 'Totems' with Sprouting Forms." *San Francisco Sunday Chronicle*, 19 September 1971, *This World*

Henry, Gerrit. "New York Letter." *Art International* 15 (February 1971): 78–80

———. "New York Letter." *Art International* 15 (March 1971): 51

Hughes, Robert. "Art: Out of the Junkyard." *Time* 97, pt. 2 (4 January 1971): 50–51

Keefe, Nancy Q. "Nancy Graves." *The Berkshire Eagle* (Pittsfield, Massachusetts), 29 January 1971, p. 5

Kramer, Hilton, "Downtown Scene: A Display of Bones." *The New York Times*, 19 January 1971, p. 30

Linville, Kasha. "Whitney 1970 Sculpture Circus." *Arts Magazine* 45 (February 1971): 28–30

———. "Nancy Graves, Reese Palley Gallery." *Artforum* 9 (March 1971): 64–65

Marandel, J. Patrice. "Lettre de New York." *Art International* 15 (March 1971): 55–56

Masheck, Joseph. "Sorting Out the Whitney." *Artforum* 9 (February 1971): 70–74

McCook, Sheila. "Camel Lady Returns." *Ottawa Citizen*, 3 September 1971, p. 20

"Nancy Graves." *Artnews* 70 (March 1971): 20

Perreault, John. "Art: Camels." *The Village Voice* (New York), 4 February 1971, pp. 13–14

Prokopoff, Stephen S. Introduction to *Depth and Presence*. Washington, D.C.: The Corcoran Gallery of Art, 1971

———. *Six Sculptors: Extended Structures*. Chicago: Museum of Contemporary Art, 1971

Rice, Leland. "Graves Totems." *Artweek* 32 (Oakland, California), 2 October 1971: 2

Rosenberg, Harold. *Art on the Edge: Creators and Situations*. New York: Macmillan, 1971

Rubenstein, Erica B. "Nancy Graves Exhibition Illustrates Imagination." *Poughkeepsie Journal*, 24 October 1971

Schjeldahl, Peter. "From Stuffed Camels to Clam Shells." *The New York Times*, 26 December 1971, p. 25

Schulze, Franz. "Matter Over Mind: The New Art Festishism [*sic*]." *Chicago Daily News*, 6–7 November 1971, p. 11

Second Annual Review of the National Gallery of Canada Ottawa, 1969–1970. Ottawa: National Gallery of Canada for the Corporation of the National Museums of Canada, 1971

Septième biennale de jeunes artistes. Paris, 1971, p. 93

Shirey, David L. "Display by Nancy Graves Adds Vitality to Art Series." *The New York Times*, 18 December 1971, p. 25

Stiles, Knute. "San Francisco." *Artforum* 10 (November 1971): 86

Tarshis, Jerome. "Art Shows Are Not Brought by the Stork." *The San Francisco Fault*, 1971, p. 21

Thomas, Karin. *Bis Heute: Stilgeschichte der bildenden Kunst im zwanzigsten Jahrhundert*. Cologne: DuMont Schauberg, 1971

Tuchman, Phyllis. Introduction to *Nancy Graves: Sculpture, Drawings, Films, 1969–1971*. Aachen, West Germany: Neue Galerie im Alten Kurhaus, 1971

Tuchman, Phyllis, Wolfgang Becker, and Michael Strohmeyer. *Nancy Graves. Stadt Aachen: Neue Galerie im Alten Kurhaus*, vol. 11. Aachen, West Germany: Neue Galerie im Alten Kurhaus, 1971

Von der Osten, Gert and Horst Keller, comps. *Art of the Sixties: The Ludwig Collection in the Wallraf-Richartz Museum, Cologne*. 5th ed. Frankfurt: K. G. Lohse Graphischer Grossbetrieb, 1971

1972

Adams, Eleanor. "CAC Show Artists Channel Energy toward the Untried." *The Cincinnati Inquirer*, 30 November 1972, p. 23

"Alumnae Week." *Vassar Quarterly* 63 (Winter 1972): 6–10

Becker, Wolfgang, ed. *Art around 1970: Sammlung Ludwig in Aachen*. Aachen, West Germany: Neue Galerie der Stadt Aachen, 1972

Borden, Lizzie, "New York." *Artforum* 10 (February 1972): 90

Celant, G. "Documenta 5: Iperealismo come imperialismo." *Qui arte contemporanea* 9 (1972) 46–49

Chandler, John Noel. "Notes toward a New Aesthetics." *Artscanada* 29 (October–November 1972): 16–41

Die Kunst und das schöne Heim (January 1972), p. 6

Documenta 5: Befragung der Realität Bildwelten Heute. Kassel: Bertelsmann, 1972

"Documenta 5—Slalom im Kassel," *Artis* 9: 24 (September 1972): 24–27

"Documenta fünf." *Magazin Kunst* 47 (Fall 1972): 2943–57

Donohoe, Victoria. "Nancy Graves and 'Dem Bones." *The Philadelphia Inquirer*, 24 September 1972, p. H8

Forman, Nessa. "The Work of Nancy Graves: And It All Began with a Camel. . . ." *The Sunday Bulletin* (Philadelphia), 24 September 1972, sec. 5

Fourth Annual Review of the National Gallery of Canada, Ottawa, 1971–1972. Ottawa: National Gallery of Canada for the Corporation of the National Museums of Canada, 1972

Gross, Michael Stephen. "Beautification of the Bizarre." *The Daily Pennsylvanian* (Philadelphia), 28 September 1972, *Thirty-Fourth Street*, p. 15

"Kunst-Bericht aus dem Rheinland." *Magazin Kunst* 47 (Fall 1972): 2974–83

McCaslin, Walt. "Graves Moves Freely in Her Trade." *The Journal Herald* (Dayton, Ohio), 13 December 1972, p. 41

Moutelbaens,Maria. "Het Echtpaar Ludwig en zijn opzienbarende Pop-Collectie." *Elegance*, 29 February 1972, p. 48

The Museum of Modern Art Annual Report, 1971–72. New York: The Museum of Modern Art, 1972, p. 14

Perreault, John. "Reports, Forecasts, Surprises, and Prizes." *The Village Voice* (New York), 6 January 1972, p. 21

Picard, Lil. Introduction to *American Woman Artist Show*. Hamburg: Kunsthaus Hamburg, 1972

Rainer, Yvonne and Martin W. Cassidy. *Nancy Graves: Sculpture and Drawings, 1970–1972*. Philadelphia: Institute of Contemporary Art, University of Pennsylvania, 1972

Ratcliff, Carter. "Reviews." *Art International* 16 (February 1972): 55

Richardson, Brenda. "Nancy Graves: A New Way of Seeing." *Arts Magazine* 46 (April 1972): 57–61

Schwartz, Barbara. "Letter from New York: Nancy Graves." *Craft Horizons* 22 (April 1972): 57

Serber, John. "The Rough Beasts of Nancy Graves." *The Drummer* (Philadelphia), 26 October 1972, pp. 15–16

Staber, Margit. "Documenta 5—Einige Bemerkungen." *Art International* 16 (October 1972): 78–85, 104

Stadnik, Tom. "Graves Exhibit 'Lusty and Exotic.'" *Pennsylvania Voice* (Philadelphia), 20 September 1972

Sundell, Michael. "Art: Nancy Graves at the New Gallery." *Cleveland* 1 (June 1972): 76–77

Townsend, Charlotte. "Documenta 5." *Artscanada* 29 (October–November 1972): 42–44

1973

Alloway, Lawrence. *Photo-Realism: Paintings, Sculpture, and Prints from the Ludwig Collection and Others*. London: The Arts Council, 1973

Budde, Rainer and Evelyn Weiss. *Katalog der Bildwerke und Objekte: Neuzugänge seit 1965 im Wallraf-Richartz Museum mit Teilen der Sammlung Ludwig*. Cologne: Walter Muller, 1973

Ekstrem realisme: Vaerker fra Neue Galerie der Stadt Aachen, Sammlung Ludwig. Humlebaek, Denmark: Louisiana Museum Humlebaek, Cultural Center and Museum of Modern Art, 1973

Hess, Thomas B. and Elizabeth C. Baker. *Art and Sexual Politics: Women's Liberation, Women Artists, and Art History*. New York: Collier, 1973. All essays originally appeared in *Artneus* 69 (January 1971)

Johnson, Charlotte Buel. *Contemporary Art: Exploring Its Roots and Development*. Worcester, Massachusetts: Davis Publications, 1973

Kalavinka, Mia. "Six Brain Maps." *Artscanada* 30 (May 1973): 50–55

Nikolajsen, Ejgil. "Skal vi sluge Kamelen?" *Berlingske Tidende* (Copenhagen), 10 February 1973

Sager, Peter. *Neue Formen des Realismus: Kunst zwischen Illusion und Wirklichkeit*. Cologne: DuMont Schauberg, 1973

1974

Arn, Robert. "The Moving Eye . . . Nancy Graves Sculpture, Film, and Painting." *Artscanada* 31 (Spring 1974): 42–48

Kelly, James J. *The Sculptural Idea*. 2d ed. Minneapolis: Burgess Publishing, 1974

Rothenberg, Jerome and Dennis Tedlock. "The Shaman as Proto-Poet." *Artscanada* 30 (December 1973–January 1974): 172–81

1975

Lippard, Lucy R. "Distancing: The Films of Nancy Graves." *Art in America* 63 (November–December 1975): 78–82

Ratcliff, Carter. "On Contemporary Primitivism." *Artforum* 14 (November 1975): 57–65

Read, Herbert. *A Concise History of Modern Painting*. 3d ed. New York: Praeger, 1975

1976

Armstrong, Tom, Wayne Craven, Norman Feder, Barbara Haskell, Rosalind E. Krauss, Daniel Robbins, and Marcia Tucker. *Two Hundred Years of American Sculpture*. New York: Whitney Museum of American Art, 1976

Weiss, Evelyn. *Stiftung Ludwig, Köln, 1976 Ludwig Gabe*. Cologne: Museum der Stadt Köln, 1976

1977

Becker, Wolfgang, ed. *The Artist Exhibited: Art for the Museum since '45: Ludwig Collection, 1977*. 2 vols. Aachen, West Germany: Neue Galerie der Stadt Aachen—Sammlung Ludwig, 1977

Becker, Wolfgang, Kristian Sotriffer, and Peter Baum. *Kunst um 1970 —Art around 1970*. Aachen, West Germany: Neue Galerie der Stadt Aachen—Sammlung Ludwig, 1977

Gablik, Suzi. *Progress in Art*. New York: Rizzoli, 1977

Heinemann, Susan. "Nancy Graves: The Painting Seen." *Arts Magazine* 51 (March 1977): 139–41

Lippard, Lucy R. "Strata: Nancy Graves, Eva Hesse, Michelle Stuart, Jackie Winsor." *Vanguard* 5–6 (October 1977): 17–18

Lippard, Lucy R. and Alvin Balkind. *Strata: Nancy Graves, Eva Hesse, Michelle Stuart, Jackie Winsor*. Vancouver: The Vancouver Art Gallery, 1977

Metken, Gunter. *Spurensicherung: Kunst als Anthropologie und Selbstforschung, fiktive Wissenschaften in der heutigen Kunst*. Cologne: DuMont, 1977

Morrison, A. "Strata: Nancy Graves, Eva Hesse, Michelle Stuart, Jackie Winsor." *Parachute* 24 (Winter 1977–78): 12–14

Thomas, Karin and Gerd de Vries. *DuMonts Künstler Lexikon: Von 1945 bis zur Gegenwart*. Cologne: DuMont, 1977

1978

Becker, Wolfgang and David Galloway. *The Ludwig Collection*. Tehran: Tehran Museum of Contemporary Art, 1978

Berger, David A. "The Gallery Scene: Three Shows of Particular Interest." *Argus* (Seattle), 6 October 1978, p. 11

"Bronze aus New York." *Quer durch Köln* (Cologne), 23 June 1978, p. K11

Campbell, R. M. "Reviews." *Seattle Post-Intelligencer*, 1 October 1978, p. P1

Cortenova, Giorgio. *La creazione volgeva alla fine: "Antropologia" come arte delle cose*. Geneva: Unimedia, 1978

Crossley, Mimi. "Nancy Graves: Recent Paintings, Watercolors, and Sculptures." *The Houston Post*, 24 November 1978, p. 9AA

Moser, Charlotte. "Energy, Spirit in Two Shows." *Houston Chronicle*, 15 November 1978, sec. 4, p. 1

Peterson, Karen and J. J. Wilson. *Women Artists; Recognition and Reappraisal from the Early Middle Ages to the Twentieth Century*. London: The Women's Press Limited by arrangement with New York: Harper and Row, 1978

"Primitivism and Cult Objects." Panel discussion with Nancy Graves, Leo Rosshandler, Tony Urquhart, and Alex Wyse in *Sculpture Today: Tenth International Sculpture Conference*. Toronto: International Sculpture Center, 1978

"Reviews." *The Weekly* (Seattle), 20–26 September 1978

Rubinfien, Leo. "Nancy Graves, Dag Hammarskjold Plaza." *Artforum* 16 (Summer 1978): 73–74

Sakali, Soumaya, "First Exchange Plan Art Exhibition Opens in City." *Kayhan International*, 12 January 1978

Senie, Harriet. "Sculpture on a Modern Plane." *New York Post*, 4 March 1978, p. 17

Tarzan, Deloris. "Graves Is Great. . . ." *The Seattle Times*, 4 October 1978, p. H1

Vomm, Wolfgang. "Ceridwen—Urwelt in Museum." *Bulletin, Museum der Stadt Köln* 8 (1978): 1642–43

1979

Annual Exhibition, American Academy in Rome. Rome: American Academy, 1979

Billeter, Erika. *Weich und Plastisch—Soft Art*. Zurich: Kunsthaus Zurich, 1979

Cladders, Johannes. Introduction to *Museum moderner Kunst: Sammlung Hahn*. Vienna: Gesellschaft der Freunde des Museum moderner Kunst, 1979

Drechsler, Wolfgang M., Monika Faber, Marietta Mautner Markhof, and Eva-Maria Triska. *Museum moderner Kunst: Kunst der letzten dreissig Jahre*. Vienna: Gesellschaft der Freunde des Museum moderner Kunst, 1979

Fillitz, Hermann, ed. *Museum moderner Kunst: Sammlung Ludwig*. Vienna: Gesellschaft der Freunde des Museum moderner Kunst, 1979

Graves, Nancy. "Nancy Graves: Excerpts from Notebooks." *Artscribe*. No. 17 (April 1979): 39–41

Kardon, Janet. *Masks, Tents, Vessels, Talismans*. Philadelphia: Institute of Contemporary Art, University of Pennsylvania, 1979

"La Chronique des arts: Principales acquisitions des musées en 1978." *Gazette des beaux-arts* 93: ser. 6 (April 1979): supp. p. 25

Munro, Eleanor. *Originals: American Women Artists*. New York: Simon and Schuster, 1979

Ruhrberg, Karl, Evelyn Weiss, and Dieter Ronte. *Handbuch Museum Ludwig: Kunst des zwanzigsten Jahrhunderts, Gemälde, Skulpturen, Collagen, Objekte, Environments*. Vol. 1. Cologne: Wienand, 1979

Russell, John. "Art People." *The New York Times*, 26 January 1979, p. C16

Sollins, Susan and Elke Solomon. *Supershow*. New York: Independent Curators Incorporated, 1979

1980

Bannon, Anthony. "Graves' Work Celebrates the Mind." *The Buffalo News*, 3 May 1980

Bass, Milton R. "Nancy Graves: A Survey, 1969–1980." *The Berkshire Eagle* (Pittsfield, Massachusetts), 29 May 1980, p. 11

Branche, Bill. "Graves Exhibit Is Pleasing Despite Some Shortcomings." *Niagara Gazette*, 8 May 1980, pp. 1D–2D

Carr, Carolyn Kinder. "Nancy Graves: A Survey, 1969–1980: Observations and . . . Discussion of Sculpture." *Dialogue* (July–August 1980, published in Munroe Falls, Ohio, for the Akron Art Institute): 18–21

Castaneda, Chris. "Nancy Graves at CAM: Boning up on Science." *Rice Thresher* (Rice University, Houston), September 1980

Cathcart, Linda L. *Nancy Graves: A Survey, 1969–1980*. Buffalo: Albright-Knox Art Gallery, 1980

Contemporary Arts Museum, Houston, Texas, Annual Report. October 1979–September 1980, p. 8

Crossley, Mimi. "Nancy Graves' Perspective of Nature." *The Houston Post*, 21 September 1980, p. 1AA

Daval, Jean-Luc, ed, "Emotional Moods." *Art Actuel: Skira Annual*. No. 6. Geneva: Skira, 1980, pp. 118–31

"Events and Openings." *The Buffalo News*, 2 May 1980

Frank, Elizabeth. "Nancy Graves at Knoedler." *Art in America* 68 (May 1980): 154–55

Hjort, Oystein. "Mot en ny sensibilitet: Några tendenser i amerikansk konst." *Paletten* (February 1980): 26–36

Huntington, Richard. "Nancy Graves' Art: Natural History in the Abstract." *Buffalo Courier-Express*, 11 May 1980, pp. E3–E4

International Sculpture Center Bulletin (Washington, D.C.). No. 25 (Fall–Winter 1980)

Kalil, S. "Illusion with Presence: Contemporary Arts Museum, Houston." *Artweek* 11 (Oakland, California), 18 October 1980: 7

Kramer, Hilton. "Nancy Graves." *The New York Times*, 21 March 1980, p. C19

La Badie, Donald. "Natural History Dominates Nancy Graves' Arena." *The Commercial Appeal* (Memphis), 24 August 1980, p. 18

———. " 'Camel' Endures Artistic Snags." *The Commercial Appeal* (Memphis), 11 November 1980, p. 26

———. "Real World Is the Springboard for Creations of Nancy Graves." *The Commercial Appeal* (Memphis), 16 November 1980, pp. 26–27

Larson, Kay. "Come Together." *The Village Voice* (New York), 24 March 1980, p. 81

Lindey, C. *Superrealist Painting and Sculpture*. London: Orbis, 1980

Littman, Robert R. Acknowledgments to *Perceiving Modern Sculpture: Selections for the Sighted and Non-Sighted*. New York: Grey Art Gallery and Study Center, 1980

Malange, Kurt and Heiner Berger. Introduction to *Zehn Jahre neue Galerie—Sammlung Ludwig: Aachen 1970–1980*. Aachen: Neue Galerie—Sammlung Ludwig in association with the Verein der Freunde der Neuen Galerie, 1980

"Masks, Tents, Vessels, Talismans." *The Pennsylvania Gazette* (Philadelphia), February 1980, pp. 25–26

Metken, G. "Skona vetenskaper—eller det humanas arkeoligi." *Paletten* (January 1980): 30–35

Minaty, Wolfgang. "Weich und Plastisch—Soft Art." *Kunstwerk* 33 (January 1980): 47–48, 82

"Nancy Graves." *Art/World* (New York), March 19–April 18, 1980, p. 8

"Nancy Graves Show to Open in Buffalo." *Herald American* (Syracuse), 27 April 1980

"Neuberger Plans Survey of Art by Graves, Architectural Plans." *Greenwich Times*, 26 December 1980

"Neuerwerbungen der Sammlung Ludwig (2)." *Aachener Nachrichten*, 19 July 1980

"New York Reviews." *Artnews* 79 (September 1980): 247

Rose, Barbara. "Nancy Graves." *Vogue* 170 (June 1980): 202–3, 235–36

Russell, John. "Nancy Graves Makes Art of Science." *The New York Times*, 1 June 1980, p. D25

Saunders, W. "Hot Metal." *Art in America* 68 (Summer 1980): 86–95

"Sculptors Meet in Washington to Talk and Show Their Work." *American Institute of Architects Journal* 69 (July 1980): 32–33

"Sculpture Carves Out Audience in U.S." *U.S. News and World Report* 89 (1 September 1980): 66–67

Tennant, Donna. "Doing What Comes Naturally." *Houston Chronicle*, 21 September 1980, pp. 16, 30

————. "Nancy Graves on View." *Houston Chronicle*, 28 September 1980, *Texas Magazine*, pp. 10, 12–13

Wedewer, Rolf. "Neuer Exotismus." *Kuntswerk* 33 (May 1980): 3–33

"Zürich, Kunsthaus Zürich Ausstellung: Weich und Plastisch—Soft Art, 16 November 1979–3 February 1980." *Pantheon* 38 (April 1980): 129–30

1981

Addington, Fran. "Graves Show Seeks Unity in Art, Science." *Minneapolis Tribune*, 3 June 1981

Balwin, Nick. "Art in Process." *Des Moines Register*, 19 April 1981, p. 5C

Beals, Kathie. "Art of the Future." *Weekend* (Gannett Westchester [New York] Newspapers), 13 February 1981, p. 13

Elliott, Thyra. "Nancy Graves: A Decade of Development." *Darien News*, 26 February 1981, sec. 3, p. 8

Fell, Derek. "The Collectors: Art in the Domestic Context." *Architectural Digest* 38, pt. 4 (December 1981): 128–35

Kelly, James J. *The Sculptural Idea*. 3d ed. Minneapolis: Burgess Publishing, 1981

Kramer, Hilton. "Art." *The New York Times*, 10 April 1981, p. C19.

McVinney, Donald. "Nancy Graves Survey at Museum an Inspirational Event." *The Load* (Purchase, New York), February 1981

Morris, Margaret. "Walker Opens Exhibition for Latest Find." *Minneapolis Tribune*, 3 June 1981, p. 2B

Morrison, Don. "Artist's Stunningly Life-like Camel Highlights Exhibition." *The Minneapolis Star*, 29 May 1981, p. 3B

Protzman, Bob. "Science Inspires Artist Graves." *Saint Paul Dispatch*, 4 June 1981

Raynor, Vivien. "From Camel Bones to Diverse Sensibilities." *The New York Times*, 1 February 1981, p. 16

Robertson, Allen. "A Graves Matter." *MPLS Saint Paul Magazine* (June 1981): 46

Russell, John. *The Meanings of Modern Art*. New York: The Museum of Modern Art and Harper and Row, 1981

Sandler, Irving. *Twenty Artists: Yale School of Art, 1950–1970*. New Haven: Yale University Art Gallery, 1981

Schwartzman, Allan. "All Nature Is But Art Unknown." *Vassar Quarterly* 77 (Winter 1981): 20–23

Sello, Gottfried. "Malerinnen (121)—Eine Brigitte-Serie Nancy Graves." *Brigitte* 19 (1981): 168

Smith, Roberta. *Four Artists and the Map Image/Process/Data/Place: Jasper Johns, Nancy Graves, Roger Welch, Richard Long*. Lawrence, Kansas: Spencer Museum of Art, The University of Kansas, 1981

Tulenko, Karelei, "Nancy Graves." *Art Voices* (July–August 1981)

Zimmer, William. "Turning Over Graves." *Soho News* (New York), 11 March 1981, p. 43

1982

Amaya, Mario. "Artist's Dialogue: A Conversation with Nancy Graves." *Architectural Digest* 39 (February 1982): 146, 150–51, 154–55

Belz, Carl, Kathy Halbreich, Kenworth Moffett, Elisabeth Sussman, and Diane W. Upright. *A Private Vision: Contemporary Art from the Graham Gund Collection*. Boston: Museum of Fine Arts, 1982

"Bronzes by Nancy Graves Receive Top Critical Praise." *The Berkshire Eagle* (Pittsfield, Massachusetts), 23 October 1982, p. 21

Brutvan, Cheryl A., Marti Mayo, and Linda L. Cathcart, comps. *In Our Time: Houston's Contemporary Arts Museum, 1948–1982*. Houston: Contemporary Arts Museum, 1982

Dickinson, Nancy Godwin. "Museum of Art/RISD, Providence: Metals: Cast-Cut-Coiled." *Art New England* (October 1982)

Elsen, Albert. Introduction to *Casting: A Survey of Cast Metal Sculpture in the Eighties*. San Francisco: Fuller Goldeen Gallery, 1982

Feldman, Edmund B. *The Artist*. Englewood Cliffs, New Jersey: Prentice-Hall, 1982

Glueck, Grace. "Art: Botanical Bronzes from Nancy Graves." *The New York Times*, 22 October 1982, p. C22

Larson, Kay. "Art." *New York Magazine* (22 November 1982): 74

Lauzon, Lorraine. "Ancient Egyptian 'Common Man' Celebrated at Museum of Fine Arts." *The Berkshire Eagle* (Pittsfield, Massachusetts), 11 March 1982, p. 21

"Malerin mit Köpfchen." *ZüriWoche*, 23 December 1982, p. 33

"New York: Graves at M. Knoedler." *The Art Gallery Scene*, Washington, D. C.: The National Gallery of Art, 16 November 1982, pp. 4–5

Osterwold, Tilman and Andreas Vowinckel. *Vergangenheit Gegenwart Zukunft: Zeitgenössische Kunst und Architektur*. Stuttgart: Württembergischer Kunstverein, 1982

Raye, Helen. "Recent Acquisition: Nancy Graves." *Albright-Knox Art Gallery Calendar*, Buffalo, November 1982

Rubinstein, Charlotte Streifer. *American Women Artists from Early Indian Times to the Present*. Boston: G. K. Hall & Co. and New York: Avon Books, 1982

Sozanski, Edward J. "RISD Exhibit Redefines Traditional Sculpture." *Providence Journal*, 27 August 1982

Tully, Judd. "New York Exhibitions." *Art World* (New York), November 1982, p. 6

Walker, James Faure. "Impressions of a Wandering Lecturer." *Artscribe*. No. 38 (December 1982): 36–45

1983

Anderson, Alexandra. "The New Bronze Age." *Portfolio* 5 (March–April 1983): 78–83

Balken, Debra Bricker. *New Decorative Art*. Pittsfield, Massachusetts: The Berkshire Museum, 1983

Brooks, Valerie. "Where Sculptors Forge Their Art." *The New York Times*, 7 July 1983, sec. 2, pp. 1, 24

Edinborough, Arnold. "'American Accents': A Tribute to the Passion to Communicate." *The Financial Post* (Stratford, Ontario), 25 June 1983, p. 21

Friedman, Jon R. "Modern Objects." *Arts Magazine* 58 (September 1983): 9

Geldzahler, Henry. *American Accents*. Don Mills, Ontario: Rothmans of Pall Mall Canada Ltd., 1983

————. "Stratford: American Accents." *Artmagazine* 14 (Summer 1983): 13–16, 74–75

Hall, L. "Material Pleasures." *House & Garden* 155 (April 1983): 6, 8, 12

Hanhardt, John G., Barbara Haskell, Richard Marshall, and Patterson Sims. *1983 Biennial Exhibition: Painting, Sculpture, Photography, Installations, Film, Video*. New York: Whitney Museum of American Art, 1983

Houston Arts. 6:1 (First Quarter 1983)

"La Chronique des arts: Principales acquisitions des musées en 1982." *Gazette des beaux-arts* 101: ser. 6 (March 1983): supp. p. 48

Myers, John Bernard. "The Other." *Artforum* 21 (March 1983): 44–49

"New York Reviews." *Artnews* 82 (January 1983): 144

Rose, Barbara. "Two American Sculptors: Louise Bourgeois and Nancy Graves." *Vogue* 173 (January 1983): 222–23

Russell, John. "It's Not Women's Art, It's Good Art." *The New York Times*, 24 July 1983, sec. 2, pp. 1, 25

Shapiro, Michael Edward. "Four Sculptors on Bronze Casting: Nancy Graves, Bryan Hunt, Joel Shapiro, Herk Van Tongeren." *Arts Magazine* 58 (December 1983): 111–17

Storr, Robert. "Natural Fictions." *Art in America* 71 (March 1983): 118–21

"Teure Tiere." *Schweizer Illustrierte* (Zurich), 1 October 1983

Timberman, M. "Metaphor and Paradox." *Artweek* 14 (Oakland, California), 5 March 1983: 16

Tuchman, Phyllis. *Nancy Graves: Painting and Sculpture, 1978–82*. Santa Barbara: Santa Barbara Contemporary Arts Forum, 1983

———. *Six in Bronze*. Williamstown, Massachusetts: Williams College Museum of Art, 1983

1984

Ashton, Dore. "On an Epoch of Paradox: 'Primitivism' at the Museum of Modern Art." *Arts Magazine* 59 (November 1984): 76–79

Bates, Mary, Bob L. Nugent, and Susan Moulton. *Works in Bronze: A Modern Survey*. Rohnert Park, California: University Art Gallery, Sonoma State University, 1984

Becker, Astrid, Wolfgang Becker, and Ardi Poels. *Aspekte amerikanischer Kunst der Gegenwart*. Aachen, West Germany: Neue Galerie der Stadt Aachen—Sammlung Ludwig, 1984

Bonenti, Charles. "Top Sculptor Nancy Graves Slips Home to Open a Show." *The Berkshire Eagle* (Pittsfield, Massachusetts), 17 January 1984, p. 16

———. "Primitivism in the Art of the Twentieth Century." *The Berkshire Eagle* (Pittsfield, Massachusetts), 27 December 1984, p. 19

Brenson, Michael. "Art: Bronze Garden of Sculptured Plants." *The New York Times*, 16 March 1984, p. C21

———. "A Lively Renaissance for Sculpture in Bronze." *The New York Times*, 4 November 1984, p. H9

Buckvar, Felice. "Museum Visitors Vote on Sculpture." *The New York Times*, 14 October 1984, sec. 22, p. WC23

Citywide Contemporary Sculpture Exhibition. Toledo: The Toledo Museum of Art, 1984

Ennis, Michael. "Art Builds a House." *House & Garden* 156 (May 1984): 174–81

Freeman, Phyllis, Eric Himmel, Edith Pavese, and Anne Yarowsky, eds. *New Art*. New York: Abrams, 1984

Hammond, Harmony. *Wrappings: Essays on Feminism, Art, and the Martial Arts*. New York: Mussmann Bruce, 1984

Hughes, Robert. "Intensification of Nature." *Time* 123, pt. 2 (2 April 1984): 80–81

Lucie-Smith, Edward. *Movements in Art since 1945*. Rev. ed. New York: Thames and Hudson, 1984

Manstein, H. "Welstadt-Phantasien: Neue Galerie—Aspekte aktueller amerikanischer Kunst." *Dem kulturellen Leben* (17 August 1984)

McDonald, Robert. *Art of the States: Works from a Santa Barbara Collection*. Santa Barbara: Santa Barbara Museum of Art, 1984

Miro, Marsha. "Sculpture Clearly for the Public." *Free Press* (Toledo, Ohio), 11 September 1984

Muchnic, Suzanne. "Santa Barbara's Bold Strokes." *The Los Angeles Times*, 10 July 1984, pp. 1, 5

Phillips, Lisa. *The Third Dimension: Sculpture of the New York School*. New York: Whitney Museum of American Art, 1984

"Reviews." *New York Magazine* (19 November 1984): 61, 63

Reynolds, Gary A. *American Bronze Sculpture: 1850 to the Present*. Newark: The Newark Museum, 1984

Ronte, Dieter. "Le Temps des vestiges ou la projection du passé dans l'art des années 70." *L'art et le temps*. Brussels: Société des Expositions du Palais des Beaux-Arts, 1984

Rose, Barbara. "Talking about . . . Art." *Vogue* 174 (February 1984): 172

Rubin, William, ed. *"Primitivism" in Twentieth Century Art*. 2 vols. New York: The Museum of Modern Art, 1984

Shapiro, Michael Edward. "Nature into Sculpture: Nancy Graves and the Tradition of Direct Casting." *Arts Magazine* 59 (November 1984): 92–96

Wallach, Amei. "Bronze in Brooklyn." *Newsday* (New York edition), 4 November 1984, pt. 2, p. 4

1985

Becker, Wolfgang. Introduction to *Amerikanskt 80–Tal: Maleri, skulptur och textil fran Neue Galerie—Sammlung Ludwig, Aachen*. Stockholm: Liljevalchs Konsthall, 1985

Bois, Yves-Alain. "La Pensée sauvage." *Art in America* 73 (April 1985): 178–89

Bourdon, David. "Lady Bountiful: Bronze Flowers, Gauze Butterflies: The Protean Nature of Nancy Graves." *Vogue* (February 1985): 82, 84

Fishman, Nancy, ed. *Mile Four: Chicago Sculpture International*. Chicago: Chicago Sculpture International, 1985

"Frito-Lay Collection." *Horizons* 28 (October 1985): 33–40

Harris, Anne Sutherland and Elaine King. *Sculpture by Women in the Eighties*. Pittsburgh: University of Pittsburgh, 1985

Hunter, Sam and J. Jacobus. *Modern Art*. New York: Abrams, 1985

Mulaire, Bernard. *Chien*. Saint-Boniface (Manitoba): Editions de Blé, 1985

Nadelman, Cynthia. "Broken Promises: Primitivism at MOMA." *Artnews* 84 (February 1985): 88–95

"Nancy Graves." *The New York Times*, 20 December 1985, p. C29

Neff, Terry A. R., ed. *Selections from the Frito-Lay Collection*. Dallas: Frito-Lay, Inc., 1985

Shantz, Judith. "The Art of Nancy Graves." *The Alumnae Bulletin*. Miss Hall's School, Pittsfield, Massachusetts (Spring 1985): 10–11

Silverthorne, Jeanne. "Nancy Graves." *Artforum* 23 (March 1985): 92

Smith, Roberta. *Vernacular Abstractions*. Tokyo: Wacoal Art Center, 1985

Yard, Sally. *An Architect's Eye: Selections from the Collection of Graham Gund*. South Hadley, Massachusetts: Mount Holyoke College, 1985

1986

Balken, Debra Bricker. *Nancy Graves: Painting, Sculpture, Drawing, 1980–1985*. Introduction by Linda Nochlin. Poughkeepsie, New York: Vassar College Art Gallery, 1986

Berman, Avis. "Nancy Graves' New Age of Bronze." *Artnews* 85 (February 1986): 56–64

"Cover Story." *The Fort Worth Art Museum March–April Calendar*, 1986, pp. 6–7

Frank, Elizabeth. "Her Own Way: The Daring and Inventive Sculptures of Nancy Graves." *Connoisseur* 216 (February 1986): 54–61

"FW Museum Acquires Eight Works." *The Dallas Times Herald*, 12 February 1986

Hunter, Sam, ed. *An American Renaissance: Painting and Sculpture since 1940*. New York: Abbeville, 1986

Kutner, Janet. "FW Art Museum Has Reason to Celebrate." *The Dallas Morning News*, 16 February 1986, pp. 1C, 8C–9C

Larson, Kay. "The Shrinking Spiral." *New York Magazine* 19 (13 January 1986): 58–59

McTavish, Brian. "Sculpture Commissioned for Downtown Bank." *The Kansas City Star*, 19 February 1986, p. 12B

Muchnic, Suzanne. "A Nancy Graves Sculpture Grows at Crocker Center." *The Los Angeles Times*, 21 February 1986, pp. VI 1, 8

Sewell, Carol. "Museum Adds Eight New Works." *The Fort Worth Star Telegram*, 12 February 1986, pp. 1, 3

Watson-Jones, Virginia. *Contemporary American Women Sculptors*. Phoenix: Oryx Press, 1986

Photograph Credits

Unless given as page numbers, all numbers refer to catalogue raisonné numbers. Unless otherwise noted, all photographs for cat. nos. 1A–33 were provided by the artist, as was the photograph reproduced on p. 25. Unless otherwise noted, all photographs of sculptures from 1977 on are reproduced courtesy of M. Knoedler & Co.

Jon Abbott: 111, 114, 133, 139, 141, 142, 146–50, 154, 155, 167

Akron Art Museum: 54

Albright-Knox Art Gallery: 77

Ken Cohen Photography: title spread, p. 42 top, 157, 160, 164, 175, 176, 190, 192, 197, 199, 203, 206, 210, 222, 231, 232, 234–38, 240

Janie C. Lee Gallery: 5, p. 51 bottom left

Ann Münchow, Aachen: 31

Mrs. John D. Murchison: 52

Museum Ludwig, Cologne: 20, 33

Museum Moderner Kunst, Vienna: 29, 45, 48, 49

National Gallery of Canada, Ottawa: 2–4, 32

Neue Galerie—Sammlung Ludwig, Aachen: 6–9, 50

Eric Pollitzer: p. 39

Shunk-Kender: p. 98 bottom left

Wharton Photography, Fort Worth: p. 26 top right, 225

Lenders to the Exhibition

Barry and Gail Berkus, Santa Barbara

Edna S. Beron, New Jersey

Mr. and Mrs. Werner Dannheisser, New York

Bruce and Judith Eissner, Marblehead, Massachusetts

The Fort Worth Art Museum, Texas

Ann and Robert Freedman, New York

The Frito-Lay Collection, Plano, Texas

Bob and Linda Gersh, Los Angeles

Mr. and Mrs. Graham Gund

Helen Elizabeth Hill Trust

Irving Galleries, Palm Beach, Florida

Richard and Barbara Lane, New York

Janie C. Lee, Houston

Sally Sirkin Lewis, Beverly Hills

Mr. and Mrs. Myron Mendelson, Connecticut

Brett Mitchell Collection, Cleveland

The Museum of Modern Art, New York

Neuberger Museum, State University of New York at Purchase

Neue Galerie—Sammlung Ludwig, Aachen, West Germany

Mr. and Mrs. Harold Price, Laguna Beach, California

Dr. J. H. Sherman, Baltimore

Candida N. Smith, New York

Holly Hunt Tackbary, Winnetka, Illinois

Anselm and Marjorie Talalay, Cleveland

Whitney Museum of American Art, New York

Mr. and Mrs. Bagley Wright, Seattle

Peg Yorkin and Bud Yorkin, Los Angeles

Mr. and Mrs. George M. Young, Fort Worth, Texas

Private collections

Checklist of the Exhibition

1. Head on Spear, 1969
Steel, wax, marble dust, acrylic, animal skin, and oil paint
96 × 24 × 12 (243.8 × 61 × 30.5)
Janie C. Lee, Houston
(cat. no. 5)

2. Mongolian Bactrian (To Harvey Brennan), 1969
Wood, steel, burlap, polyurethane, animal skin, wax, acrylic, oil paint, and fiber glass
96 × 126 × 48 (243.8 × 320 × 121.9)
Neue Galerie—Sammlung Ludwig, Aachen, West Germany
(cat. no. 8)

3. Fossils, 1969–70
Plaster, gauze, marble dust, acrylic, and steel
36 × 300 × 300 (91.4 × 762 × 762)
Private collection
(cat. no. 14)

4. Inside-Outside, 1970
Steel, wax, marble dust, acrylic, fiber glass, animal skin, and oil paint
48 × 120 × 120 (121.9 × 304.8 × 304.8)
Private collection
(cat. no. 16)

5. Mummy, 1969–70
Latex, steel, wax, and gauze
108 × 36 × 42 (274.3 × 91.4 × 106.7)
Anselm and Marjorie Talalay, Cleveland
(cat. no. 17)

6. Variability of Similar Forms, 1970
Steel, wax, marble dust, and acrylic on wood base
84 × 126 × 180 (213.4 × 320 × 457.2)
Private collection
(cat. no. 23)

7. Quipu, 1978
Bronze with polychrome patina
70 × 60 × 58 (177.8 × 152.4 × 147.3)
Helen Elizabeth Hill Trust
(cat. no. 38)

8. Archaeoloci, 1979
Bronze and brass with polychrome patina and red oil color
39½ × 30 × 27 (100.3 × 76.2 × 68.6)
Barry and Gail Berkus, Santa Barbara
(cat. no. 42)

9. Archaeologue, 1979
Bronze with polychrome patina and oil color
32 × 25½ × 11 (81.3 × 64.8 × 27.9)
Mr. and Mrs. Myron Mendelson, Connecticut
(cat. no. 43)

10. Aves, 1979
Bronze and steel with polychrome patina and oil paint
46½ × 82 × 30 (118.1 × 208.3 × 76.2)
Private collection
(cat. no. 44)

11. Gravilev, 1979–80
Bronze with polychrome patina on steel base
88 × 143 × 32 (223.5 × 363.2 × 81.3)
Dr. J. H. Sherman, Baltimore
(cat. no. 57)

12. Trace, 1979–80
Bronze and steel with polychrome patina and Ronan superfine Japan colors
107 × 59 × 115 (271.8 × 150.8 × 292.1)
Mr. and Mrs. Graham Gund
(cat. no. 60)

13. Fayum, 1981
Bronze with polychrome patina
77½ × 78 × 57 (196.9 × 198.1 × 144.8)
Private collection, San Francisco
(cat. no. 66)

14. Kariata, 1981
Aluminum, Cor-ten steel, brass, copper, and polyurethane paint
51½ × 50 × 65 (130.8 × 127 × 165.1)
Peg Yorkin and Bud Yorkin, Los Angeles
(cat. no. 68)

15. Agni, 1982
Bronze with polychrome patina
73½ × 59 × 51 (186.7 × 149.9 × 129.5)
Mr. and Mrs. Bagley Wright, Seattle
(cat. no. 80)

16. Bilanx, 1982
Bronze with polychrome patina
41½ × 41 × 17½ (105.4 × 104.1 × 44.5)
Private collection
(cat. no. 81)

17. Catepelouse, 1982
Bronze with polychrome patina
21 × 25 × 16½ (53.3 × 63.5 × 41.9)
Sally Sirkin Lewis, Beverly Hills
(cat. no. 83)

18. Colubra, 1982
Bronze with polychrome patina
35¾ × 28 × 22½ (90.8 × 71.1 × 57.1)
Barry and Gail Berkus, Santa Barbara
(cat. no. 84)

19. Columnouveau, 1982
Bronze with polychrome patina
98 × 42 × 24 (248.9 × 106.7 × 61)
Private collection, Fort Worth, Texas
(cat. no. 85)
(Exhibited in Fort Worth only)

20. Conjugate, 1982
Bronze with polychrome patina
64 × 50 × 55 (162.6 × 127 × 139.7)
Mr. and Mrs. Werner Dannheisser, New York
(cat. no. 86)

21. Five Fans, Lampshades and Lotus, 1982
Bronze with polychrome patina
81 × 34 × 35 (206 × 86.4 × 89)
Private collection
(cat. no. 98)

22. Krater, 1982
Bronze with polychrome patina
57½ × 41 × 40 (146 × 104.1 × 101.6)
Irving Galleries, Palm Beach, Florida
(cat. no. 100)

23. Kylix, 1982
Bronze with polychrome patina
19 × 22 × 19 (48.3 × 55.9 × 48.3)
Bob and Linda Gersh, Los Angeles
(cat. no. 102)
(Not exhibited in Brooklyn)

24. Pilot, 1982
Bronze with polychrome patina
57½ × 41 × 40 (146 × 104.1 × 101.6)
Holly Hunt Tackbary, Winnetka, Illinois
(cat. no. 105)

25. Scylla, 1982
Bronze with polychrome patina
31½ × 30 × 28 (80 × 76.2 × 71.1)
Brett Mitchell Collection, Cleveland
(cat. no. 107)

26. Cantileve, 1983
Bronze with polychrome patina
98 × 68 × 54 (248.9 × 172.7 × 137.2)
Whitney Museum of American Art, New York. Purchase, with funds from
the Painting and Sculpture Committee. Acquisition no. 83.39
(cat. no. 113)

27. Chimera, 1983
Bronze with polyurethane paint
84 × 68 × 63 (213.4 × 172.7 × 160)
Barry and Gail Berkus, Santa Barbara
(cat. no. 115)

28. Counter, 1983
Bronze with polychrome patina
25½ × 41 × 8 (64.8 × 104.1 × 20.3)
Bruce and Judith Eissner, Marblehead, Massachusetts
(cat. no. 118)

29. Et Sec, 1983
Bronze with polychrome patina
24½ × 30½ × 12 (61.6 × 77.5 × 30.5)
Helen Elizabeth Hill Trust
(cat. no. 121)

30. Extend-Expand, 1983
Bronze with polychrome patina
85 × 51 × 33⅝ (215.7 × 129.5 × 85.4)
The Museum of Modern Art, New York. Gift of Mr. and Mrs. Sid R. Bass
(cat. no. 122)

31. Lacinate, 1983
Bronze with polychrome patina
54 × 48 × 41 (137.2 × 121.9 × 104.1)
Edna S. Beron, New Jersey
(cat. no. 127)

32. Nike, 1983
Bronze with polychrome patina
67½ × 64½ × 58¼ (171.5 × 163.8 × 148)
Mr. and Mrs. Harold Price, Laguna Beach, California
(cat. no. 132)

33. Penda (Pendula Series), 1983
Bronze with polychrome patina and baked enamel
29¼ × 43 × 18 (74.3 × 109.2 × 45.7)
Private collection
(cat. no. 135)

34. Rotota, 1983
Bronze with polychrome patina
73½ × 44½ × 30 (186.7 × 113 × 76.2)
Dr. J. H. Sherman, Baltimore
(cat. no. 139)

35. Aspira (Glass Series), 1984
Baked enamel on bronze
35½ × 21½ × 11 (90.2 × 54.6 × 27.9)
The Frito-Lay Collection, Plano, Texas
(cat. no. 157)

36. Bel-Smelt, 1984
Bronze with polychrome patina and baked enamel
44¾ × 96 × 19 (113.7 × 243.8 × 48.3)
Richard and Barbara Lane, New York
(cat. no. 158)

37. Pendelance (Pendula Series), 1984
Bronze and steel with polychrome patina
51 × 41 × 24½ (129.5 × 104.1 × 62.2)
Candida N. Smith, New York
(cat. no. 171)

38. Pinocchio (Pendula Series), 1984
Bronze with polychrome patina and baked enamel
92½ × 28 × 41 (235 × 71.1 × 104.1)
Private collection
(cat. no. 172)

39. Rebus, 1984
Baked enamel on bronze and stainless steel with polychrome patina and
oil paint
95 × 48½ × 43 (241.3 × 123.2 × 109.2)
Neuberger Museum, State University of New York at Purchase, museum
purchase with funds from Friends of the Neuberger Museum and support
from the Frances and Benjamin Benenson Foundation and Lois and
Philip Steckler
(cat. no. 173)

40. Span-Spun, 1984
Bronze with polyurethane paint
93 × 62½ × 31 (236.2 × 158.8 × 78.7)
Private collection
(cat. no. 174)

41. Tanz (Glass Series), 1984
Baked enamel on bronze
19 × 19½ × 10 (48.3 × 49.5 × 25.4)
Ann and Robert Freedman, New York
(cat. no. 175)

42. Trax, 1984
Bronze with polychrome patina and baked enamel
24 × 23¼ × 20½ (61 × 59.1 × 52.1)
Private collection
(cat. no. 178)

43. Closed-Open-Down, 1985
Bronze and steel with polyurethane paint and baked enamel
63 × 82 × 74½ (160 × 208.3 × 189.2)
Private collection
(cat. no. 186)

44. Hay Fervor, 1985
Bronze and steel with polychrome patina, baked enamel, and
polyurethane paint
95¾ × 87 × 38½ (243.2 × 220.9 × 97.8)
Private collection
(cat. no. 193)

45. Looping, 1985
Bronze and steel with polyurethane paint and baked enamel
106 × 41¾ × 29¼ (269.2 × 106 × 74.3)
Private collection
(cat. no. 199)

46. The Singer, 1985
Bronze with polyurethane paint
56 × 33½ × 25 (142.2 × 85.1 × 63.5)
Private collection
(cat. no. 209)

47. Variable Forms, 1985
Bronze and steel with polyurethane paint and baked enamel
20½ × 25 × 27 (52.1 × 63.5 × 68.6)
Mr. and Mrs. George M. Young, Fort Worth, Texas
(cat. no. 222)

48. Wheelabout, 1985
Bronze and steel with polyurethane paint
92½ × 70 × 32½ (235 × 177.8 × 82.6)
The Fort Worth Art Museum, gift of Mr. and Mrs. Sid R. Bass
(cat. no. 225)

49. Cuboid Spheres, 1986
Steel and bronze with polychrome patina
64½ × 52½ × 41 (163.8 × 133.4 × 104.1)
Private collection
(Not in catalogue)